# Harry Potter™

## MAGICAL PLACES

*from the Films*

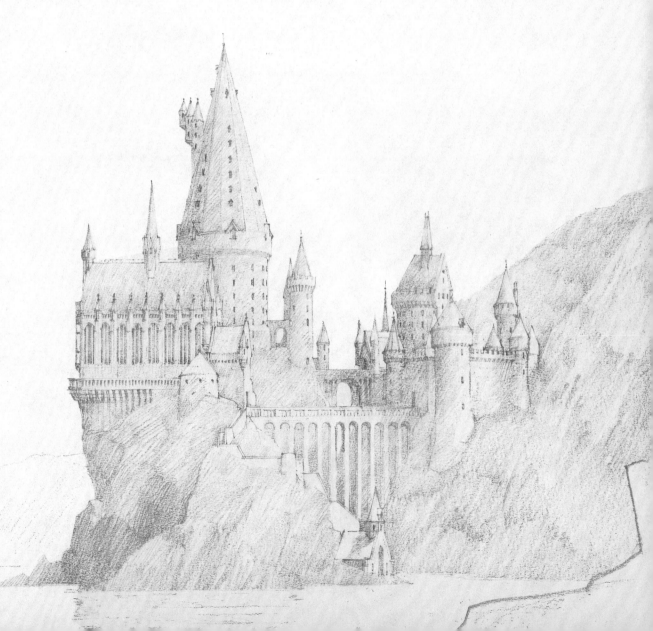

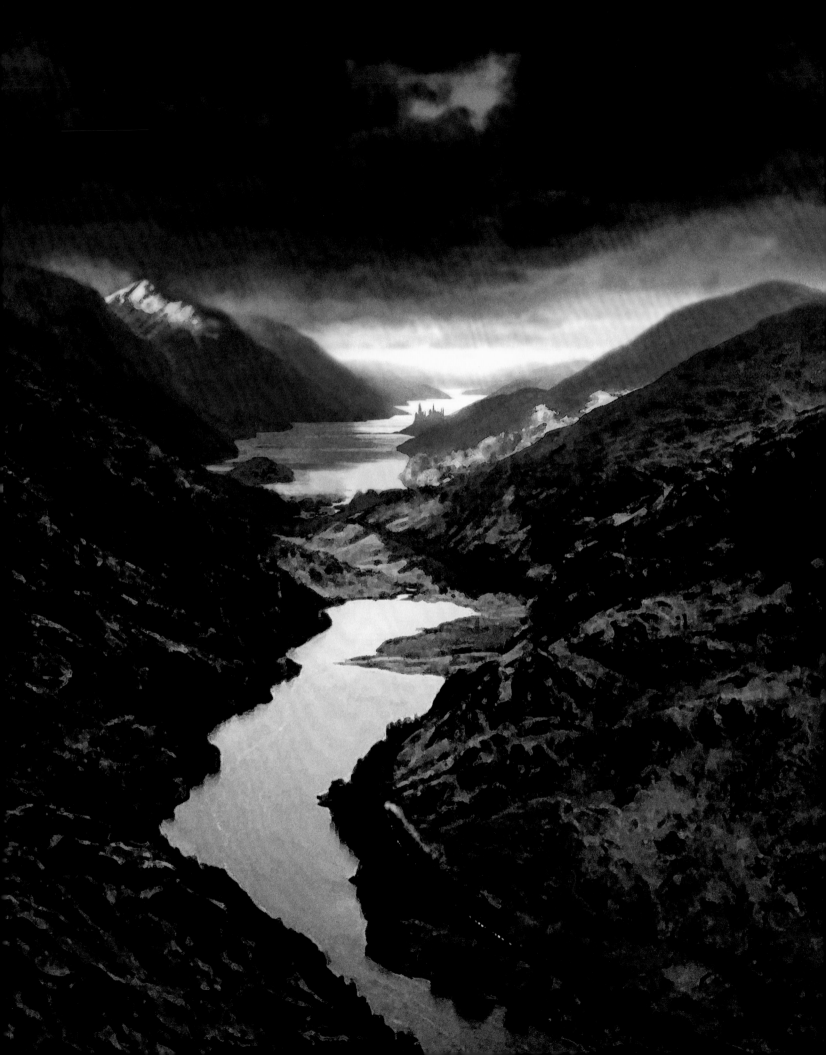

# Harry Potter™

# MAGICAL PLACES

## from the Films

### HOGWARTS, DIAGON ALLEY, AND BEYOND

BY JODY REVENSON

HARPER DESIGN
An Imprint of HarperCollins Publishers

*An Insight Editions Book*

# CONTENTS

*Introduction* ........................................................ 7

CHAPTER 1: THE DURSLEYS' HOUSE ...................... 13
Number Four, Privet Drive

CHAPTER 2: DIAGON ALLEY ................................... 21
The Leaky Cauldron * Diagon Alley * Gringotts
Wizarding Bank * Ollivanders Wand Shop *
Flourish and Blotts * Weasleys' Wizard
Wheezes * St Mungo's Hospital for Magical
Maladies and Injuries

CHAPTER 3: KING'S CROSS STATION ..................... 45
King's Cross Station * Platform Nine and
Three-Quarters * The Hogwarts Express

CHAPTER 4: HOGWARTS CASTLE ........................... 55
Hogwarts Castle * Moving Staircases * The Great
Hall * Gryffindor Common Room * Gryffindor
Boys' Dormitory * Slytherin Common Room *
Owlery * Library * Hospital Wing * Prefects'
Bathroom * Chamber of Secrets * Room of
Requirement * Astronomy Tower

CHAPTER 5: HOGWARTS CLASSROOMS
AND OFFICES .......................................................... 99
Herbology Greenhouse * Defense
Against the Dark Arts Classroom *
Dolores Umbridge's Office * Divination
Classroom * Potions Classroom * Horace
Slughorn's Office * Headmaster's Office *
Transfiguration Classroom * Astronomy
Classroom * Charms Classroom

CHAPTER 6: HOGWARTS GROUNDS ...................... 121
Hogwarts Grounds * Forbidden Forest *
Hagrid's Hut * Clock Tower and Courtyard *
The Bridge and Stone Circle * Quidditch Pitch *
Triwizard Tournament Arenas * Boathouse

CHAPTER 7: HOGSMEADE ...................................... 145
Hogsmeade Village * Hogsmeade Station * The
Shrieking Shack * The Hog's Head * The Three
Broomsticks * Honeydukes

CHAPTER 8: MINISTRY OF MAGIC...................... 161
  Ministry of Magic * Trial Chamber * Hall
  of Prophecy * Muggle-Born Registration
  Commission and Office

CHAPTER 9: WIZARDING HOMES........................ 175
  Grimmauld Place * Shell Cottage * Godric's
  Hollow * Lovegood House * Budleigh Babberton *
  Wool's Orphanage * Little Hangleton Graveyard *
  Malfoy Manor * Spinner's End * The Burrow

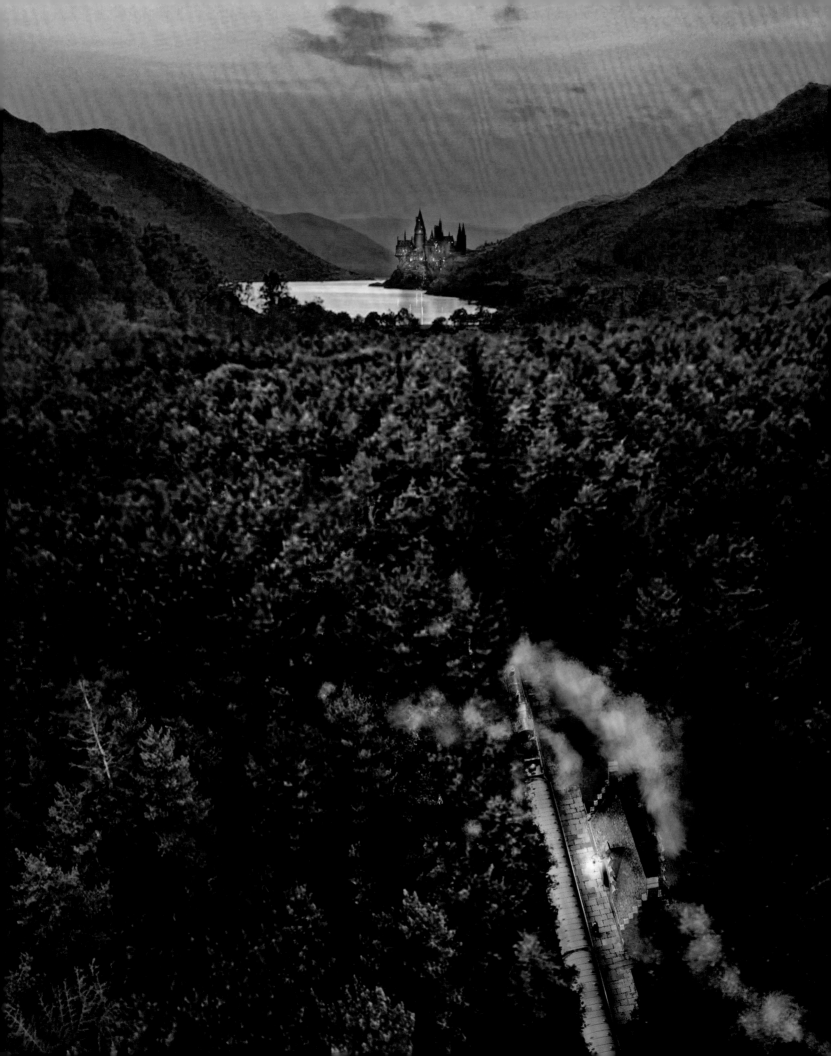

# INTRODUCTION

The world we journey through in the *Harry Potter* films is magical and extraordinary and completely believable. From a bank run by goblins to a castle filled with staircases that move from a sport played on flying broomsticks to a cottage built out of shells, we are continually taken to new and incredible places, following a young boy who has discovered a world he never knew existed, but one he—and we—quickly accept as authentic and credible.

Credibility was of the utmost importance to Production Designer Stuart Craig, who agreed to take on the construction of a cinematic version of the wizarding world of J.K. Rowling's novels. Craig had a list of questions from the start, all of which were answered in his first meeting with the author. Finding a sheet of paper and a pen, Rowling drew him a map of Hogwarts and its surroundings—Hogsmeade, the lake, the Quidditch pitch, the Forbidden Forest, even the Whomping Willow. "It was all there in this very simple map," says Craig. "It was the ultimate authority, this piece of paper, and I referred to it throughout the ten years of filming."

To help him populate the classrooms and houses, Craig brought aboard set decorator Stephenie McMillan. She and her team purchased from flea markets and antique shops, rented from stock companies, and frequently constructed original furniture and props. She employed a knitter whose efforts covered the Weasleys' dubious furnishings. She worked with

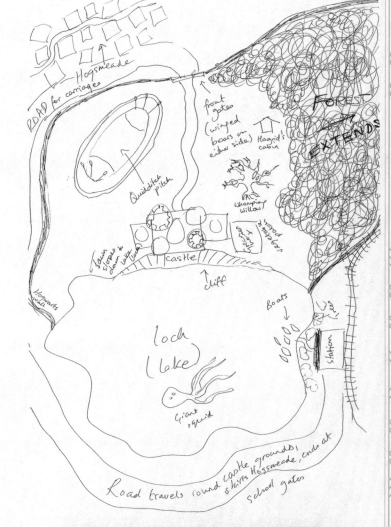

OPPOSITE: *The Hogwarts Express approaches Hogwarts castle in concept art by Andrew Williamson for* Harry Potter and the Half-Blood Prince. ABOVE RIGHT: *The map of Hogwarts castle and grounds that J.K. Rowling drew during her first meeting with Stuart Craig.* BELOW: *Concept art by Andrew Williamson for* Harry Potter and the Chamber of Secrets.

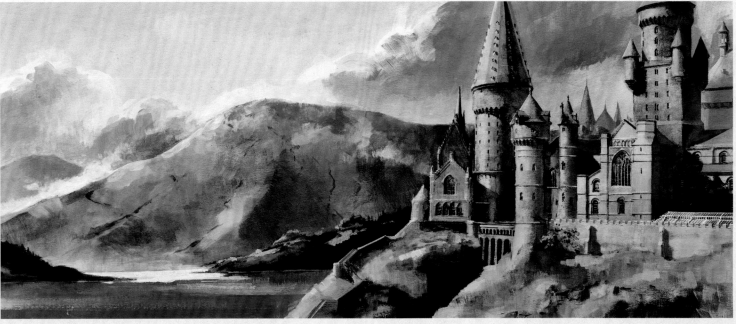

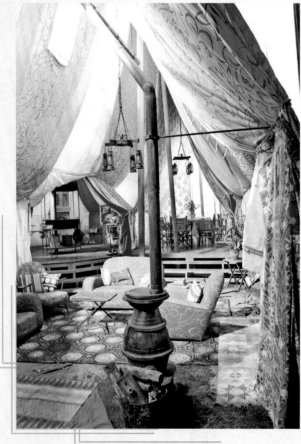

the costumes department to coordinate the fabric for Professor Horace Slughorn's chair and pajama incarnations. McMillan made it a policy to consult with the actors about the spaces that were personal to them. She asked Alan Rickman (Professor Severus Snape) his thoughts about the set for Spinner's End in *Harry Potter and the Half-Blood Prince*; he asked her to remove items that seemed too personal. Her consultation with Emma Watson (Hermione Granger) about her character's room in *Harry Potter and the Deathly Hallows – Part 1* yielded one key piece of advice: add more books.

Each film brought new places and new challenges. The team of Craig and McMillan worked with producers David Heyman and David Barron, directors Chris Columbus, Alfonso Cuarón, Mike Newell, and David Yates, and author J.K. Rowling. Conceptual artists Adam Brockbank, Andrew Williamson, and Dermot Power, among others, developed looks for the locations based on pencil sketches that Stuart Craig provided. These ideas would then become dimensional, physically or digitally, utilizing time-honored methods or newly developed techniques. The art department crews included fabricators, sculptors, modelers, plasterers, and carpenters. Propmakers filled Diagon Alley with cauldrons and cages. Art directors supervised the creation of paintings to hang on the staircase walls. Graphic artists labeled potion vials, wrapped Weasleys' Wizard Wheezes products, and posted signs in Flourish and Blotts.

For the first few *Harry Potter* films, the production company took advantage of existing locations for time and budgetary reasons. Craig and his location scouts searched out universities and cathedrals in England that could represent Hogwarts castle and give it the timelessness that a roughly thousand-year-old institution merited. Stephenie McMillan knew that these disparate places needed to connect, even on a subconscious level, and so made sure that recognizable objects were always available so that locations

LEFT: *The set for the Weasley family's spacious tent at the Quidditch World Cup, used in* Harry Potter and the Goblet of Fire. TOP: *Concept art by Andrew Williamson for* Harry Potter and the Deathly Hallows – Part 1. OPPOSITE: *Art by Dermot Power shows a view of Hogwarts from the Forbidden Forest.*

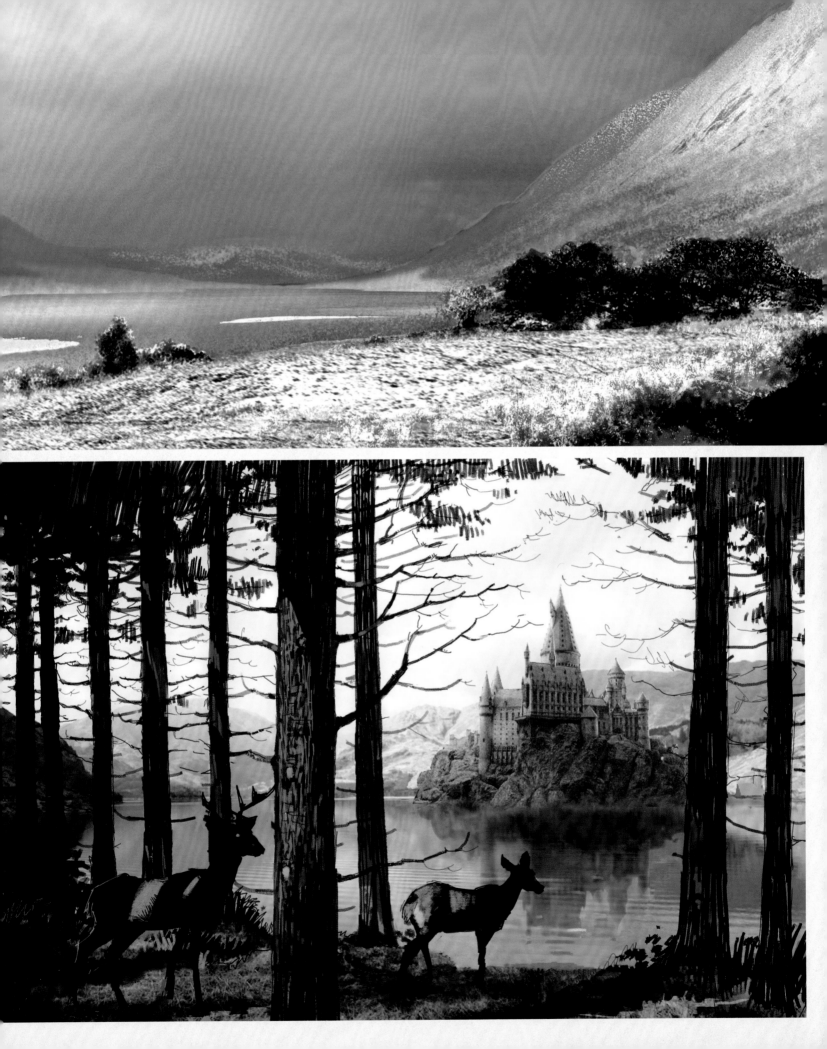

matched. "We had several five-foot-high columns topped by owl-shaped lamps that were portable," explains McMillan. "So between Oxford [University] and Durham Cathedral, for instance, we took our owl lamps with us, placed them in the corridors, and made both places look like Hogwarts."

As the films continued, sets were re-created at Leavesden Studios, a 1940s airplane engine factory that had been converted into a film studio. David Heyman, who was looking for a space large enough to shoot the films, was shown the area—which had half a million square feet of space surrounded by eighty acres of land—and he knew he had found a place they could call their own. Throughout the series, footage of the magnificent Scottish Highlands was filmed for use as establishing shots, inspiration for matte paintings, and digitally composited backdrops. A miniature model was also crafted, which was eventually scanned into the computer. The spires and towers of Hogwarts appeared and disappeared as the story required, and Stuart Craig took advantage of these opportunities to redesign the silhouette of the castle and its environs, noting that "Nobody seemed to mind. They seemed to accept that that was part of a magical world."

This magical world has inspired the imaginations of Harry Potter fans everywhere. Who wouldn't want to share a Butterbeer at the Three Broomsticks, spend hours perusing the candies in Honeydukes, or overnight at The Burrow with the Weasleys? We know that all we have to do is tap a brick wall behind the Leaky Cauldron to enter. Following is a compilation of noteworthy behind-the-scenes information, informative screen captures, and captivating artwork showcasing the wondrous places we visit on-screen in the *Harry Potter* films.

THESE PAGES, CLOCKWISE FROM TOP RIGHT: *Art by Dermot Power for* Harry Potter and the Chamber of Secrets *shows a river next to the Quidditch pitch—a piece of geography that did not appear in the films; a blueprint of the Hogwarts gate; concept art by Adam Brockbank.*

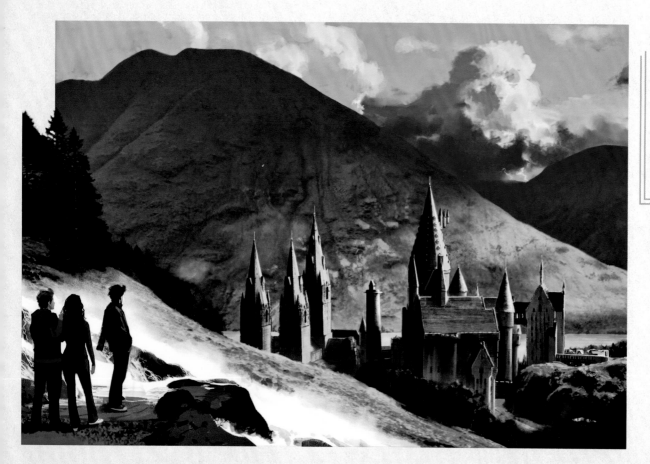

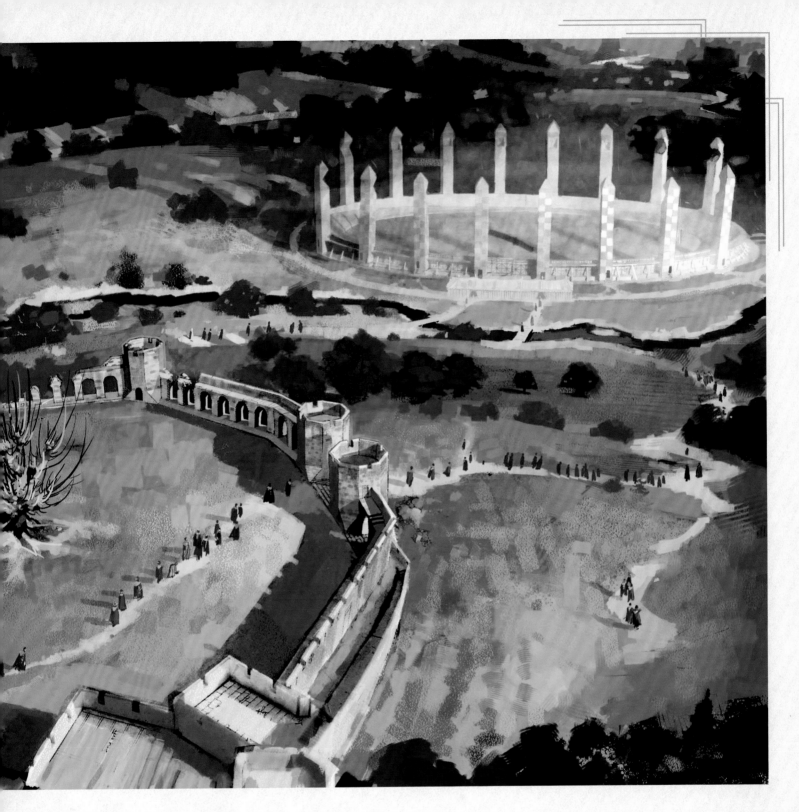

# CHAPTER 1

# THE DURSLEYS' HOUSE

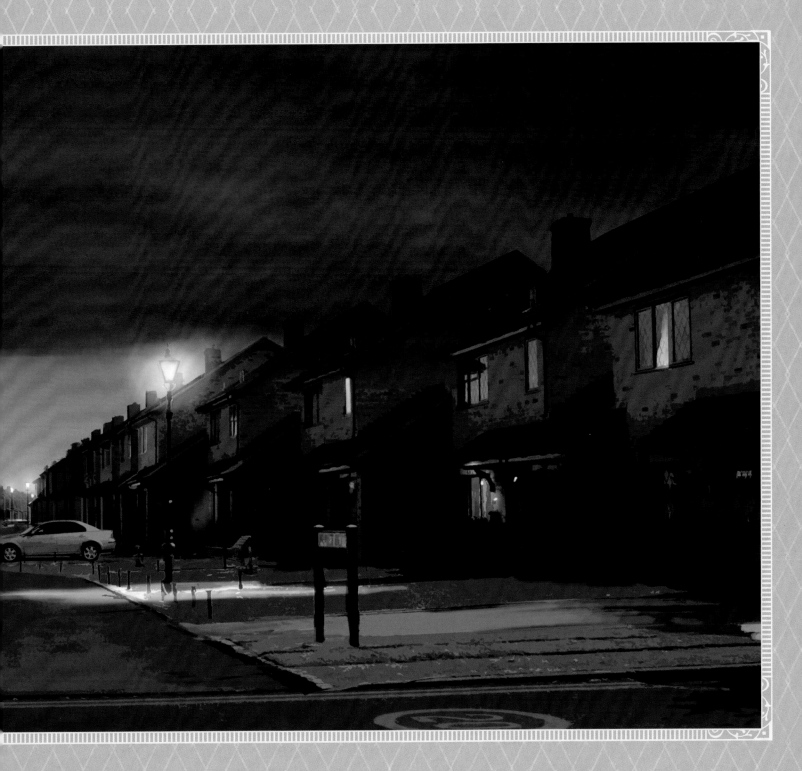

## NUMBER FOUR, PRIVET DRIVE

Number four, Privet Drive, is the residence of the Dursleys—Vernon, Petunia, and their son, Dudley—and, to their chagrin, of Petunia's nephew, Harry Potter. As first seen in *Harry Potter and the Sorcerer's Stone*, the Dursleys make Harry sleep in the cupboard under the stairs, and they deny his wizard heritage. Harry later learns that he needed to stay with the Dursleys until he was seventeen as a form of protection against Voldemort.

The director of the first two *Harry Potter* movies, Chris Columbus, states simply, "Privet Drive had to feel like this mean, awful place." Author J.K. Rowling said that she imagined the house in the suburbs of Surrey, which had developed, like many post–World War II neighborhoods, into a "ribbon development" where identical-looking houses snake along curved, cul-de-sac streets. In consultation with the producers and Production Designer Stuart Craig, Columbus wanted a place "that felt like it would kill any creativity or originality that anyone would ever have who lived there. It was someplace that would not be staggeringly beautiful for the audience, but a place that had a real sense of oppression."

OCCUPANTS: Vernon, Petunia, and Dudley Dursley, Harry Potter

FILMING LOCATIONS: Picket Post Close, Bracknell, Berkshire, England; Leavesden Studios

APPEARANCES: *Harry Potter and the Sorcerer's Stone, Harry Potter and the Chamber of Secrets, Harry Potter and the Prisoner of Azkaban, Harry Potter and the Order of the Phoenix, Harry Potter and the Deathly Hallows – Part 1*

THESE PAGES, CLOCKWISE FROM TOP: *Concept art depicting the limitless stretch of similar homes around Privet Drive; the Privet Drive set; a still showing Harry Potter being dropped off at Number four, Privet Drive, as a baby; a photo of Picket Post Close in Bracknell.*

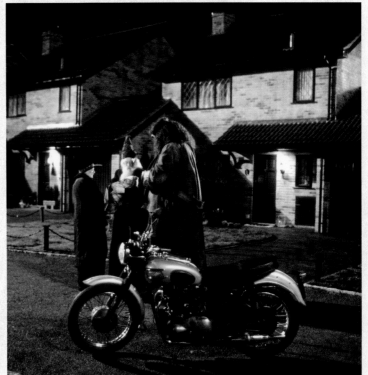
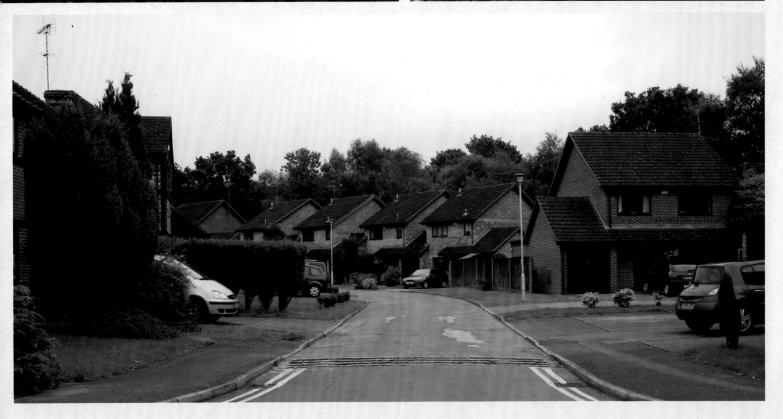

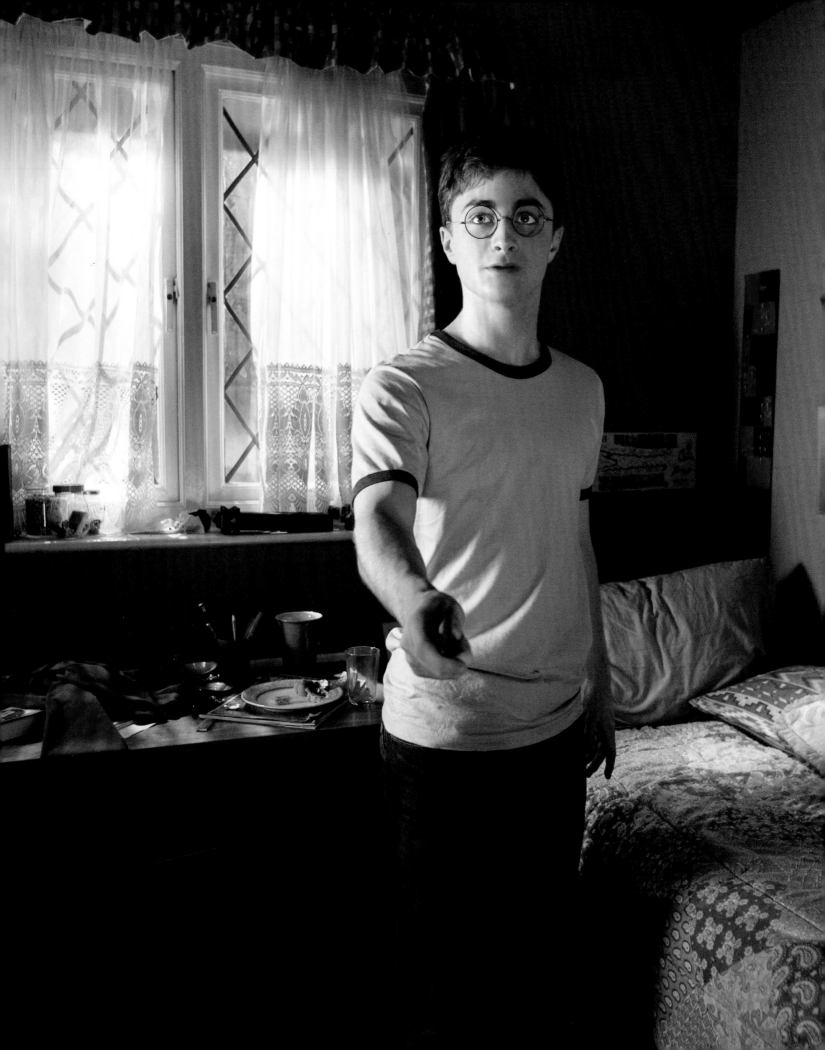

The director was also very interested in capturing the despair of Harry's situation. "There are very few intimate spaces in the movies. Harry's cupboard under the stairs in his aunt and uncle's house is one," says Stuart Craig. "And the cupboard under the stairs would seem all the more desperate if he was in a huge urban sprawl. This was the biggest possible contrast with the magical world, really."

Bracknell, a neighborhood west of London, fit the bill and filming for the first film commenced. To add to the sense of conformity, the same manufacture of car was parked at each house. But by the end of the shoot, the filmmakers realized that this was a less than optimal situation for residents. The night shoots required bright lights on the street, and owls flew around during the day. The team knew this was too much to ask of the locals. "So, we came back to the studio [for the second film] and reproduced those houses exactly," says Craig. And that set, with five houses on either side of the street, was used through the entirety of the film series. The street was extended by a matte painting "limitlessly, to the horizon," Craig describes. "Chris's request was that it be that big and that sprawling. And in the center of it was Harry's cupboard under the stairs." The cupboard was so small, in fact, that it needed to be constructed with removable walls, called "wild" walls, in order to film from different angles.

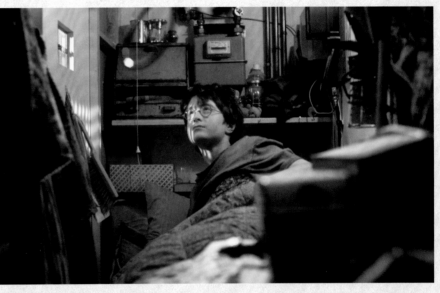

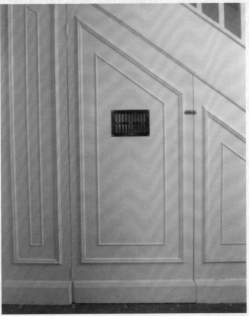

FAR LEFT: *A still of Harry Potter (Daniel Radcliffe) in* Harry Potter and the Order of the Phoenix. ABOVE: *Harry in his cupboard under the stairs in* Harry Potter and the Sorcerer's Stone. LEFT: *The door to the cupboard.*

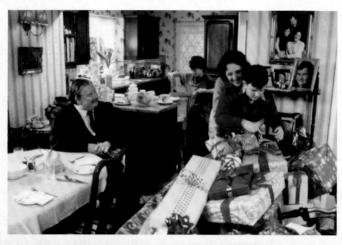

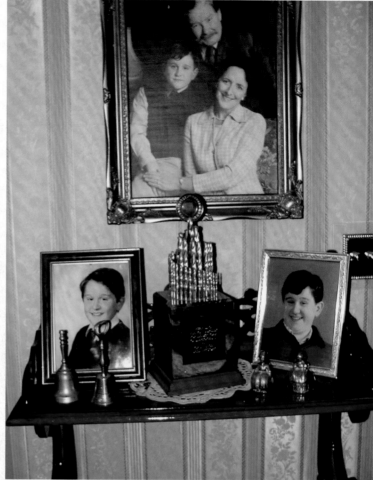

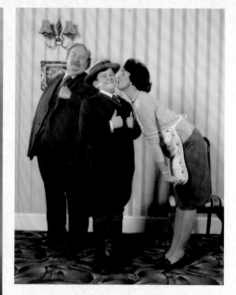

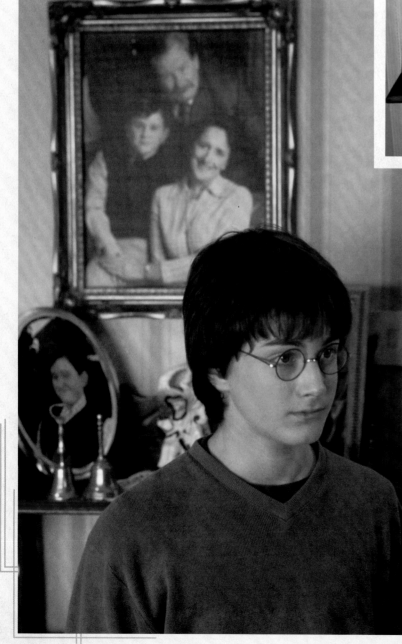

THIS PAGE, CLOCKWISE FROM TOP LEFT: *Harry makes breakfast for the Dursleys as Dudley (Harry Melling) complains about having only thirty-six presents to open in* Harry Potter and the Sorcerer's Stone; *photographs of the Dursley family along with one of Dudley's trophies; a dapper, self-satisfied Dudley stands with his family; Harry (Daniel Radcliffe) in* Harry Potter and the Chamber of Secrets.

The interior of the Dursley residence contrasts greatly with its bland, featureless exterior. "There is a brash vulgarity there that we haven't denied," Craig admits. "It's not particularly tasteful." He had worked with set decorator Stephenie McMillan on several films prior to their association on the *Harry Potter* films, and he describes her taste as exquisite. "I'm constantly amazed how she is able to adopt somebody else's taste—in this case, Petunia Dursley's—and do it so successfully." McMillan notes that they looked "for the ugliest sofas; the worst tiles for the kitchen; the shiniest, most horrible fireplace," and the furniture needed to be in "really nasty colors."

## "THEY'RE THE WORST SORT OF MUGGLES IMAGINABLE."

Professor McGonagall, *Harry Potter and the Sorcerer's Stone*

The majority of the furniture was purchased in shops in Watford, to which McMillan jokingly apologized for any poor impressions. Myriad pictures of Dudley adorn every mantel and shelf, capturing his growth through the years, as do certificates of Dudley's dubious achievements. Created by the graphics department, the certificates proclaim Dudley's acumen at such skills as "always eating his lunch," and a Smeltings Academy document, complete with an image of a leaping salmon, lauds him for swimming five meters (fifteen feet).

*Stephenie McMillan sought out bourgeois furnishings to decorate the Dursley home (above and left), and augmented the set with vulgar pieces such as this image of Dudley eating a hot dog.*

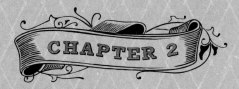

# DIAGON ALLEY

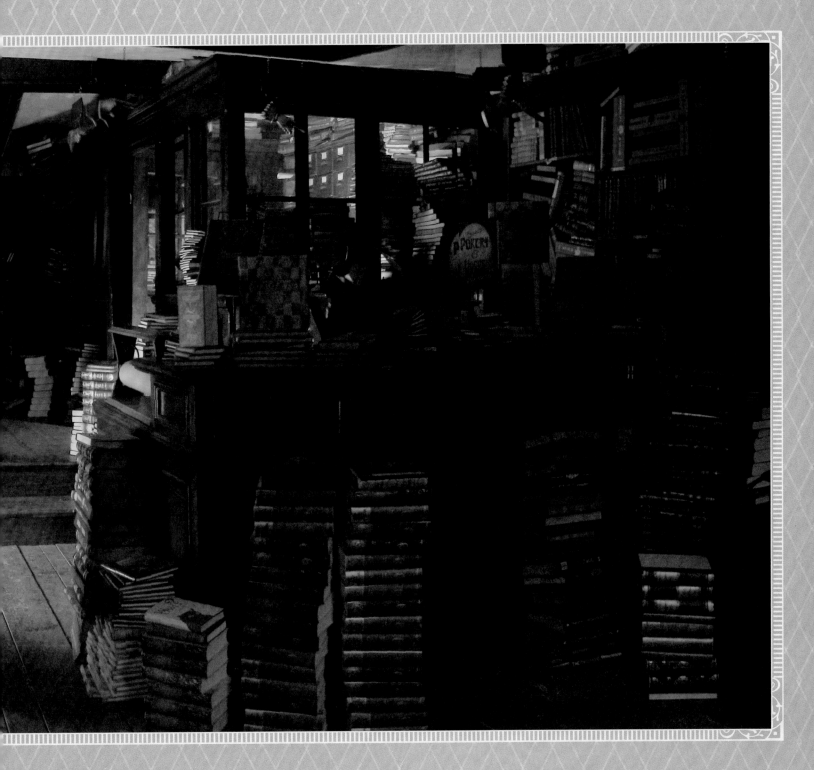

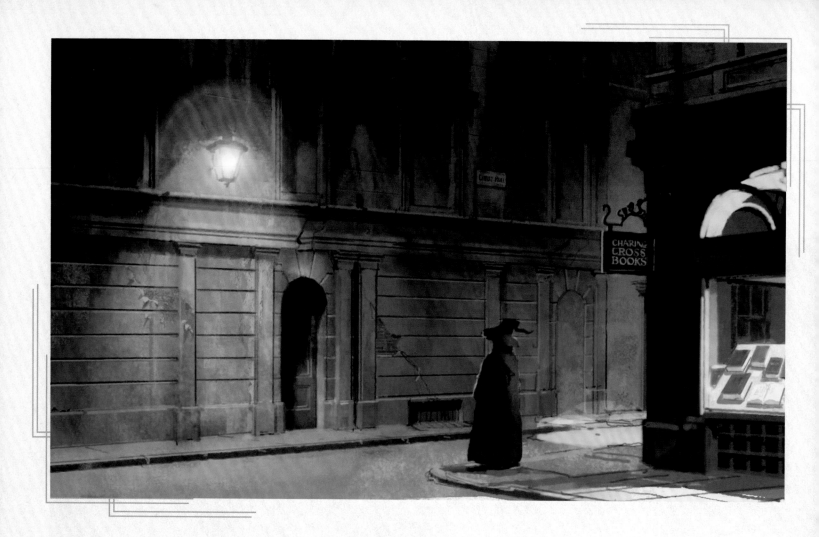

# THE LEAKY CAULDRON

In *Harry Potter and the Sorcerer's Stone*, Rubeus Hagrid brings Harry to the Leaky Cauldron, a London tavern and inn, and reveals it to be the entryway to Diagon Alley and the wizarding world. Behind a nondescript door lies a large dining area complemented by a huge fireplace that blazes under a Tudor-style arch. In the tavern, interior walls of plastered-over brick are framed by long wood beams and tall, trefoiled windows. A chalkboard advertises the Cauldron's luncheon fare, which includes roast hog, game pie, and pickled eel.

Harry returns to the Leaky Cauldron, having been picked up by the Knight Bus, in *Harry Potter and the Prisoner of Azkaban*, where he stays the night before leaving for Hogwarts. While here, Harry also meets the Minister for Magic, Cornelius Fudge, in a private parlor, which is encased in the dark, weathered wood panels that characterize Tudor style. Harry stays in room eleven on the second floor, which has simple plastered walls and a bed with ornately carved bedposts and headboard. "The Tudor room and its Tudor bed were a deliberate choice," says Stuart Craig, "to reinforce the idea that the wizarding world has a different timescale." The view from the window is of London's Borough Market and

the towers of Southwark Cathedral. The corridor, where a chambermaid attempts to provide room service, was created utilizing forced perspective, a time-honored technique used in set decoration that compresses relative heights in order to make places appear taller or longer. In what is in reality ten or so feet of corridor, the illusion of fifty feet is created. As with so many of the visual effects in the *Harry Potter* films, practical solutions could be just as applicable as computer-generated ones, and, as Craig describes, "this was much less expensive and a lot more fun."

OCCUPANTS: Tom, the owner; visiting witches and wizards

FILMING LOCATION: Leavesden Studios

APPEARANCES: *Harry Potter and the Sorcerer's Stone, Harry Potter and the Prisoner of Azkaban*

---

THESE PAGES, CLOCKWISE FROM TOP LEFT: *Concept art of the Leaky Cauldron exterior by Andrew Williamson, created for* Harry Potter and the Prisoner of Azkaban; *two views of the Leaky Cauldron set; the dining area as seen in* Harry Potter and the Prisoner of Azkaban; *other Leaky Cauldron set highlights, including signage, the desk used by Cornelius Fudge, and a pub menu.*

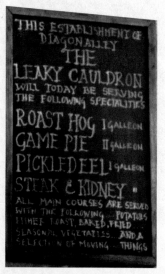

THIS ESTABLISHMENT OF DIAGON ALLEY
THE LEAKY CAULDRON WILL TODAY BE SERVING THE FOLLOWING SPECIALTIES

ROAST HOG  I GALLEON
GAME PIE  II GALLEON
PICKLED EEL I GALLEON
STEAK & KIDNEY  II

ALL MAIN COURSES ARE SERVED WITH THE FOLLOWING POTATOES THREE TOAST, BAKED, FRIED SEASONAL VEGETABLES AND A SELECTION OF MOVING THINGS

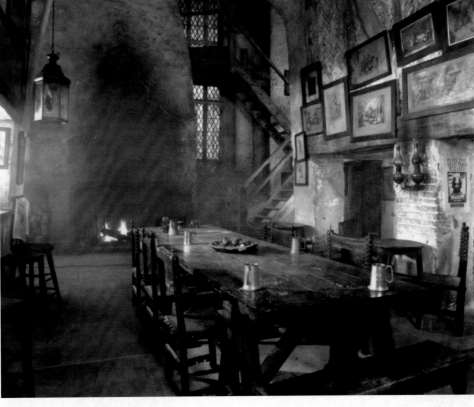

"DID YOU HEAR THAT, ERN? THE LEAKY CAULDRON. THAT'S IN LONDON."

Stan Shunpike, *Harry Potter and the Prisoner of Azkaban*

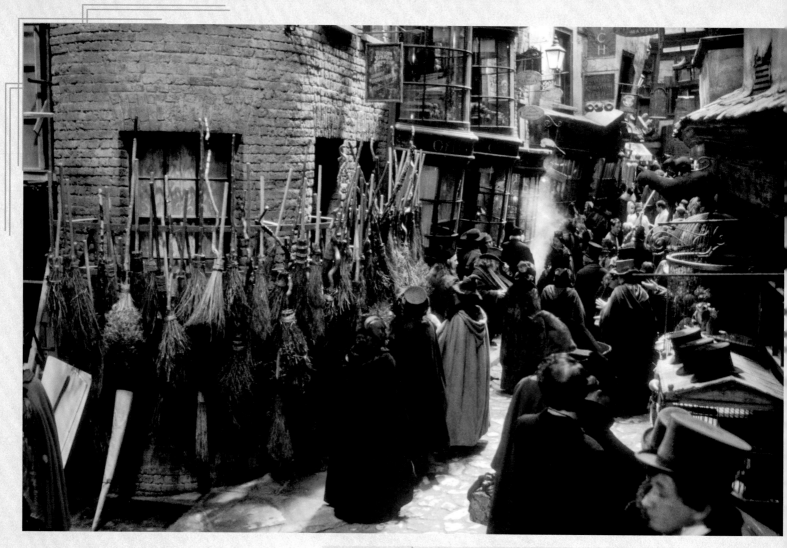

## DIAGON ALLEY

In the films, Diagon Alley is Harry Potter's first introduction to the wizarding world, and it is the film audience's as well. Here, the latest Quidditch brooms are for sale, wizard authors give book signings, and young Hogwarts students can acquire their required supplies—cauldrons, quills, robes, wands, and perhaps an owl, toad, or rat.

"Diagon Alley was one of the first sets we created for *Harry Potter and the Sorcerer's Stone*," recalls Stuart Craig. "We started with the notion of a Dickensian-type street." During his research of the time period, Craig noted that buildings had an interesting structural inclination. "Very, very early Victorian architecture had this gravity-defying *lean*. So we began to explore the idea of architecture that was leaning so much it would appear to be falling over." He also added

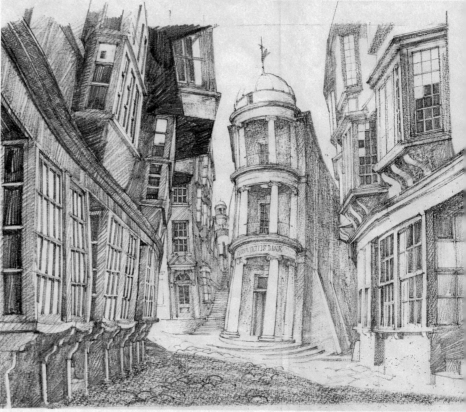

THESE PAGES, CLOCKWISE FROM TOP LEFT: *Diagon Alley shoppers gather near the Magical Menagerie in a scene from* Harry Potter and the Sorcerer's Stone; *views of the Diagon Alley set, including the storefronts of Sugar Plum's Sweetshop and Eeylops Owl Emporium; Hagrid (Robbie Coltrane) and Harry make their way through the alley in* Harry Potter and the Sorcerer's Stone; *a sketch showing the entrance to Gringotts.*

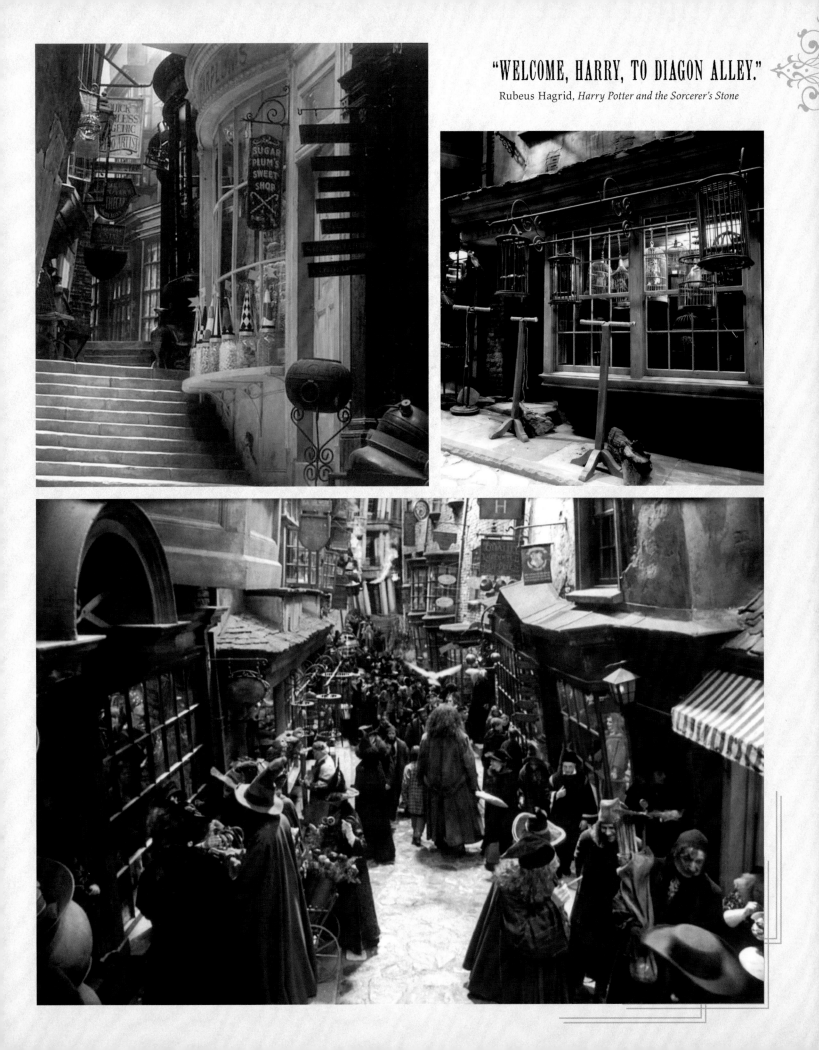

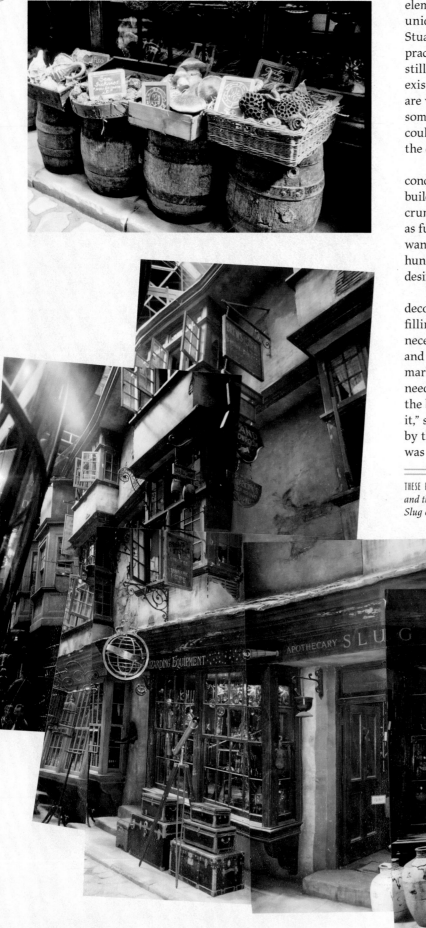

elements of Tudor, Georgian, and Queen Anne styles for a unique architectural mash-up. Director Chris Columbus and Stuart Craig then scouted the London streets, searching for a practical location to film Diagon Alley. "We hoped there were still places that actually looked like that Dickensian world existing somewhere in London," explains Columbus, "but there are very few. And if a place did look like that, there would also be something modern there—a phone booth or a grocery store. We could have tried to work around those, but in order to really have the complete idea, we realized we'd have to build it."

Craig felt that the wizarding world wouldn't be overly concerned with imperfections, and so no one would mind buildings that seemed to be holding one another up: "We wanted crumbling, ancient dereliction. Nothing too smart or done up. It's as full of character as we could possibly make it." Chris Columbus wanted the street to feel not only as if it had been there for hundreds of years but "as if it goes on forever." Craig fulfilled this desire with the use of forced perspective and painted backdrops.

Once the look and design of the street were determined, set decorator Stephenie McMillan and her team took on the task of filling the shops with broomsticks, cauldrons, and other wizard necessities. For this and throughout the film series, McMillan and her assistants scoured antique shops, auctions, and flea markets, as well as having the prop makers construct what they needed. For Diagon Alley, "we took the names of the shops from the book, and any contents mentioned, and then expanded upon it," says McMillan. Often a purchased item would be duplicated by the prop shop to create the amount of stock required. "There was a lot of accumulating to do," McMillan laughs. Fortunately,

THESE PAGES: *Views from the Diagon Alley set, including street wares perched on barrels and the storefronts of Flourish and Blotts, Florean Fortescue's Ice Cream Parlour, and Slug & Jiggers Apothecary.*

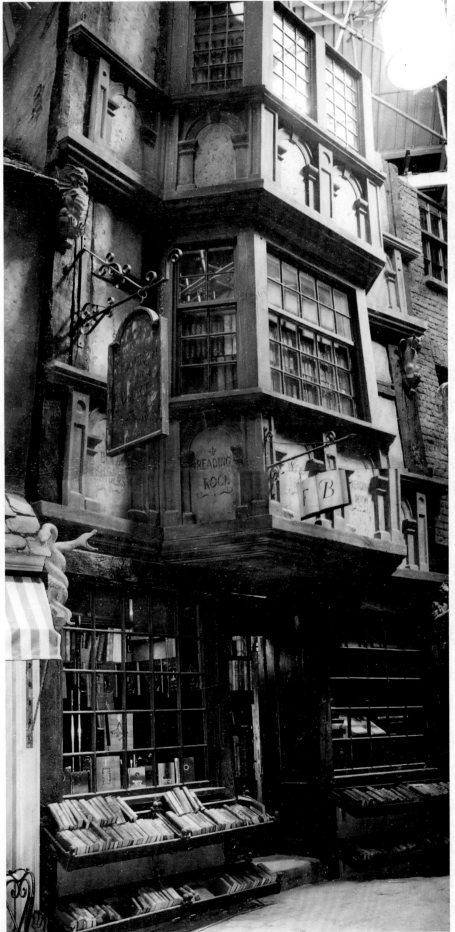

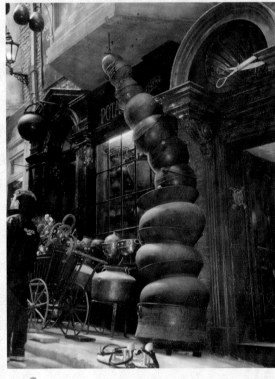

OCCUPANTS: Wizards, witches, goblins, all sort of magical folk and animals

SHOPS: Eeylops Owl Emporium, Potage's Cauldron Shop, Madam Malkin's Robes for All Occasions, Quality Quidditch Supplies, Flourish and Blotts, Gringotts Wizarding Bank, Mr. Mulpepper's Apothecary, Ollivanders Wand Shop, Weasleys' Wizard Wheezes

FILMING LOCATION: Leavesden Studios

APPEARANCES: *Harry Potter and the Sorcerer's Stone, Harry Potter and the Chamber of Secrets, Harry Potter and the Half-Blood Prince, Harry Potter and the Deathly Hallows – Part 2*

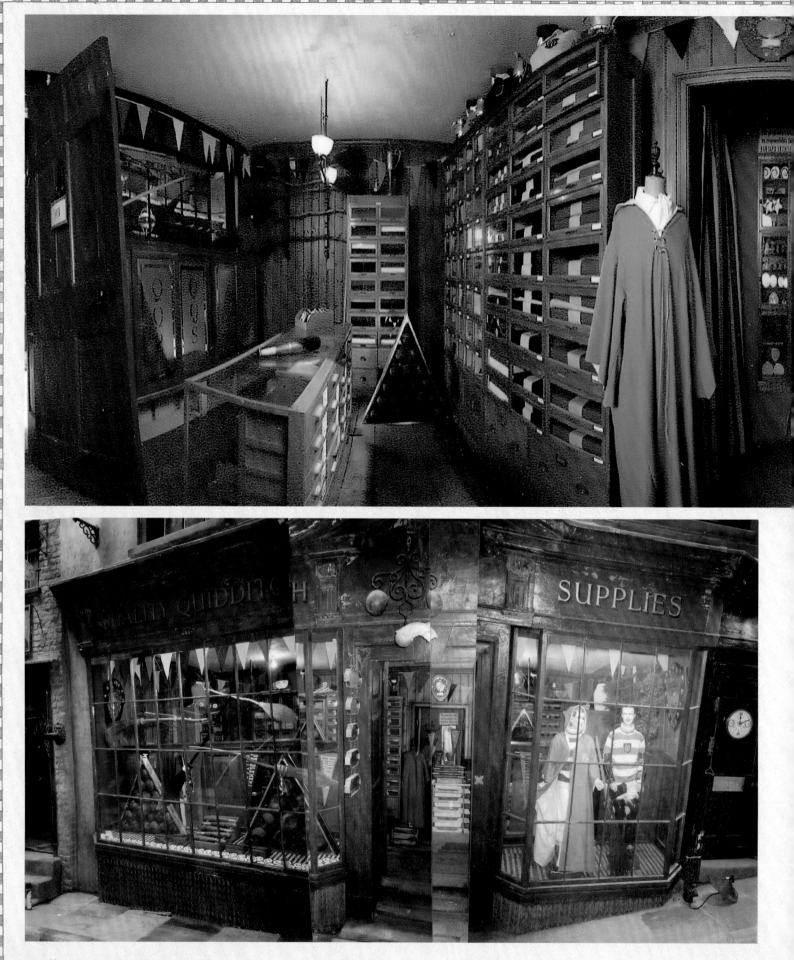

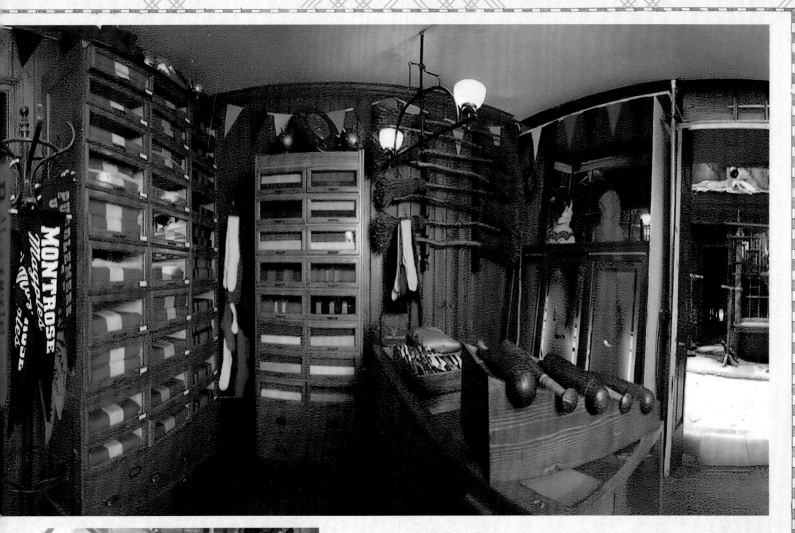

her assistant, an ardent *Harry Potter* fan, made it her mission to catalogue everything with the precision "of a military operation," McMillan adds. The props buyers who looked in the city and countryside were asked not to explain why they needed so many jars, books, and owl cages. One buyer who was amassing an unusually large amount of broomsticks told the shop owner she had a lot of sweeping to do.

Dressing the set was its own adventure. Stacks of cauldrons teeter in front of Potage's shop; brooms literally hover next to Quality Quidditch Supplies. Mr Mulpepper's Apothecary, a potions shop created for the films and video games, was constructed with shelves ten feet wide and twenty-four feet high. "Only one prop man could dress it at a time," explains McMillan, "and he needed a cherry picker in order to reach all the shelves."

The passion in constructing Diagon Alley and the attention to detail paid off when author J.K. Rowling made a visit to the set. "I wasn't there," says McMillan, "but I was told she just stood there almost with a tear in her eye because it was exactly as she had imagined it from the book." Chris Columbus admitted to being a little nervous before touring the set with Rowling, but "I walked her through Diagon Alley and she loved it."

THESE PAGES: *The set for Quality Quidditch Supplies was painstakingly dressed with brooms, banners, and uniforms.*

# GRINGOTTS WIZARDING BANK

Hagrid takes Harry to Gringotts Wizarding Bank in *Harry Potter and the Sorcerer's Stone* to get money to purchase supplies for Harry's first year at Hogwarts. Run by goblins, Gringotts is, above ground, an impressive, three-story building. Yet the marbled main hall sits atop many strata of underground vaults, the oldest and most protected of which are at the deepest level. The vaults are accessed via twisting tracks traveled by small carts. Stuart Craig wanted Gringotts to exemplify the best attributes of a bank. "Banks are traditionally symbols of stability," he explains. "That is the intention in bank architecture—to convey a feeling of reassurance." For *Harry Potter and the Sorcerer's Stone*, the filmmakers filmed in a real-life location, Australia House, which is the longest continuously occupied foreign mission in London. Australia House's Beaux Arts interior gave Craig the proportions he desired, which contrasted perfectly with its inhabitants. "Everything should conspire to make the goblins look very small and to make the bank look—as banks do—dignified, solid, and important," he says. "So our banking hall, like others, is made of marble, with big marble columns." Desks were created to line the hall, as well as ledgers, quills, and metal coins: Knuts, Sickles, and Galleons, which too frequently disappeared from the set. The lower vaults were built in the studio and visually extended with matte paintings and special effects. The intricate mechanism that clicks and shifts while unlocking the door to vault 687 in *Sorcerer's Stone* and to the Lestrange vault in *Deathly Hallows – Part 2* was a practical effect crafted by Mark Bullimore, who did the same for the snake-locked door to the Chamber of Secrets.

Harry returns to Gringotts with Ron Weasley, Hermione Granger, and the goblin Griphook in

THESE PAGES, CLOCKWISE FROM TOP LEFT: *Knuts, Sickles, and Galleons designed for the films; concept art depicts one of Gringotts's track-bound carts; detailed receipts were created as props; blue screen was used on the set in* Harry Potter and the Sorcerer's Stone *to film the cart traveling on the track; goblin bankers at work in a scene from* Harry Potter and the Deathly Hallows – Part 2.

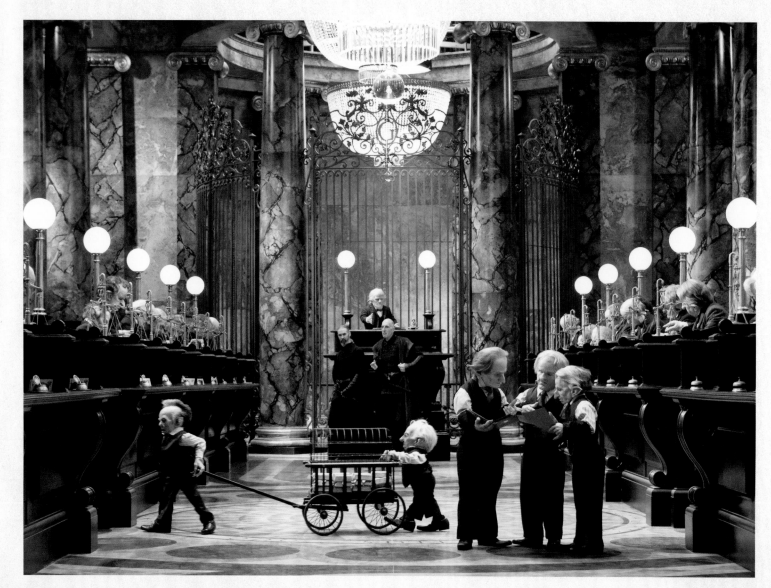

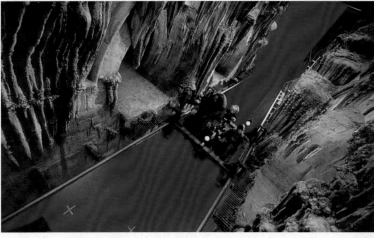

"WELL, THERE'S YOUR MONEY, HARRY. GRINGOTTS, THE WIZARD BANK. T'AIN'T NO SAFER PLACE, NOT ONE, 'CEPT, PERHAPS, HOGWARTS."

Rubeus Hagrid, *Harry Potter and the Sorcerer's Stone*

OCCUPANTS: Goblins

FILMING LOCATIONS: Australia House, The Strand, London, England; Leavesden Studios

APPEARANCES: *Harry Potter and the Sorcerer's Stone, Harry Potter and the Deathly Hallows – Part 2*

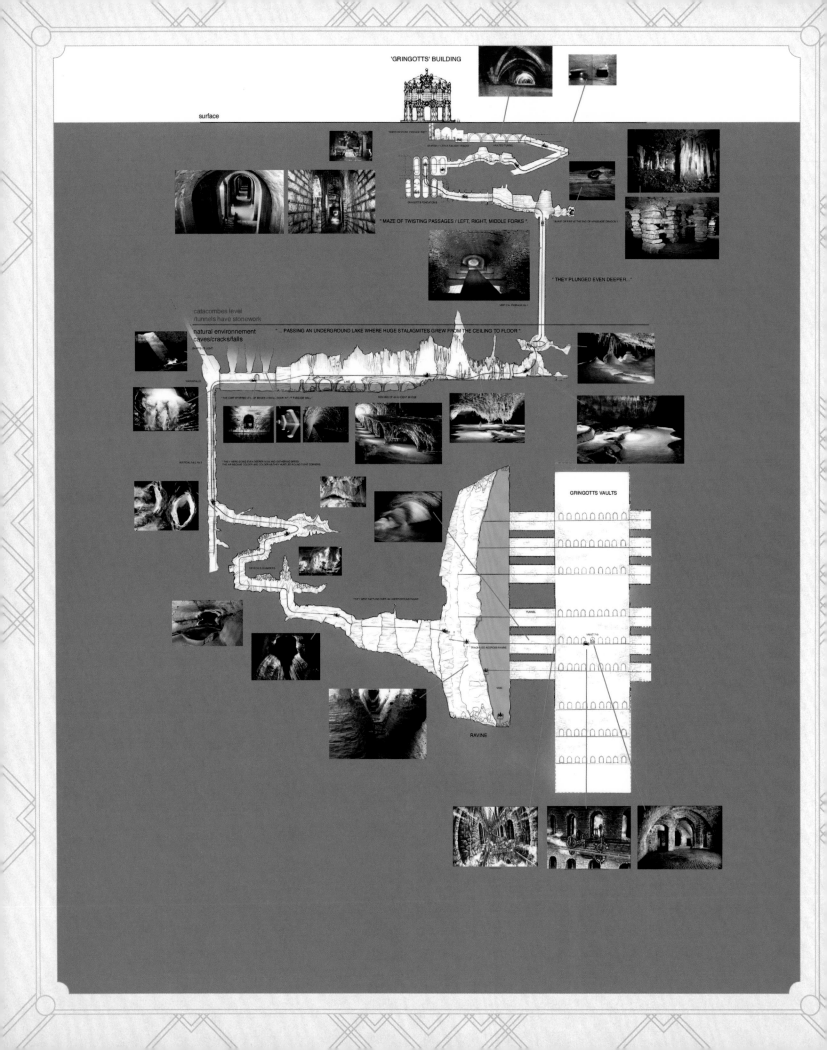

'GRINGOTTS' BUILDING

surface

" NARROW STONE PASSAGE WAY "

STATION / LITTLE RAILWAY TRACKS

HAUTES TUNNEL

ON PASSETS FONDATIONS

" MAZE OF TWISTING PASSAGES / LEFT, RIGHT, MIDDLE FORKS ".

" BURST OF FIRE AT THE END OF A PASSAGE DRAGON ? "

" THEY PLUNGED EVEN DEEPER... "

VERTICAL PASSAGE No 1

catacombes level
/tunnels have stonework

natural environnement
caves/cracks/falls

SHAFTS OF LIGHT

" ... PASSING AN UNDERGROUND LAKE WHERE HUGE STALAGMITES GREW FROM THE CEILING TO FLOOR ".

WATERFALLS

" THE CART STOPPED IT 5 - ST BESIDE A SMALL DOOR IN T- " PASSAGE WALL "

REMAINS OF AN ACIENT BRIDGE

VERTICAL FALL No 2

" THEY WERE GOING EVEN DEEPER NOW AND GATHERING SPEED
THE AIR BECAME COLDER AND COLDER AS THEY HURTLED ROUND TIGHT CORNERS.

CRYSTALS CHAMBERS

GRINGOTTS VAULTS

" THEY WENT HURTLING OVER AN UNDERGROUND RAVINE "

TUNNEL

TRACKS GO ACCROSS RAVINE

VOID

VAULT 713

RAVINE

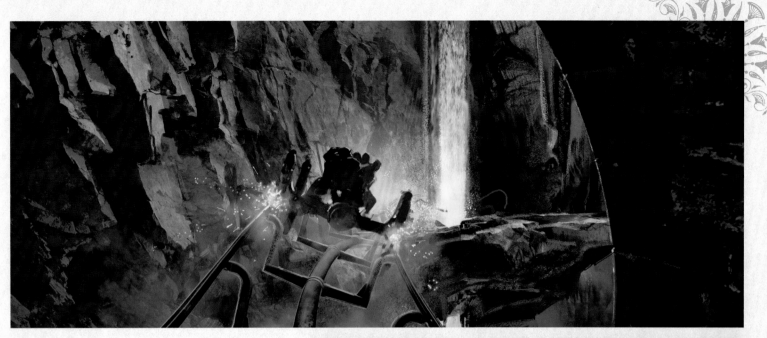

*Harry Potter and the Deathly Hallows – Part 2* in an effort to retrieve a Horcrux from the Lestrange vault, during which the bank is damaged by an escaping dragon. "It smashes out of its pen, smashes through the top of a cave hundreds of feet above, smashes through the banking hall, and up through the glass roof. We obviously could not go back to Australia House," says Craig with a smile, and so the bank was duplicated at Leavesden Studios. For this iteration, the marble columns and floor were constructed using paper. "We had quite a considerable faux-marble-making factory," he says, which worked like oil on water—literally. To make marble paper, oil paint is swirled on top of a large, square, water-filled container, then special paper is placed on top. "As you pull the paper up, the oil paint that sticks to it looks very like swirly marble. All that's needed is a bit of finishing brushwork," Craig explains. The design team also utilized large digital printers that made copies of the marbleized paper at widths up to twelve feet. The chandeliers, each with a twelve-foot diameter, were strung with thousands of injection-molded "crystals," which were painstakingly assembled following a precise order. However, he admits, "They were supposed to measure sixteen feet from top to bottom. We made the bottom half physically and then the top half was a computer-generated addition." The bank tellers' props of scales and desks were brought out of storage, with the desks receiving a new paint job and a slightly refined redesign. This time around, the original metal coins were made in plastic and glued together in stacks.

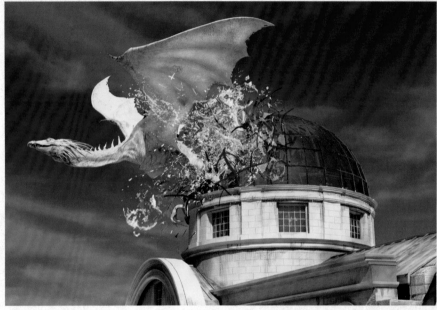

OPPOSITE: *A schematic created for* Harry Potter and the Sorcerer's Stone *diagrams Gringotts's labyrinthine tunnels, showing how the carts (top and right) travel to the vaults.* ABOVE: *Concept art by Paul Catling depicts the dragon escaping through Gringotts's domed roof.*

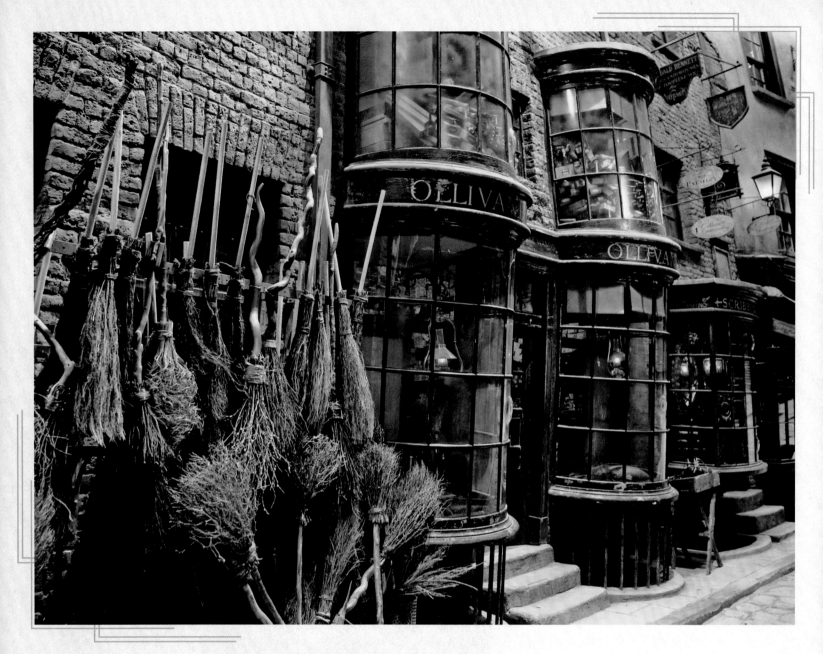

# OLLIVANDERS WAND SHOP

OCCUPANT:
Mr. Ollivander

FILMING
LOCATION:
Leavesden Studios

APPEARANCES:
*Harry Potter and
the Sorcerer's Stone,
Harry Potter and the
Half-Blood Prince*

Every wizard must have a wand, so on his first trip to Diagon Alley in *Harry Potter and the Sorcerer's Stone*, Harry Potter visits Ollivanders, "Makers of Fine Wands since 382 BC."

More than seventeen thousand boxes of wands were stacked, heaped, stuffed, packed, and crammed throughout the shop set for *Sorcerer's Stone*, some on shelving that reached seventeen feet high. The store's uppermost wand boxes were reached by twelve-foot-high sliding ladders. Each wand box was individually affixed with a choice of labels containing information about the wand's core, its type of wood, or other identifying data written in runes, alphabets, and script styles from many different eras and countries. Some even had tassels or cording attached. Then the boxes were aged and overlaid with dust to convey the impression that Ollivanders' wand stock has

been around for a very long time, each wand waiting to choose its witch or wizard.

Stuart Craig enjoyed the character of the Ollivanders set. "It's dense and compact: rich in detail, quite modest in size." The success of the dark set, with its extensive use of various shades of black, encouraged Craig when creating other similarly shadowy, dim locations. "The furniture and woodwork were painted with an ebonized effect: literally black paint on oak, and then rubbed back so that the grain of the wood can show through. Antiques, and particularly Jacobean ones, are like that, and I think we've employed it throughout the films to good effect."

ABOVE: *The dark ebony storefront of Ollivanders' Wand Shop.* OPPOSITE: *Mr. Ollivander (John Hurt) searches for the right wand for the young Harry Potter in* Harry Potter and the Sorcerer's Stone.

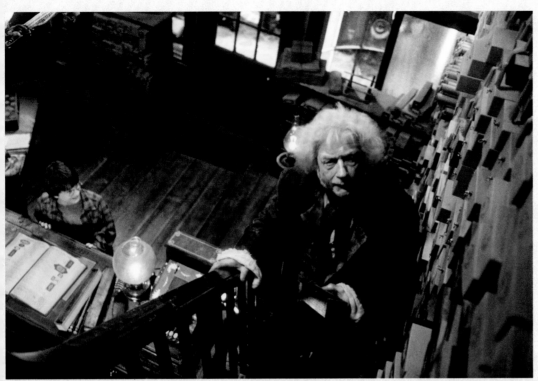

"A WAND? WELL, YOU'LL WANT OLLIVANDERS. T'AIN'T NO PLACE BETTER."

Rubeus Hagrid, *Harry Potter and the Sorcerer's Stone*

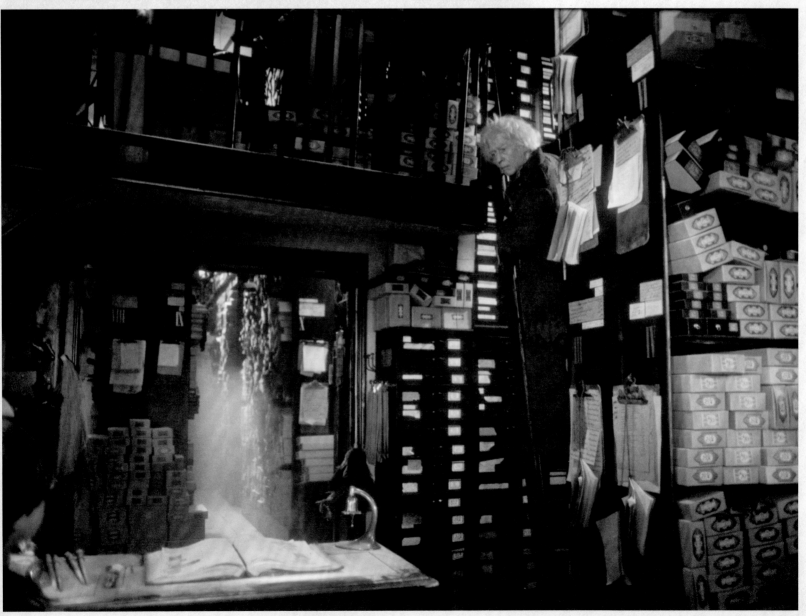

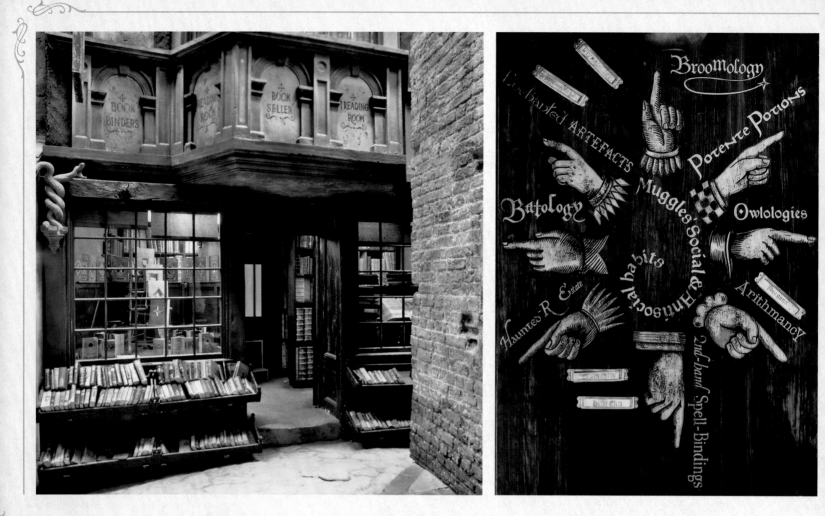

> "WHAT AN EXTRAORDINARY MOMENT THIS IS, WHEN YOUNG HARRY STEPPED INTO FLOURISH AND BLOTTS THIS MORNING TO PURCHASE MY AUTOBIOGRAPHY *MAGICAL ME.*"
>
> Gilderoy Lockhart, *Harry Potter and the Chamber of Secrets*

# FLOURISH AND BLOTTS

Flourish and Blotts is a wizarding shop where, among other tomes, students can pick up their course books for each year's curriculum at Hogwarts. In *Harry Potter and the Chamber of Secrets*, Flourish and Blotts hosts a book signing for the publication of Gilderoy Lockhart's *Magical Me*, attended by many wizarding families, including the Weasleys and the Malfoys.

While the exterior of Flourish and Blotts is that of a straightforward "bookshop," its interior decoration complements the aesthetic Stuart Craig created for Diagon Alley, with its "slightly impossible spirals of books that don't conform to the laws of physics and the natural world," he explains. "I think it works better for magic if it takes you by surprise. When you walk into an environment, you think you understand it. But then if something strange and magical grows out of that, it has a great surprise element." The Flourish and Blotts set was actually a redress of Ollivanders.

The set decoration and graphics departments embellished the shop with gilt-colored signage that pointed to sections on arithmancy, invisibility, and historical sorcery. The stacks also haphazardly held books on the "ologies": batology, owlology, and broomology, as well as wand welfare and broomstick maintenance, Muggles' social and historical habits, and "elf and safety." The graphics department, headed by Miraphora Mina and Eduardo Lima, created the books for all the films, binding them in cloth and leather in dark earth tones with gilded pages. Mina and Lima were informed by J.K. Rowling that the books for Lockhart should be treated more like "trashy airport novels," and so his books were bound with obviously fake leather in garish, shiny colors.

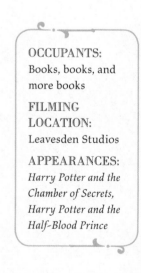

OCCUPANTS:
Books, books, and more books

FILMING LOCATION:
Leavesden Studios

APPEARANCES:
*Harry Potter and the Chamber of Secrets*, *Harry Potter and the Half-Blood Prince*

ABOVE: *The Flourish and Blotts storefront and gilt-colored signage.*
OPPOSITE: *A curved metal bar was run through holes drilled in the books to give the floor-to-ceiling stacks of tomes their gravity-defying bend.*

# WEASLEYS' WIZARD WHEEZES

Fred and George Weasley have opened a business on Diagon Alley in *Harry Potter and the Half-Blood Prince*, Weasleys' Wizard Wheezes, which sells practical jokes, love potions, defensive magic products, and their signature Skiving Snackbox, among its many magic items. The tall, purple-painted building is fronted by a twenty-foot-tall moving figure of one of the Weasley twins clad in the signature Weasley orange color. Debate still occurs as to which brother is the model: actor James Phelps (Fred Weasley) claims it's him "because I'm the better-looking one," but actor Oliver Phelps (George Weasley) maintains it's him because his is "the funnier face." The statue has moving eyes and eyebrows, and raises and lowers a top hat that covers an appearing and disappearing rabbit, just the first of many plays on Muggle jokes in the store.

In the film, the tall building stands out on Diagon Alley, not only because most of the street's shops were recently destroyed by Death Eaters, but because it contrasts with the production's chosen color palette. Stuart Craig always tries to find ways to make his sets cohesive, and for Diagon Alley, he limited the number of colors. "In the case of the Weasleys' shop," Craig explains, "we needed to break with that practice, so made it brighter and cleaner

than anything else we've done. It needed to leap out at you deliberately."

The three-story shop features shelves crammed with thousands of boxes, bottles, and packages, all labeled by the graphics department. "At first, our paper and designs were pretty and delicate," Miraphora Mina recalls, "and then Stuart said, 'Can you please make it more vulgar?' So we looked at packaging for fireworks and firecrackers because they're really cheap and disposable and the printing is always wrong." Graphics scanned in textures and colors to use, which, Eduardo Lima adds, "don't always print out the way you'd want, especially on the poor quality paper we used, which to us was an advantage." The artists also went to shops that sold kitschy items and brought back tins and other containers they often altered and added to their stores. "I think we created about one hundred and forty different product designs," says Lima. "And then we would need to make two hundred of an item, four hundred of another, even two thousand of some," recalls Mina. "All made by

LEFT: *Concept art for the moving figure featured on the Weasleys' Wizard Wheezes storefront.* ABOVE: *The doffing of the figure's hat reveals a rabbit.* RIGHT: *The colorful, overloaded set of Weasleys' Wizard Wheezes.*

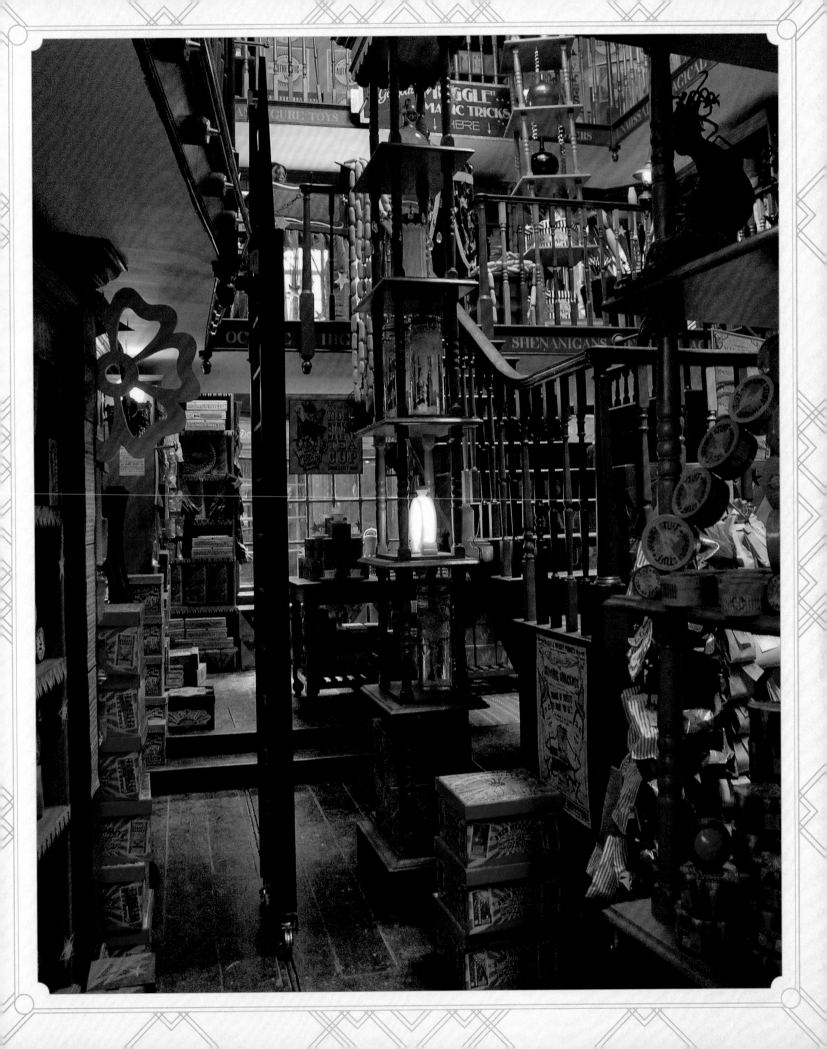

our crew in-house. Like elves." It took weeks to create all the toys and gags, and it took several weeks more to stock the shelves in the store. The graphics department also created shopping bags, order forms, receipts, and all of the store's display signage.

Several large display stands and dispensers added to the fun. Concept designer Adam Brockbank channeled the garish toys and large, crudely sculpted figures that were used for charity donations outside British stores in the 1950s. "There is the Ten-Second Pimple Vanisher," Brockbank explains, "for a pimple cream, so we thought, 'How about a head where the pimples come up and then disappear back down again?'" It was crafted by prop maker Pierre Bohanna and his team, who also manufactured the six-foot-tall Puking Pastilles dispenser. "We wanted that to be funny and disgusting at the same time," says Brockbank. "This was a girl throwing up a never-ending stream of Puking Pastilles into a bucket, so you can just put your cup under to fill it up and go pay." Pierre Bohanna's department also created thousands of green-and-purple pastilles to be "puked," in addition to numerous Nosebleed Nougats, Fainting Fancies, and Fever Fudge candies. Says James Phelps (Fred Weasley), "The set for Weasleys' Wizard Wheezes had so much in it that you could stay in there for days and not see it all."

## "STEP UP, STEP UP. WE'VE GOT FAINTING FANCIES, NOSEBLEED NOUGAT ... AND JUST IN TIME FOR SCHOOL, PUKING PASTILLES."

Fred and George Weasley, *Harry Potter and the Half-Blood Prince*

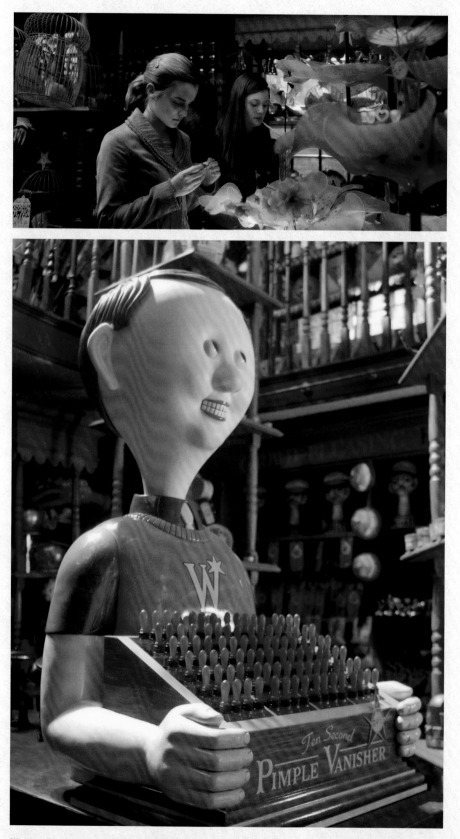

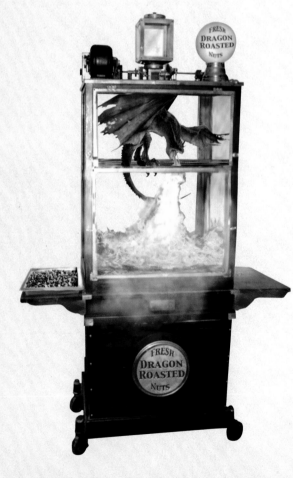

TOP: *Hermione (Emma Watson) and Ginny (Bonnie Wright) examine love potions.* ABOVE AND OPPOSITE: *Large, intricate, and interactive displays were crafted for the Weasleys' Wizard Wheezes set.* LEFT: *A schematic of the "dragon-roasted" nut cart placed outside the joke shop.*

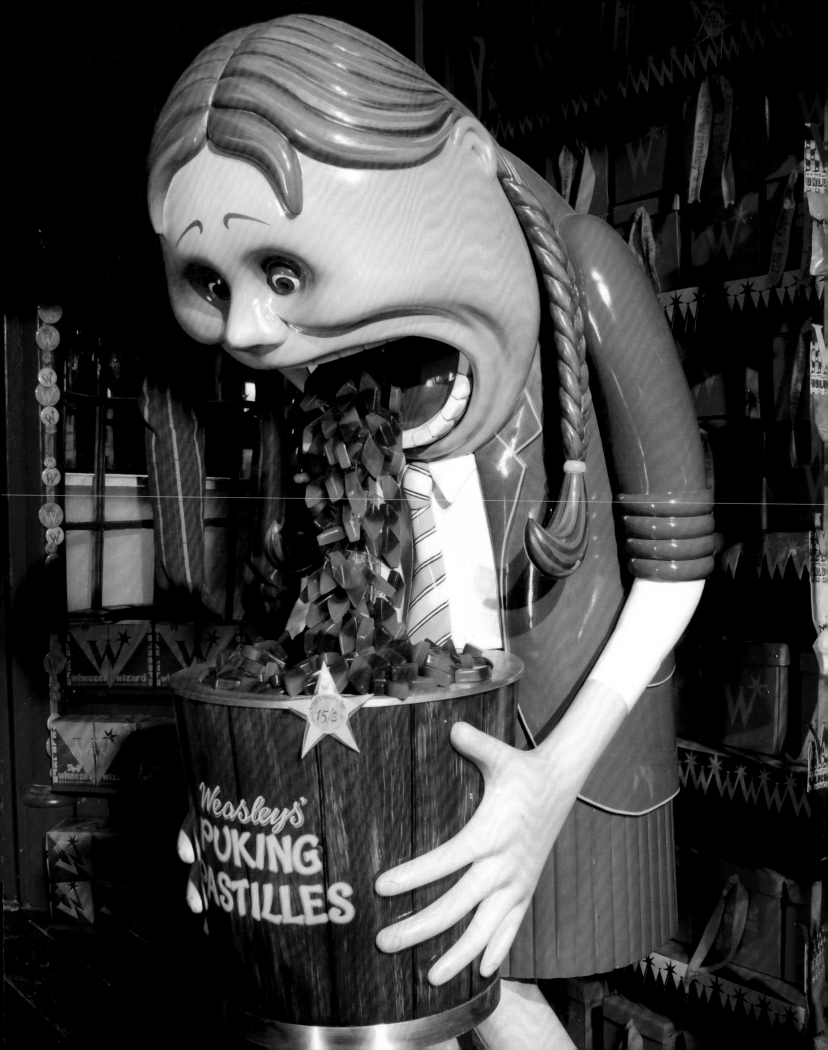

ELEVATION AA     SECTION BB     SECTION CC     SECTION EE     SECTION GG

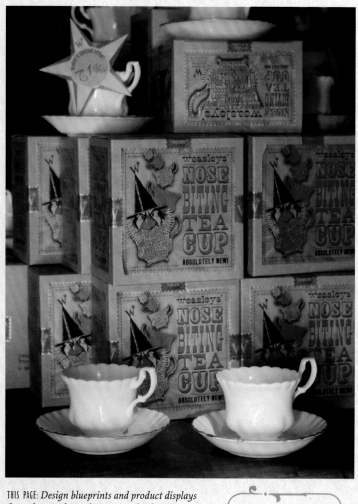

THIS PAGE: *Design blueprints and product displays from the set of Weasleys' Wizard Wheezes.*

OCCUPANTS:
Fred Weasley,
George Weasley

FILMING
LOCATION:
Leavesden Studios

APPEARANCE:
*Harry Potter and the
Half-Blood Prince*

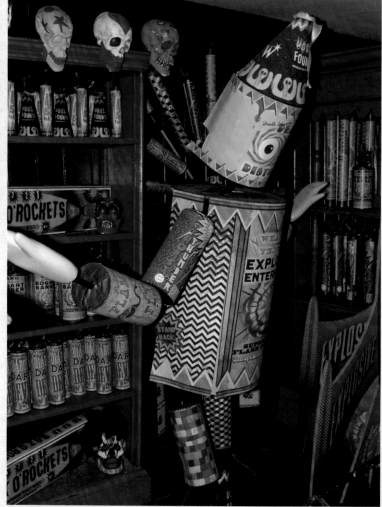

# ST MUNGO'S HOSPITAL FOR MAGICAL MALADIES AND INJURIES

As often happens, there are places and scenes described in books that are written in the script but do not make it on-screen. For the scenes in *Harry Potter and the Order of the Phoenix* when Arthur Weasley is attacked by Nagini, Voldemort's snake, visual development art was created for St Mungo's, but these scenes were cut from the final shooting script.

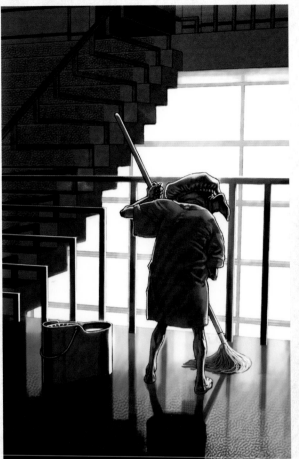

THIS PAGE, CLOCKWISE FROM TOP LEFT: *In concept art by Adam Brockbank, a house-elf in scrubs mops the floor, Quidditch players accompany an injured team member, and strange ailments afflict those in the waiting room.*

# CHAPTER 3

# KING'S CROSS STATION

# KING'S CROSS STATION

King's Cross station is the London departure point for the Hogwarts Express, which transports students to Hogwarts School of Witchcraft and Wizardry. First seen in *Harry Potter and the Sorcerer's Stone*, King's Cross station, built in the Victorian era, sports two eight-hundred-foot-long train sheds topped by barrel-vaulted roofs that rise to over seventy feet. The vastness of the station even makes Hagrid look small as he and Harry stop on one of the sky bridges, where Hagrid gives Harry his ticket to the Hogwarts Express. For *Harry Potter* and the Order of the Phoenix, Stuart Craig chose to set the scene when the Weasleys bring Harry to the station against the more elaborately designed Victorian Gothic exterior of St Pancras station, its neighbor, rather than using the plain front of King's Cross. Inside, Harry once again crosses the sky bridge, this time accompanied by Sirius Black in his Animagus form as a black dog, as Sirius sees Harry off at the beginning of the school year.

In *Harry Potter and the Deathly Hallows – Part 2*, Harry finds himself in a dreamy, improbable version of the station, where he encounters Albus Dumbledore. The interior of King's Cross station—possibly only imagined in Harry's mind—is reinvented in a bright white. The station was actually mostly imagined by the special effects team. Daniel Radcliffe (Harry Potter) and Michael Gambon (Albus Dumbledore) shot their scene on a white stage, instead of green screen, which allowed for enhanced lighting effects. The filmmakers'

"NOW, UH, YOUR TRAIN LEAVES IN TEN MINUTES. HERE'S YOUR TICKET. STICK TO IT, HARRY, THAT'S VERY IMPORTANT. STICK TO YOUR TICKET."

Rubeus Hagrid, *Harry Potter and the Sorcerer's Stone*

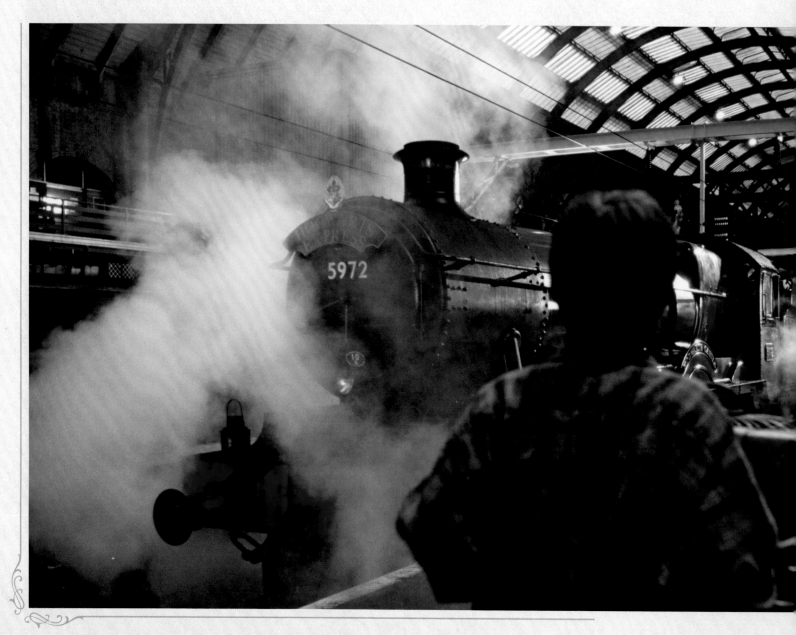

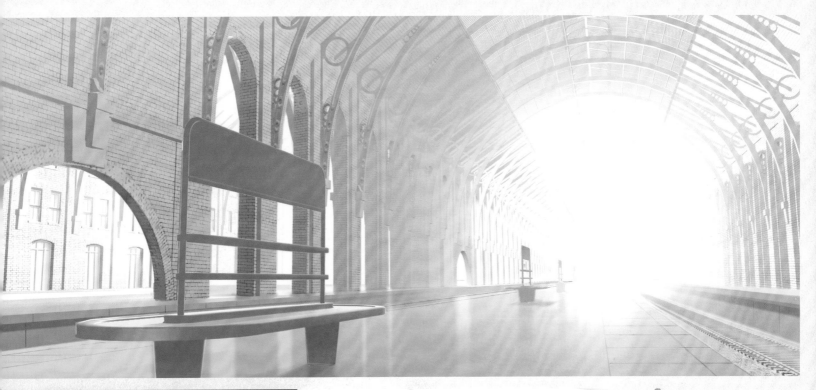

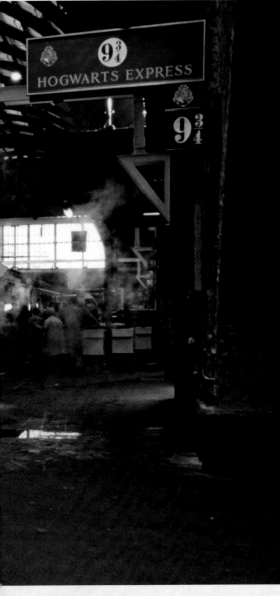

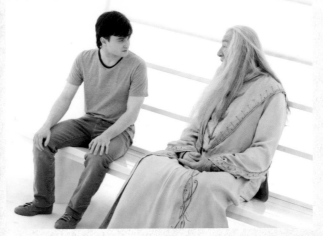

green screen, which allowed for enhanced lighting effects. The filmmakers' initial thought was to have the station look almost like an ice palace, but when rendered, it did not deliver the emotional environment everyone wanted. Special effects went back to the drawing board (or rather the computer keyboard) and started from a simpler concept. Instead of having the station re-created with realistic details, they removed the walls and arches, leaving the roof, the columns, and the platforms, to give it a sense of ethereal infiniteness. A bright horizon line, which added an additional light source, and a dimensional mist were added. Pleased with the outcome, the producers and director asked for one more thing: very subtly, the columns phase in and out of opaqueness to add to the otherworldly feel.

OCCUPANTS:
Hogwarts students and families

FILMING
LOCATIONS: King's Cross station and St Pancras station, London, England

APPEARANCES:
*Harry Potter and the Sorcerer's Stone, Harry Potter and the Chamber of Secrets, Harry Potter and the Order of the Phoenix, Harry Potter and the Deathly Hallows – Part 2*

TOP: *Concept art for the clean and white King's Cross station seen toward the end of* Harry Potter and the Deathly Hallows – Part 2. ABOVE: *Harry Potter and Albus Dumbledore (Michael Gambon) at King's Cross station in* Harry Potter and the Deathly Hallows – Part 2. OPPOSITE: *Harry approaches the Hogwarts Express at platform nine and three-quarters in* Harry Potter and the Sorcerer's Stone.

# "BUT HAGRID, THERE MUST BE A MISTAKE. THIS SAYS PLATFORM NINE AND THREE-QUARTERS. THERE'S NO SUCH THING . . . IS THERE?"

Harry Potter, *Harry Potter and the Sorcerer's Stone*

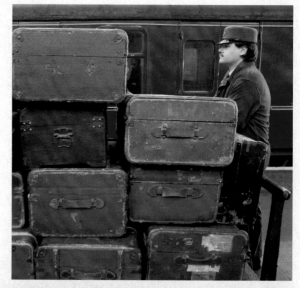

## PLATFORM NINE AND THREE-QUARTERS

After Rubeus Hagrid hands Harry his ticket for the Hogwarts Express in *Harry Potter and the Sorcerer's Stone*, Harry is left to get to platform nine and three-quarters by himself. Though he finds platforms nine and ten, he's baffled at what to do next. Fortunately, the wizarding Weasley family arrives and shows Harry how to go through a brick wall to get onto a hidden platform.

It would be natural to assume that the filmmakers would use King's Cross station's real platforms nine and ten for the location shoot. But as Stuart Craig explains, "Platforms nine and ten are not in the main station building, but in a little annex to the side." Craig wanted to showcase the station's Victorian architecture and get a strong image: "We chose a platform that had big brick piers, under big supporting arches that connected to another platform, which gave it a substantial wall to run at before they pass through it to the other side." Platform nine and three-quarters was actually set between platforms four and five.

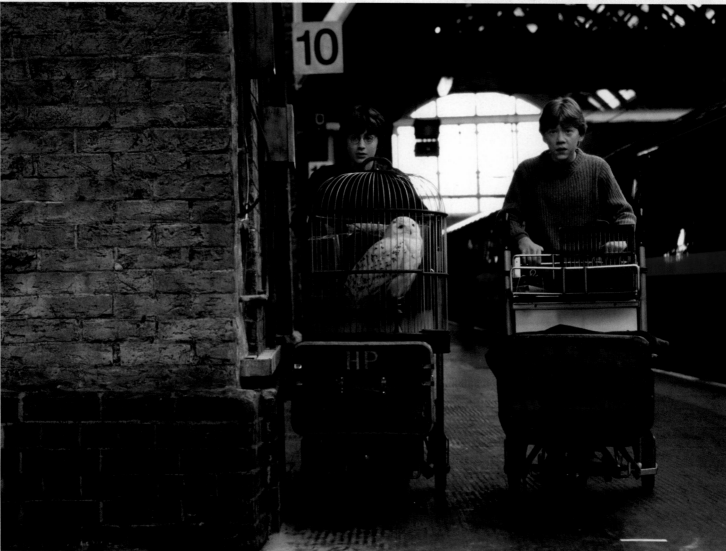

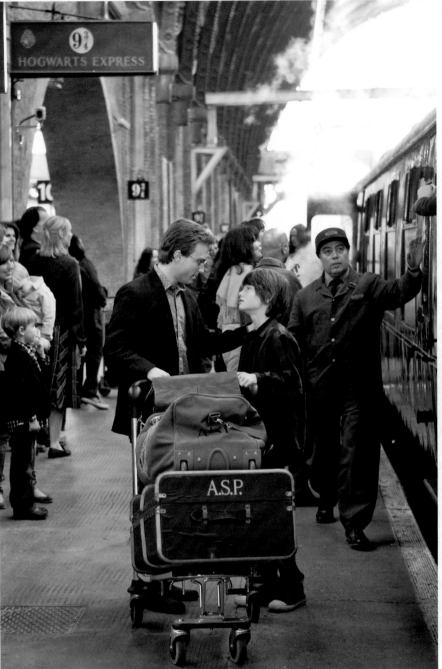

OCCUPANTS: Hogwarts students and families

FILMING LOCATION: Between platforms four and five, King's Cross station, London, England

APPEARANCES: *Harry Potter and the Sorcerer's Stone, Harry Potter and the Chamber of Secrets, Harry Potter and the Prisoner of Azkaban, Harry Potter and the Order of the Phoenix, Harry Potter and the Deathly Hallows – Part 2*

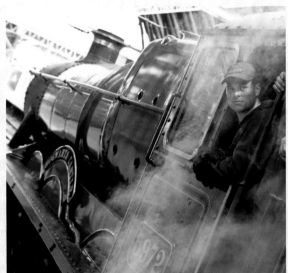

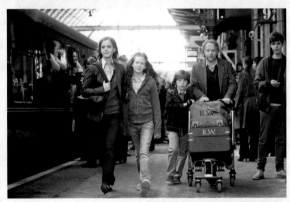

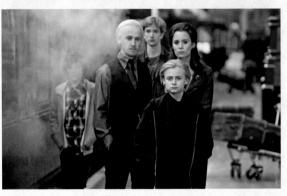

THIS PAGE: *Images from* Harry Potter and the Deathly Hallows – Part 2 *show the next generation of Potters, Weasleys, and Malfoys getting ready to board the Hogwarts Express.* OPPOSITE, TOP TO BOTTOM: *Old and weathered suitcases were used as props; the young Harry Potter and Ron Weasley (Rupert Grint) push their inscribed luggage onto platform nine and three-quarters in* Harry Potter and the Sorcerer's Stone.

Throughout the films, going through the wall to the platform was achieved digitally. However, as *Sorcerer's Stone* director Chris Columbus preferred to use practical effects when possible, he did have a brick-walled passageway constructed in the studio for Daniel Radcliffe (Harry) to run through for the first time. The King's Cross location was filmed on a Sunday, when the station would be least crowded. And it was uncrowded—that is, until weekend passengers noticed the shoot. Recalls Columbus, "We had pulled the real Hogwarts Express onto the platform's tracks, and had replaced the sign with the one for platform nine and three-quarters. There was a tremendous amount of visitors that day who couldn't believe they were actually seeing the train at King's Cross station." In *Harry Potter and the Deathly Hallows – Part 2,* nineteen years after Harry's graduation from Hogwarts, he, Ginny, Ron, and Hermione return to platform nine and three-quarters: now, as parents accompanying their children, who are taking the train as Hogwarts students. Once again, the platform held not only the train but, nearby, delighted onlookers.

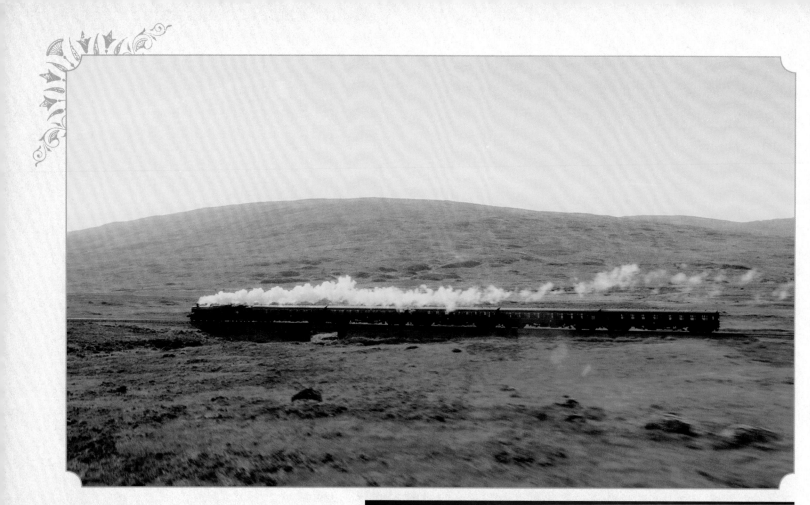

# THE HOGWARTS EXPRESS

The Hogwarts Express appears in all of the *Harry Potter* films. The train brings new and returning students from London to Hogsmeade, where students finish their journey to Hogwarts by other means, and the train returns students to London at the end of the school year. To create the Hogwarts Express, the filmmakers rescued an abandoned steam locomotive named *Olton Hall* (no. 5972). Built in 1937 by the Great Western Railway, *Olton Hall* ran until 1963, when, sadly, it ended up in a South Wales scrap yard. After it was found in 1997, *Olton Hall* was fully restored for use in *Harry Potter and the Sorcerer's Stone*. The train was painted crimson, which is the antithesis of the traditional Great Western Railway standard color of Brunswick green. The engine itself was fitted with new nameplates, as it was now called "Hogwarts Castle," and it pulled four British Rail Mark 1 carriages. In between the movies, the train was used as a tourist train between Scarborough and York and as the Shakespeare Express to Stratford-upon-Avon.

TOP: *A still from* Harry Potter and the Half-Blood Prince, *shot from helicopter.* MIDDLE AND RIGHT: *Signage and nameplates used on the trains.* OPPOSITE: *A view of the Hogwarts Express locomotive, previously named* Olton Hall *(no. 5972).*

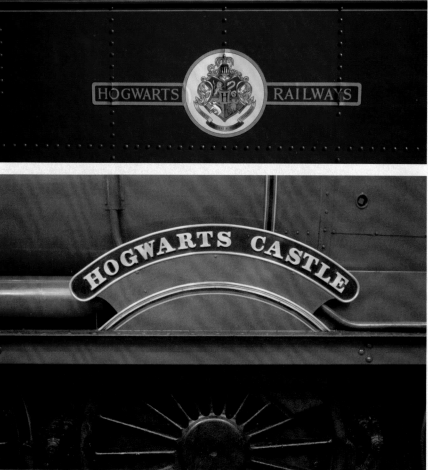

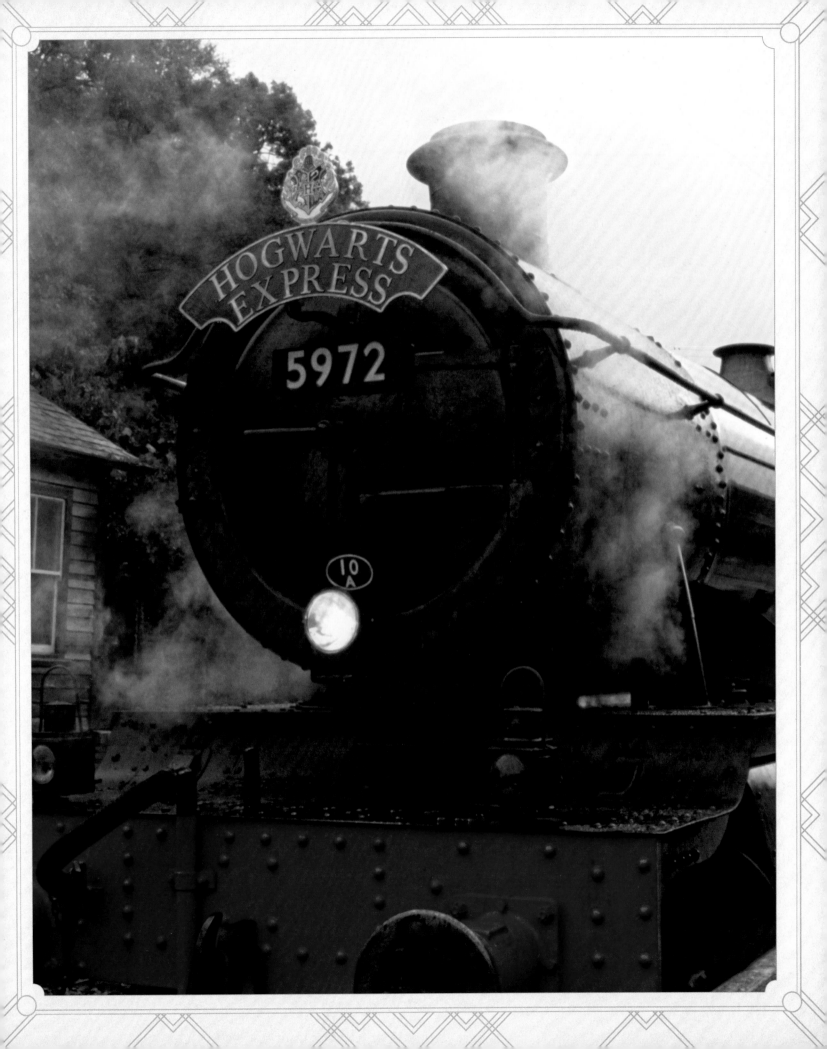

# "ANYTHING OFF THE TROLLEY, DEARS?"

Trolley witch, *Harry Potter and the Sorcerer's Stone*

The interiors and exteriors of the Hogwarts Express weren't filmed at the same time. "Unfortunately, we couldn't shoot the scenes *on* a real train traveling through Scotland, so we utilized helicopter shots of the train, and then we shot the compartments in front of a green screen," notes *Harry Potter and the Sorceror's Stone* director Chris Columbus.

The look of the train's interior compartments was influenced by one of Columbus's favorite movies: *A Hard Day's Night*, filmed in 1964, starring the Beatles. "It may be my favorite film of all time," Columbus says. "And I wanted the compartments to feel exactly like those John, Paul, George, and Ringo were riding in at the beginning of the movie. And Stuart Craig re-created the look of that train."

RIGHT: *The Trolley witch pauses by a compartment in* Harry Potter and the Sorcerer's Stone. BELOW: *The young actors were allowed to stuff themselves with candy on set.* OPPOSITE, TOP: *The dated, weathered compartments were the result of a conscious decision by Sorcerer's Stone director Chris Columbus.* OPPOSITE, BOTTOM: *The Hogwarts Express passing by a home for sale in an image that wasn't used in the films.*

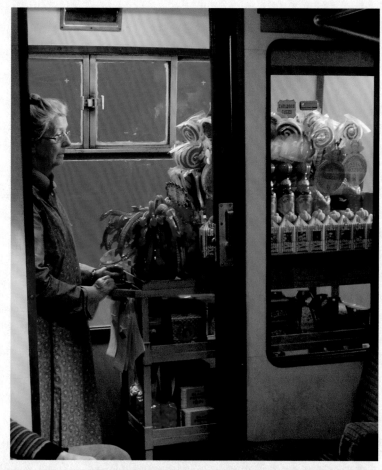

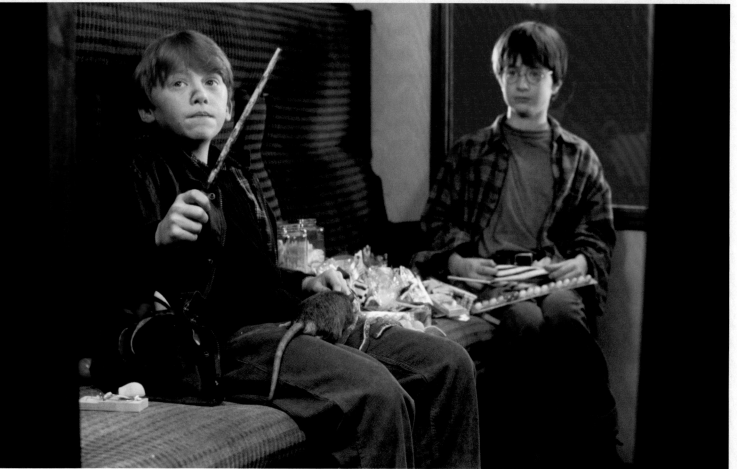

**OCCUPANTS:** Hogwarts students, the trolley witch

**MACHINE:** *Olton Hall (no. 5972)*

**APPEARANCES:** *Harry Potter and the Sorcerer's Stone, Harry Potter and the Chamber of Secrets, Harry Potter and the Prisoner of Azkaban, Harry Potter and the Goblet of Fire, Harry Potter and the Order of the Phoenix, Harry Potter and the Half-Blood Prince, Harry Potter and the Deathly Hallows – Part 1, Harry Potter and the Deathly Hallows – Part 2*

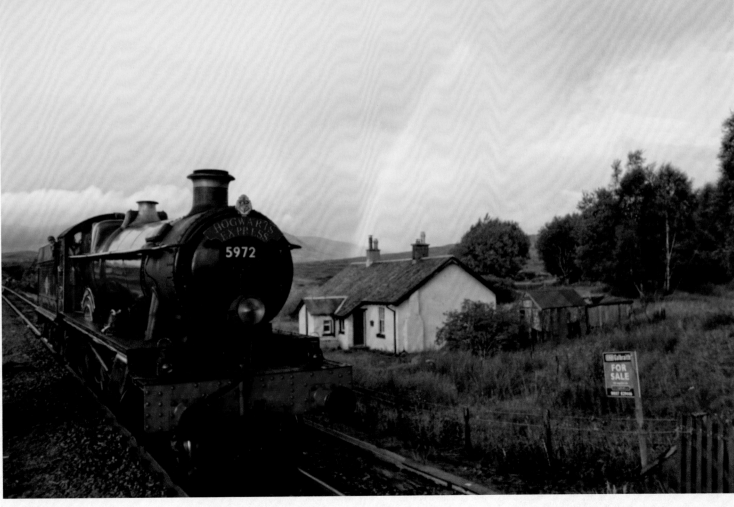

# HOGWARTS CASTLE

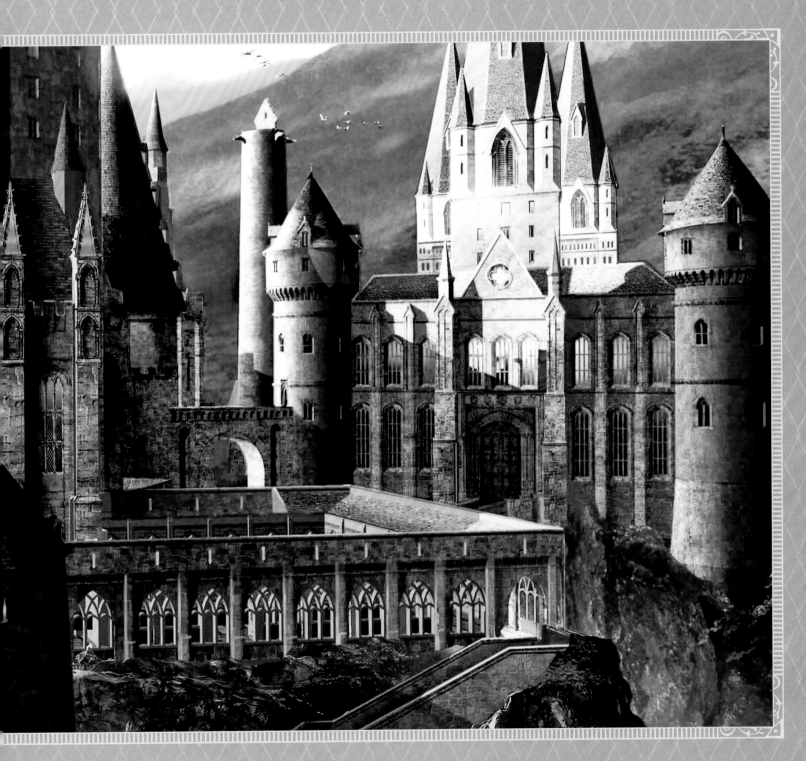

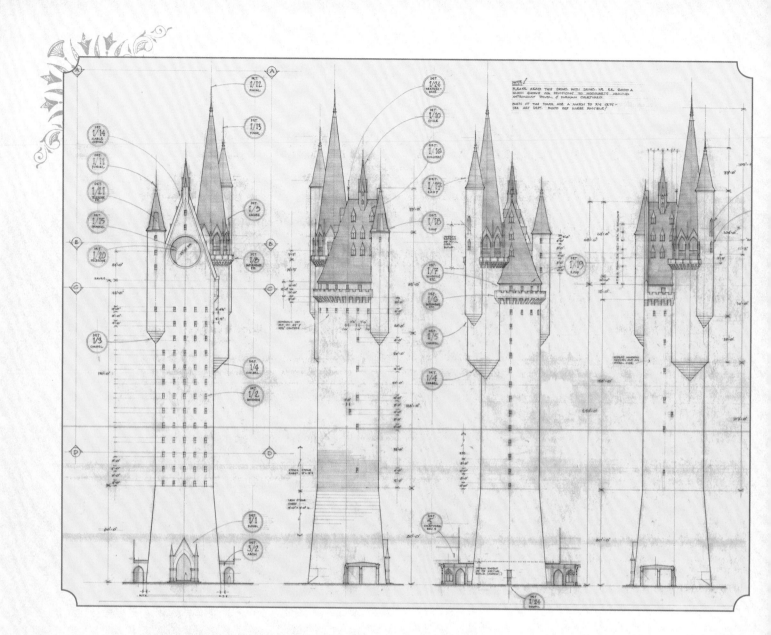

# HOGWARTS CASTLE

ABOVE: *A 360-degree blueprint showing the design of the Hogwarts Clock Tower.* OPPOSITE: *Hogwarts students follow Professor McGonagall into the Great Hall in the first film.*

For Production Designer Stuart Craig, bringing one of the most iconic locations in one of the most popular, profitable, and influential book series to the screen started with a question. "The first and biggest thing to me was, how old is Hogwarts?" says Craig. "It's suggested to be a thousand years old, a timeless institution, and there are very few examples of architecture in existence that are that old." To find his answers, he first considered the two oldest existing schools in the English-speaking world, Oxford and Cambridge Universities in England. "These are great European Gothic institutions," he explains, "in a style that is strong and dramatic. In the beginning we used that literally and we've been emulating that architectural style ever since." Craig also researched the great cathedrals of England, and all these places not only influenced the sets but provided actual locations

for shooting. "It was unaffordable and impractical to build the entire castle for the first two films. But as we moved forward and re-created locations in the studio, we benefited from being obliged to acknowledge the original locations in that the sets are more real. We paid attention to authenticity and architectural detail. We documented paint finishes, weathering, and erosion. We took many photographs of the way the elements had eroded stone inside and out of these ancient buildings and emulated those in our sets. For that, the real locations did us a great service, because then we weren't building a world that was completely fantastical or whimsical." Throughout the course of the film series, Craig returned again and again to this underlying design philosophy. "I think magic is made all the stronger when it grows out of something real."

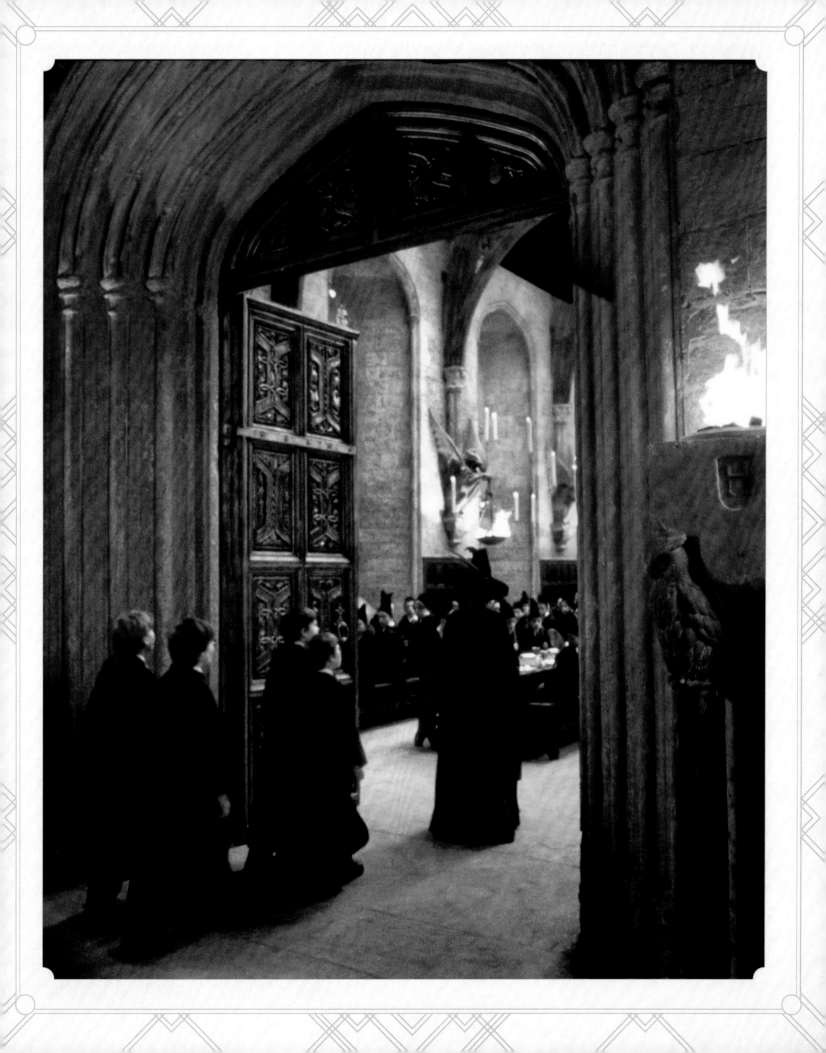

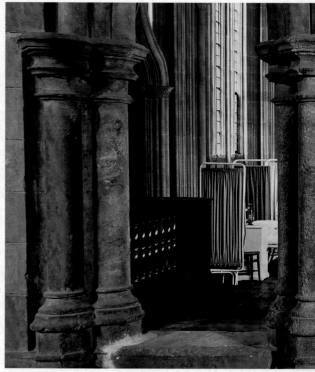

With a laugh, Craig acknowledges, "The way to go would have been to be able to read through all seven books when we started. But I think the changes and additions to Hogwarts added a level of interest to the films. I think everybody accepts that each film had its own kind of integrity and that the spirit was probably more important than continuity jumps between films." Some of the sets remained basically unchanged for the entire film series, such as the Great Hall, Professor Dumbledore's office, and the Gryffindor common room. "They literally stood there for ten years, those sets. They got a fresh coat of paint a couple of times. But there they were; there forever."

Through eight films and ten years, the face of Hogwarts changed, as does everything as it ages. Craig admits that he was pleased when he had a chance to reshape parts of the castle. One example is the castle's main entrance, which was initially shot under the iconic fan vaulting of Christ Church, a college in Oxford, for *Harry Potter and the Sorcerer's Stone.* "In the first films, the students would enter a modest entryway and go up a grand staircase to the Great Hall on the first floor. But for *Harry Potter and the Goblet of Fire*, the students arriving for the Yule Ball needed to arrive at the front door and go straight in. There was no place to do this at Christ Church. Its external door was in a teeny, tiny little courtyard that you couldn't get a carriage into, so the entrance needed to be reinvented. We *hugely* reinvented it for the final film because it was going to become a battlefield. If Voldemort was going to challenge the school and the kids were going to defend it, then it had to be about the main entrance, which didn't have the scale or the seriousness that we needed. So we reinvented the front entrance again, building a massive courtyard based on the cloister at Durham Cathedral, which we'd taken from before."

Craig continues, "When you look at the profile of Hogwarts in the first film, it's a mixture of different locations. There's a bit of Christ Church, a bit of Durham, a bit of Gloucester Cathedral, a little bit of Alnwick Castle. To me, the original silhouette of the school, which was forced, in a way, to incorporate these places, wasn't as I would have liked. But as the films went on, the chance to improve and strengthen that silhouette offered itself, and I became quite pleased with it. It was always huge and complicated, but it progressively got more elegant."

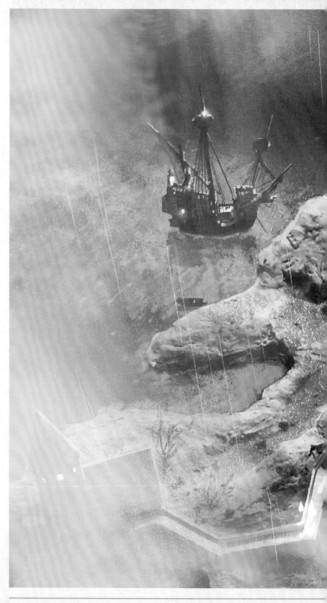

ABOVE: *Students approach the castle by boat in* Harry Potter and the Sorcerer's Stone. TOP RIGHT: *A view of the hospital ward and Madame Pomfrey's station.* BOTTOM RIGHT: *Concept art by Adam Brockbank depicts an aerial view of Hogwarts in winter for* Harry Potter and the Goblet of Fire.

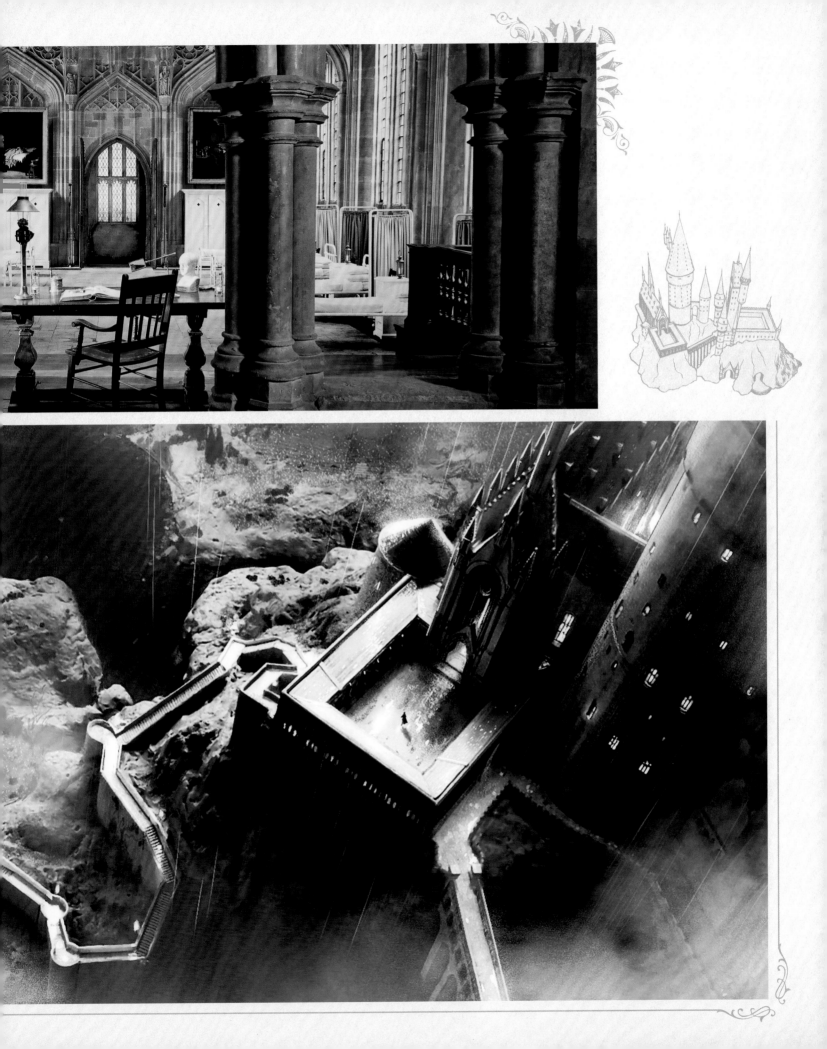

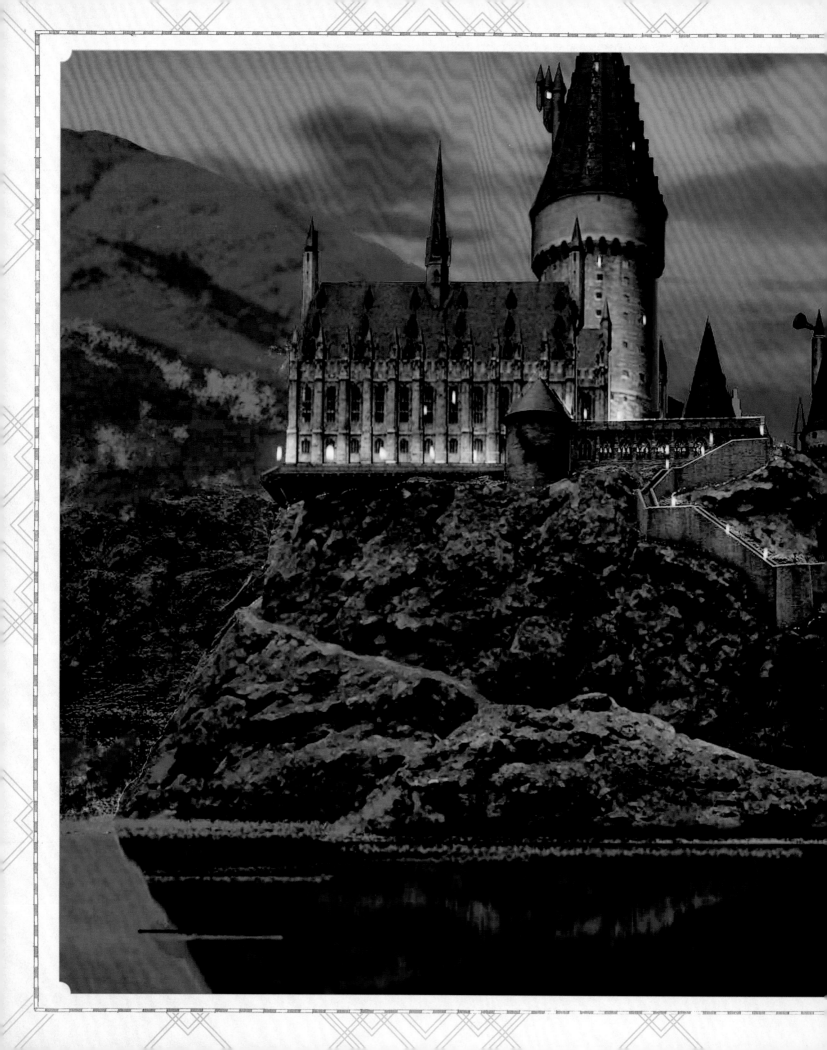

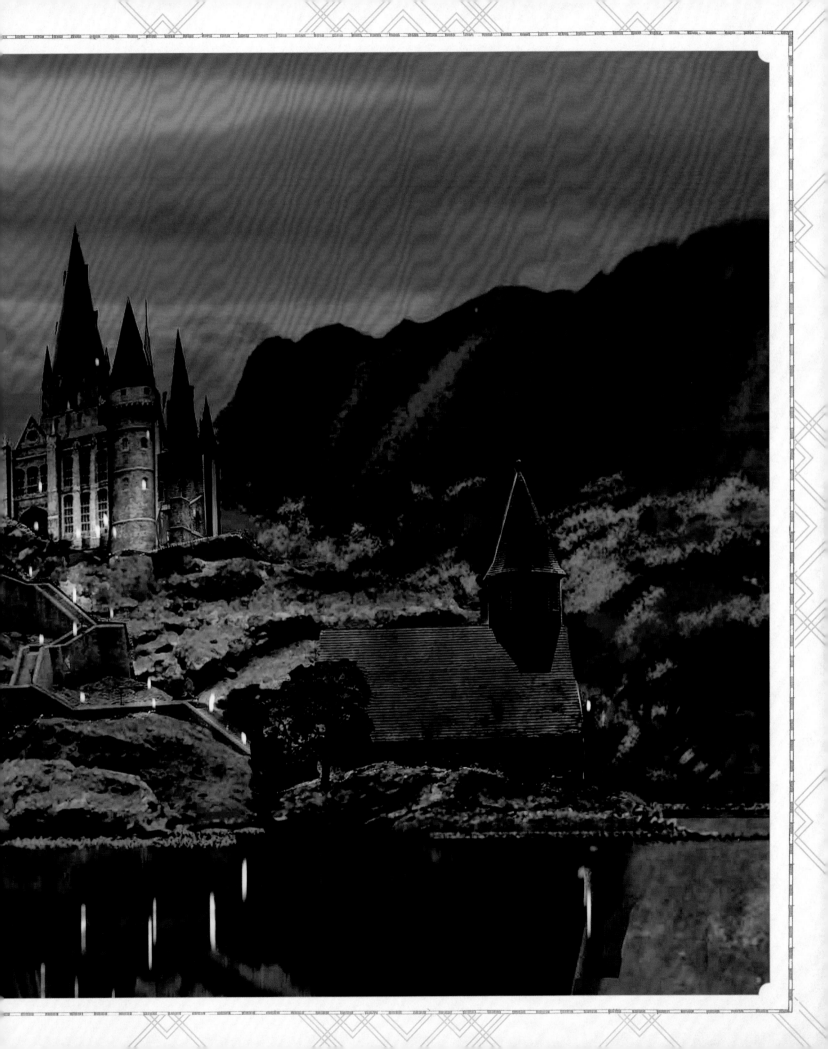

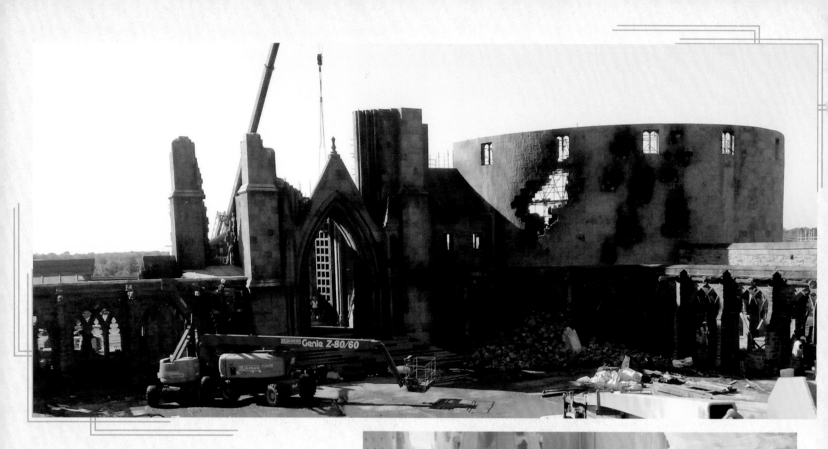

## ✶ Hogwarts Under Siege ✶

*Harry Potter and the Deathly Hallows – Part 2* contains the ultimate battle between the population of Hogwarts and Lord Voldemort's Dark Forces, and it showcases the final confrontation between Harry Potter and Voldemort. The destruction of the castle was as important to Stuart Craig as its creation. *Deathly Hallows – Part 2* director David Yates wanted the battle to be *large*, and so for the final time, driven as always by the story, Hogwarts underwent revision. "We were providing a place for the mother of all battles," says Craig, "so the marble staircase was increased 500 percent. The courtyard was doubled again, and bridges and access ways were added. It was required that statues jump down and take part in the battle, so we needed to change the look of the entrance hall." And he explains that destroying the castle didn't mean just knocking it down. Its ruin needed to be as iconic as its pristine state. "The areas that would be damaged—the Great Hall, the staircases, the roofs—still needed to be recognizable among the shattered stones and charred beams." Practical considerations also came into play. "The scenery is plywood, so if you try to destroy a section, you've

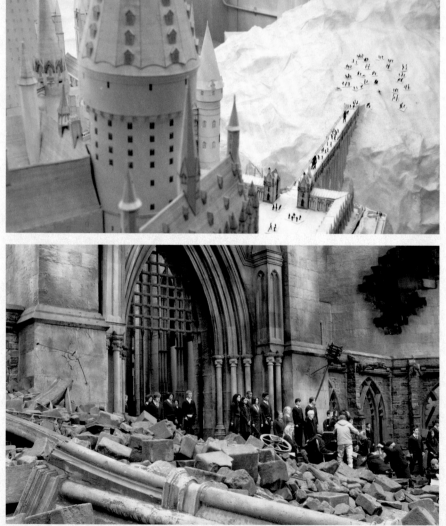

PRECEDING PAGES: *Concept art by Andrew Williamson for* Harry Potter and the Half-Blood Prince *shows Hogwarts castle at sunset.* TOP AND RIGHT: *Views from the set of the destroyed Hogwarts castle, in production and during filming.* ABOVE MIDDLE: *A white card model maps out the positions of Hogwarts's defenders and invaders.* OPPOSITE: *Concept art by Andrew Williamson depicts the battle of Hogwarts.*

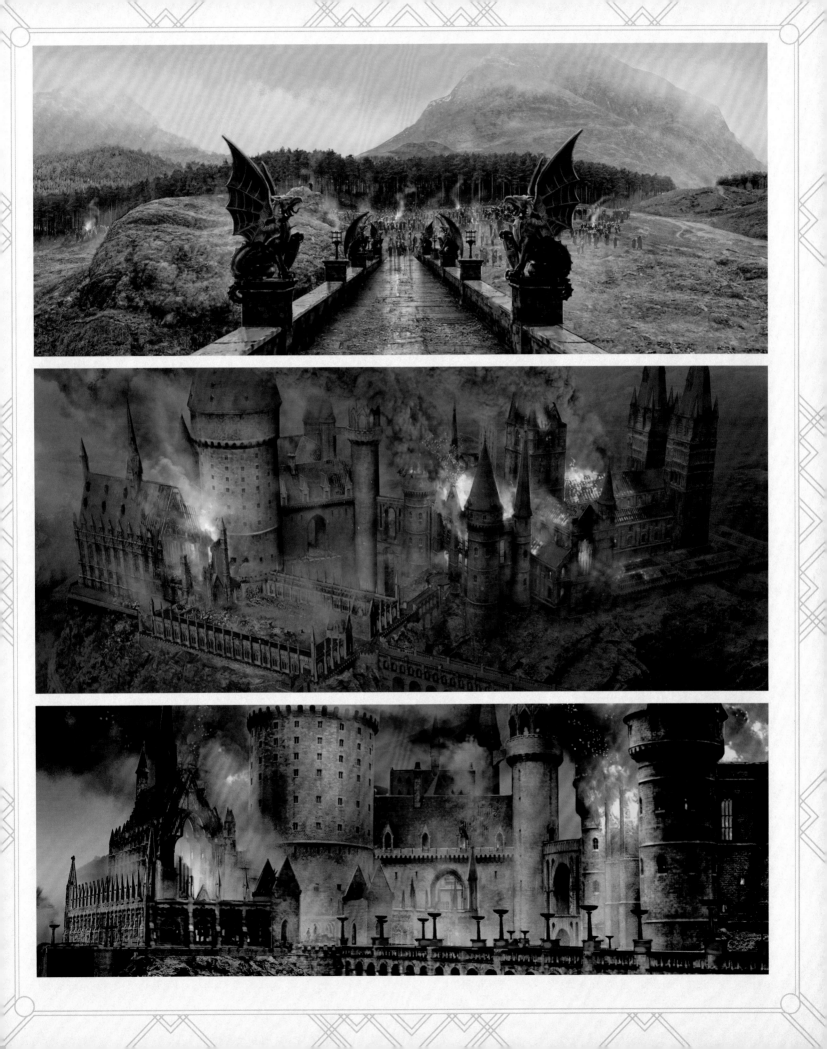

just got the raw edges of plywood. You'll just get a lot of visible Styrofoam and plaster. So the ruins of Hogwarts had to be considered as a new build, not just a taking apart of the old."

To assist in this incredibly challenging task, for the first time, the entire Hogwarts model was constructed digitally by the visual effects team. "We scanned the model that had evolved from the first film," says Senior Visual Effects Supervisor Tim Burke, "which gave us every facet of the building to work with, and then built a destroyed version of the school." Having the model in a digital form gave David Yates the flexibility to make changes or add in new ideas that a practical model would have prevented. As is common in filmmaking, shooting the

battle and post-destruction Hogwarts needed to take place before filming the pre-battle scenes. Property Master Barry Wilkinson and his crew created thousands of pieces of rubble in soft polystyrene, including sculpted fragments of Hogwarts's architectural details, which were strewn over the set. "There was a human chain of rubble production for months," says Stephenie McMillan. "You can never have too much rubble." After shooting was complete, it was cleaned away. Stuart Craig appreciated the challenge and hard work this set required. "The final standoff between Voldemort and Harry in the ruined courtyard in front of the school with what is essentially the sun rising behind them and the smoke seen through the walls is so emotionally effective."

BELOW: *Harry Potter prepares to battle Voldemort.* OPPOSITE, TOP TO BOTTOM: *Brought to life by Professor McGonagall's spell, the center statue wields a shield with a badger, symbol of Hufflepuff house; Ron and Hermione run down the enlarged marble staircase; the Hogwarts defenders and invaders gather among the ruins in* Harry Potter and the Deathly Hallows – Part 2.

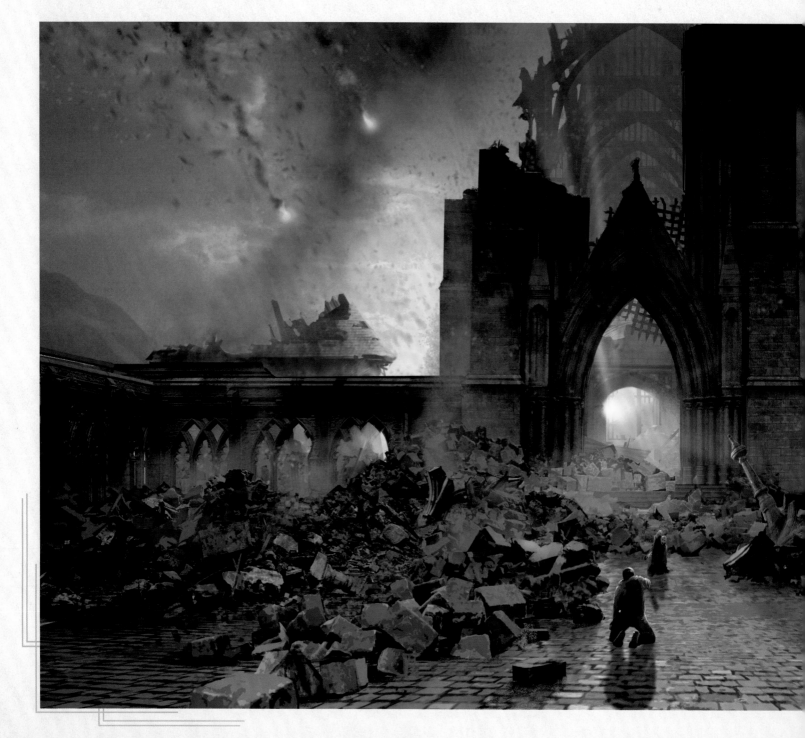

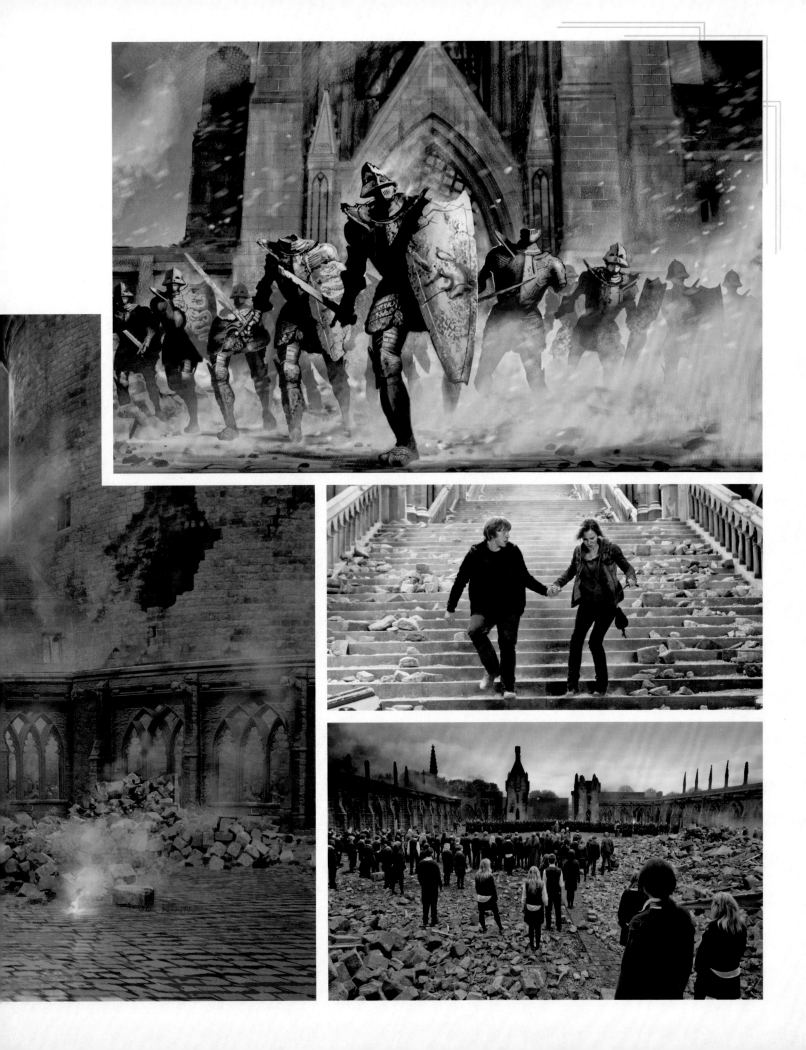

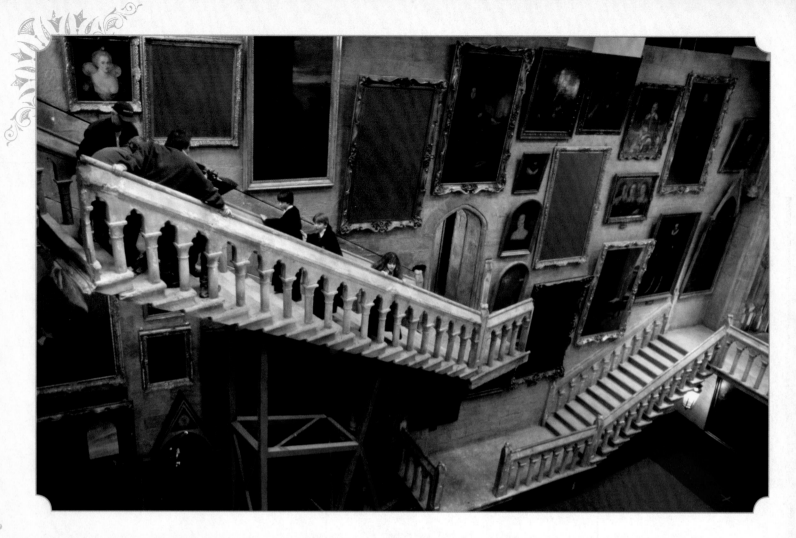

"OH, AND KEEP AN EYE ON THE STAIRCASES. . . . THEY LIKE TO CHANGE."

Percy Weasley, *Harry Potter and the Sorcerer's Stone*

## MOVING STAIRCASES

One of Stuart Craig's first assignments for *Harry Potter and the Sorcerer's Stone* was to install the moving staircases that travel from floor to floor in Hogwarts. To start, he needed to determine *how* the staircases would move. An initial thought was to mimic an escalator, but Craig says, "as the stairs are made of marble, it seemed too much of a stretch!" He came up with the idea of a staircase literally swinging ninety degrees from one position to the next. "It could be lying against a wall and then swing across space and form a bridge from one landing to another. That seemed the simplest mechanically." He envisioned the complete stairwell as a square made up of staircases on four sides. "Those staircases then led to four sides of another square above, and that led to four sides of another square, and so on. It was like a double helix; the stairs did actually wrap themselves around one another. And somehow this simple module and this simple mechanical move suddenly became a complicated piece of geometry." The final look, when Harry Potter first learns

about the moving staircases, is quite breathtaking. A moving staircase in *Sorcerer's Stone* is what leads Harry, Ron Weasley, and Hermione Granger to the out-of-bounds third-floor corridor and their first encounter with Fluffy, the three-headed canine guardian of the Sorcerer's Stone. As a practical effect, the actors stood on a single staircase that moved hydraulically in front of a green screen.

The main marble staircase was lined with two hundred and fifty magical paintings, whose subjects could move and talk to the students. Bringing these images to life involved coordination between several of the studio's departments. "The art director in charge of props on each film would research and commission what portraits were needed and then coordinate getting them painted," explains set decorator Stephenie McMillan. Over the course of the film series, this task fell to Lucinda Thomson, Alex Walker, and Hattie Storey, and it involved both reinterpreting real classical paintings and creating new ones. The costume, props, and makeup

TOP: *Harry, Ron, and Hermione ascend a staircase before encountering Fluffy in Harry Potter and the Sorcerer's Stone.* OPPOSITE TOP: *A white card model of the moving staircases was used to illustrate the layout of the portraits.* OPPOSITE BOTTOM: *Concept art by Andrew Williamson.*

OCCUPANTS: Hogwarts students and teachers, paintings

SET INSPIRATION: Modeled on the staircase at Christ Church college, Oxford University, Oxfordshire

APPEARANCES: *Harry Potter and the Sorcerer's Stone, Harry Potter and the Chamber of Secrets, Harry Potter and the Prisoner of Azkaban, Harry Potter and the Goblet of Fire, Harry Potter and the Order of the Phoenix, Harry Potter and the Half-Blood Prince, Harry Potter and the Deathly Hallows – Part 2*

departments all contributed their talents. A photo of the scene would be taken and digitally given a painterly texture and "varnish" so that it imitated the look of an oil painting. Other paintings were original pieces by studio artists, who often painted them "in the style" of famous artists. Ultimately, the range of art represented the history of painting from Egypt to the Renaissance to the early twentieth century. However, many of the portrait subjects in the paintings were actually the filmmakers, the crew members, and their families. Stuart Craig's portrait (inscribed *Henry Bumblepuft, 1542*) has a prominent place on the grand staircase. Portraits that would have moving subjects were placed on the wall with a blue-screen overlay within the frame for digital insertion in editing. For *Harry Potter and the Deathly Hallows – Part 2*, the portraits were re-created with empty backgrounds, as all the subjects fled their paintings for safety.

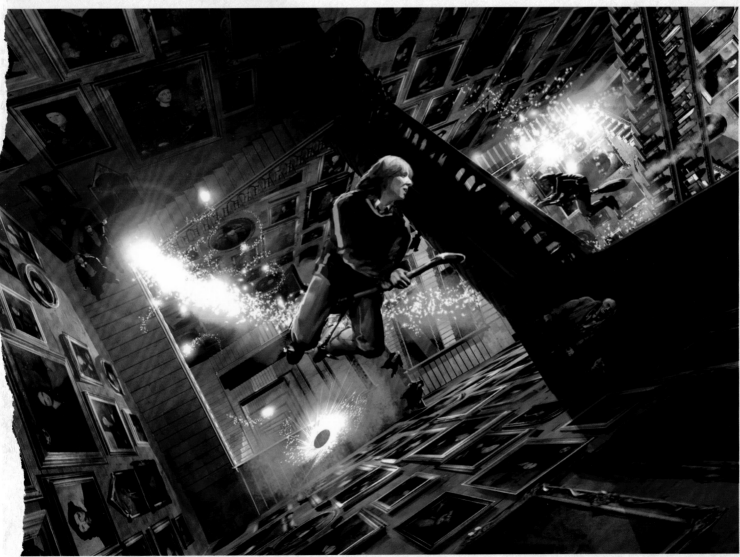

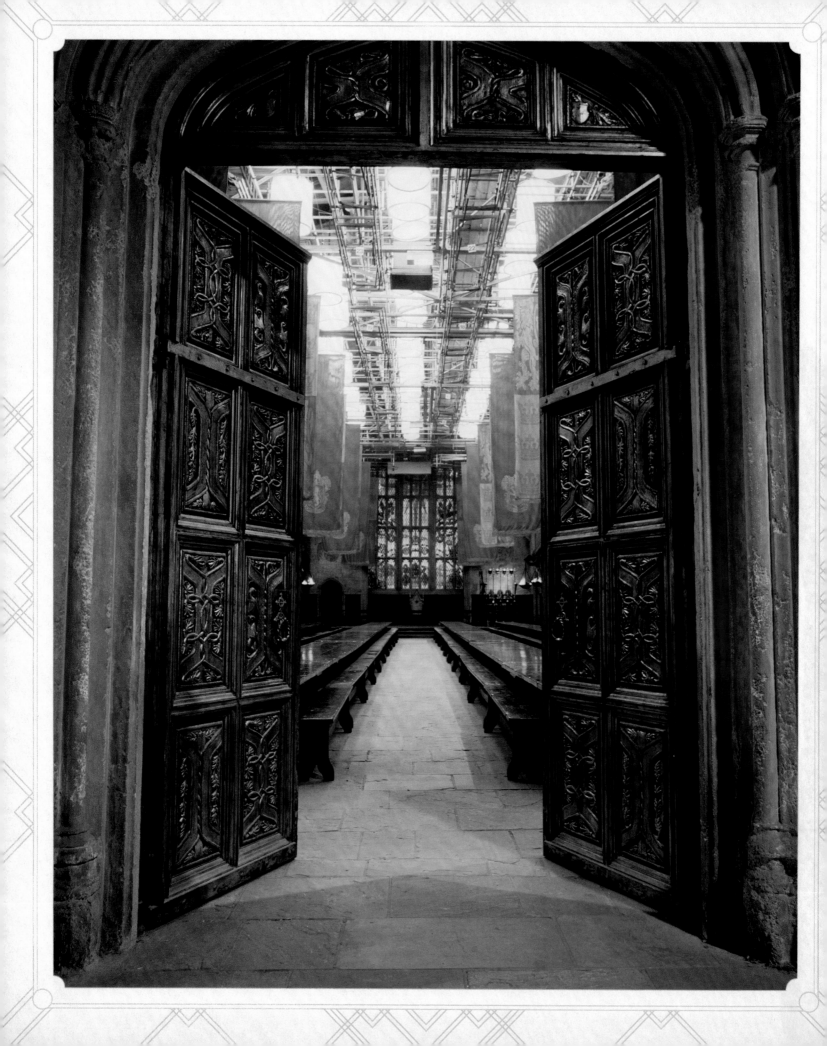

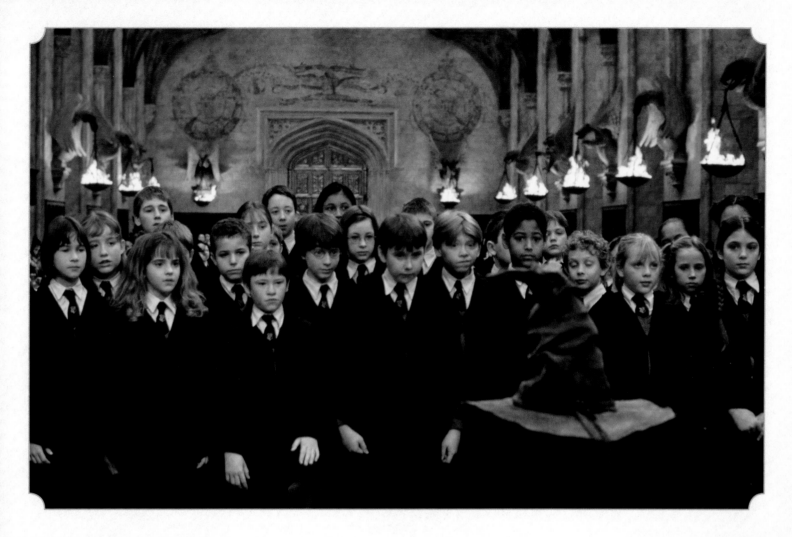

# THE GREAT HALL

"I vividly remember being on the set of the Great Hall when we began shooting *Harry Potter and the Sorcerer's Stone*, so early in the morning," says Chris Columbus, director of the first two *Harry Potter* films. "It was freezing cold. Leavesden was in its early days as a studio and the roof leaked. And we could sometimes hear cars and planes outside. But it had a sense of real magic about it."

The Great Hall at Hogwarts is an inspired composite of several renowned buildings in England. The entrance, where the students congregate before the Sorting Ceremony, was filmed on the stairway leading to the Great Hall at Christ Church college, Oxford. Its fan-vaulted ceiling, an architectural style unique to England, is famed for the delicacy of its construction. Hogwarts' Great Hall is based on the same style as Christ Church, keeping the sixteenth-century room's dimensions of 40 feet by 120 feet. It is topped with the fourteenth-century ceiling from Westminster Hall in the Houses of Parliament, replete with hammer-beam style trusses. Then Stuart Craig made alterations to better serve the films. "To me, windows are the most important thing on any set. They're the eyes of the set," he explains. "The windows at Christ Church are very

high, and they would have literally been out of the top of the frame most of the time. So we brought the windowsills down very low, and also added a big oriole window at one end, which is a great dramatic statement and gives the length a focal point." He then let these design choices speak for themselves. "It's really a simple structure, not overcomplicated at all. It has two or three classic features that have stood it in good stead. I think if we'd had too many ideas running in parallel, it would actually have become boring." The most important decision Craig made about the Great Hall set was to install real Yorkstone for the floors. "Although we were told there would be seven books, when we began only the first two novels existed. There was no guarantee that the second movie would be made—not until the first one was a proven success." But he trusted his intuition based on his long filmmaking experience. "If we'd made it in our usual materials, like plaster or fiberglass, the paint would have just worn off," he explains. "Sometimes the fake stuff costs a good deal more in effort and money than getting the real thing." The Yorkstone floor endured through ten years of camera tracks, lighting equipment, and hundreds and hundreds of actors crossing its surface.

OPPOSITE: *The entrance to the set of the Great Hall.* TOP: *First-years prepare to be sorted in Harry Potter and the Sorcerer's Stone.* ABOVE: *The hourglasses used to tally house points for Slytherin, Hufflepuff, Gryffindor, and Ravenclaw.*

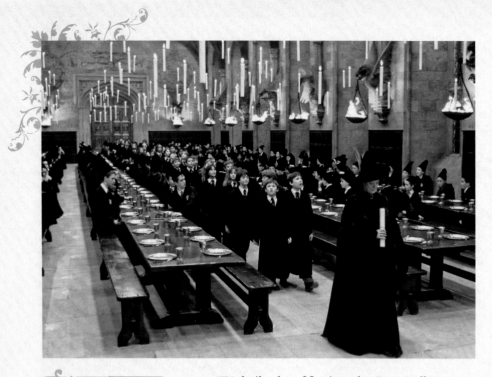

TOP: *A still from* Harry Potter and the Sorcerer's Stone *shows the floating candles in the Great Hall. After some experimenting, the candles were created digitally for the film.* RIGHT AND OPPOSITE: *Graphics and concept art by Dermot Power illustrate how the celestial night sky might be projected over the sleeping students in* Harry Potter and the Prisoner of Azkaban.

"We built a lot of fire into the Great Hall," says director Chris Columbus, "for it needed to be this magical, warm, loving place." A huge hearth decorated with the Hogwarts crest was placed on one side of the room, and the walls were decorated with flambeaux held by the heraldic creatures that represent the four houses. "Not surprising, though, we were faced with a few challenges. Particularly floating candlesticks and a ceiling that went on forever."

"We had three hundred and seventy real floating candles in the Great Hall," says Special Effects Supervisor John Richardson. "All floating up and down at different times. It looked really magical." Richardson and crew met almost all the challenges needed to have that many candles in the air. Each was suspended by two wires ten to fifteen feet over the heads of four hundred actors, and they could move up and down. "We had to have a quick way of refilling them," Richardson says. "We had to have a quick way of getting to them and lighting them up and a quick way of putting them out, and we did that." Chris Columbus was in awe of their work: "I remember the very first shot of the Great Hall, where we craned down through all of these floating candles. You couldn't see anything holding them up." But drafts on the Great Hall set blew the candle flames onto the wires. After burning for an hour or so, the flames would cause the wires to break, and the candles would fall, so for practical and safety reasons the floating candles were redone as a special effect. Creating the candles digitally, however, allowed the visual effects artists to arrange them in different patterns, such as circles or tiers, or even add pumpkins during Halloween, throughout the films.

As Hermione Granger tells Harry Potter upon their entrance into the Great Hall, "It's not real, the ceiling. It's just bewitched." Stuart Craig considered several ways to create the ever-changing ceiling view, but he wanted to ensure that it did not look like a two-dimensional painting. Initial thoughts were to treat the ceiling as if it were glass or as if the ceiling itself were made of sky. "We tried to illustrate this, I must say, impossible-sounding idea," Craig says with a laugh. "In other words, you would see bits of cloud within one of the roof beams. But this would cause great problems for the camera, and it's such an absurd notion that the roof is made of sky that we didn't go terribly far with that." Craig and Concept Artist Dermot Power drafted illustrations that showed the changing sky as a section of a virtual globe that intersected the ceiling. With that idea in mind, the sky and the ceiling's trusses were computer-generated, and the digital artists could have a defined lower limit. When rain or snow fell in the Great Hall, it always disappeared on the same horizon line. To show the "real" exterior outside the Great Hall, an enormous hand-painted cyclorama encircled the whole set. "It's a big matte painting of the view from Hogwarts," says Craig, "so that every time you get a glimpse out a window, you see it in the background. This was no static painting, however. When it was supposed to be winter during the films, snow was painted on each of the mountaintops."

Set decorator Stephenie McMillan then filled the space. "We either make, rent, or buy," McMillan explains. "Making the furniture for the Great Hall was obvious because there's nowhere I knew of where you could buy or rent four one-hundred-foot tables and the eight one-hundred-foot benches that go with them!" The tables then needed to be aged as if they had seen many generations of students. To that end, the young actors were never discouraged from carving their names or images into the wood.

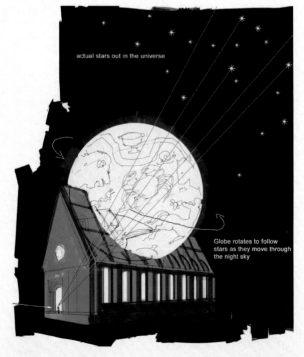

actual stars out in the universe

Globe rotates to follow stars as they move through the night sky

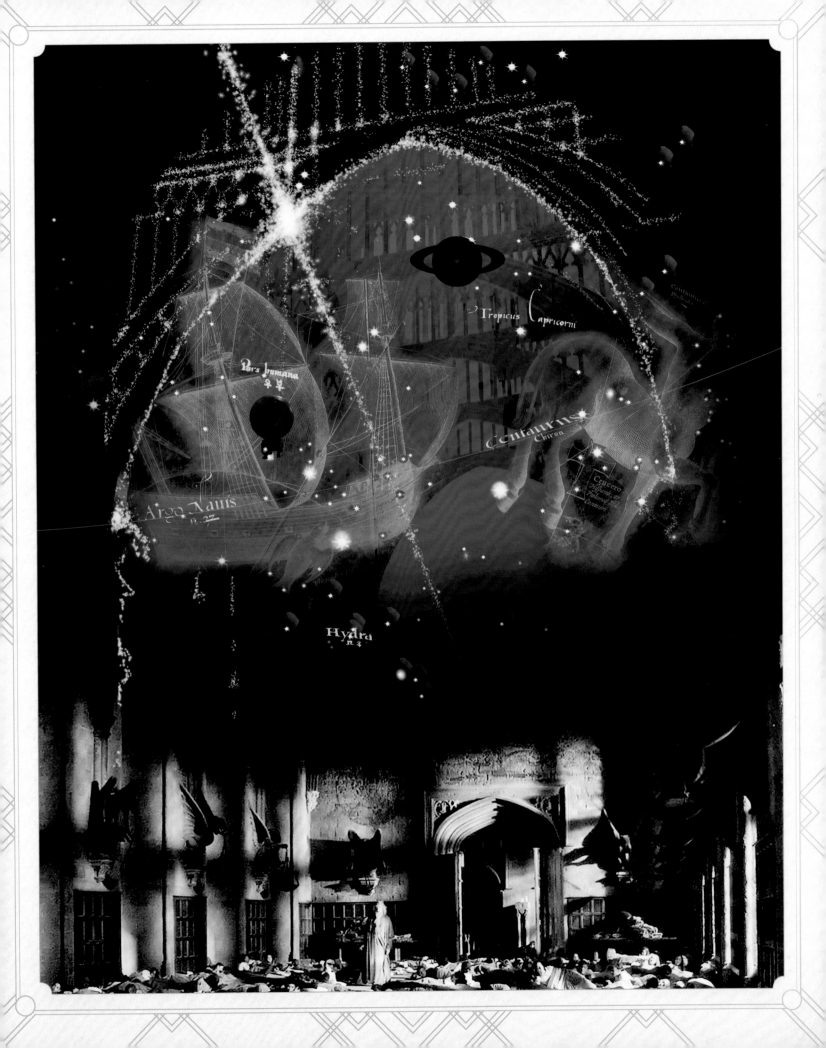

## ✦ The Yule Ball ✦

The Great Hall became the location of the
Triwizard Tournament's traditional Yule Ball
in *Harry Potter and the Goblet of Fire*. Stuart Craig
and Stephenie McMillan agreed that the Great
Hall wasn't really the best place for a party. "I
remember Stuart and I looking into the Great Hall
and saying, 'Now what can we do to this place to
transform it?'" McMillan recalls. Explains Craig,
"The Great Hall is this rather stolid environment,
with massive bits of masonry. It's very brown
and—apart from its ceiling and its floating
candles—it's not very party-like." The novel
describes the space as being "a sort of ice palace,"
McMillan says, and she came up with the idea of
making it silver, although the next challenge was
how. "Silver paint is actually flat and not reflective
enough," says Craig. "If you're not careful, it
photographs as if it was just gray stone." Then
McMillan recalled how drapery had transformed
Sybill Trelawney's Divination classroom. They
located and bought massive amounts of a fireproof
silver Lurex fabric, and they fastened it to the
walls, wrapped it around the trusses, draped it

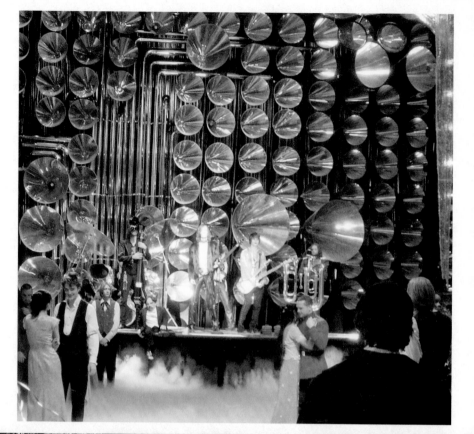

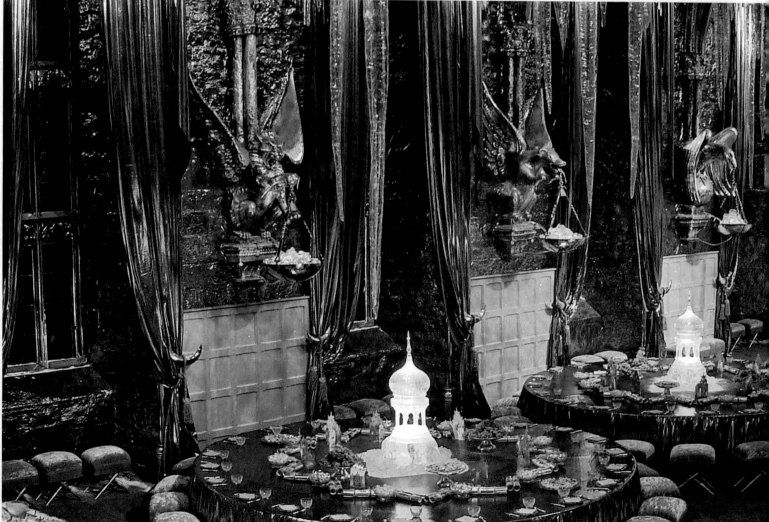

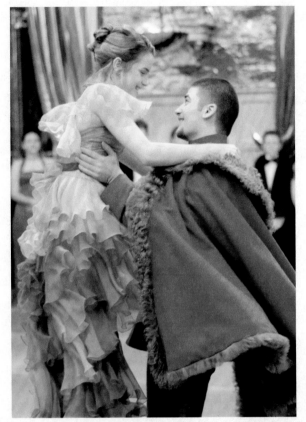

from the windows, and used it to cover the tables. What wasn't swathed in fabric was still silver, including the Christmas trees that bordered the room and the instruments for the twenty-four-piece orchestra. "It just sort of gathered momentum," confesses McMillan. The icy theme carried throughout, from the blue-lit ice in the flambeaux's bowls to the icicle-encrusted ceiling.

Another change McMillan made was to the seating arrangements. Instead of the long tables, she stocked the room with thirteen-foot-diameter round ones, which were surrounded by two hundred and fifty French-style silver cross-legged stools. The tables were topped with ice sculptures based on the Royal Pavilion in Brighton, although these were cast in resin and lit from underneath with blue gels. The majority of the food served was resin as well. McMillan and her team ransacked London's famous fish market, Billingsgate, for lobster, crabs, prawns, and more. Some were utilized to create resin molds, but others were real. These had to be treated so they wouldn't go rancid under the studio lights. This meant no one could eat them, but no one could smell them either.

OPPOSITE TOP: *Students dance at the Yule Ball.* LEFT: *Hermione and Viktor Krum (Stanislav Ianevski) in* Harry Potter and the Goblet of Fire. BELOW: *The elegant transformation of the Great Hall was achieved in part with silver Lurex fabric.*

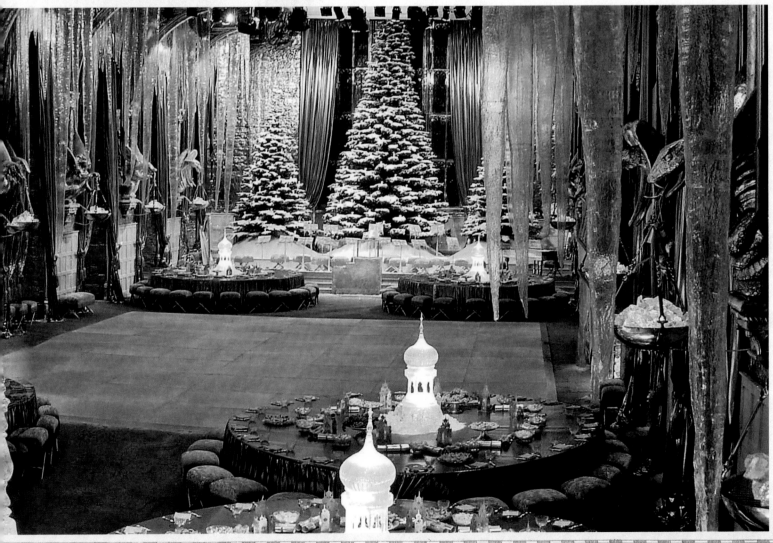

# GRYFFINDOR COMMON ROOM

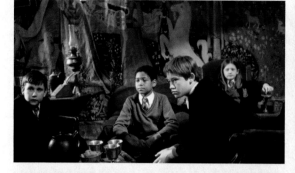

Stuart Craig wanted the Gryffindor common room to provide "a reassuring feeling of warmth and comfort, with a beat-up sofa (Craig designed the sofa cushions himself), a threadbare carpet, and a massive fireplace." He put a *large* emphasis on the last item. "The fireplace is significant because Harry has come from this rather unpleasant existence with his aunt and uncle. The common room is the first warm, comforting home experience he's ever had and so the hearth was very important. Then surrounding the fireplace with lush tapestries in a room decorated in rich reds made this place enveloping, almost womblike."

Production design employed a team of researchers that explored the architecture and decoration of various time periods in order to supplement descriptions from the books. The red-and-gold tapestries that decorate the common room were brought to Stuart Craig's attention by researcher Celia Barnett. "She showed me these splendid tapestries with a scarlet background from the Cluny museum in Paris," he explains, "and the subject of these tapestries is a beautiful French medieval woman and a unicorn. So we asked the

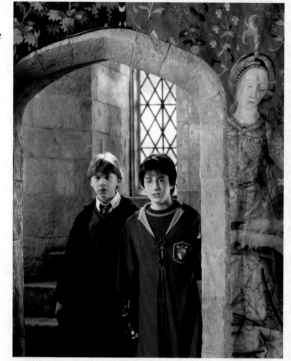

TOP AND RIGHT: *Two stills show the common room's warm contrast to the stone castle.* BELOW AND OPPOSITE: *The Gryffindor common room was one of the few sets that went unchanged throughout the film series.*

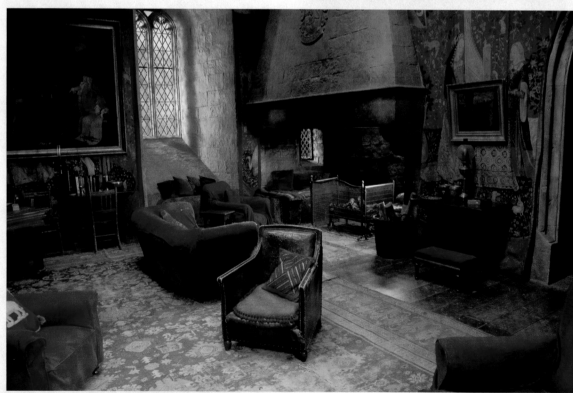

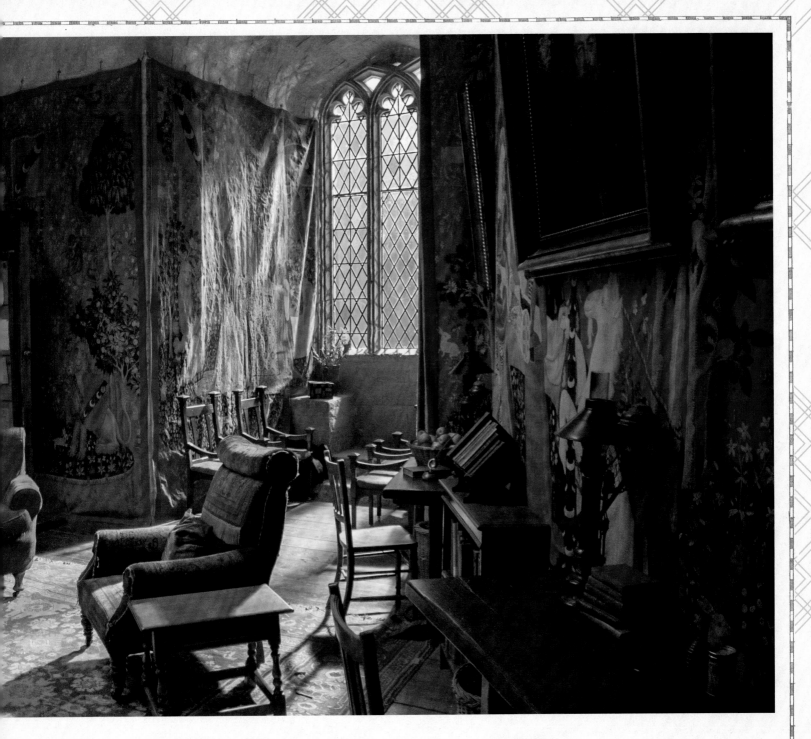

museum if we might reproduce them." The museum was happy to oblige, providing transparencies of the fifteenth-century work *The Lady and the Unicorn* that the design team turned into digital prints.

"With only a few changes," says Stephenie McMillan, "the common room remained the same throughout the films." One constant prop was various issues of the wizard comic book *The Adventures of Martin Miggs the Mad Muggle*, created by the graphics department. Announcements on the notice board changed every year, as would timely issues of the *Quibbler* and the *Daily Prophet*, which were scattered around the room. For *Harry Potter and the Prisoner of Azkaban*, director Alfonso Cuarón asked for moving portraits in the common room. "So we painted portraits of past heads of Gryffindor, a small Quidditch match oil painting, and a Hogarth-inspired painting of wizards playing cards." McMillan referred to the common room as "the home base." Near the end of the film series, "when that particular combined set of the common room and the dormitory was struck," she recalls, "it was like, my goodness, our home is gone."

## "PASSWORD?"

Fat Lady portrait, *Harry Potter and the Sorcerer's Stone*

OCCUPANTS: Gryffindor students

APPEARANCES: *Harry Potter and the Sorcerer's Stone, Harry Potter and the Chamber of Secrets, Harry Potter and the Prisoner of Azkaban, Harry Potter and the Goblet of Fire, Harry Potter and the Order of the Phoenix, Harry Potter and the Half-Blood Prince*

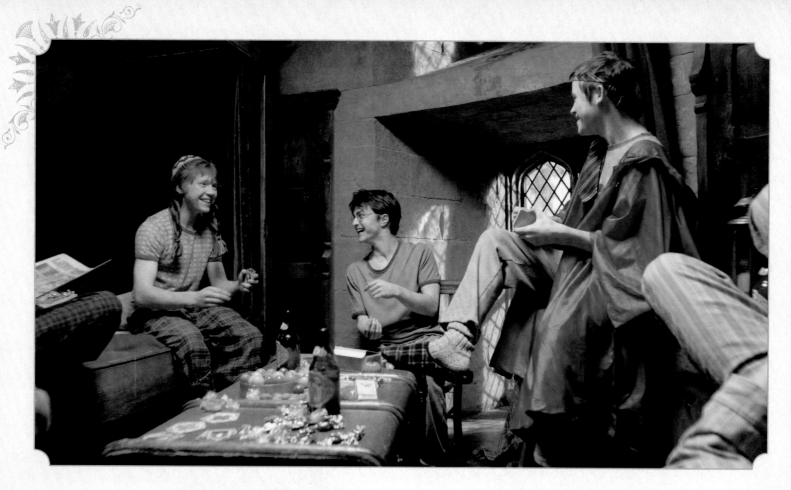

# GRYFFINDOR BOYS' DORMITORY

Stuart Craig continued the theme of intimate space in the Gryffindor boys' dormitory. "Harry's lack of security was an aspect of his character that we wanted to explore," he explains, "and in designing the dormitory and his little four-poster bed we were very conscious of the fact that this was a refuge for him. He felt more at home here than anywhere else, and we deliberately made it small. We draped the beds with curtains because they cocooned him; they made him feel comfortable and safe, which contrasted with the vastness of the rest of the place." The bed frames, with Roman numerals inscribed on top, were stained "a sort of medium to dark oak," says Stephenie McMillan, "which seems to be the standard for English school furniture." McMillan wanted the curtains to be Gryffindor scarlet, of course, and printed with gold magical and astrological symbols and images. She searched antique markets and fabric stores for something to match her idea, but after several weeks of fruitless efforts, McMillan was resigned to creating the fabric for the film. Then, at the eleventh hour, she spotted the very design she desired in a London shop window. Almost. "The design was what I wanted," McMillan says, "but unfortunately, the fabric was purple. Mauve, actually." McMillan told the shopkeeper she liked the pattern but not the color, and she was about to walk out the door when the woman asked, "What color would you like it to be?" The fabric store was able to provide McMillan with curtain material in the rich scarlet of the Gryffindor house colors.

The cast-iron stove in the middle of the room was by the French manufacturer Godin; McMillan had used it in a previous film. The tables beside the beds were decorated to reflect aspects of each student's interests. Ron Weasley, a devout Chudley Cannons fan, had posters and pennants of his favorite Quidditch team draped around his table, as well as the Quidditch magazine *Seeker Weekly*. Neville Longbottom had books about plants. Seamus Finnigan had shamrocks on his table. For *Harry Potter and the Goblet of Fire*, Seamus "supported the Irish National Quidditch Team," says Stuart Craig, so "we put mementos on his table after the Quidditch World Cup." Teen-related products were created by the graphics department and set on various tables, including Tolipan Blemish Blitzer and Fergus Fungal Budge. Through the course of the films, the actors grew in height, but the beds remained the same size: five feet, nine inches. Clever camera angles hid any feet that hung over the ends of the mattresses when filming.

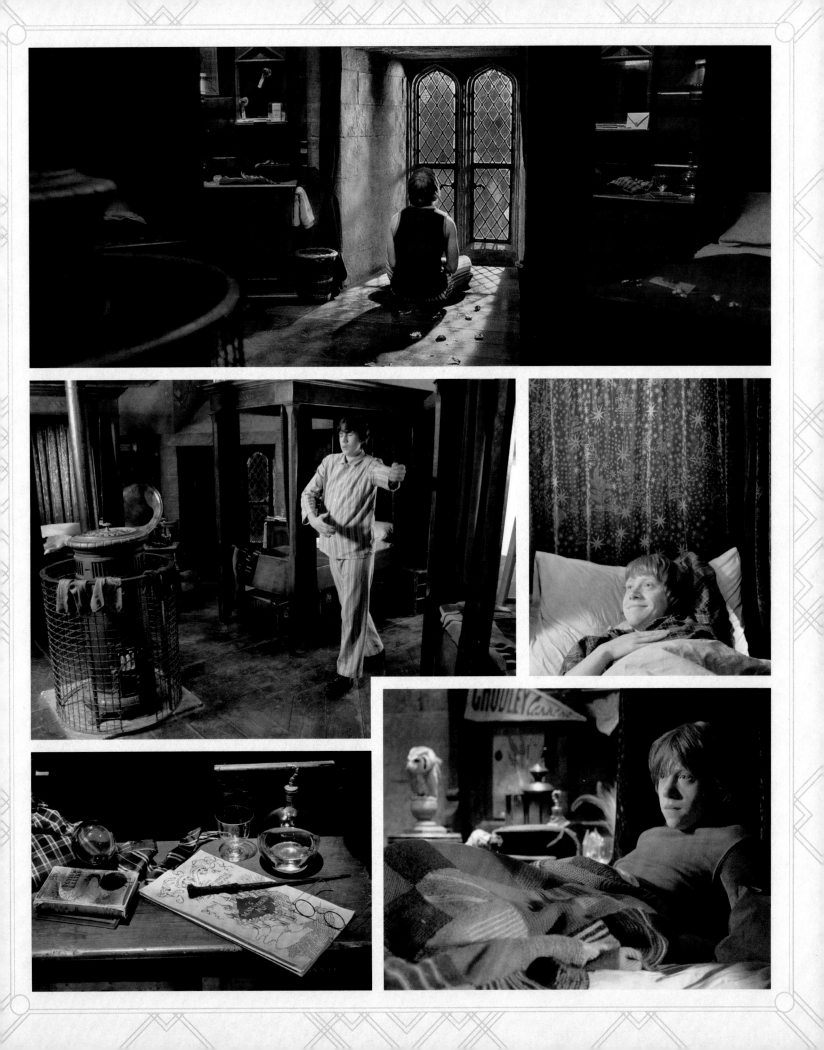

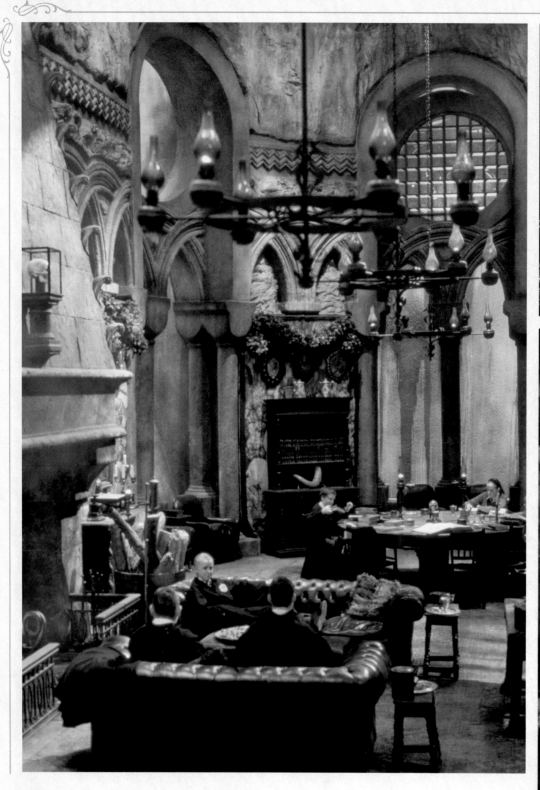

"WE ALSO NEED TO MAKE SURE THAT THE REAL CRABBE AND GOYLE CAN'T BURST IN ON US WHILE WE'RE INTERROGATING MALFOY."

Hermione Granger, *Harry Potter and the Chamber of Secrets*

ABOVE: *Harry and Ron use Polyjuice Potion to disguise themselves as Crabbe and Goyle in order to question Draco Malfoy (top right).* RIGHT: *Art by Andrew Williamson shows light refracted by lake water entering the Slytherin common room.*

# SLYTHERIN COMMON ROOM

In *Harry Potter and the Chamber of Secrets*, the common room used by Slytherin Draco Malfoy and his cohorts Crabbe and Goyle contrasts in every way with its Gryffindor counterpart. Unlike the airy tower that accommodates Gryffindor students, Slytherin's cavernous common room is situated under the lake. Stuart Craig wanted a stockier, sturdier feel to it, "as if it was carved out of solid rock." Inspired by Jordan's Petra Treasury, the room was constructed with no blocks or joints in its masonry. Craig chose an earlier style of architecture than in the rest of the castle. "It's more Norman or Romanesque, so there's a slightly different feel about it, although I think this is perceived subconsciously." The silver-and-green Slytherin colors provided Stephenie McMillan with her palette for the tall, dungeon-like room. "We had black leather sofas, and tapestries on the walls with all the red taken out, so they were printed with more green and blue." This also added to the room's underwater feel. The ornaments and decorations were crafted in silver and featured serpentine designs. While the fireplace is as large, if not larger, than Gryffindor's, there is no fire lit; it is cold and dark.

OCCUPANTS:
Slytherin students

FILMING LOCATION:
Leavesden Studios

APPEARANCE:
*Harry Potter and the Chamber of Secrets*

# OWLERY

OCCUPANTS:
Owls of the Owl Post and
students' personal owls

FILMING LOCATION:
Leavesden Studios

APPEARANCE:
*Harry Potter and the
Goblet of Fire*

*Harry Potter and the Goblet of Fire* featured the Yule Ball, for which the students needed to find dancing partners. The Owlery is where Harry Potter invites Cho Chang to accompany him, only to find out she has already accepted an invitation from Cedric Diggory. Although the Owlery is mentioned in previous films, this was its first on-screen appearance. As with many of the sets for the *Harry Potter* films, the Owlery was a combination of a live set, a miniature, and special effects. For the design, Stuart Craig pursued his philosophy of treating structure like sculpture. "It's not just one tower, but two," he explains, "kind of melded together. There are landings and different levels, which always adds interest to a place, and windows with views back to Hogwarts and the new bridge that had been added, and views out to the third task's maze, still under construction." Craig wanted the Owlery to be dramatic and attention-grabbing. "We found the best silhouette we could and set it on top of this seemingly impossible pentacle-shaped base of rock. Then we set that on top of a ridge of rock that had been filmed in Inverness, Scotland."

Knowing that the Owlery would house live birds as well as faux owls, Craig consulted with Animal Supervisor Gary Gero. Craig wanted uniformity in the Owlery's interior design, but real owls are different sizes, and providing safety for the birds meant accommodating their diverse measurements. Eventually, Craig came up with an optimum size and shape for the perches, one that allowed any species of owl to fly onto it and grip. Faux owls were used on perches farthest from the camera. Closer owls were a combination of plastic, mechanical, and digital animals as well as real birds. During filming, each real owl was connected to a light, invisible security line called a "jesse," which was attached to a safety latch behind the perch. The owls also wore jesses when they flew around the Owlery. In the most populated Owlery scene, sixty live owls were featured, most

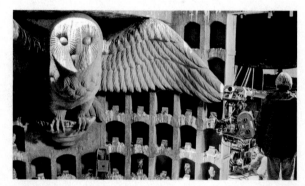

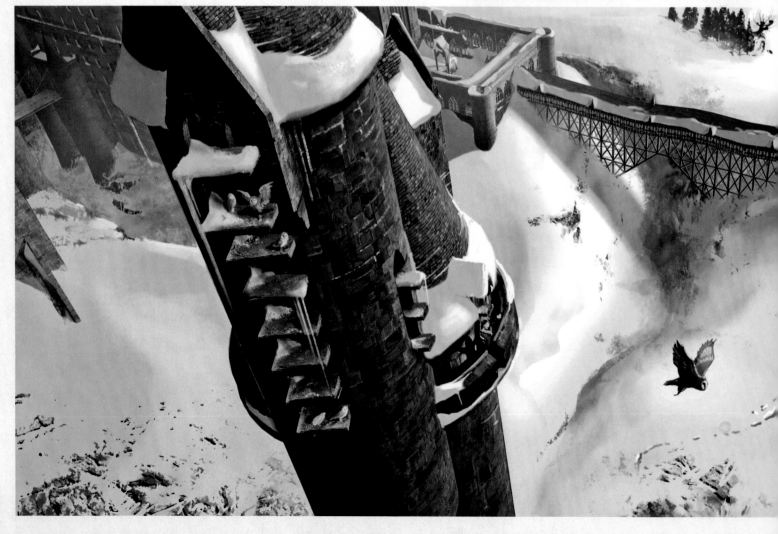

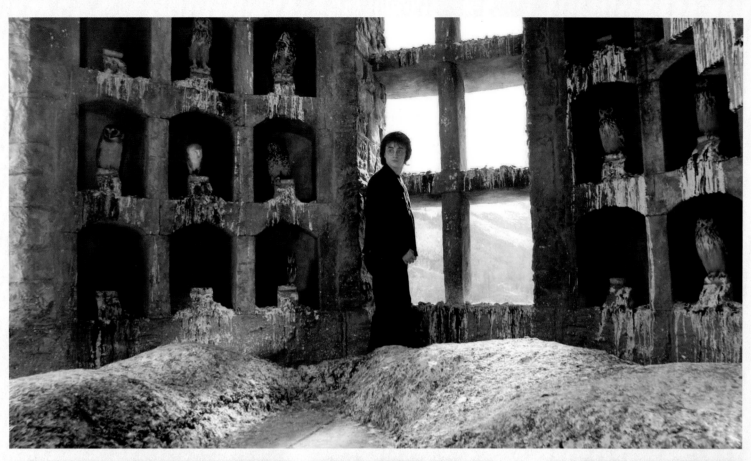

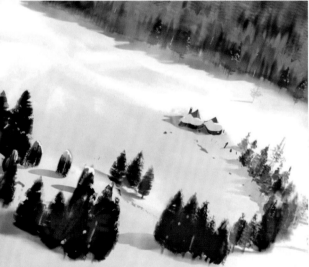

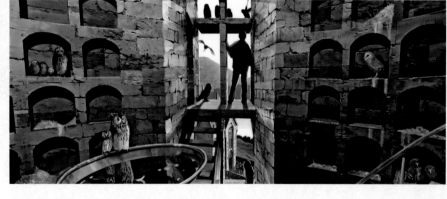

## "WATCH YOURSELF ON THE STAIRS. IT'S A BIT ICY AT THE TOP."

Cho Chang, *Harry Potter and the Goblet of Fire*

of them brought in from rescue centers. But since really large and really small owls cannot fly together (think: lunch), different groups of owls were filmed separately and composited together. Even though most owls are nocturnal, the owls trained by Gero and his team were used to filming in the daytime, though occasionally they would take naps.

The owl droppings in the Owlery were made from Styrofoam that was then dripped over with plaster and paint. The attention to detail that characterized the construction and dressing of the sets carried over to the Hogwarts model created for the films. The Owlery on the model was filled with miniature owls that also depicted different species and sizes.

TOP: *Harry surrounded by real and faux owls in* Harry Potter and the Goblet of Fire. ABOVE AND LEFT: *Concept art by Andrew Williamson depicts the interior and exterior of the Owlery.* OPPOSITE, TOP: *The crew on the Owlery set.*

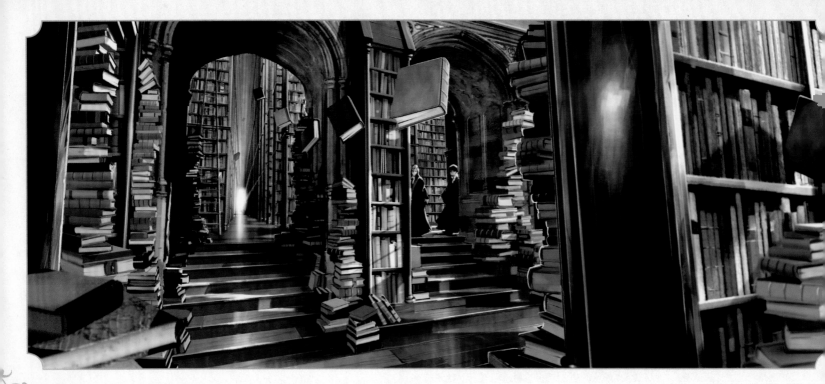

"YOU CAN HELP HARRY, THEN. HE'S GOING TO GO AND LOOK IN THE LIBRARY FOR INFORMATION ON NICOLAS FLAMEL."

Hermione Granger, *Harry Potter and the Sorcerer's Stone*

# LIBRARY

During *Harry Potter and the Sorcerer's Stone,* Harry uses his Invisibility Cloak to sneak into the restricted section of the Hogwarts library in an attempt to find out more about Nicolas Flamel and the Sorcerer's Stone. For the filming of the library scene, the filmmakers chose to shoot on location in Duke Humfrey's Library, one of forty libraries that comprise the Bodleian Libraries of Oxford University. Duke Humfrey's Library is the oldest reading room at Oxford, dating back to the mid-1400s. "It was a bit of a coup to shoot in the beautiful Bodleian Library," says Stuart Craig. "To even get permission. The restrictions, as you might quite reasonably imagine, were very difficult. And compromises in camera angles happened often, so we decided to build it ourselves for the later films." Duke Humfrey's Library has a system of chaining the oldest books to a frame embedded in the bookshelves, and Craig copied this practice in the re-created version built at Leavesden Studios.

Harry does research in the library to help him in the second task of the Triwizard Tournament in *Harry Potter and the Goblet of Fire*; Hermione observes Romilda Vane flirting with Harry in the library during *Harry Potter and the Half-Blood Prince* while they look for information on Horcruxes. The library books seen in these films were created in different materials for different purposes. "We used a combination of really nice leather books and books that are made out of other materials, like Styrofoam," explains Stephenie McMillan. "Sometimes you have to have books flying through the air! And there are very, very tall piles of books that are part of the library set, so these also needed to be lightweight." In *Half-Blood Prince,* as Hermione and Harry discuss her most recent frustration with Ron Weasley, she carries a stack of books that float out of her hands to their proper places. A simple practical effect was used to shelve the books. As actress Emma Watson held a book out, crew members wearing gloves made of green-screen material would reach through from behind the stacks, take the book, and place it on the shelf. Their hands were then digitally removed from the scene.

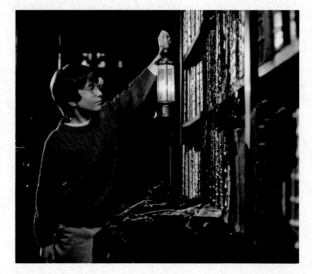

TOP: *Concept art for* Harry Potter and the Goblet of Fire *by Andrew Williamson.* ABOVE: *Harry explores the restricted section of the library in* Harry Potter and the Sorcerer's Stone. OPPOSITE: *In a scene from* Harry Potter and the Half-Blood Prince, *crew members wearing green gloves reach out for books. Their hands were later digitally erased.*

OCCUPANTS: Madam Pince, students

FILMING LOCATIONS: Duke Humfrey's Library, Bodleian Library, Oxford University, Oxfordshire, England; Leavesden Studios

APPEARANCES: *Harry Potter and the Sorcerer's Stone, Harry Potter and the Chamber of Secrets, Harry Potter and the Goblet of Fire, Harry Potter and the Half-Blood Prince*

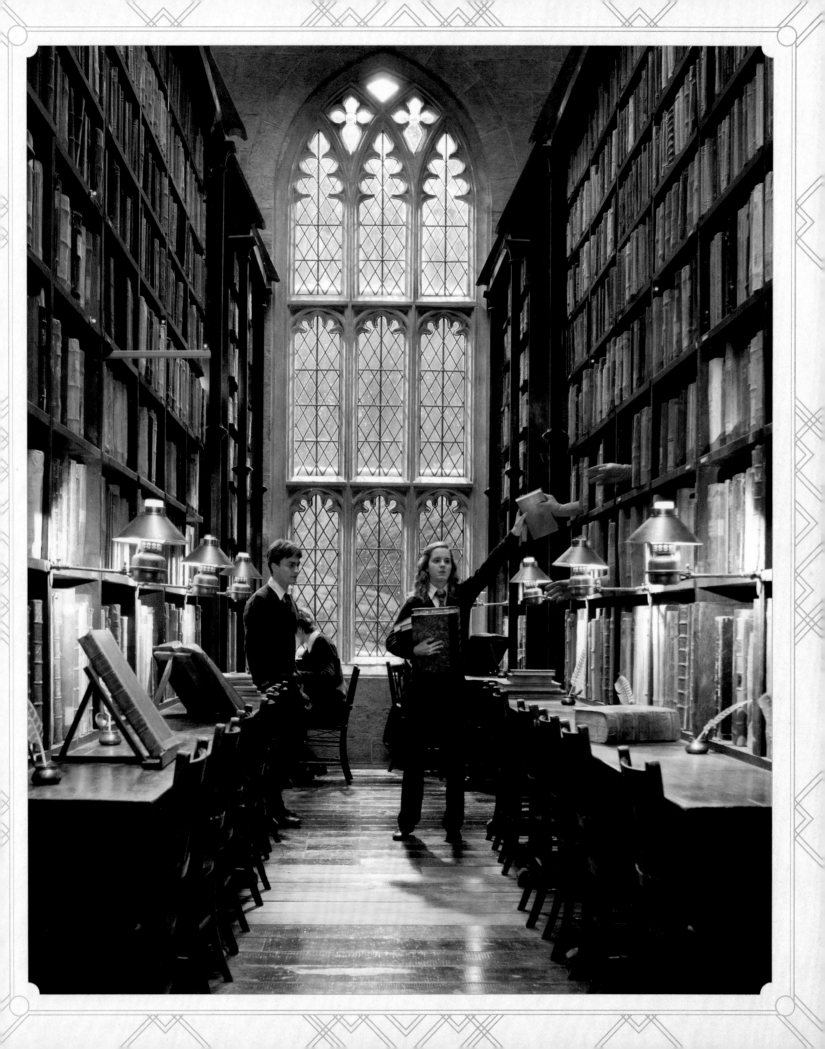

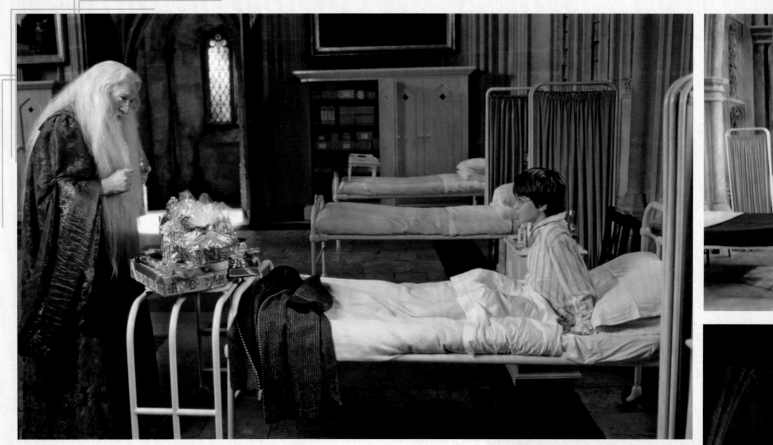

# HOSPITAL WING

Like Hogwarts' library, the hospital wing scenes for *Harry Potter and the Sorcerer's Stone* and *Harry Potter and the Chamber of Secrets* were filmed in the Bodleian Library at Oxford University, this time in the Divinity School. The Divinity School also dates back to the late fifteenth century, and its ceiling is another exquisite example of fan vaulting, this time in the lierne method.

For *Harry Potter and the Prisoner of Azkaban*, the wing was re-created at Leavesden Studios, with a slight restructure. The wing now opened out onto a hallway through which the top half of the Clock Tower pendulum could be seen. Chandelier lighting was also added. Eight beds fill the wing, each with a clipboard at its end that holds the patient's medical information, printed on a Hogwarts form, and the medicine cabinets are filled with pill bottles and potions, all labeled by the graphics department. The hospital wing remains unchanged in *Harry Potter and the Half-Blood Prince*; Draco recovers there after he is injured by the *Sectumsempra* Curse cast by Harry, and Ron is brought there after ingesting a love potion meant for Harry.

Sharp eyes will notice that the Hospital Wing has been converted into the room where Professor McGonagall teaches the Gryffindor students how to dance the waltz prior to the Yule Ball, in *Harry Potter and the Goblet of Fire*.

---

THESE PAGES, CLOCKWISE FROM TOP LEFT: *A still from* Harry Potter and the Sorcerer's Stone; *Harry and Hermione prepare to use the Time-Turner in* Harry Potter and the Prisoner of Azkaban; *a prop clock; the hospital wing set as it appears in* Harry Potter and the Prisoner of Azkaban.

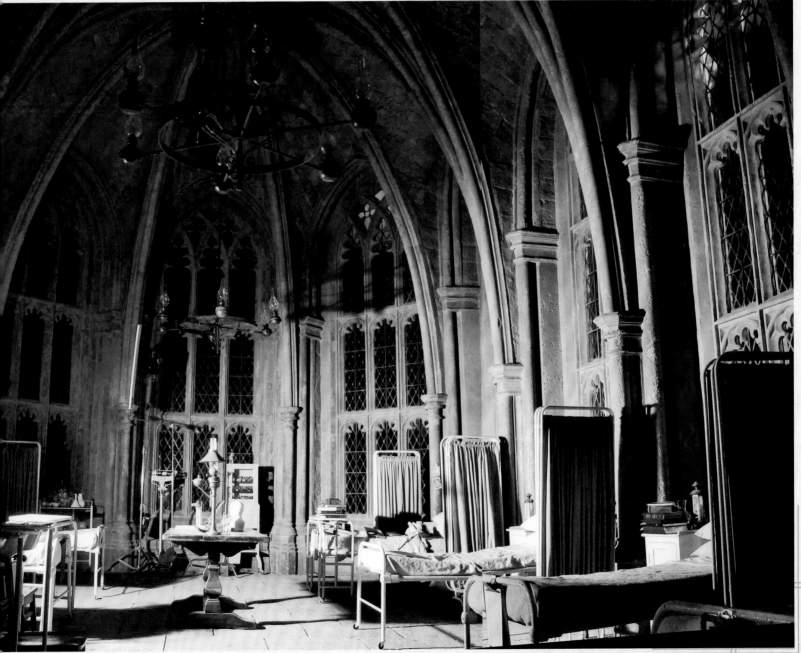

# "WE NEED TO GET YOU UP TO THE HOSPITAL WING, SIR, TO MADAM POMFREY."

Harry Potter, *Harry Potter and the Half-Blood Prince*

**OCCUPANTS:** Madam Pomfrey, ill or injured students

**FILMING LOCATIONS:** The Divinity School, Bodleian Library, Oxford University, Oxfordshire, England; Leavesden Studios

**APPEARANCES:** *Harry Potter and the Sorcerer's Stone, Harry Potter and the Chamber of Secrets, Harry Potter and the Prisoner of Azkaban, Harry Potter and the Half-Blood Prince*

"YOU KNOW THE PREFECTS' BATHROOM ON THE FIFTH FLOOR? IT'S NOT A BAD PLACE FOR A BATH. JUST TAKE YOUR EGG AND MULL THINGS OVER IN THE HOT WATER."

Cedric Diggory, *Harry Potter and the Goblet of Fire*

## PREFECTS' BATHROOM

Among Hogwarts's many dramatic backdrops for action, bathrooms are rather prominent—one contains the entrance to the Chamber of Secrets in *Harry Potter and the Chamber of Secrets*, and another is where Harry Potter and Draco Malfoy have their most violent confrontation, in *Harry Potter and the Half-Blood Prince*. The most sumptuous is the Prefects' bathroom in *Goblet of Fire*. As part of the Triwizard Tournament, Harry has to interpret a screeching audio broadcast from a large golden egg to discover vital clues about the second task. His fellow Hogwarts champion, Cedric Diggory, offers an obscure suggestion: that Harry take a bath with the egg in the Prefects' bathroom.

Stuart Craig finds locations like these can fulfill a production designer's dream, as bathrooms contain mirrors and windows. "They're the juicy bits, aren't they?" he says with a laugh. "They're the things that have magic, really. Windows and mirrors, reflected or transparent, give you that layered extra dimension, give you a bit of sparkle. They can be your ultimate weapon." The Prefects' bathroom has three Gothic-arched windows; the middle one features a moving stained glass portrait of a beautiful merperson, designed by Conceptual Artist Adam Brockbank. She combs her hair while watching Harry and his uninvited guest, the ghost Moaning Myrtle, fathom the second task's clue. The nearly room-size tub is filled via three raised levels of taps that pour out streams of water, colored blue, red, and yellow. In order to ensure durability, the dozens of taps were sand-cast in bronze.

LEFT: *Concept art by Adam Brockbank shows the stained glass window in the Prefects' bathroom.* RIGHT: *The Prefects' bathroom set as seen in* Harry Potter and the Goblet of Fire.

OCCUPANTS: Prefects, Moaning Myrtle

FILMING LOCATION: Leavesden Studios

APPEARANCE: *Harry Potter and the Goblet of Fire*

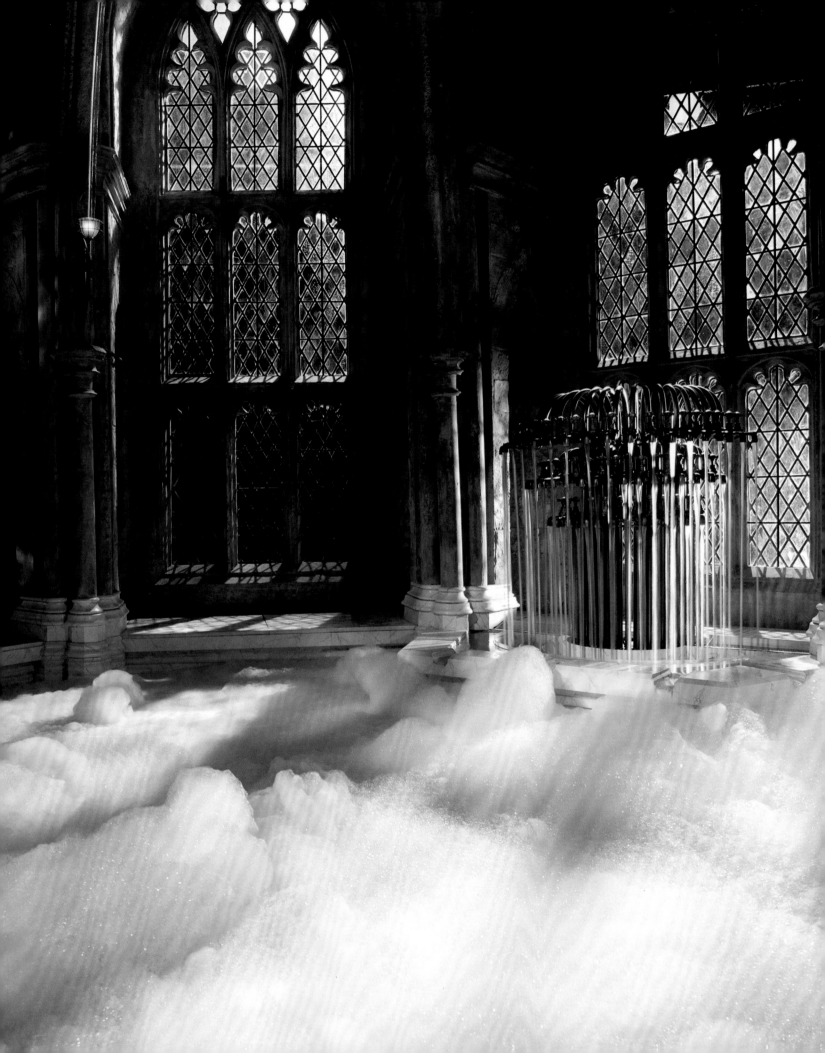

# CHAMBER OF SECRETS

*Harry Potter and the Chamber of Secrets* features a giant serpent, the Basilisk, which has been living under Hogwarts castle for nearly a thousand years. In Harry Potter's second year, the underground Chamber of Secrets is opened, and the beast that was once controlled by Salazar Slytherin prowls the pipes, searching for helpless victims. Taking his cue from the Basilisk's history, Production Designer Stuart Craig knew that the Chamber existed in, he says, "Slytherin territory. Their place is in the dungeons of Hogwarts. So this secret part of the castle had to be in Slytherin space. It is a Slytherin temple." Craig and crew took a trip into the sewers of London to study the architecture and engineering, bringing back inspiration for the Chamber's design. Craig also made several trips to Scotland and created molds of the rock faces of the cliffs and hills. Then these molds were cut into blocks and constructed to resemble masonry walls. A portion of the "original" rock face was kept intact, into which a sculpture of the face of Salazar Slytherin was carved, its mouth opening into a tunnel from which the Basilisk appears. This huge piece was molded in polystyrene and then dressed by sculptor Andrew Holder to match the rock face.

## "THE CHAMBER OF SECRETS HAS BEEN OPENED."

Writing on a Hogwarts corridor wall, *Harry Potter and the Chamber of Secrets*

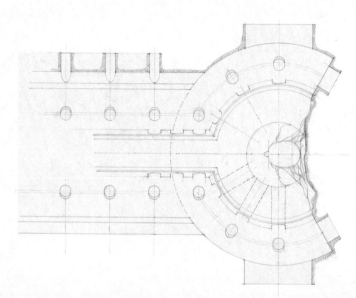

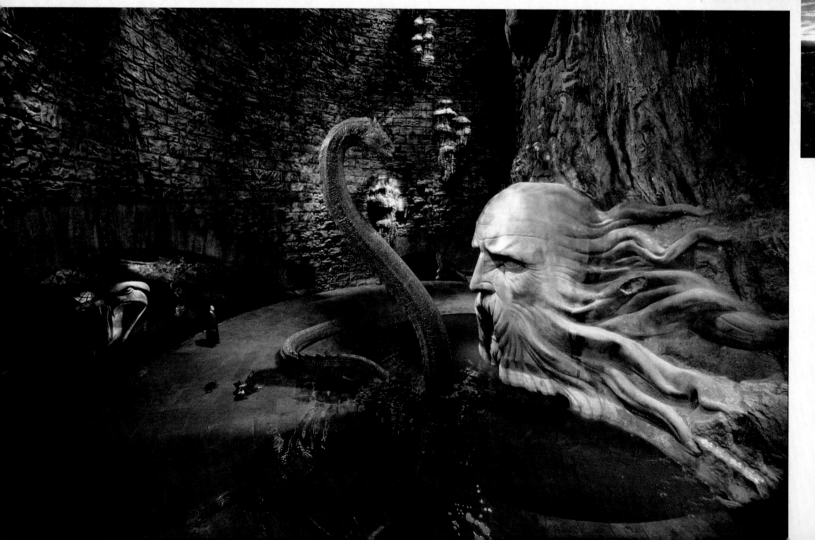

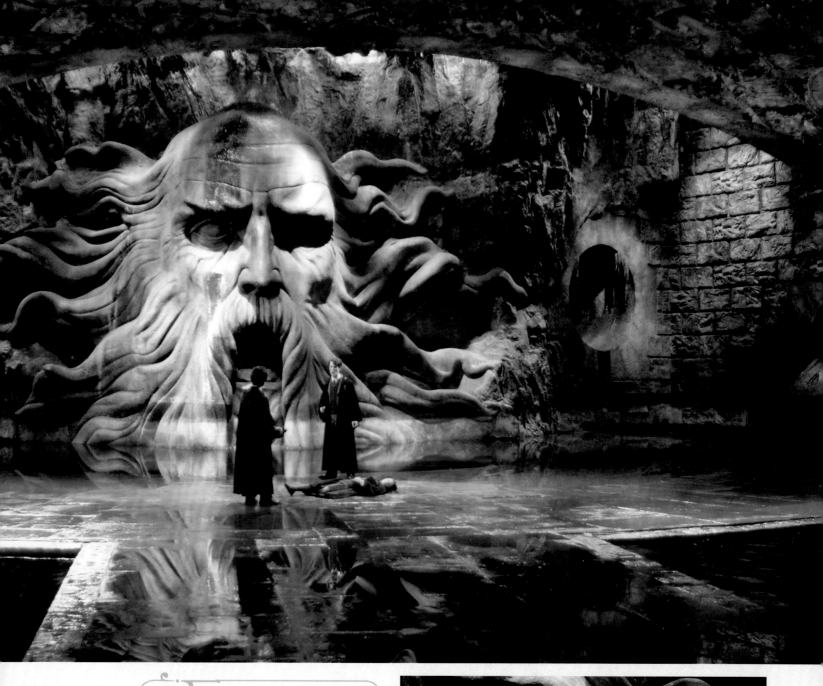

OCCUPANT: Basilisk

FILMING LOCATION: Leavesden Studios

APPEARANCES: *Harry Potter and the Chamber of Secrets, Harry Potter and the Deathly Hallows – Part 2*

OPPOSITE TOP: *Designs for the Chamber of Secrets.* TOP, ABOVE, AND OPPOSITE BOTTOM: *Stills from* Harry Potter and the Chamber of Secrets *show the size of the room and the scale of the molds used.* LEFT: *A sketch of the Basilisk by Stuart Craig.*

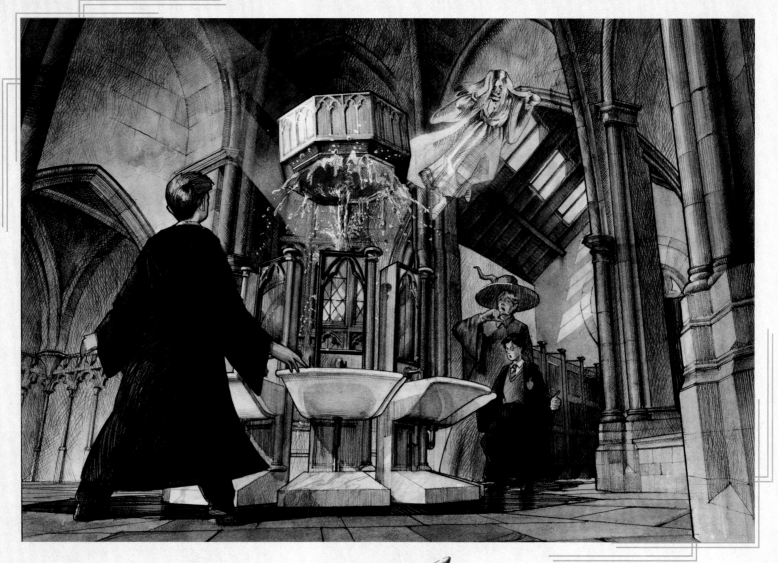

The Chamber of Secrets, at 250 feet long by 120 feet wide, was one of the biggest sets constructed for the films. Per the book's description, the Chamber was also supposed to be of an incredible depth, but the tallest stage at the time at Leavesden Studios reached only twenty-eight feet high. "I thought I could solve this by building down, or at least creating the illusion of depth. So, the idea is that the Chamber is hundreds of feet tall, but flooded, so you are seeing only the very top of Salazar Slytherin's statue." In reality, the water is only a foot deep and dyed black to give it a sense of depth.

In order to save Ginny Weasley and stop the Basilisk, Harry Potter must enter the Chamber of Secrets using an access in a girls' bathroom on an upper floor at Hogwarts. To expose the entrance, a circle of sinks was created that moved apart in a practical effect "like the petals of a flower," says Craig. Once Harry, Ron Weasley, and Professor Lockhart slide down to the Chamber, they become separated. Harry must enter the Chamber alone, but first he must open a large and locked circular door decorated with snakes. After Harry speaks in Parseltongue, each snake pulls back,

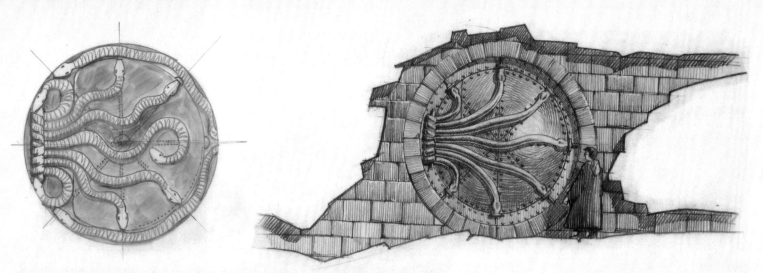

unlocking the door. "This was a very clever piece of engineering," says Craig. "Not a visual effect." Special Effects Supervisor John Richardson designed the mechanism, which was then realized by Mark Bullimore, a special effects supervising engineer who also constructed the Gringotts bank vault door locks.

The Chamber is entered again, in *Harry Potter and the Deathly Hallows – Part 2*, when Ron Weasley and Hermione Granger retrieve a Basilisk tooth in order to destroy a Horcrux. As the Chamber was used only briefly in the film, a digital reconstruction was created and the scene was filmed entirely in green screen—from ceiling to floor.

THESE PAGES, CLOCKWISE FROM TOP LEFT: *Harry, Ron, and Professor Lockhart (and Moaning Myrtle, who is not seen in the film) look on as the sink in the girls' bathroom reveals the entrance to the Chamber of Secrets; concept art for the circular door to the Chamber, which was engineered for the film (left); art depicting Ron and Hermione's visit to the Chamber of Secrets in* Harry Potter and the Deathly Hallows – Part 2; *artwork by Adam Brockbank shows the Chamber's intricate snake-shaped locking device.*

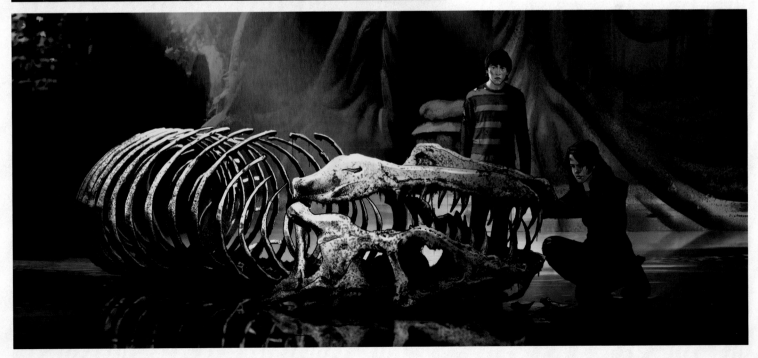

ABOVE: *The Room of Requirement
set.* RIGHT: *Concept art by Andrew
Williamson depicting the Room
of Requirement as it appears
in* Harry Potter and the
Deathly Hallows – Part 2.
BELOW: *Blueprint for the door to
the Room of Requirement.*

# ROOM OF REQUIREMENT

The Room of Requirement first appears in *Harry Potter and the Order
of the Phoenix* when Harry Potter needs a place to practice defensive
magical arts with Dumbledore's Army, the newly formed group
of students prepared to arm themselves against Lord Voldemort.
With a long, mysterious history, the Room of Requirement can only
be found by those in need of it, and the room changes to provide
whatever the seeker needs. To complement the Gothic style of
Hogwarts castle, the Room of Requirement was created with a high,
vaulted ceiling whose arches dropped down into columns that were
suspended above the floor. Stuart Craig wanted the emphasis to be
on the students, and so he did not fill the room with everything
that's described in the books. Craig's "neutral space," as he describes
it, was surrounded by mirrors. "I felt that was appropriate in that
it reflected the students and their needs back to themselves. And
photographically, the reflections offered exciting possibilities."
Hanging from the ceiling were five chandeliers made of high-
quality plastic, since they needed to shake when Dolores Umbridge
eventually discovers the room and explodes open the door. Actor
Matthew Lewis (Neville Longbottom) described the set as looking
like "an underground fight club in Hogwarts."

Lighting a room encircled by mirrors can be, as Craig admits,
"enormously difficult. You not only reflect the camera and the
crew, you reflect all the lighting, so it was a cause of great
concern." To control these things, he angled the mirrors and used
a dulling spray that eliminated reflections. But a conversation
with the director of photography, Sławomir Idziak, offered
the most ingenious solution. Craig explains, "We invented an
under-floor lighting system, where he could literally light from
grilles underneath." The lighting would be imperceptible. The
only problem was, this also lit the bottoms of people's shoes.
The solution: cover everyone's soles with black velvet. Another
requirement, due to the black floor, was that the crew and anyone
walking into the room had to wear blue plastic slippers to keep
from treading dust onto the set.

In the films, the Room of Requirement set was sometimes
redressed as something else: it became the Trophy Room in *Goblet
of Fire*, with glass cabinets supporting the hanging columns, and it
was Professor Slughorn's office in *Harry Potter and Half-Blood Prince*,
where the dropped columns rested on bases of four Ionic columns.

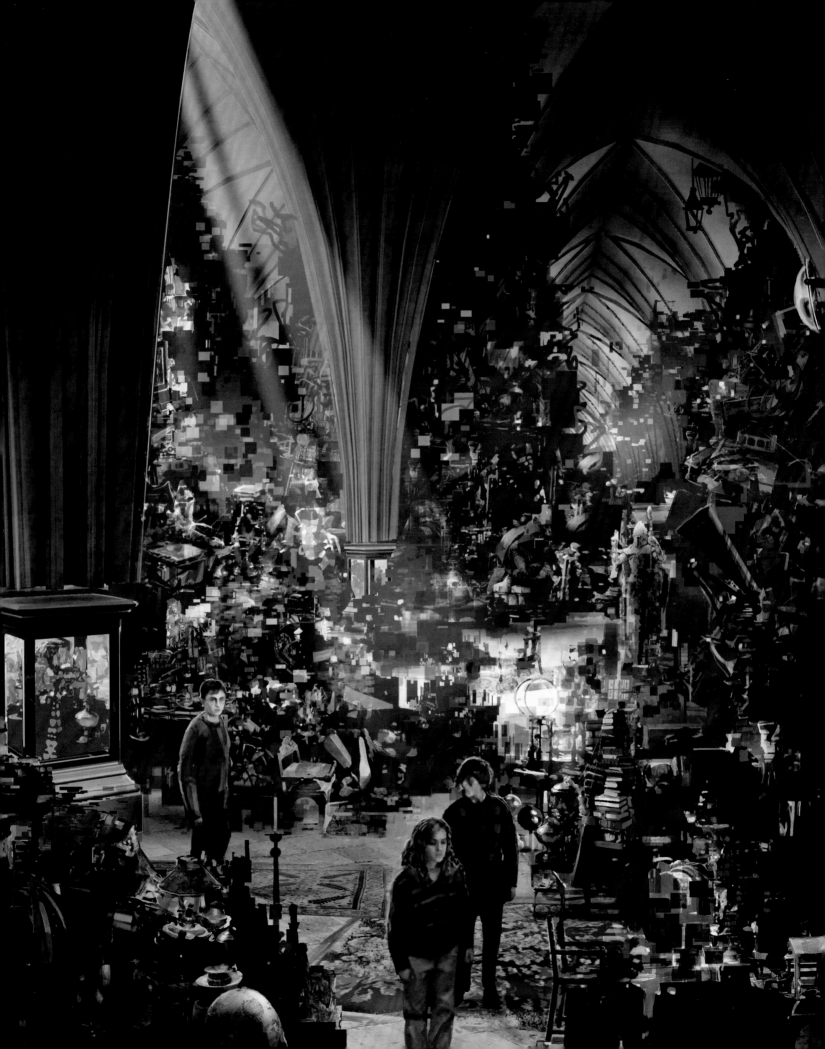

## "YOU'VE DONE IT, NEVILLE! YOU'VE FOUND THE ROOM OF REQUIREMENT."

Hermione Granger,
*Harry Potter and the Order of the Phoenix*

RIGHT AND BELOW: *Among the many objects stored in the Room of Requirement are the Mirror of Erised and the record player used in Professor Lupin's Riddikulus lesson.* OPPOSITE TOP: *Concept art for* Harry Potter and the Deathly Hallows – Part 2 *shows the Room engulfed in flames.* OPPOSITE MIDDLE AND BOTTOM: *Concept art and a preliminary sketch show the room prepared with hammocks for displaced students.*

The Room of Requirement also appears as itself in *Half-Blood Prince:* Harry Potter hides his annotated *Advanced Potion-Making* book there, and the room is where Draco Malfoy places a Vanishing Cabinet, which serves as a passageway to allow Death Eaters into Hogwarts. For this iteration, in which the room is filled with endless piles of abandoned things people have wanted to hide over the centuries, Craig did not want to emphasize the high ceiling. "So the glass cabinets were put back under the columns to support them and these gave the room a structure that we could then fill with mountains of stuff rising up from the floor, so that the dressing was more dominant." Fortunately, set decorator Stephenie McMillan and the art department, who created and retained the props from all the films, already had a considerable inventory of props to fill the space. Sharp eyes will spot pieces from the wizard's chess set that guarded the Sorcerer's Stone, and the projection machine Snape used in *Harry Potter and the Prisoner of Azkaban.*

In *Harry Potter and the Deathly Hallows – Part 2,* the Room of Requirement becomes the base for Neville Longbottom and the other students threatened or displaced by Headmaster Snape and his new teachers, the Carrows. The room is stripped down to its bones, populated only by a few pieces of furniture and hammocks hung from the beams. Once again, the

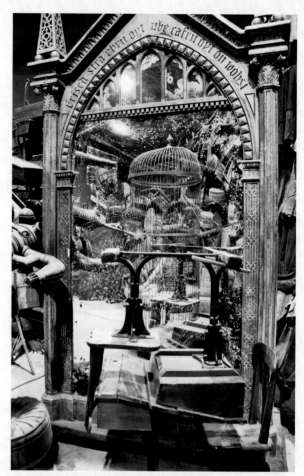

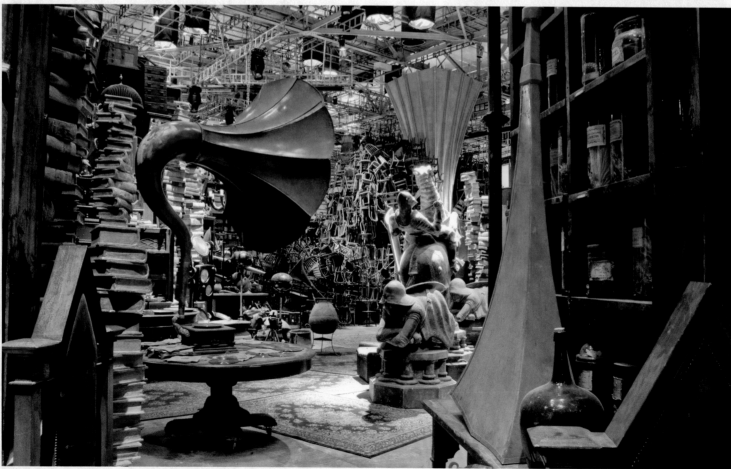

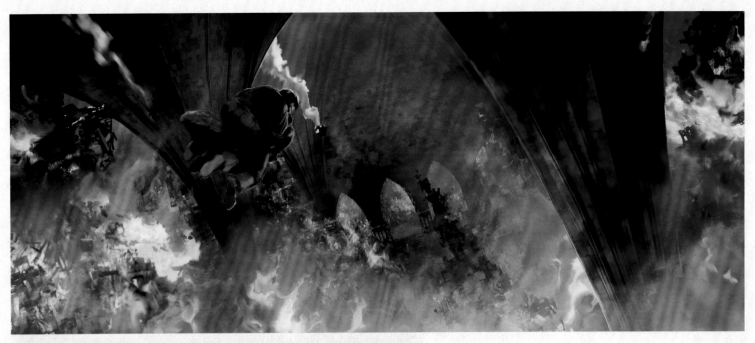

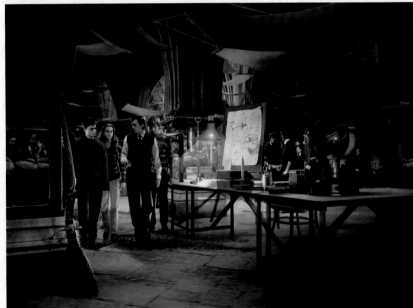

glass cabinets, this time completely empty, support the dropped columns. Later, Harry returns to the Room of Requirement in his search for Ravenclaw's diadem, which has been transformed into one of Voldemort's Horcruxes. Once again, the room appears as a junk pile of abandoned things in one of the final film's most spectacular action sequences. This time, the height of the room was used to its advantage, and Craig and McMillan left no space uncluttered: Craig knew that less wasn't more. "The fact that they were looking for a tiara—this tiny little jewel of an object—in something so massive and complicated just made the task all the more impossible." Craig began "sculpting" the room by fabricating a model out of small Styrofoam blocks, to create what he called its "mountainscape." A bigger model was then made, using doll's house furniture. "And then [director] David Yates came in to look at the model," recalls Stephenie McMillan, "and said, 'I need another sixty-five feet for them to escape.' So we added more doll's house furniture. And think, for every tiny doll's house chair that was added, we would have to buy the same amount of real chairs."

In preparation to fill the room with the several thousand pieces of furniture necessary, McMillan started buying additional furniture several months prior to shooting the scene. She also used the studio's stock to fill the space and create what she referred to as "the thirteen mountains." Incorporated into the piles was furniture from all the previous films. "We had thirty-six desks," McMillan recounts, "all the tables of the Great Hall, all the benches, all the professors' stools. The trophy cabinet dressing. The chess pieces from the second film. The party dressing from Slughorn's party." McMillan enjoyed walking through the set and seeing these. "And even then, of course," admits Craig, "we cheated and each pile's center was a series of big plywood boxes, just to bulk it up. The furniture was just one or two layers on top of that." Computer-generated imagery extended and filled the room even more.

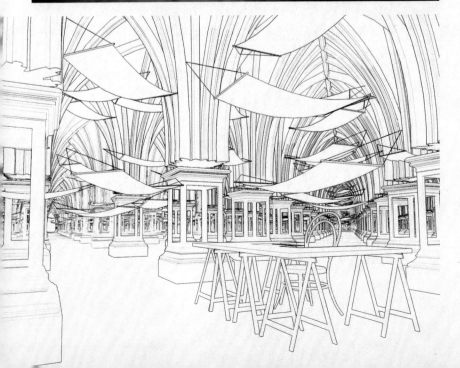

OCCUPANTS:
Hogwarts students
and professors

FILMING
LOCATION:
Leavesden Studios

APPEARANCE:
*Harry Potter and the
Half-Blood Prince*

# ASTRONOMY TOWER

The Astronomy Tower did not appear on the Hogwarts model used for filming until *Harry Potter and the Half-Blood Prince*, when Harry Potter and Albus Dumbledore Apparate there after retrieving the fake Horcrux locket. Unbeknownst to them, Draco Malfoy has smuggled Death Eaters into Hogwarts, which leads to a confrontation atop the tower and the death of Dumbledore. The tower is seen again in ruins as Harry and Voldemort battle during *Harry Potter and the Deathly Hallows – Part 2*. "We move things around, let things expand, develop, and disappear altogether," Craig affirms. "So as the series went on, we kept reinventing things, changing things, often because there was a script requirement." Craig reveals that there probably always was an Astronomy Tower on the castle, but "the movies' scripts didn't call for it, so it wasn't represented in the early films." On the Hogwarts model for *Half-Blood Prince*, the Astronomy Tower was placed in the same location as the tower where Sirius Black was imprisoned in *Prisoner of Azkaban* (which disappeared from the model after that film).

For Craig, the appearance of the Astronomy Tower was another opportunity to improve the school's silhouette. "The profile of Hogwarts in the first film is a mixture of different locations. Adding the Astronomy Tower was a huge improvement. It's replete with these rather dreamy spires and towers now, and to me a much more satisfactory silhouette with more exaggeration, more theatricality."

The Astronomy Tower, at an estimated 350 feet high, became the tallest tower on Hogwarts Castle, but it was also the smallest. "We had seen the interior of it, actually an earlier iteration of a room dedicated to Astronomy," says Craig, referring to the

scene in *Harry Potter and the Prisoner of Azkaban* where Professor Lupin teaches Harry the Patronus Charm. "But for this version, it needed to be impressive. It called for a highly detailed piece of architecture." The Astronomy Tower is actually a composite. "There are towers that are cantilevered off the main tower. So the structure is architecturally very interesting, and although it sits in one space, it's more three spaces melded together." The tower was filled with scientific instruments, mirrors, spheres, and a telescope that dwarfs the humans. Craig's design for the tower modestly echoes that of Dumbledore's office, with a nod to its series of three circles.

THESE PAGES, CLOCKWISE FROM TOP LEFT: *Art by Andrew Williamson shows Dumbledore and Harry conferring before leaving to search for Slytherin's locket; Dumbledore awaits his fate in* Harry Potter and the Half-Blood Prince; *Death Eaters scale the Tower; Harry, Ron, and Hermione watch Fawkes depart.*

# HOGWARTS CLASSROOMS AND OFFICES

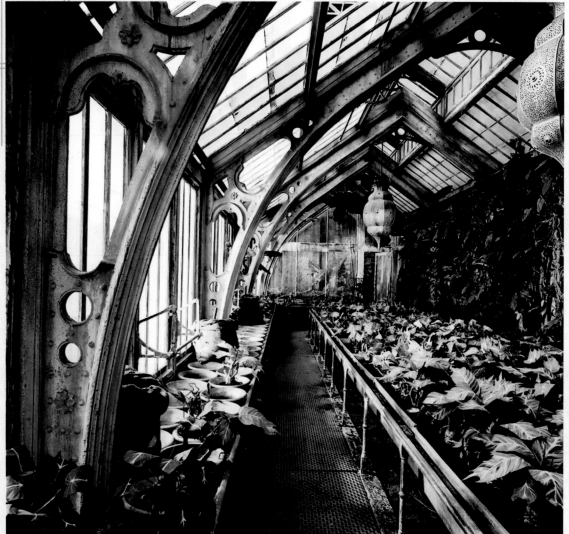

# HERBOLOGY GREENHOUSE

Harry Potter and the other second-year students are taught how to repot Mandrakes by Professor Pomona Sprout in the Herbology greenhouse during *Harry Potter and the Chamber of Secrets*, and the set appears again in *Harry Potter and the Half-Blood Prince*, when Harry comes across Professor Horace Slughorn sneakily clipping leaves off a Venomous Tentacula.

"We started with Kew Gardens as the idea for the structure of the Herbology greenhouse, particularly Temperate House at Kew," says Stuart Craig. Temperate House, at the Kew Royal Botanic Gardens, is the largest existing Victorian glass greenhouse, opened in 1863. However, in *Chamber of Secrets*, "the point of the scene is learning about the Mandrakes and putting them into new pots," he explains, "so the focus and grouping of the set is staged around this massively long table covered with potted plants." The design style of the greenhouse echoed Hogwarts' Gothic feel, with pointed arches running the length of the ceiling. Craig was particularly pleased by the painting of the interior. "There is lichen and moss, a verdigris finish, stains and runs in the weathering. It's very rich and beautiful and special skills are needed to achieve that layering of age."

THESE PAGES, CLOCKWISE FROM TOP LEFT: *Ironwork arches adorn the greenhouse set; Professor Slughorn (Jim Broadbent) snips Venomous Tentacula leaves as Harry looks on in* Harry Potter and the Half-Blood Prince; *Professor Sprout instructs the second-years in repotting Mandrakes in* Harry Potter and the Chamber of Secrets.

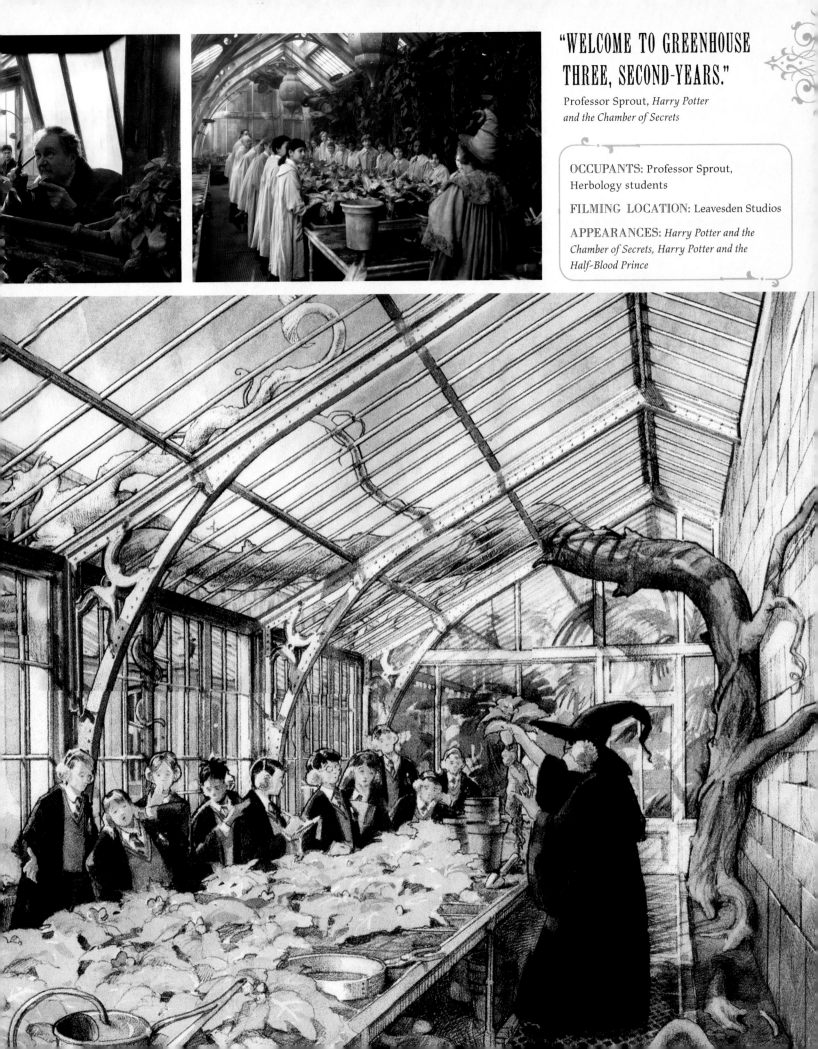

# "WELCOME TO GREENHOUSE THREE, SECOND-YEARS."

Professor Sprout, *Harry Potter and the Chamber of Secrets*

**OCCUPANTS:** Professor Sprout, Herbology students

**FILMING LOCATION:** Leavesden Studios

**APPEARANCES:** *Harry Potter and the Chamber of Secrets, Harry Potter and the Half-Blood Prince*

# DEFENSE AGAINST THE DARK ARTS CLASSROOM

Filming Professor Quirinus Quirrell's Defense Against the Dark Arts classroom for *Harry Potter and the Sorcerer's Stone* took place on location in the Warming Room in Lacock Abbey, which was the only room in the thirteenth-century building where the nuns were allowed to have a fire. However, Stuart Craig explains, "it is always easier to film on a studio set than take your cast and crew on location, so for *Chamber of Secrets*, we built the Defense Against the Dark Arts classroom." For this, the production designer did not re-create the Warming Room, but started anew, with two concepts in mind: the sculptural quality of the room and familiarity. "Though the decoration changes with each new professor of the Dark Arts, it's nice that we're in a familiar classroom." For Craig, the shape is of utmost importance.

Craig's design started with a blank sheet of paper. "It was one of those experiences where I started to doodle, and I came up with the idea of trusses, which would support huge beams of timber that themselves supported a very steeply pitched roof. It's an attic room, in the roofline, and I thought this would be a welcome counterpoint to all the masonry we were seeing in so many other interiors." Craig continued developing the room with a master camera shot in mind. "I decided the set should be curved so you looked into a curving wall with the trusses radiating around it." Light was also an important consideration, so he integrated the huge windows on one side. Then he

OCCUPANTS: Professors Quirrell, Lockhart, Lupin, Moody, and Umbridge; Defense Against the Dark Arts students

FILMING LOCATIONS: Warming Room, Lacock Abbey, Wiltshire, England; Leavesden Studios

APPEARANCES: *Harry Potter and the Sorcerer's Stone, Harry Potter and the Chamber of Secrets, Harry Potter and the Prisoner of Azkaban, Harry Potter and the Goblet of Fire, Harry Potter and the Order of the Phoenix*

BELOW AND OPPOSITE TOP: *On the set of Professor Quirrell's Defense Against the Dark Arts classroom, filmed on location at Lacock Abbey in Wiltshire.* OPPOSITE BOTTOM: *Blueprints for the construction of the classroom's entrance.*

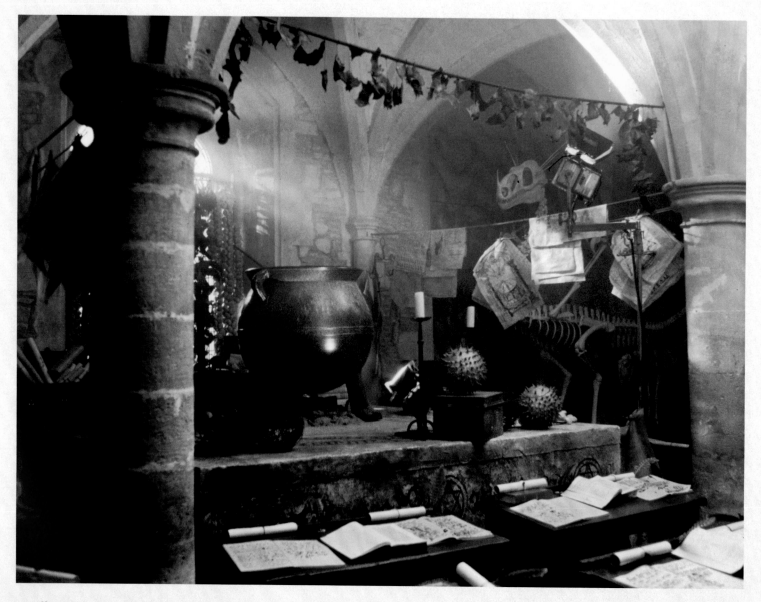

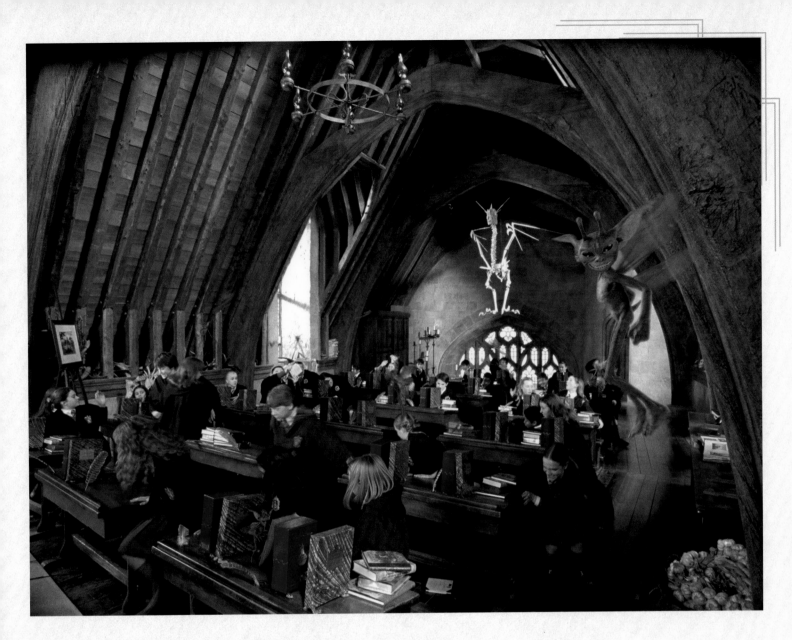

# "FEARFULLY F~FASCINATING SUBJECT. N~NOT THAT YOU NEED IT, EH, POTTER?"

Professor Quirrell, *Harry Potter and the Sorcerer's Stone*

needed to connect the classroom to the professor's office. "An attic space, almost by definition, is triangular, and so, in the two sloping sides of the triangle, the Gothic pulpit shape atop the stairs was a nice vertical accent." This fit Gilderoy Lockhart, the Dark Arts professor in *Chamber of Secrets*, perfectly. "This design created a stage-like setting that was ideal for Lockhart who—always the actor— was able to make dramatic entrances and exits."

Since the Defense Against the Dark Arts professor changes every year, Craig and Stephenie McMillan had the opportunity to redress the classroom regularly to reflect each successive teacher's personality. "Professor Lockhart was incredibly vain," explains McMillan, "so he had lots of photographs and paintings of himself and all the books that he'd written arranged around the room." The photographs showcased Professor Lockhart in various extreme or sporting exploits, many of which became moving photographs. "For the largest portrait, which was about ten feet by five feet," McMillan continues, "we had the idea of him painting a portrait of himself. And we were hoping that, in a visual effect, Lockhart would walk out of the portrait into the class." In the end, Lockhart only exchanges a wink with his painted double.

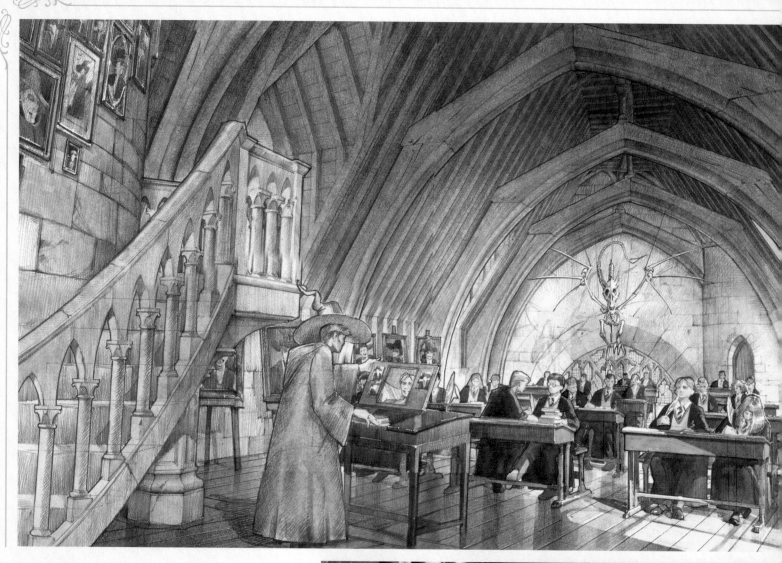

McMillan found Professor Remus Lupin in *Harry Potter and the Prisoner of Azkaban* a bit difficult to pin down. She decided to give him the look of a true naturalist, "so we put in things that he might have found on his travels, which included lots of skulls under glass domes." McMillan was also tasked with specific props called for by the script—such as the record player, the projector system, and the Boggart-containing cabinet. "We looked at French furniture, specifically in the Art Nouveau style. The wardrobe was an amalgam of the curving, flowing Art Nouveau lines, but we made them chunkier than they should have been to be more threatening." The set dressing for Professor Mad-Eye Moody in *Harry Potter and the Goblet of Fire* came much easier for her. "Of course, because of his glass eye, we took the theme of lenses, so everything in his room had to do with optical things, which we took to an extreme with *huge* hanging devices." McMillan found Professor Dolores Umbridge, in *Harry Potter and the Order of the Phoenix*, "a great relief. She actually didn't teach at all. So we had the room completely bare of any

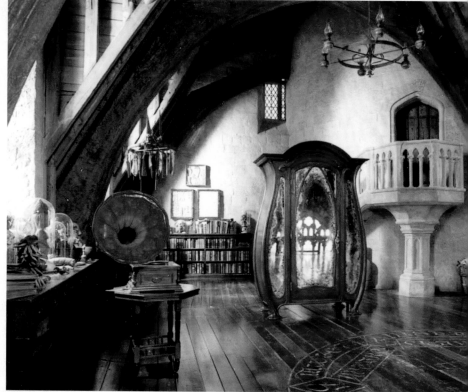

extra props except for these books that come down magically onto the desks. No decoration at all in the room. And so when you went up the stairs and saw her office it was a real shock."

In addition to the idiosyncratically decorative needs of each professor, McMillan also provided schoolroom basics. Each class had a pivoting blackboard, to which McMillan added her own bit of magic: a horizontal pair of boots at the bottom that acted as the "feet." Eighteen double desks in each class gave enough room to house thirty-six students—for a time. As the actors grew, admits Stuart Craig, "We had to extend their beds and their little school desks and chairs, too. They outgrew them literally and quite quickly."

THESE PAGES, CLOCKWISE FROM TOP LEFT: *Concept art for Gilderoy Lockhart's classroom displays the many portraits Lockhart kept of himself; Dolores Umbridge (Imelda Staunton) scowls in* Harry Potter and the Order of the Phoenix; *Mad-Eye Moody's classroom features a myriad of different-sized lenses; Remus Lupin's classroom features tusks and other anthropological relics.*

# DOLORES UMBRIDGE'S OFFICE

Harry Potter visits the incumbent Defense Against the Dark Arts professor's office in several of the films, but perhaps the most striking and surprising version is that of Dolores Umbridge in *Harry Potter and the Order of the Phoenix.* "The office's soft, rather sickly sweet veneer is a complete contradiction of her really aggressive, nasty actions," Stuart Craig says with a laugh. "It's a great contrast to everything that we have previously established." The curtains are pink, the Aubusson-style carpet is pink, and even the stone walls are tinted pink. "Umbridge's office is a circular room, and the decorations look slightly off; they contradict the basic architecture of the room so it has this rather hostile quality underneath it all." Slight modifications were made to the room for practical reasons. "We moved the windows around, basically to have her desk positioned in relation to the door for when Harry comes in and confronts her."

"We hadn't used French furniture before," explains Stephenie McMillan, "but we felt it would suit her character. It's not a very peaceful style; it's spiky and brittle." The obviously fake French reproduction furniture is slightly oversized, with thick upholstering and shiny drapery. "Her desk chair is also large enough so that her feet can't touch the floor; her legs just swing there because [actress] Imelda Staunton is rather tiny," McMillan says. The office is filled with an abundance of lace and well-organized knickknacks. "There are also items in the cabinets, collections of little scissors, and hatpins," describes McMillan. "Again, spiky and sharp." Umbridge's desk includes cat-ornamented pink notepaper, a cat-topped letter opener, and a cat-adorned bottle of perfume. And, most memorably, forty plates set on the walls that feature kittens.

"We decided that they'd be in tapering sizes, so the biggest ones are at the top," says McMillan. "Then we added a variety of borders. We had some plates that would feature still photographs, and then we had a fantastic session with the second unit as they filmed kittens dressed in hats, next to crystal balls, playing on a 'beach.'" These moving images were then composited onto plates that had blue-screen centers.

## "I MUST NOT TELL LIES."

Written punishment given to Harry Potter, *Harry Potter and the Order of the Phoenix*

OCCUPANT: Professor Umbridge

FILMING LOCATION: Leavesden Studios

APPEARANCE: *Harry Potter and the Order of the Phoenix*

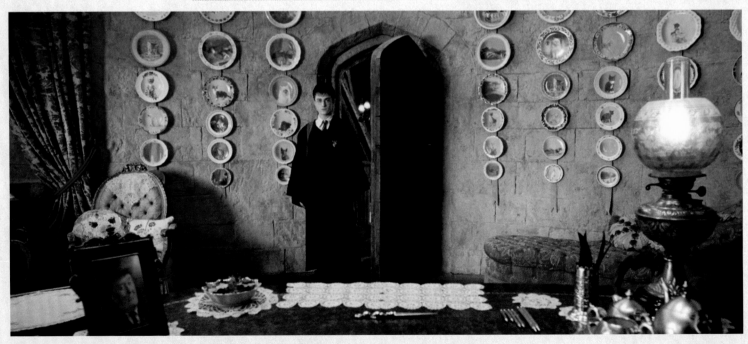

THESE PAGES, CLOCKWISE FROM TOP: *One of the forty kitten plates that adorn Umbridge's office walls; concept art by Adam Brockbank for a scene in Harry Potter and the Order of the Phoenix; images from the executed set; blueprint for Umbridge's chaise.*

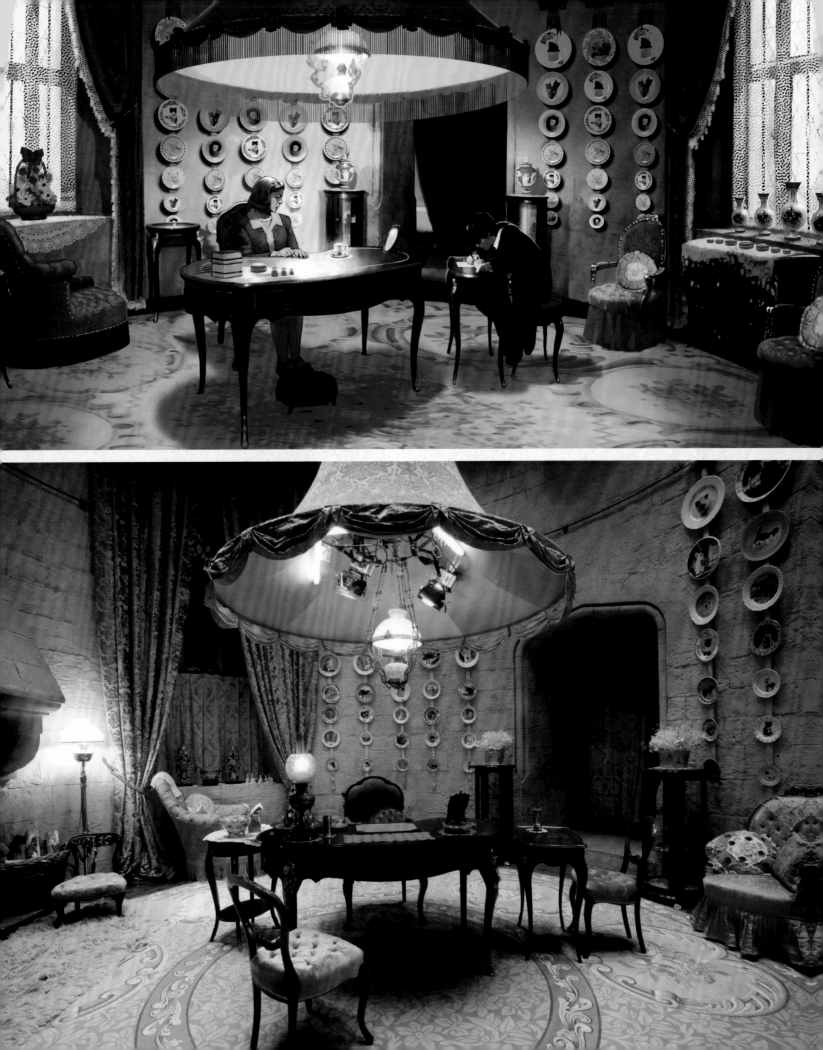

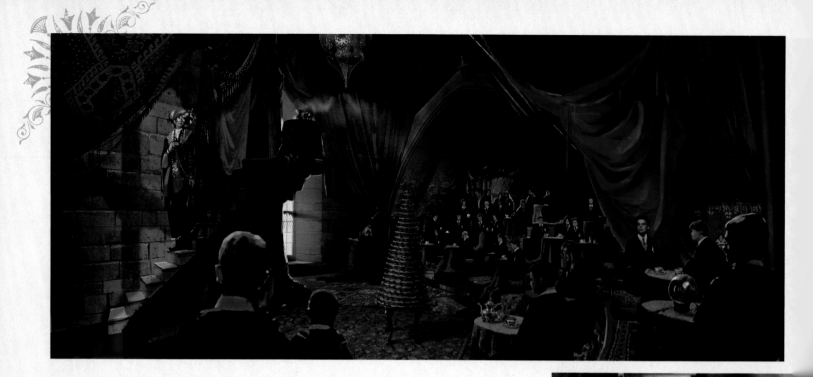

## "IF YOU ASK ME, DIVINATION'S A VERY WOOLLY DISCIPLINE."

Hermione Granger, *Harry Potter and the Prisoner of Azkaban*

# DIVINATION CLASSROOM

"Professor Sybill Trelawney's Divination classroom is an attic-type space," says Stuart Craig, "somewhere right at the top of Hogwarts. And she almost never comes down, does she." And like a well-used attic, Trelawney's loft in *Prisoner of Azkaban* is filled with her treasures. It has an *Arabian Nights* feel, flamboyantly swathed from wall to wall in exotic fabrics in bright colors, combined with the accoutrements of an old-fashioned tea shop. The amphitheater-style room is dressed in cloth-covered round tables that hold crystal balls and other divination equipment that surround a central table stacked high with teacups; in total there were more than five hundred tea cups in the room. The circular staircase that leads to the Divination Tower was filmed on location at St. Paul's Cathedral on Ludgate Hill in London; the staircase was used again in *Harry Potter and the Goblet of Fire*, leading away from the Defense Against the Dark Arts classroom.

In *Harry Potter and the Order of the Phoenix*, after Dolores Umbridge elevates herself to Headmistress of Hogwarts, she attempts to oust Sybill Trelawney from the school. "Trelawney's a very sad and rather more sympathetic character this time," says Craig, "and our job is to reflect that. This time, the colors are much more subdued. There are fewer shiny, gold-threaded fabrics. This time they're more earthy, suggesting her rather depressed situation and ultimate sadness." In fact, the classroom was made smaller than in its first appearance. "We minimized the actual conversion of the structure of the room to make it feel more compressed," explains Stephenie McMillan, agreeing with Craig that this better conveyed Trelawney's changed character. "This time it's much more down-market. She's a broken woman. So it's quite somber."

THESE PAGES, CLOCKWISE FROM TOP LEFT: *A concept by Andrew Williamson (top left) explores the lavish style used for the Divination classroom set in* Harry Potter and the Prisoner of Azkaban *(top right, right).*

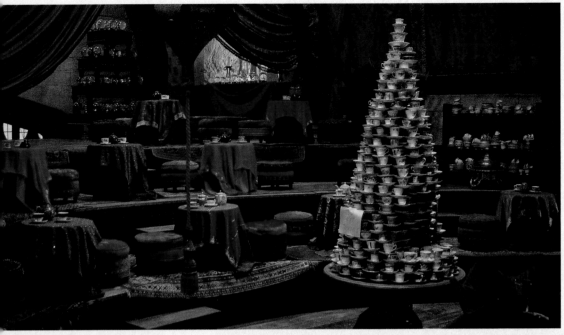

OCCUPANTS: Professor
Trelawney, Divination students

FILMING LOCATIONS:
St. Paul's Cathedral, Ludgate Hill,
London; Leavesden Studios

APPEARANCES: *Harry Potter and
the Prisoner of Azkaban, Harry Potter
and the Order of the Phoenix*

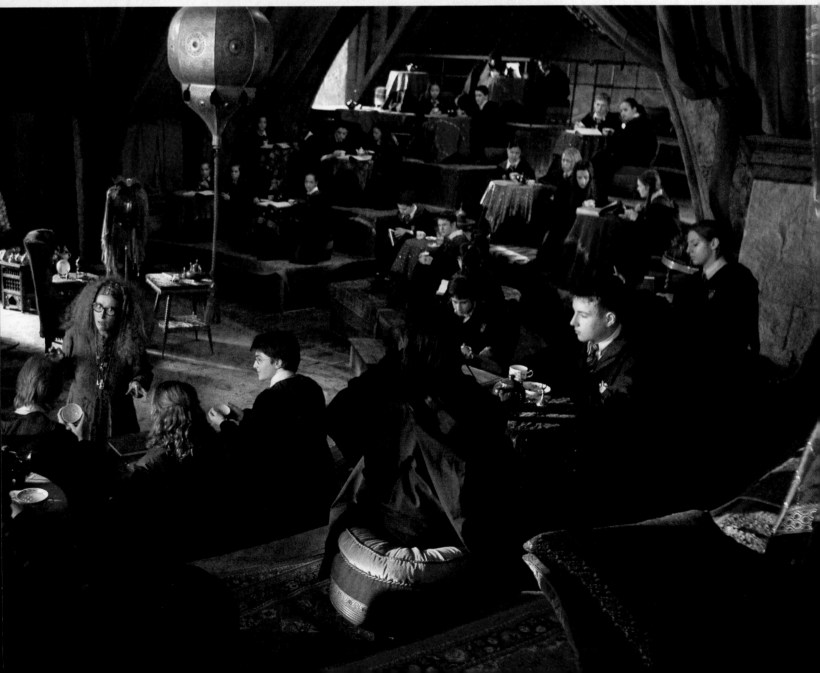

## POTIONS CLASSROOM

For Harry Potter's first five years at Hogwarts, Potions class is taught by his (presumed) nemesis, Severus Snape. Snape's Potions classroom in *Harry Potter and the Sorcerer's Stone* was shot on location in the Sacristy at Lacock Abbey, which provided several locations for that film: in addition to Professor Quirrell's Dark Arts classroom, the room housing the Mirror of Erised and the courtyard featuring cloister walks were also shot there. For Stuart Craig, the key to the Potions classroom is that it is a dungeon. "Dungeons have a particular kind of architecture. They have massive masonry, they have low ceilings. The ceilings are always vaulted, as they have to support what is above them. So the idea grew very logically out of the notion of a dungeon in a medieval school." The real-life room is not underground, and so the filmmakers had its windows covered up to a certain point to suggest a subterranean location. Stephenie McMillan provided heavy square desks that held cauldrons bubbling over wizard Bunsen burners, and the graphics department labeled the hundreds of jars and vials of ingredients that were shelved around the room. For the next three films, Professor Snape gained an office that similarly abounded with Potions ingredients and grew slightly bigger upon each viewing. Professor Snape's office desk was originally a table in the Slytherin common room used in *Chamber of Secrets*.

In *Harry Potter and the Half-Blood Prince*, Snape's wish to teach Defense Against Dark Arts is granted, and Professor Dumbledore asks a former Potions professor, Horace Slughorn, to return to Hogwarts. The Potions classroom was re-created at Leavesden, but the set for Snape's office, including the desk, was used and the room was expanded once again. The shelves were extended, and the jars from Snape's stockroom were added. Special new cauldrons were created, including a miniature cauldron for the Felix Felicis potion. The same student tables were used, but with an effective alteration. McMillan explains, "The tabletops were wood, but the cameraman asked if the tops could be changed to reflect light from a source in the ceiling. So we covered them with zinc, which I think makes them look much more interesting. It's a set that has benefited from being repeated," she concludes, "because we've truly improved it this time."

THESE PAGES, CLOCKWISE FROM TOP LEFT: *A still from* Harry Potter and the Sorcerer's Stone, *shot in Lacock Abbey; the expanded studio set of the Potions classroom; a collection of potion bottles that were hand-labeled by the graphics department.*

> "I CAN TELL YOU HOW TO BOTTLE FAME, BREW GLORY, AND EVEN PUT A STOPPER IN DEATH."
>
> Professor Snape, *Harry Potter and the Sorcerer's Stone*

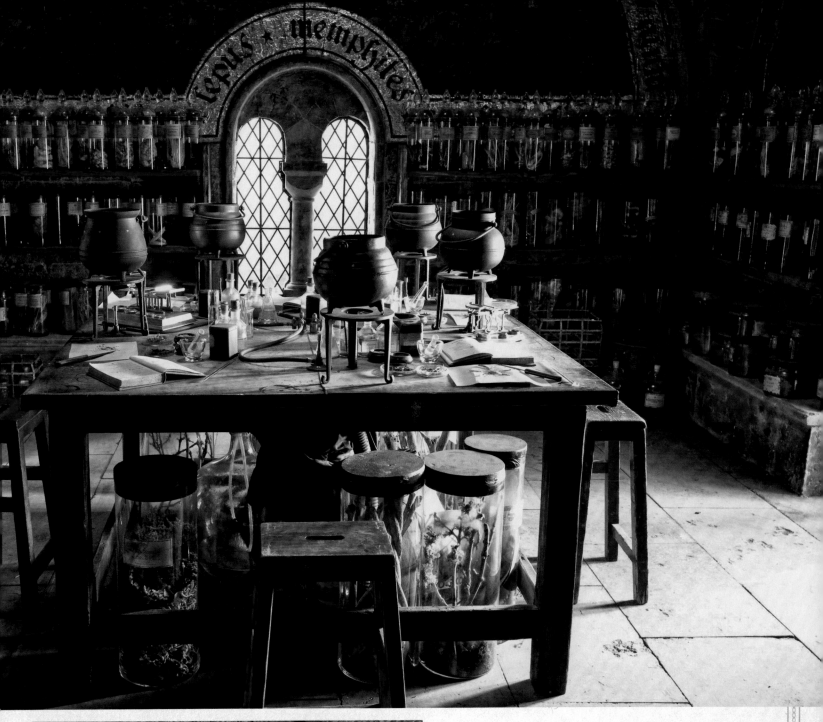

**OCCUPANTS:** Professor Snape (*Harry Potter and the Sorcerer's Stone* through *Harry Potter and the Order of the Phoenix*), Professor Slughorn (*Harry Potter and the Half-Blood Prince*), Potions students

**FILMING LOCATIONS:** Sacristy, Lacock Abbey, Wiltshire, England (*Harry Potter and the Sorcerer's Stone*); Leavesden Studios (*Harry Potter and the Half-Blood Prince*)

**APPEARANCES:** *Harry Potter and the Sorcerer's Stone*, *Harry Potter and the Half-Blood Prince*

# HORACE SLUGHORN'S OFFICE

Stuart Craig was given a brief for *Harry Potter and the Half-Blood Prince* to create an office for the returned Potions professor, Horace Slughorn, that was "fairly substantial, very plush." To accommodate that, he knew he needed to appropriate a fairly substantial set. What he chose "converted very well," Craig asserts. "I don't think it's recognizable at all as the Room of Requirement." Stephenie McMillan described the revamped set as "very Victorian, and sort of pompous, as he is." McMillan knew that the costume department was dressing the character in browns, and she decided that his office's color should complement the colors of his wardrobe. "There were big leather Chesterfields [sofas] in brown, and other carved brown furniture. Dark brown drapes and silk wools covered the stone walls. We put in a big round table for about thirteen people, with carved chairs, because he was always hosting dinner parties. We also gave him a grand piano in one corner and a large desk in another. And a huge fireplace." McMillan gives kudos to the combined efforts of the drapes department and the sign-writing department, who made all the curtains and the upholstery. "We screened all the curtains in Slughorn's office," McMillan explains. "Sometimes we decide that the fabrics need to be printed, because we can't find exactly what we want. And more often, we find it but need it in a much larger scale. So the sign-writing department screens the fabrics with prints we want." Craig felt the set nicely evoked Slughorn's character. "It has a certain sort of theatricality, doesn't it? Faded, a bit threadbare, but, nonetheless, theatrical."

OCCUPANTS:
Professor Slughorn, the Slug Club

APPEARANCE:
*Harry Potter and the Half-Blood Prince*

THESE PAGES, CLOCKWISE FROM TOP LEFT: *Scenes from* Harry Potter and the Half-Blood Prince *show Professor Slughorn entertaining guests; framed photographs of Slughorn's favorite students; a box containing bezoars; a blueprint for the construction of Slughorn's hourglass.*

"ALL RIGHT! I'LL DO IT. BUT I WANT PROFESSOR MERRYTHOUGHT'S OLD OFFICE, NOT THE WATER CLOSET I HAD BEFORE."

Professor Slughorn, *Harry Potter and the Half-Blood Prince*

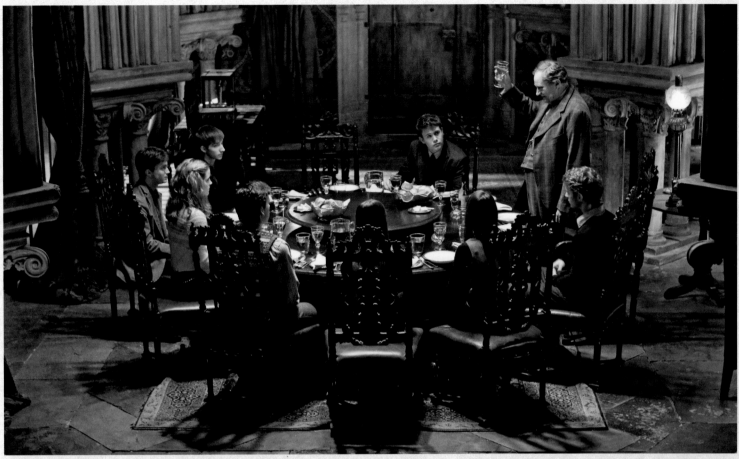

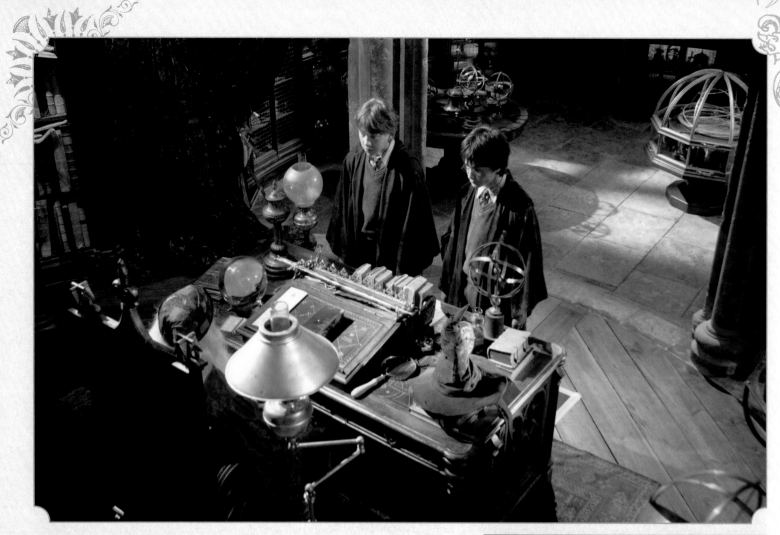

# HEADMASTER'S OFFICE

"When you look at the three little cantilevered turrets on the castle exterior," says production designer Stuart Craig, "you think, 'Well that's the place I'd like to be,' and so it became an obvious place for Headmaster Albus Dumbledore's office. There's the big tower with the conical roof, and then on the big conical roof, and then cantilevered out from the roof, are three little turrets, one hanging on the other. And with those three connecting circles—three connecting cylinders—it had the potential to become a very interesting interior space."

Harry Potter's first visit to Dumbledore's office comes in *Harry Potter and the Chamber of Secrets*, when he is called in to discuss the Petrification of several students. Over the course of the films, Dumbledore's office becomes a place of care and consultation for the pair. It is where Harry meets Fawkes the phoenix, where Dumbledore shows him the cracked Horcrux ring, and where Harry learns his role in defeating Voldemort.

The headmaster's office was one of Craig's favorite sets. "We gave it not just three different spaces, but we gave it different landings, and different heights as well. It was very complex, and at the same time, peaceful, stuck three hundred feet in the air on a two-hundred-foot-high cliff way above a Scottish loch. It was like an eagle's nest, like an aerie." Craig gave the headmaster an area for his desk and chair, an area for his cabinets, instruments, and books, and a cozy room in the smallest turret that is perhaps a place for reflection and relaxation.

THESE PAGES, CLOCKWISE FROM TOP LEFT: *Harry and Ron meet with Professor Dumbledore in* Harry Potter and the Chamber of Secrets; *telephone books were carefully covered to make the tomes on Dumbledore's bookshelves; a gold motif was followed in designing props and furnishings; a griffin statue guards Dumbledore's office in* Harry Potter and the Chamber of Secrets.

## "SHERBET LEMON."

Professor McGonagall giving the password to Dumbledore's office, *Harry Potter and the Chamber of Secrets*

Dumbledore's office housed many of the iconic elements necessary to Harry's journey, including the Sorting Hat and the sword of Gryffindor. The small office set was constructed with wild walls, which were shifted to accommodate camera and lighting equipment. The memory cabinets against these walls, filled with hundreds of glass vials with labels handwritten by the graphics department, were moved often—and very carefully. The Pensieve seen in *Harry Potter and the Goblet of Fire* was set into a stone goblet-shaped table within a cabinet. Digital artists created a complex water surface that included not only realistic "wave generations" but also threads of silver fluid swirling in the shallow basin that dissolved into the memory, pulling Harry into it. For *Harry Potter and the Deathly Hallows – Part 2*, the Pensieve bowl was rendered digitally. It was no longer sunk into the tabletop but removable, and digitally hovered in the air as Harry searched Severus Snape's memories.

OCCUPANT: Professor Dumbledore, Fawkes

FILMING LOCATION: Leavesden Studios

APPEARANCES: *Harry Potter and the Chamber of Secrets, Harry Potter and the Half-Blood Prince, Harry Potter and the Deathly Hallows – Part 2*

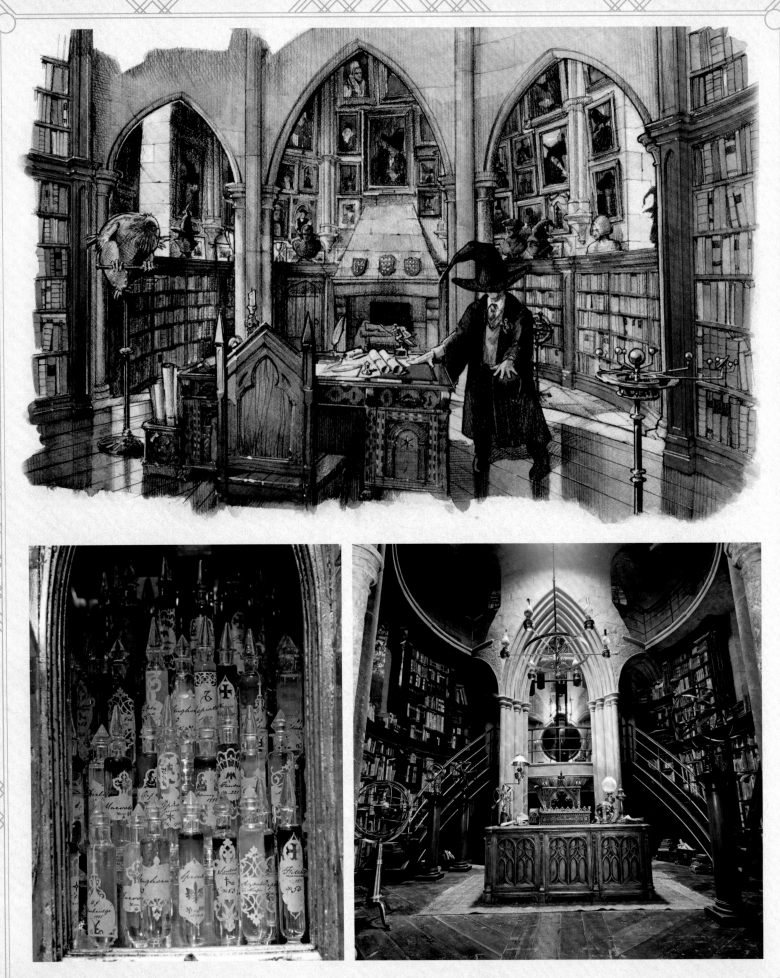

# "NOW, TODAY, WE WILL BE TRANSFORMING ANIMALS INTO WATER GOBLETS."

Professor McGonagall, *Harry Potter and the Chamber of Secrets*

## TRANSFIGURATION CLASSROOM

In *Harry Potter and the Sorcerer's Stone,* Harry Potter and Ron Weasley arrive late for Professor Minerva McGonagall's Transfiguration class, which she initially monitors in her Animagus cat form. Stephenie McMillan recalls the film shoots of McGonagall's class in a large room with a simple architecture in the Romanesque Durham Cathedral. "I had chosen a desk that was much too small for the room, so I asked one of the representatives helping us at Durham if by any chance they had a bigger desk we could use. And she offered this wonderful old table, which had a very interesting design and was absolutely perfectly aged, with the leather top worn down to the wood." After the location shoot, McMillan realized they would need to cover some additional shots of the scene in the studio, and asked if the table could be brought back with them. To her delight, the representative said that the table wasn't actually being used anymore, and McMillan could purchase it if she wanted.

Not only was the table used in the Transfiguration classroom, but, she says, "We used the table's design as the basis for various pieces of furniture for other rooms in different sizes throughout the films." A worthy transfiguration, indeed.

In the course of their second year, in *Harry Potter and the Chamber of Secrets,* Hermione Granger interrupts a Transfiguration lesson with queries about the history of the Chamber of Secrets. The filmmakers returned to Durham, but McMillan was determined to bulk up the large, simple space: "We needed to fill it up more, so we added new light fittings and some very big, tall cages that lined the walls." The cages contained a variety of animals, including birds, snakes, lizards, and even raccoons.

*OPPOSITE, CLOCKWISE: Harry tries on the Sorting Hat in concept art depicting his first visit to the headmaster's office, a version of the scene that was never filmed; an interior shot of the headmaster's office; props of memory vials, varying in color. BELOW: Professor McGonagall instructs Transfiguration students in* Harry Potter and the Sorcerer's Stone.

OCCUPANTS:
Professor McGonagall, Transfiguration students

FILMING LOCATION:
Chapter House, Durham Cathedral, Durham, England

APPEARANCES:
*Harry Potter and the Sorcerer's Stone, Harry Potter and the Chamber of Secrets*

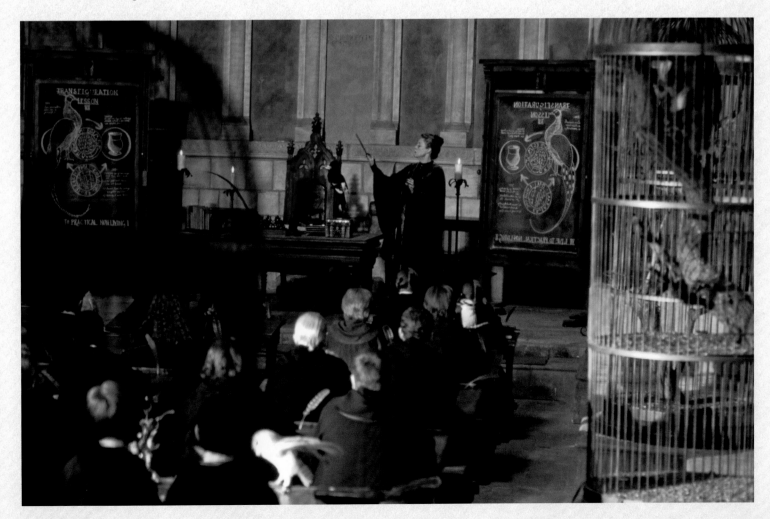

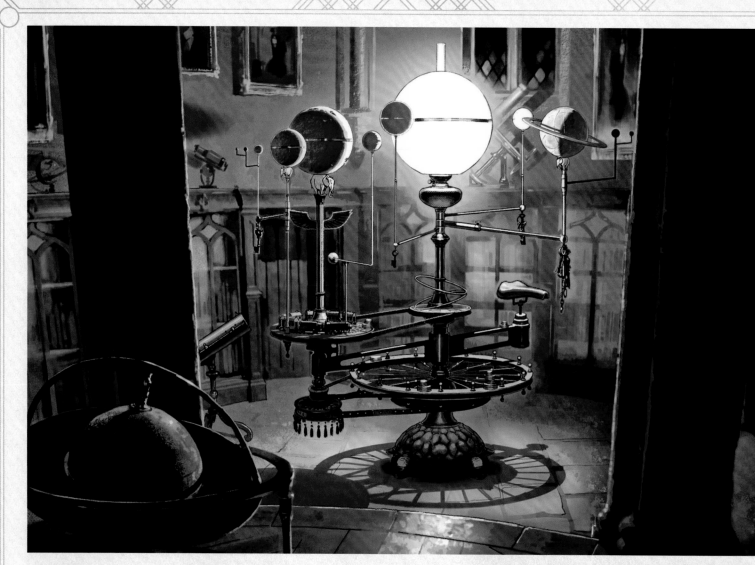

## ASTRONOMY CLASSROOM

FILMING LOCATION:
Leavesden Studios

APPEARANCE:
*Harry Potter and the Prisoner of Azkaban*

When Harry Potter needs to learn the Patronus Charm in *Harry Potter and the Prisoner of Azkaban*, Professor Remus Lupin teaches it to him in the Astronomy classroom. *Prisoner of Azkaban* is the only time this location is used, and it is actually a redress of Albus Dumbledore's office, with the portraits removed. The headmaster's office already had numerous pieces of astronomical equipment, and these were supplemented by even more globes and instruments placed on the shelving surrounding the room. Two large orreries, which are moving models of the solar system showing the relative positions of the planets, were placed inside, one of which, for some reason, also features a model train set. These orreries were painstakingly decorated with etched figures and symbols, similar to the brass astrolabes and small orreries from Dumbledore's office.

TOP: *Art depicting the orrery constructed for the Astronomy classroom (right).* OPPOSITE: *The Charms classroom used in* Harry Potter and the Sorcerer's Stone *was shot on location in Middlesex in Greater London.*

**"DON'T FORGET THE NICE WRIST MOVEMENT WE'VE BEEN PRACTICING. THE SWISH AND FLICK."**

Professor Flitwick, *Harry Potter and the Sorcerer's Stone*

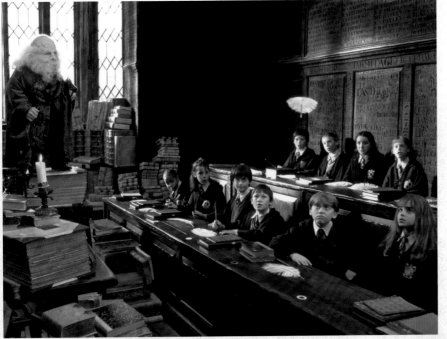

# CHARMS CLASSROOM

Harry Potter and his classmates learn the Levitation Charm in *Harry Potter and the Sorcerer's Stone*, trying to get feathers to fly, with varying results. The Charms class was shot in the Fourth Form Room at Harrow Old School, built in the late 1500s. Professor Filius Flitwick stands in front of a bay of lead-paned glass windows in a schoolroom that would have originally held only boys. Oak-paneled walls on each side of the room contain the original carved signatures of former students, including Lord Byron and Winston Churchill.

OCCUPANTS: Professor Flitwick, Charms students

FILMING LOCATION: Fourth Form Room, Harrow Old School, Middlesex, England

APPEARANCE: *Harry Potter and the Sorcerer's Stone*

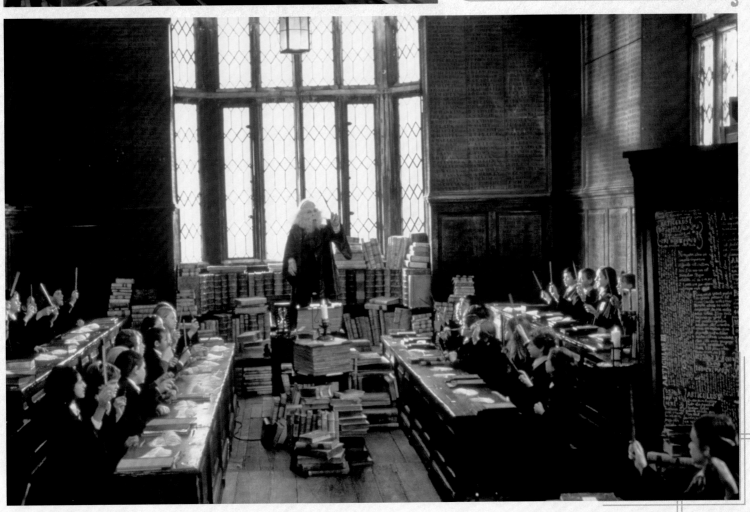

# HOGWARTS GROUNDS

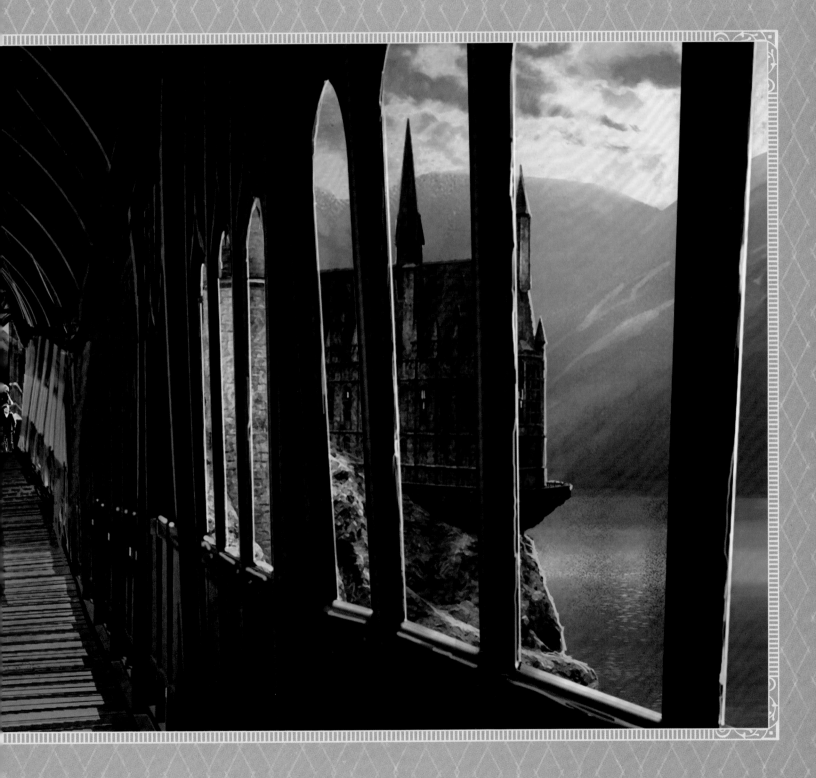

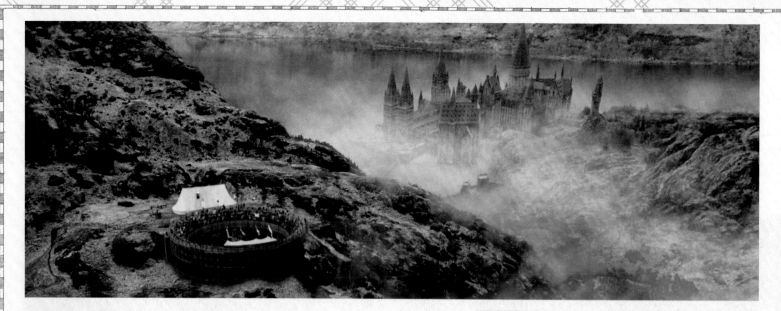

# HOGWARTS GROUNDS

Surrounding Hogwarts castle is a long, quiet lake; a dark, unfriendly forest; deep valleys; and soaring mountains. "J.K. Rowling never actually says that Hogwarts is in Scotland," says production designer Stuart Craig. "But we worked it out pretty quickly that that's probably where we should be looking for the backgrounds to the films. Some of the most dramatic landscapes in these islands are the Highlands of Scotland. So we went there and asked, what's the most dramatic, iconic place? It's Glencoe, which is the highest pass in Scotland. The mountains are sensational. The valley and the rivers that run through it are beautiful. In our Highland exploration, we found Loch Shiel and Rannoch Moor and Fort William." He searched these and other locations in Scotland with Location Manager Keith Hatcher. Craig explains, "It gave a sense of where the world should be. We did spread the net wider in an effort just to prove, really, that our first choice was right. But that question was quickly settled."

The second unit crew made several trips up north prior to shooting *Harry Potter and the Sorcerer's Stone* to photograph these locations for establishing shots or background shots. And in a time-honored movie tradition, the sites were manipulated to serve the story. "All the best elements in Scotland," says Craig, "are not remotely together; we forced them together. There were Scottish lochs where there were no lochs, and mountains where there were no mountains. We made this idealized, beautiful, dramatic landscape out all these different places."

*Harry Potter and the Prisoner of Azkaban* required a considerable amount of exterior shooting, so for the first time the cast and crew went to Scotland with the first unit and shot in various locations. "Hogwarts *should* be in the Scottish Highlands," says Alfonso Cuarón, the director of *Prisoner of Azkaban*. "You needed to have the sense of the hills, not the flatness that you find in locations around London. We went to Scotland for three weeks to shoot in the environment around the castle. That was important, and something that Stuart Craig fought for. He found the most amazing locations to make everything happen." For a movie of this size and complexity, with young actors who required teachers and chaperones, it was a major undertaking. "And it rained, and it rained, and it rained," Craig recalls, "which added time and cost to the film."

The filmmakers never went on location as extensively as that again, but they did continue to send the second unit to Scotland to shoot backgrounds, which were composited with scenes shot surrounded by green screen. The filmmakers regularly pulled from this digital database of location photography and film footage. "We cherry-picked all," Craig affirms. "The best loch, the most photogenic mountain pass, the best valleys and forests, and slammed all these things together. And we ended up with a pretty powerful set of images."

THESE PAGES, CLOCKWISE FROM TOP LEFT: *The final composited image of the arena used in the first task of the Triwizard Tournament; a visualization used in the development of the bridge built for the third Harry Potter film;* Hagrid's hut in Harry Potter and the Prisoner of Azkaban; *construction of Hogwarts's covered bridge was started well before the filming of* Harry Potter and the Prisoner of Azkaban.

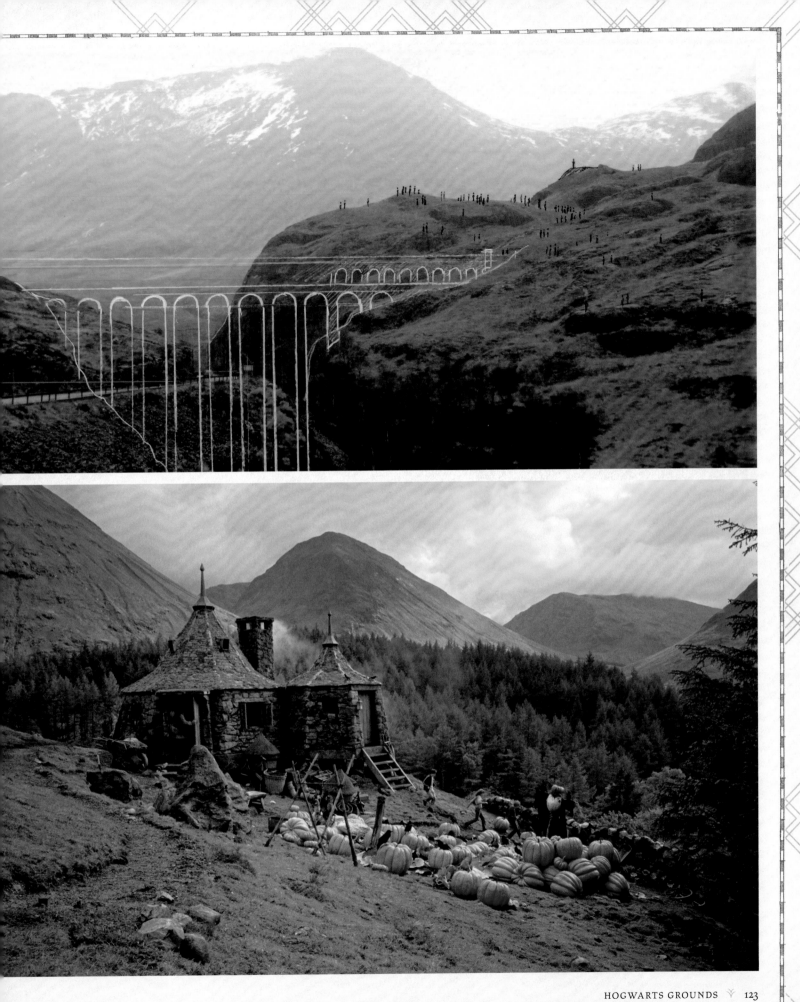

# FORBIDDEN FOREST

Whether it is called the dark forest or the Forbidden Forest, Stuart Craig considers the forest in the *Harry Potter* films a character in itself. For *Harry Potter and the Sorcerer's Stone*, the first forest scenes were filmed on location in Black Park in Buckinghamshire, England. This was, according to Craig, "the affordable and expedient thing to do." However, for the scene where Harry encounters the centaur over the dead unicorn, the forest was a built set, and from then on, except for part of *Goblet of Fire*, the Forbidden Forest was a studio creation. "The problem with real places is they're full of things you don't want," he states, "things that don't contribute to the story. A manmade forest has more potential than a real one." Another consideration was the animal actors that often appeared in the forest scenes. For *Sorcerer's Stone*, the forest ground was covered in soft moss to provide stable footing for any animals and to protect the delicate footpads of the canine actor who played Hagrid's dog, Fang.

For *Harry Potter and the Chamber of Secrets*, the forest "became more fantastical. It was based on truth, but it was an exaggeration of truth, so the tree forms, the root forms, and even Aragog and the Acromantula in their lair were very real but their size was hugely exaggerated." Craig's intention was that as one went farther into the forest, it got bigger in scale, more theatrical, and more creepy and frightening. "It's relatively recognizably normal on the outside, and the deeper you penetrate it, the bigger it gets. More intimidating and mysterious. Even the mist gets thicker."

Craig was challenged once again for the forest scenes in *Harry Potter and the Order of the Phoenix*. "We always think, how can we develop this forest idea? How can we make it more interesting this time?" He looked back to Aragog's lair in *Chamber of Secrets* for inspiration, particularly the sheltering trees' massive roots. "So I took those roots and made them bigger again, rethinking the shape." He thought of mangrove swamps and how mangrove trees are perched on their root system. "It almost looks as if the trunk is being supported by fingers, which was a great profile. Mangroves are

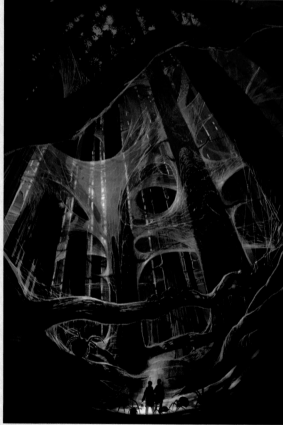

TOP: *A view of the Whomping Willow from between the trees of the Forbidden Forest.* ABOVE AND OPPOSITE BOTTOM: *In art by Dermot Power, Harry, Ron, and Fang enter into Aragog's webbed lair.*

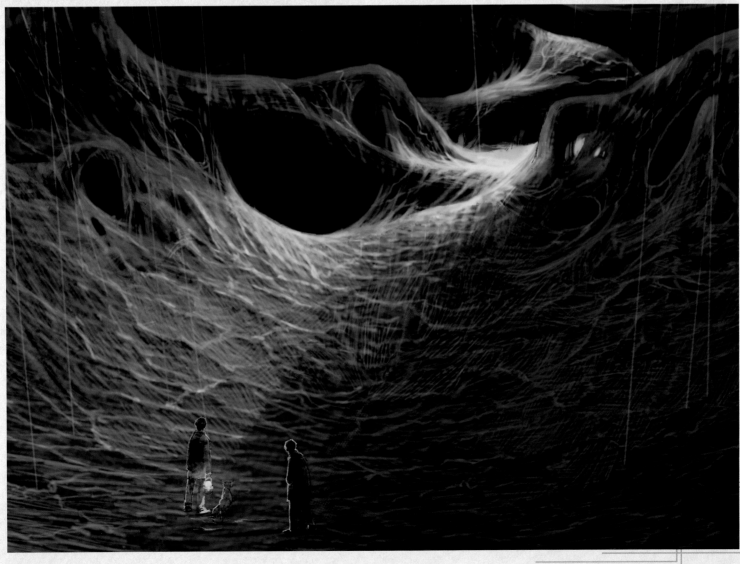

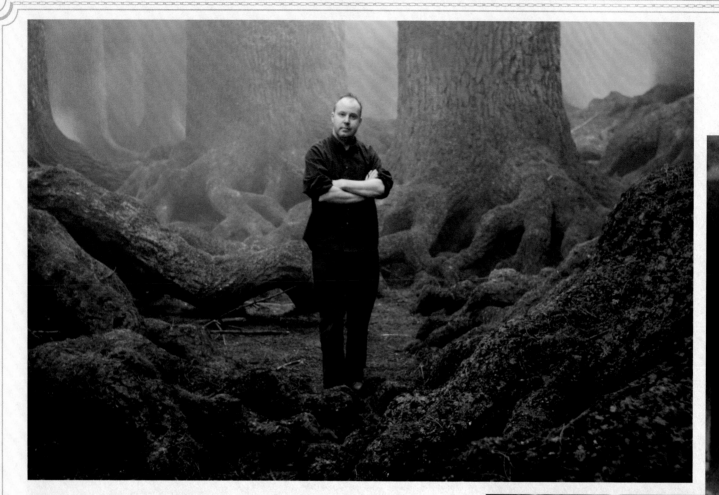

OCCUPANTS: Centaurs, unicorns, Acromantula, and other creatures

FILMING LOCATIONS: Black Park, Buckinghamshire, England; Frithsden Beeches Wood, Ashridge, Hertfordshire, Chiltern Hills, England; Leavesden Studios

APPEARANCES: *Harry Potter and the Sorcerer's Stone, Harry Potter and the Chamber of Secrets, Harry Potter and the Prisoner of Azkaban, Harry Potter and the Goblet of Fire, Harry Potter and the Order of the Phoenix, Harry Potter and the Half-Blood Prince, Harry Potter and the Deathly Hallows – Part 2*

TOP: *Director David Yates on the set of the Forbidden Forest.* RIGHT: *Harry Potter and Draco Malfoy search for an injured unicorn in* Harry Potter and the Sorcerer's Stone.

relatively small, however, and so we made the trees twelve to fourteen feet around. Bigger even than the redwoods in Northern California." Again, the forest became darker and more sinister as it canopied that movie's confrontation between Dolores Umbridge and the centaurs.

*Harry Potter and the Deathly Hallows – Part 2* offered the biggest Forbidden Forest to date. Not only were the trees even larger than before, the ground cover was thicker and more verdant. By the time of the eighth film, the painted cyclorama that served as the backdrop to the scenes had grown to six hundred feet in length.

Professor Dumbledore, *Harry Potter and the Sorcerer's Stone*

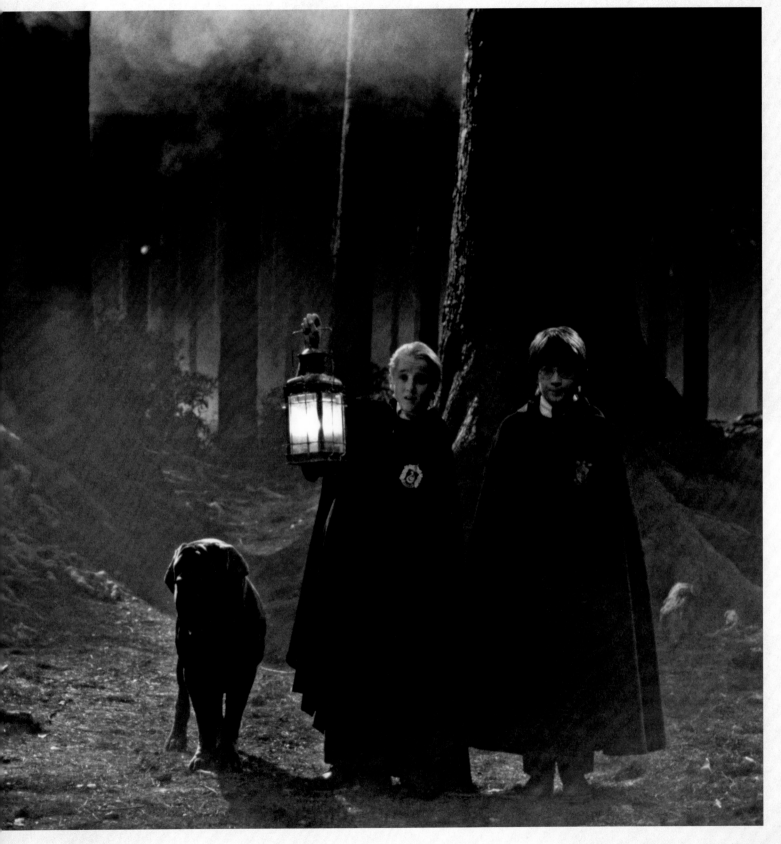

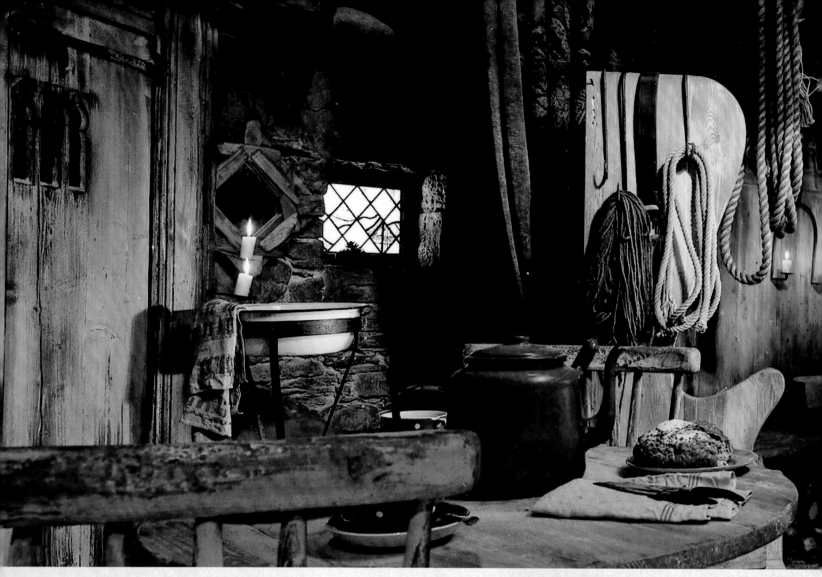

# HAGRID'S HUT

The hut belonging to Rubeus Hagrid, Keeper of Keys and Grounds at Hogwarts, is a place of friendship and safety for Harry, Ron, and Hermione. Hagrid's hut appears in the first six *Harry Potter* films, until it is burned down by Death Eaters in *Harry Potter and the Half-Blood Prince*. The hut began as a one-room octagonal structure filled with the trappings of the groundskeeper, set on a flat landscape near the school. For the first two films, it was constructed and filmed in Buckinghamshire's Black Park. For the third film, *Prisoner of Azkaban*, "a large part of the story takes place at or around Hagrid's hut," director Alfonso Cuarón explains. "And I wanted to see the kids go to Hagrid's hut and see what connected it to the castle." Stuart Craig was happy with the decision: "When we shot on location in England, the background on one side was pine trees. I do not imagine that's what J.K. Rowling had in mind. We needed to shoot it outside in the right location, and so we persuaded everyone to go to Scotland and build Hagrid's hut in Glencoe in the Highlands."

Not only did Hagrid's hut get a change of location, it was also extended, which Craig jokingly attributes to Hagrid's promotion to Care of Magical Creatures professor. "We needed a bedroom," says Craig, "for a story-driven need. So we added a second octagon melded to the first. We built it in glorious sunshine," he continues, "and when we started shooting, it rained continuously for five weeks!" Although it became a challenging shoot, muddy and cold, the designer was happy with the results. "It paid off in dividends, didn't it? Even in the rain, it looked great on the screen. The shadows of the rainclouds really

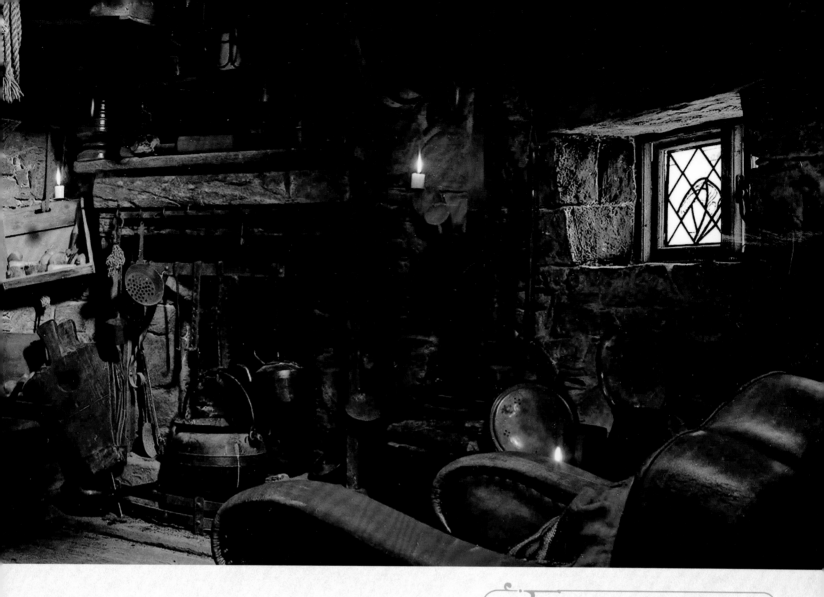

energized the image. It had a more serious look to it, and the movies did start to get serious around then. And it brought all the elements together, no pun intended. Shooting there allowed you to understand the context of the story: the relationship of the castle, the back entrance as it were, Hagrid's hut, the landscape, and the dark forest." The set was taken down after the filming and re-created in the studio, with a digital Highlands background, for the films that followed.

The interior of Hagrid's hut was not actually one set, but two. "You have to do a combination of builds to achieve Hagrid's hut," explains Alfonso Cuarón. "The first is a huge hut and the chairs and tables are large because Hagrid is a giant. The kids are filmed in there. Then you have to shoot the whole thing again, but now in a smaller hut where everything is a normal size in relation to Hagrid's size." The set decorators would buy whatever props were needed for the scenes—cups, buckets, or blankets—and then replicate them at Hagrid's scale. When the set was rebuilt for *Prisoner of Azkaban*, Cuarón asked for its thematic décor to be expanded. "He wanted Hagrid's hut to be filled with animals and creatures," says Craig. "After all, it is basically the hut of a lodge keeper. If you look at the detail of that hut, you see that it's decorated with little animals all around, and you get the feeling some real animals might be under the bed!"

OCCUPANTS: Rubeus Hagrid, Fang, Norbert

FILMING LOCATIONS: Black Park, Buckinghamshire, England; Clachaig Gully, Glencoe, Scotland

APPEARANCES: *Harry Potter and the Sorcerer's Stone, Harry Potter and the Chamber of Secrets, Harry Potter and the Prisoner of Azkaban, Harry Potter and the Goblet of Fire, Harry Potter and the Order of the Phoenix, Harry Potter and the Half-Blood Prince*

THESE PAGES, CLOCKWISE FROM TOP: *The warm and comfortable interior of Hagrid's hut from* Harry Potter and the Half-Blood Prince; *early storyboarding for a scene in the hut; a sketch and a photo of the hut created for* Harry Potter and the Prisoner of Azkaban.

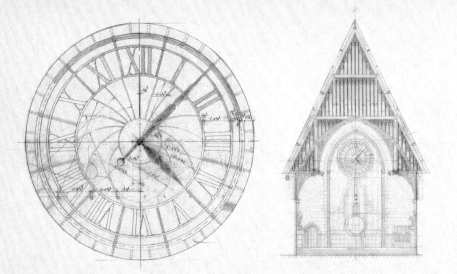

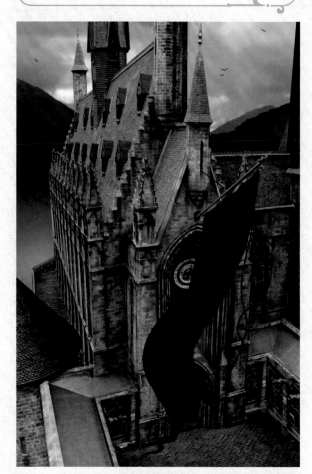

FILMING LOCATION: Leavesden Studios

APPEARANCES: *Harry Potter and the Prisoner of Azkaban, Harry Potter and the Goblet of Fire, Harry Potter and the Order of the Phoenix, Harry Potter and the Half-Blood Prince, Harry Potter and the Deathly Hallows – Part 2*

# CLOCK TOWER AND COURTYARD

In addition to new elements being added over the course of the *Harry Potter* films for story-driven reasons—such as the extension of Hagrid's hut and the design of the Owlery—locations were also rebuilt for visual and thematic goals. This was the case for the Clock Tower and its attached courtyard in *Harry Potter and the Prisoner of Azkaban.* Various Hogwarts courtyards appear in the first two films; most were shot on location, such as at Durham Cathedral and New College at Oxford. But for *Prisoner of Azkaban,* time is an overarching focus in the story, and director Alfonso Cuarón wanted to represent this visually at Hogwarts Castle. "It developed over a long period of discussions with Alfonso," recalls Stuart Craig. "Time-Turning was the theme, especially of the third act of the film. So references to clocks, references to time, were extremely relevant."

Cuarón also wanted a more connected and logical geography to the school, and so several major revisions folded the new Clock Tower into the Hogwarts profile. In *Prisoner of Azkaban,* the Clock Tower and its courtyard are set at the back of Hogwarts. The students gather there before and after visiting Hogsmeade, and the courtyard is used as another way out of the castle, over a (new) wooden

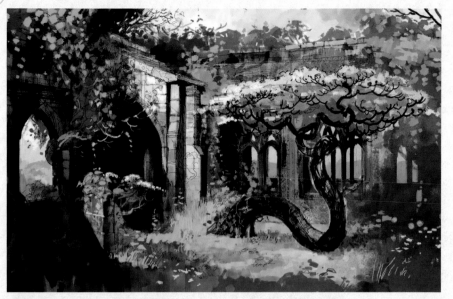

bridge. Cuarón put his own stamp on the courtyard with a reference to his Mexican heritage. The Gothic-arch-topped sculpture around the terrace's fountain features serpents and eagles, which are the coat of arms on the Mexican flag. The view through the clock, which had a transparent face in this film, was toward Hagrid's hut, where Buckbeak's execution was supposed to take place. For *Harry Potter and the Goblet of Fire*, the Clock Tower was moved to the front of Hogwarts—since a reconstructed back entrance was needed for Yule Ball attendees—and turned into part of the entrance hall and viaduct courtyard. As the clock has made its way around the school throughout the films, so has an individual component: its pendulum is used to monitor the time during Dolores Umbridge's O.W.L. test in *Harry Potter and the Order of the Phoenix*.

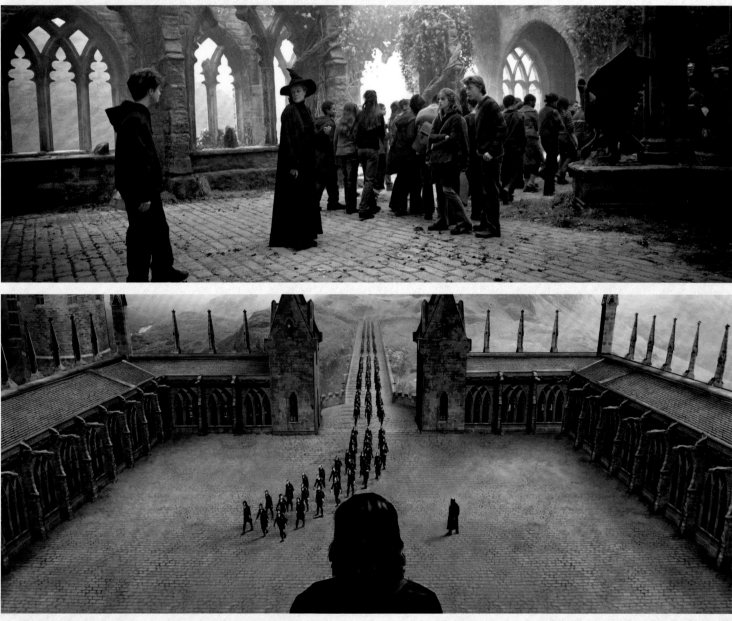

OPPPOSITE, CLOCKWISE FROM TOP LEFT: *Building plans for the Clock Tower; two pieces of concept art by Andrew Williamson provide aerial views of the Clock Tower and clock face.* TOP: *Dermot Power depicted the courtyard in spring.* MIDDLE: *Harry is left behind as the students leave for Hogsmeade in* Harry Potter and the Prisoner of Azkaban. BOTTOM: *Concept art by Andrew Williamson for* Harry Potter and the Deathly Hallows – Part 2 *depicts Severus Snape supervising a stark, grey courtyard.*

FILMING
LOCATION:
Clachaig Gully,
Glencoe, Scotland

APPEARANCES:
*Harry Potter and the
Prisoner of Azkaban,
Harry Potter and the
Goblet of Fire, Harry
Potter and the Order
of the Phoenix, Harry
Potter and the Half-
Blood Prince, Harry
Potter and the Deathly
Hallows – Part 2*

## "TO BLOW IT UP? BOOM?"

Neville Longbottom,
discussing the
destruction of the
Wooden Bridge, *Harry
Potter and the Deathly
Hallows – Part 2*

TOP: *Art shows the setting
of Hagrid's new hut near
the stone circle.* RIGHT:
*Concept art by Andrew
Williamson depicts
students approaching the
bridge from the courtyard.*

# THE BRIDGE AND STONE CIRCLE

To connect the new Clock Tower courtyard and the
relocation of Hagrid's hut in *Harry Potter and the Prisoner of
Azkaban*, a covered Gothic-style wooden bridge was added.
"It was to be two hundred fifty feet long and look very
rickety and tumbledown," says art director Alan Gilmore,
"leaning from side to side and twisting as it goes, spanning
over a little canyon, about halfway between the castle and
Hagrid's hut." The bridge was originally intended to be
a combination of a miniature model and a short section
built in the studio for the actors, with background shots
composited over blue screen at a later date. But when the
location shoot in Scotland was put together for Hagrid's
new hut, Alfonso Cuarón asked if at least part of the bridge
could be built there as well. "And to me," says Stuart Craig,
"the gauntlet was thrown!" A fifty-foot section of the
bridge was prefabricated in London and transported to
Scotland. "The location was incredibly windy," Craig recalls.
"*Extraordinarily* windy." The construction of the bridge, with
its pieces lifted into place by helicopter, could only take
place on non-windy days. "Then a really, really solid steel
scaffolding structure was put into place," adds Craig, "to tie
that down against the wind. But it looked good, I must say."

The five stone monoliths that were placed at the end
of the bridge, before the hilly descent to Hagrid's hut, were
designed to look as if they had been there before Hogwarts
was built. England and Scotland are known for their Celtic
stone circles, the most documented ones being Stonehenge
and Avebury. As the purpose of these structures has long
been in debate, the filmmakers assigned this one to be a
sundial. "With an enigmatic, magical quality, as all stone
circles should have," adds Gilmore. During the bridge's
construction, five very big holes were dug into the earth
near it, and a helicopter was used to drop the stones in.
Gilmore revels in the actors' reaction to them. "Someone
told me that the kids asked Alfonso if he had chosen the
location because of the stones. That's very gratifying."

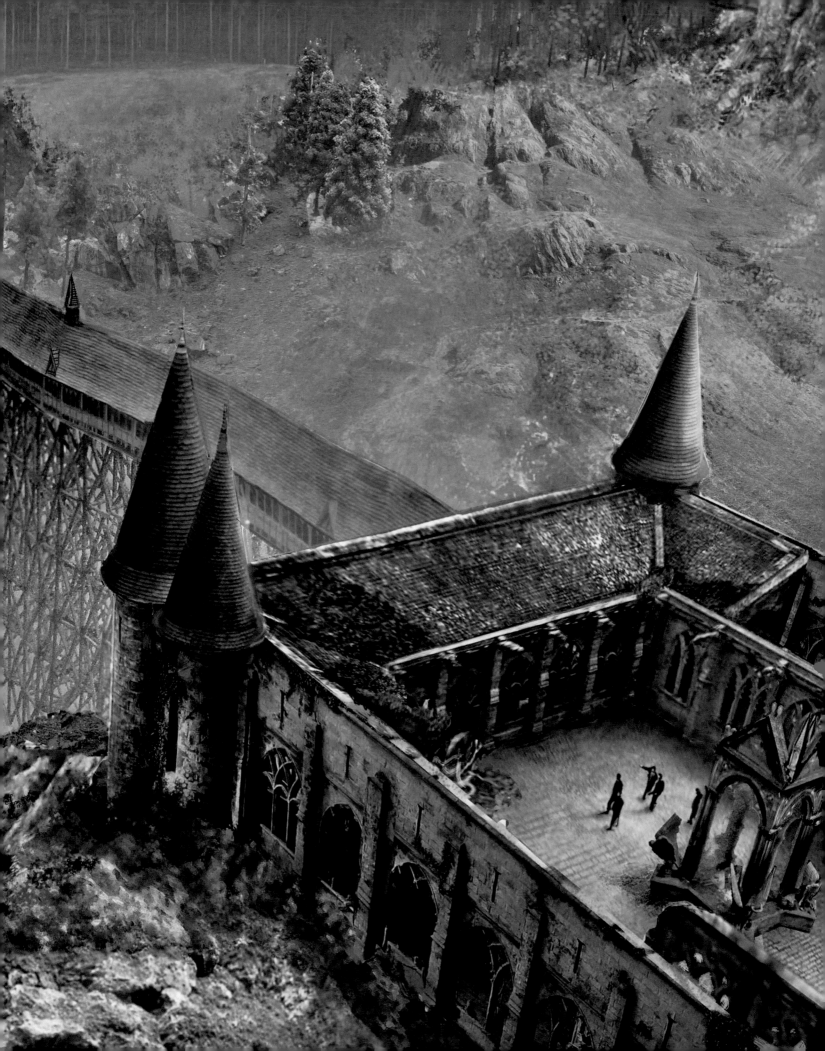

## QUIDDITCH PITCH

OCCUPANTS: Madam Hooch, Quidditch teams

APPEARANCES: *Harry Potter and the Sorcerer's Stone, Harry Potter and the Chamber of Secrets, Harry Potter and the Prisoner of Azkaban, Harry Potter and the Half-Blood Prince, Harry Potter and the Deathly Hallows – Part 2*

*Harry Potter and the Sorcerer's Stone* included the highly anticipated first view of the wizard game Quidditch. "Though we call it the Quidditch pitch, the game is not actually played on a pitch," says Stuart Craig. "It's played in the air. The pitch is just the takeoff point, really. So how do you make sense of a game that's played in the air when spectators are on the stadium's grounds?" Craig began doodling out his ideas and realized that towers were the obvious way to take the spectators up into a position where they could actually see the action. "There are two tiers of spectators," he explains. "The expensive seats are up in the towers, and the groundlings are down in terraces on the ground. But that gave the stadium a very distinctive look: a ring of bleachers and a high circle of towers." He further reasoned that as Hogwarts was set beside an endless forest, the stadium would be constructed out of the local timber. And while the towers would certainly sport the house colors of the four Quidditch teams, the design of the arena would have the feeling of a medieval tournament, inspired by the age of the castle, complete with heraldic-looking banners.

"The pitch was huge, so we couldn't possibly fit it in any stage at the studio," explains Craig. "It could fit on the back lot, but there wasn't much point, since the background needed to be the Highlands of Scotland. And, of course, it would have been *hugely* expensive and inconvenient to go and build it in Scotland, so, inevitably, it became one of our first almost entirely computer-generated sets." As needed, sections of the stadium were built for live-action shots, including at least one base and lower stand as well as a tower top.

As the films continued and the athletes got older, the game became more extreme. Dementors and dangerous weather elements caused trouble in *Harry Potter and the Prisoner of Azkaban*. For *Harry Potter and the Half-Blood Prince*, Craig re-created the stadium for what he called "super-deluxe Quidditch." The mountainous backdrop was brought closer, and the surrounding meadow shrunk down. The towers were heightened and more were added, which forced the towers closer together. The bleachers were reconfigured from one basic box to tiered stands. Craig notes, "In addition to a redesign that I felt was smarter and more impressive, now Ron was playing." Director David Yates wanted "comedy Quidditch" for the last time the game would be seen on-screen. "By introducing more towers, there were more opportunities for weaving in and out of them, and more things whizzing by in close proximity gives a greater sense of speed, so the changes were really required," Craig says.

Prior to Ron Weasley's Quidditch debut, the tryouts and practice matches for the Gryffindor team were seen, for which Craig gave the stadium a different look. "The trials, the practices, wouldn't have all the colorful fabric. For this we changed it to a sort of skeletal wood form." Sadly, in *Harry Potter and the Deathly Hallows – Part 2*, the Quidditch pitch is seen as Voldemort's followers burn it to the ground.

THESE PAGES, CLOCKWISE FROM TOP LEFT: *Art shows Harry Potter reaching for the Snitch in a Quidditch match against Slytherin; the two teams make their way to the pitch; a sketch of the stands by Stuart Craig.*

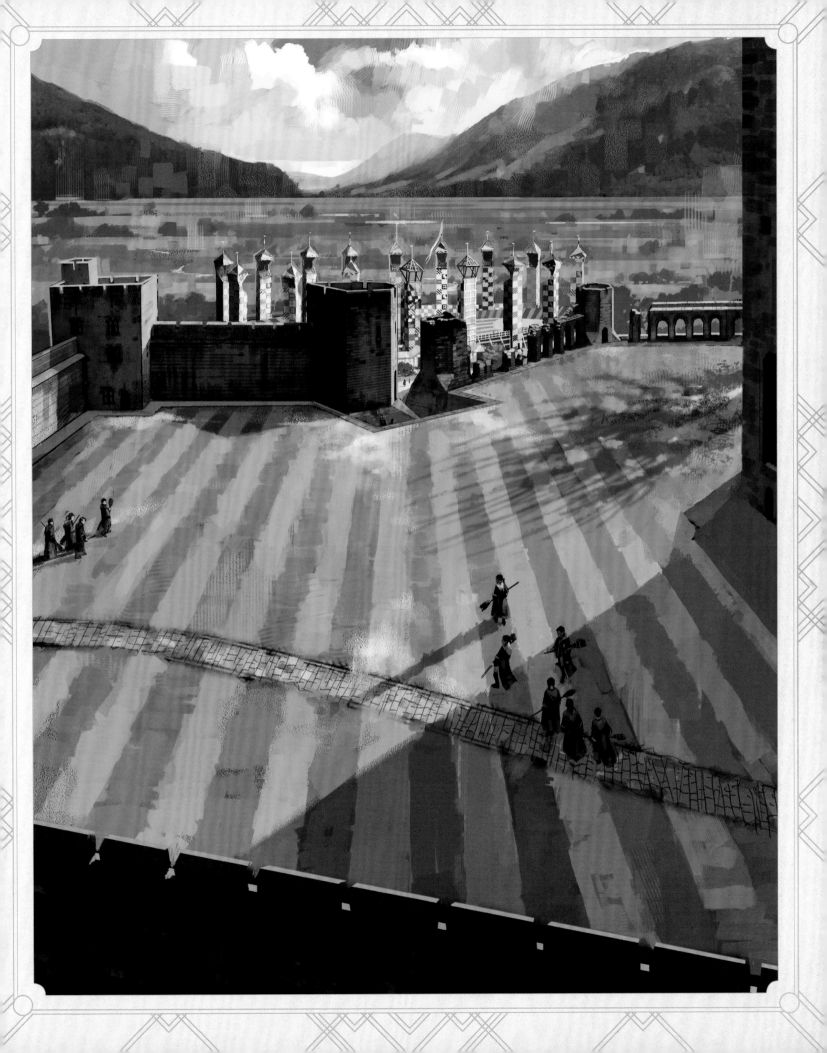

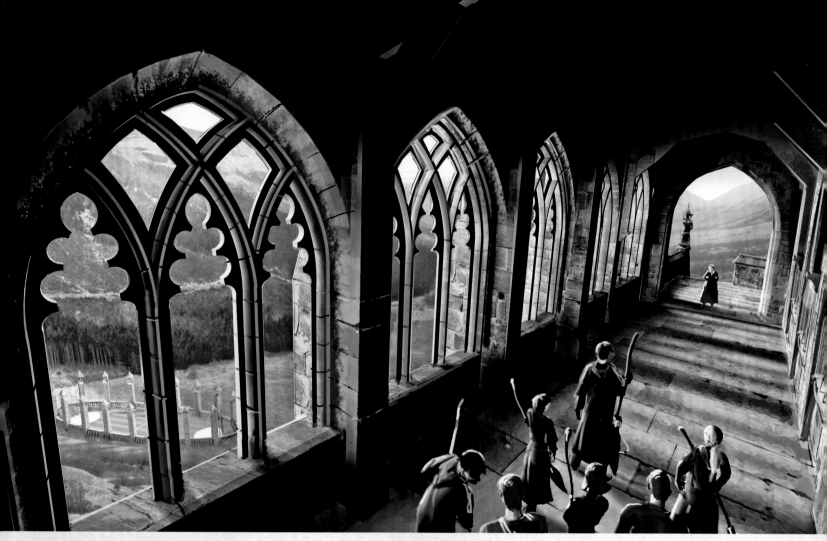

THESE PAGES, CLOCKWISE FROM TOP LEFT: *Art by Andrew Williamson for a scene that was never filmed; concept art of the Quidditch pitch; Harry and Draco chase the Golden Snitch in art by Adam Brockbank; unlike in the books, the Quidditch pitch in the films is adorned with all the school colors; professors look on from the stands.*

"OUR JOB IS TO MAKE SURE THAT YOU DON'T GET BLOODIED UP TOO BAD. CAN'T MAKE ANY PROMISES, OF COURSE. ROUGH GAME, QUIDDITCH."

George Weasley, *Harry Potter and the Sorcerer's Stone*

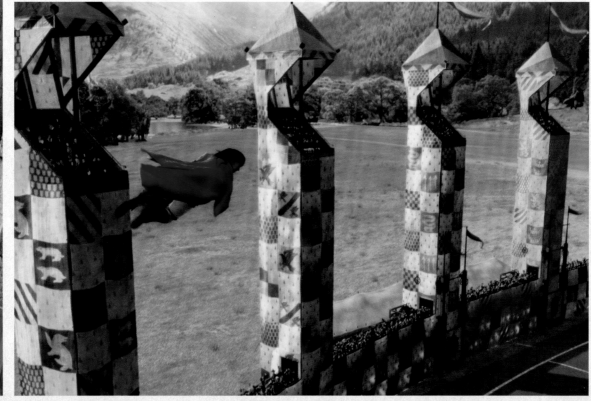

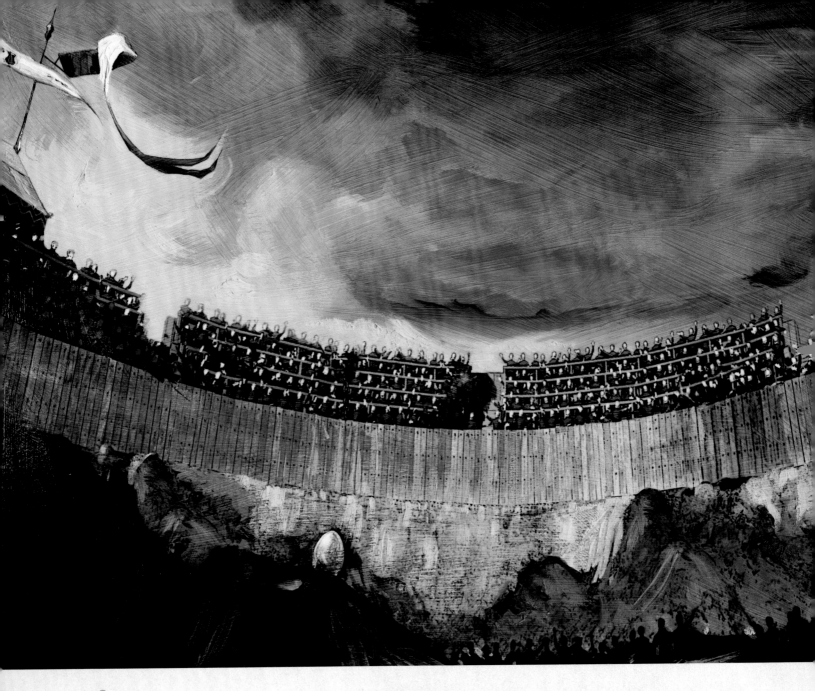

OCCUPANTS: The Triwizard Tournament
Champions, Dragons

FILMING LOCATIONS: Steall Falls, Glencoe,
Scotland; Black Rock Gorge, Evanton, Scotland

APPEARANCE: *Harry Potter and the Goblet of Fire*

# TRIWIZARD TOURNAMENT ARENAS

### ✶ Triwizard Tournament First Task: Dragon Arena ✶

Location shoots in Scotland provided the backdrop for Harry Potter's
encounter with the Hungarian Horntail dragon during the first task of the
Triwizard Tournament in *Harry Potter and the Goblet of Fire*. As is his practice,
Stuart Craig saw the construction of the dragon arena as a sculptural form. "It
seemed that the starkest, rawest, most interesting thing we could do would
be to set it in a bare, rocky pit," he explains. "So we scouted rock quarries and
places with very sharp, jagged rocks." The quarry bottom was built on the
studio and above that, Craig placed the spectators on bleachers at a very steep
angle looking down on the action. "There's a massive wooden fence around the
top of the arena and then the bleachers are behind that. So it has the kind of
concentration and intimacy that's equivalent to a bull ring. Then we've set all
that on a mountaintop in Glen Inverness in Scotland. If you didn't see it with
the backdrop, I think it would appear quite ordinary. You composite it with
Glen Inverness and it's stunning."

# "DRAGONS? THAT'S THE FIRST TASK? YOU'RE JOKING."

Harry Potter, *Harry Potter and the Goblet of Fire*

THESE PAGES, CLOCKWISE FROM TOP LEFT: *Art by Emma Vane shows the view from the floor of the Triwizard Tournament dragon arena; two locations in the Highlands of Scotland were used to shoot back plates for the task; a still shows Harry taking cover in* Harry Potter and the Goblet of Fire.

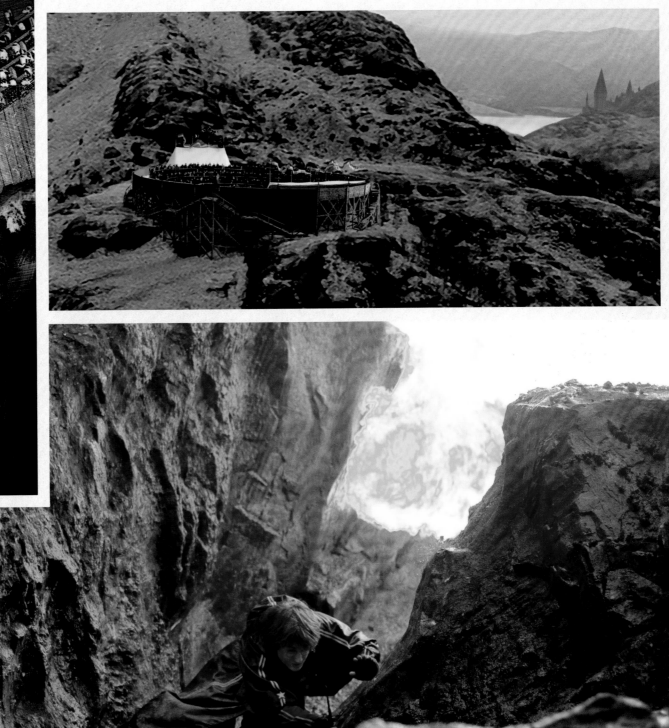

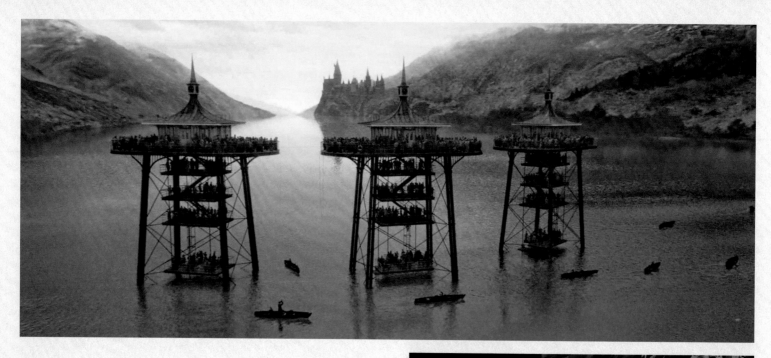

## ✷ Triwizard Tournament Second Task: The Lake ✷

The lake beside Hogwarts castle is as much a part of the school's silhouette as its towers and spires. Throughout the films, various locations have been used to portray the lake, including Virginia Water Lake in Surrey, England. This is the lake over which Harry takes flight on Buckbeak, and later encounters Dementors, in *Harry Potter and the Prisoner of Azkaban*; it was also filmed for the lakeside scenes in *Harry Potter and the Goblet of Fire*. Other locations used, especially in background shots, include Loch Shiel, Loch Eilt, and Loch Arkaig in Lochaber, Scotland.

## "MYRTLE, THERE AREN'T MERPEOPLE IN THE BLACK LAKE, ARE THERE?"

Harry Potter, *Harry Potter and the Goblet of Fire*

The second task of the Triwizard Tournament in *Goblet of Fire* takes place below the lake, and this was achieved by merging studio and digital shots. However, the stands above the waterline for spectators were an ingenious choice by designer Stuart Craig. He wanted to place them in a position that would add the proper amount of drama for those waiting for the champions to reappear from the lake bottom. "Rather than just have people sitting on rocks on the perimeter of the lake, not able to see very much, it occurred to me to have these rather dramatic viewing stands out in the middle of the lake." He based his design for these platforms on Victorian pier structures. "Not just stationary seaside piers," he explains, "but there were these structures on great long legs that actually ran on rails under the water. So these became mobile viewing stands." Underwater viewing scopes were also conceived to watch the champions underwater but ultimately were not created for the film.

TOP: *A composited image of the lake used in Harry Potter and the Goblet of Fire.* ABOVE RIGHT: *Concept art shows Harry in the lake and, in art by Dermot Power, pursued by Grindylows.* OPPOSITE: *Film stills and concept art show Harry Potter in the maze.*

OCCUPANTS: The Triwizard Tournament champions, Merpeople, Grindylows

FILMING LOCATIONS: Virginia Water Lake, Surrey, England; Loch Shiel, Loch Eilt, and Loch Arkaig, Lochaber, Scotland

APPEARANCES: *Harry Potter and the Sorcerer's Stone, Harry Potter and the Chamber of Secrets, Harry Potter and the Prisoner of Azkaban, Harry Potter and the Goblet of Fire, Harry Potter and the Order of the Phoenix, Harry Potter and the Half-Blood Prince, Harry Potter and the Deathly Hallows – Part 2*

## ✶ Triwizard Tournament Third Task: The Maze ✶

The final task for the champions in the Triwizard Tournament in *Goblet of Fire* is to negotiate a maze in order to reach the Triwizard Cup. "We all think we know what a maze should be," says Production Designer Stuart Craig with a smile, "but it seems nothing in Hogwarts is ever what we think it is." He designed the maze to be taller and bigger than anything that could possibly be created in real life. The maze's channels were set with the proportion of being five feet wide and twenty-five feet high. "It's misty and altogether completely disorienting and disturbing," Craig says. "Things move and attack, but all of that is, as you know, just the lead-up to the graveyard that is the final confrontation." Craig "set" the maze near Fort William in the Highlands near Glen Nevis, Scotland. "We were standing in that spectacular valley, thinking about how much area the maze should occupy. Well, the whole point of the thing is to find the center, which should not be easy. Then let's make it as difficult as it possibly could be, so the whole thing became two miles long and half a mile wide and filled the valley. Exaggeration," he asserts, "is one of the best weapons in our armory."

## "YOU SEE, PEOPLE CHANGE IN THE MAZE."

Professor Dumbledore, *Harry Potter and the Goblet of Fire*

Special Effects Supervisor John Richardson was tasked with creating the moving maze. Richardson's crew built a forty-foot-long section of maze with walls that moved independently, rippling and tilting, coming together and moving apart. "It had to move as if it was chasing them, as if it was going to crush them, but of course we installed a fail-safe mechanism in it." Craig says. "The walls were built out of heavy steel, so that they were strong enough to support themselves, and they moved via a system of complex hydraulics that allowed the operators full control. The maze was enhanced with digital effects, but it also used practical effects, such as a dry ice mist that drenched the whole set. Robert Pattinson (Cedric Diggory) found the authenticity of the effects helpful when acting. He says, "There [were] real explosions going off, and the whole maze [was] moving, so you're running around, actually fearing for your life!"

OCCUPANTS: The Triwizard Tournament champions

APPEARANCE: *Harry Potter and the Goblet of Fire*

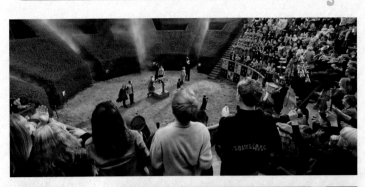

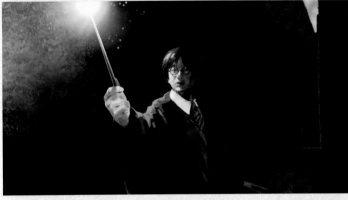

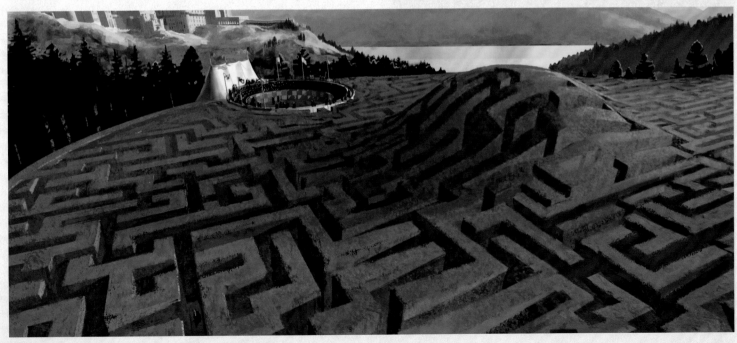

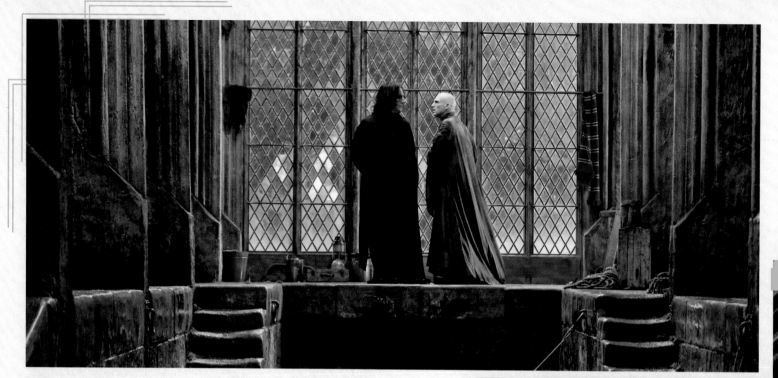

# BOATHOUSE

There are times when turning a book into a movie calls for more "theatrical, operatic locations," says Stuart Craig. In the last book of the series, Severus Snape dies in the Shrieking Shack, but this didn't feel right for the movie version. Craig explains, "Although the Shrieking Shack, as a movie set, is quite richly decorated, it's honestly more interesting externally than it is internally." He had always felt that the Hogwarts boathouse, where the first-year students arrive in their boats in *Harry Potter and the Sorcerer's Stone*, had been underused in the films. "I was sorry that a potentially interesting set had never been exploited. So we went to J.K. Rowling and asked, specifically, if she minded if Snape died in the boathouse.

## "YOU HAVE YOUR MOTHER'S EYES."

Professor Snape, *Harry Potter and the Deathly Hallows – Part 2*

Thankfully, she agreed." Craig designed the structure in full, giving it walls of windows. "It was a very skeletal Gothic structure with lots and lots of leaded glass. Something like the Crystal Palace." Situated at the bottom of a cliff below Hogwarts, the boathouse would offer "maximum reflection of the burning school. It seemed magical that Hogwarts was on fire above it, and there was a sense of the flame from the fire above being reflected in the glass, also reflected in the water, which in turn reflected back in the glass. That created a very romantic, atmospheric place. A deserving place for Snape to die." After the scene was shot, Alan Rickman, who portrays Severus Snape, expressed his thanks to the designer for the setting, which he said had helped him. "That's so unusual," says Craig, "and so gratifying to know that he was pleased."

ABOVE AND RIGHT: *Lord Voldemort (Ralph Fiennes) and Severus Snape (Alan Rickman) on the boathouse set.* OPPOSITE TOP: *Blueprints for the construction of the boathouse for* Harry Potter and the Deathly Hallows – Part 2.

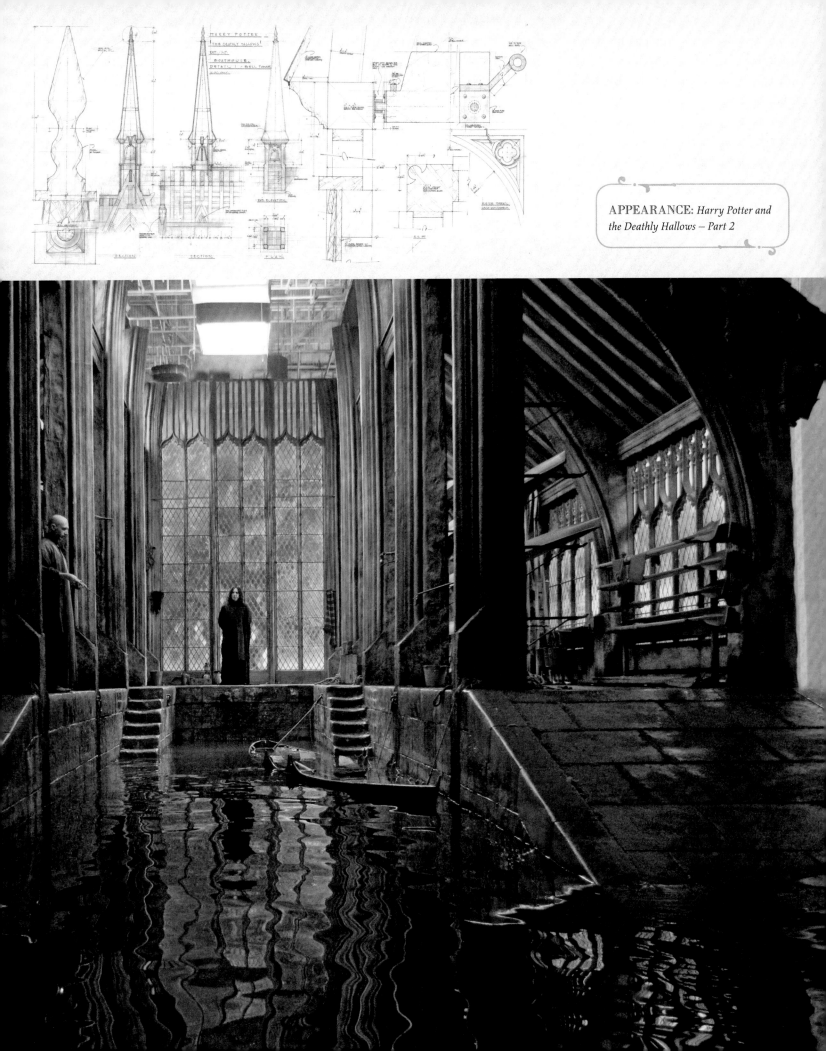

APPEARANCE: *Harry Potter and the Deathly Hallows – Part 2*

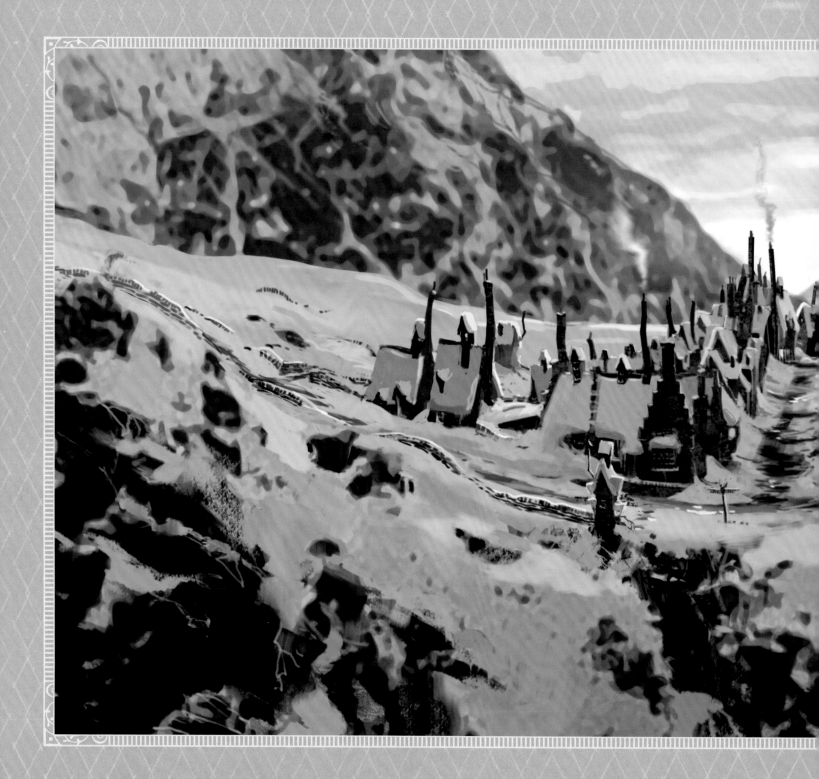

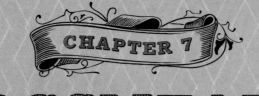

# CHAPTER 7

# HOGSMEADE

Professor McGonagall, *Harry Potter and the Prisoner of Azkaban*

## HOGSMEADE VILLAGE

The village of Hogsmeade is the first "field trip" allowed away from Hogwarts, and only third-year and older students can go. Harry Potter and his fellow third-years visit it for the first time in *Harry Potter and the Prisoner of Azkaban*, although Harry has to use a secret tunnel to Honeydukes to get there.

Stuart Craig envisaged the village of Hogsmeade as being firmly rooted in the Scottish Highlands. "Hogsmeade is the country version of Diagon Alley. It's just off the perimeter road around Hogwarts. For Hogsmeade, we did need to have a distinctive theme and feel, so we said that it's above the snow line. That gave it a remote feeling. Every time we see Hogsmeade it is covered in snow." Craig's artistic decision brought to cinematic life the description that author J.K. Rowling wrote in *Prisoner of Azkaban*: "Hogsmeade

*TOP: Concept art of Hogsmeade village by Andrew Williamson.*
*OPPOSITE: Construction plans (bottom right) show the slope of a Hogsmeade street, also seen in a very realistic model (bottom left).*

looked like a Christmas card."

Hogsmeade was actually a redress of the Diagon Alley set. The buildings of Hogsmeade were covered in the granite found in the Scottish mountains, and they displayed the characteristics of seventeenth-century Scottish architecture: steeply pitched roofs bordered by gables called "crow steps"; tiny dormer windows; and tall, skinny chimneys. Though covered in swirling snow, the village has a friendly atmosphere. "I think it is jolly," says Craig. "It's cold and rugged on the outside, but every shop window is warm and inviting and full of magical things, like Butterbeer and great sweets." As the high-altitude double of Diagon Alley, there are little to no right angles to the buildings; they have a similar lean. Assistant art director Gary Tomkins recalls, "We

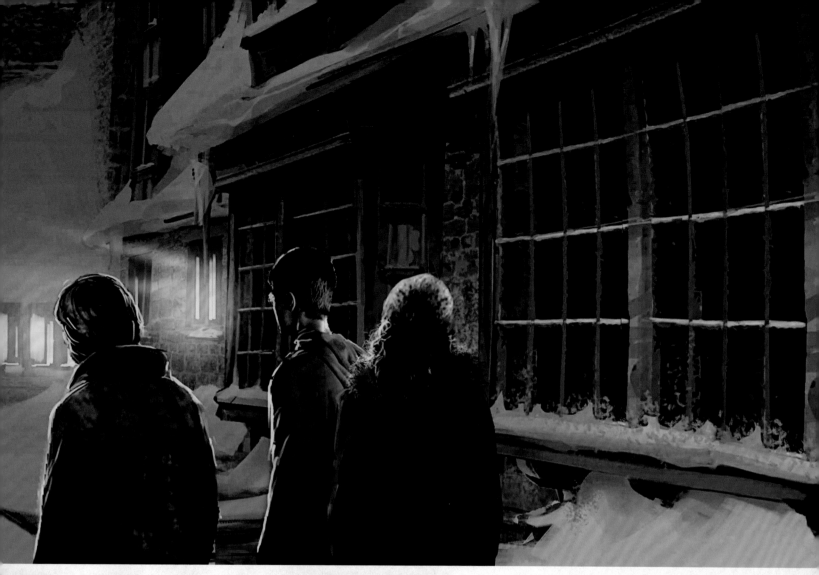

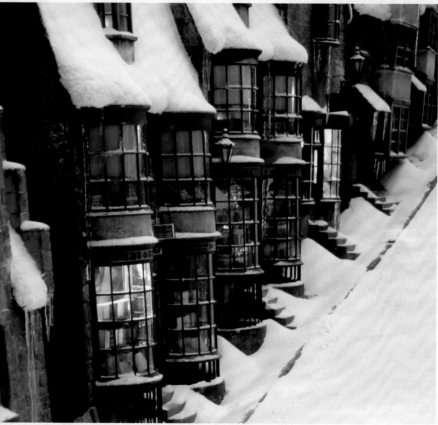

OCCUPANTS: Villagers, Hogwarts students and teachers

FILMING LOCATION: Leavesden Studios

APPEARANCES: *Harry Potter and the Prisoner of Azkaban, Harry Potter and the Order of the Phoenix, Harry Potter and the Deathly Hallows – Part 2*

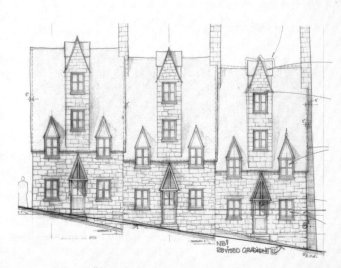

had endless discussions about how a door frame would shift or a window would tilt. Every building was twisted, skewed, or bent, with every one of them leaning in a different way to its building next door. There wasn't a vertical wall in sight!"

The snow that covers the Hogsmeade buildings and streets consists of dendritic salt. "The salt that you put on your fish and chips is quite dry and fine," says Tomkins. "Dendritic salt clumps like snow when you put it on. It even squeaks like freshly fallen snow when you step on it."

In fact, this same "snow" fell on a scale model of the village, used in quick establishing or long shots, shaken over the Hogsmeade model from a cherry picker. The model filled out the rest of the village that had not been rendered in full-scale buildings, and it is as detailed as the studio set. Working brass-etched lanterns are placed outside the buildings to light up the street. Inside, the shops are lit by miniscule electric bulbs, which also illuminate the shop windows, filled to the top with goods. There are jars of sweets in Honeydukes, and cauldrons piled up outside the Hogsmeade branch of Potage's Cauldron Shop. Scrivenshaft's Quill

Shop features incredibly tiny quills in its windows, and small brooms were produced for Spintwitches sporting goods store. "You'd think we could use doll's house items," says Tomkins, "but there isn't much you can find in owl cages or cauldrons. We made 90 percent of what's in the storefronts." Tomkins would set up a display of props, such as witches' hats or owl cages, take photographs, reproduce these at a smaller percentage, and paste the photo on cardstock, which was then placed inside the tiny bow windows. Tomkins also "populated" the Hogsmeade street. "We made up two sticks with little feet to scale," he explains, "and then 'walked' footprints through the snow coming out of some of the doors and going up the street. We even made up some dog footprints to appear as if someone walked a dog through the village!"

THIS PAGE, CLOCKWISE FROM TOP LEFT: *A white card model of Hogsmeade; dendritic salt, a common movie stand-in for snow, was drizzled over the Hogsmeade sets and models; the film crew on the Hogsmeade set.* RIGHT: *Concept art shows a street view of Hogsmeade with the Shrieking Shack looming in the background.*

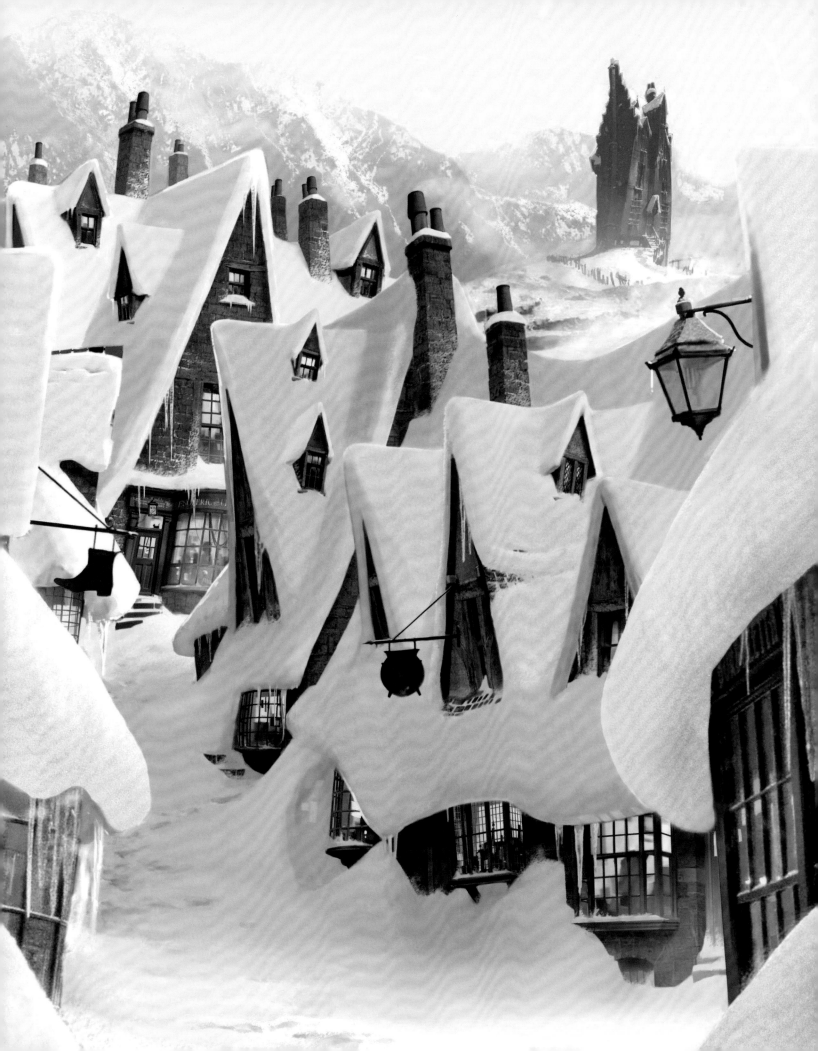

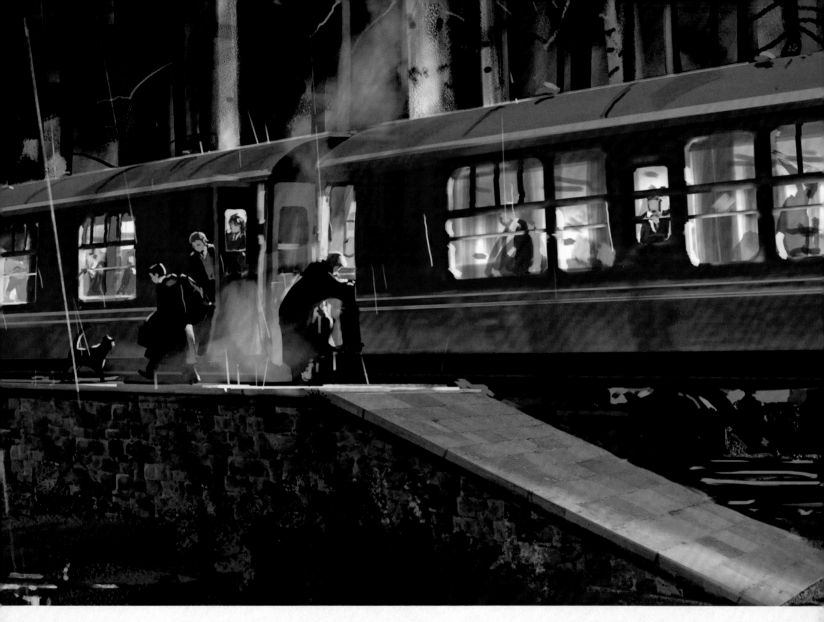

# HOGSMEADE STATION

Hogsmeade Station is the arrival and departure point for Hogwarts students riding the Hogwarts Express. In *Harry Potter and the Sorcerer's Stone*, Hagrid greets the new first-year students here, and then, at the end of the film, he sees them back onto the Hogwarts Express for the summer. The *Sorcerer's Stone* scenes were shot at the Goathland village station, part of a popular heritage train line run by the North Yorkshire Moors Railway. The station, built in 1865, required very few changes beyond altering the station's signs and digitally inserting the castle into the background to bring it into the wizarding world. For its appearance in *Harry Potter and the Order of the Phoenix*, where the students disembark and transfer to the Thestral-pulled carriages, the station and a section of track were re-created in Black Park, a location used throughout the films to represent the Forbidden Forest.

OCCUPANTS: Passengers on the Hogwarts Express

FILMING LOCATIONS: Goathland village station, North Yorkshire, England; Black Park, Buckinghamshire, England

APPEARANCES: *Harry Potter and the Sorcerer's Stone, Harry Potter and the Order of the Phoenix*

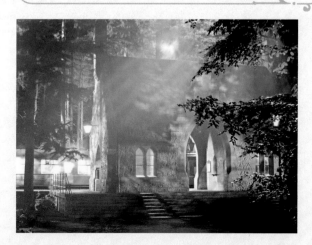

TOP AND OPPOSITE BOTTOM: *Concept art depicts the arrival of Hogwarts students at Hogsmeade Station.* RIGHT: *A view of Goathland station.*

# THE SHRIEKING SHACK

The Shrieking Shack is a rickety, juddering structure set on a hill near Hogsmeade village. During the events of *Harry Potter and the Prisoner of Azkaban*, it is discovered that the building was created to house Remus Lupin during his transformations into a werewolf during his time as a Hogwarts student.

Stuart Craig knew that the iconic Shrieking Shack had to have a character of its own. "It needed to be creaking and moving, as if being continually buffeted by the wind," he says. He enlisted the help of Special Effects Supervisors John Richardson and Steve Hamilton to construct the set. First, a miniature model was created to determine the building's movement. Then the full-size set was built on a hydraulic platform, as a structure within a structure. "It had a massive steel frame," Craig explains, "that was pushed around by the hydraulics. Then we built the set to hang on to the frame." Because of the amount of sway, the movement was not confined to just the walls: "The door swings back and forth, the shutters swing back and forth, the wall fabric kind of flaps. . . . the whole room literally moves." Director Alfonso Cuarón adds, "It was Stuart's idea that everything is shaking and everything

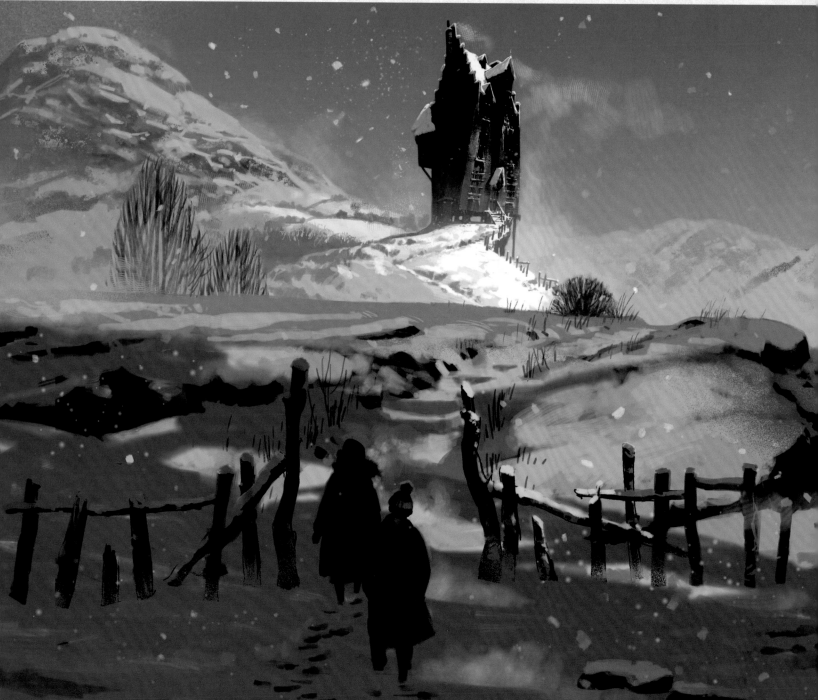

is swaying. So it was a huge set that was built with this structure that allowed the whole construction to be tilting back and forth, squeaking all the time, and the walls moving back and forth. Some people got motion sickness just because of the walls moving like that!"

Craig was also influenced by Remus Lupin himself. "The journey to the Shrieking Shack is meant to represent the terrible journey Lupin endures during his transformation into a werewolf," he says. The room, which he presumed was furnished out of Hogwarts furniture, is decimated and reflects Lupin's inner torment. "He has this once rather splendid bed, now completely wrecked and completely dilapidated. To me, this room was designed to represent the history of these terrible transformations, the terrible agonies, and the violence and the damage that he wrought upon the place." The hard work of Craig and his team met the challenge of the complicated construction and detailed design, and that contributed to the shack's emotional resonance.

The shack also presented challenges to the director and the actors. Alfonso Cuarón explains, "Everything was supposed to be dusty. So, for the first take, everything is dusted, and we do the take. When we go to take two, we have to dust everything again because you see everyone's footprints. And again, take after take." Daniel Radcliffe (Harry Potter) recalls that, "The creaking of the walls was so loud sometimes we couldn't actually hear what the other was saying."

Craig is proud of the fact that though the audience might not see it, they can feel the layers of detail that were used in realizing the shack. "If you look closely, you can see that within the special-effects steel frame there is a wooden frame. There are external boards as well as interior, internal ones. And then the whole thing is covered in this silk tapestry." He believes that ever-improving technology justifies this attention to detail. "I think that in any era of moviemaking what you half-saw and what you half-understood always played a part. But in these days of DVDs, where viewers are able to stop a film frame and analyze it, no detail is wasted in my view."

OCCUPANTS:
The Marauders
(Remus Lupin, James Potter, Sirius Black, Peter Pettigrew)

APPEARANCE:
*Harry Potter and the Prisoner of Azkaban*

THESE PAGES, CLOCKWISE FROM TOP LEFT: *A model was constructed of the Shrieking Shack exterior; the living room set as seen in* Harry Potter and the Prisoner of Azkaban; *concept art by Adam Brockbank shows Ron and Hermione approaching the Shack.*

# THE HOG'S HEAD

To convince potential members to pledge to the newly established Dumbledore's Army in *Harry Potter and the Order of the Phoenix*, Hogwarts students gather in Hogsmeade's Hog's Head pub, a slightly seedy place that Hermione Granger believes will offer them privacy. Entering the establishment, the students can't help but notice its namesake at the entrance—a large hog's head mounted on the wall that rolls its eyes, snuffles its nose, and dribbles "profusely," according to Nick Dudman, a creature effects supervisor and special makeup effects artist. Dudman designed the head to have broad movements. "It's a comic aside," he explains. "And those are always a pleasure to do, even if it's a one-off gag that will just help a scene along or give you a diversion for a minute." Though the gag is seen only fleetingly on-screen, Dudman and his team gave as much attention to the animatronic creation as to any other creature in the films. "There's actually a lot of time that goes into creating something like this. It has to be sculpted and molded, then the skin is produced in silicone, and then it's painted." The most time-consuming aspect was inserting every single hair individually into the head. "But," he adds, "that gives it an air of realism you really can't achieve any other way."

The Hog's Head is an exaggeration of a typical London pub. "The iconic ingredients are there," notes Stuart Craig. "The heavy oak beams, the leaning walls, the uneven floor. But it leans more than any real pub ever could. The oak beams are heavier than you would ever find in a real pub. It's more decrepit and the wood is more worm-eaten than hopefully you would ever find in a real pub."

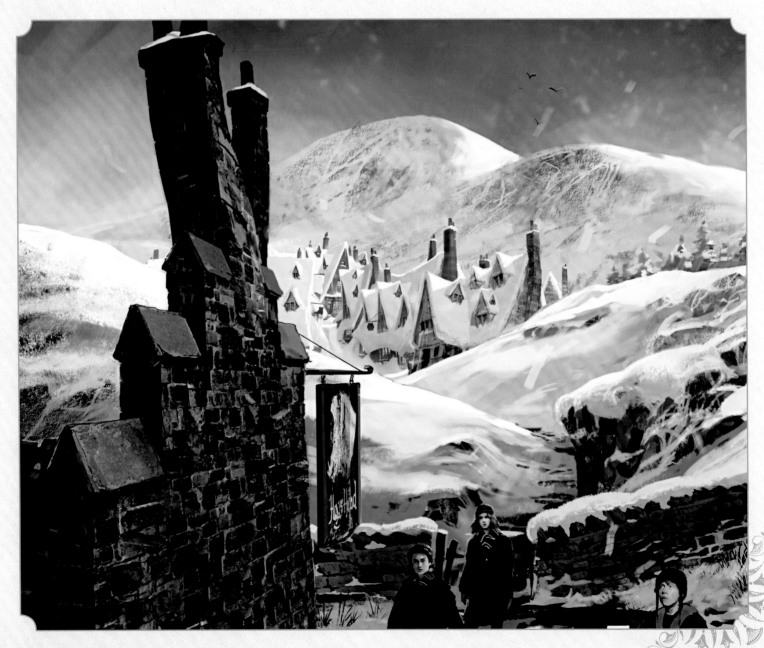

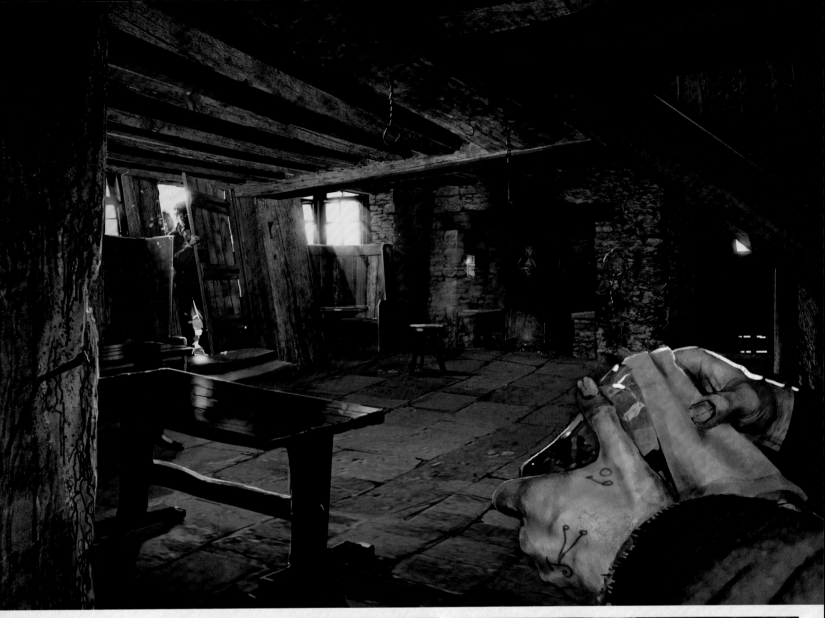

THESE PAGES, CLOCKWISE FROM TOP LEFT: *The design of the animatronic hog's head; art by Andrew
Williamson shows a view from the bartender's perspective; Neville Longbottom (Matthew
Lewis) emerges from behind a portrait of Ariana Dumbledore; the hog's head as seen in*
Harry Potter and the Order of the Phoenix; *art by Andrew Williamson.*

TOP: *In art by Andrew Williamson, Harry, Ron, and Hermione follow Hagrid and Professor McGonagall to the Three Broomsticks.* OPPOSITE: *Photos of the Three Broomsticks interior set.*

# THE THREE BROOMSTICKS

The Three Broomsticks is seen briefly in *Harry Potter and the Prisoner of Azkaban*, when Harry Potter (covered by his Invisibility Cloak) follows Professor McGonagall, Minister for Magic Cornelius Fudge, and Madam Rosmerta upstairs and secretly listens as they discuss Sirius Black. The room where they meet mirrors the Tudor-style carved wood walls of the Leaky Cauldron. In fact, the Three Broomsticks could be Hogsmeade's counterpart to the Leaky Cauldron, with the added decoration of mounted stuffed animal heads.

The Three Broomsticks is all about the details, with no flagon unturned. There are casks of Butterbeer, jugs, and pint glasses. Under a broad-beamed arch, a huge fireplace roars at one end of the room, the wall above it adorned with trophies bearing all sizes of antlers. There is even a small bell on the bar used for the traditional ring announcing the last drink of the night. The graphics department provided labels for the inn's beverage offerings, including Blishen's Firewhisky and Dragon Barrel Brandy, and they labeled the bar food, which would be popular in both the wizarding and Muggle worlds: Black Cat Potato Crisps and the Three Broomsticks—produced famous Spellbinding Nuts (roasted on-site).

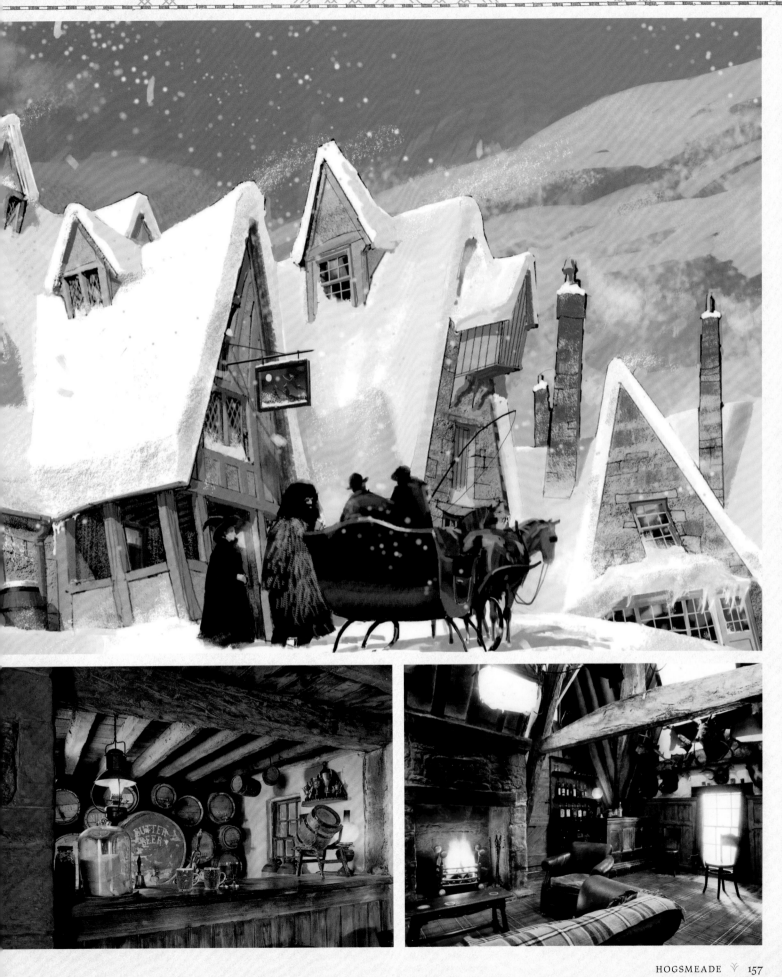

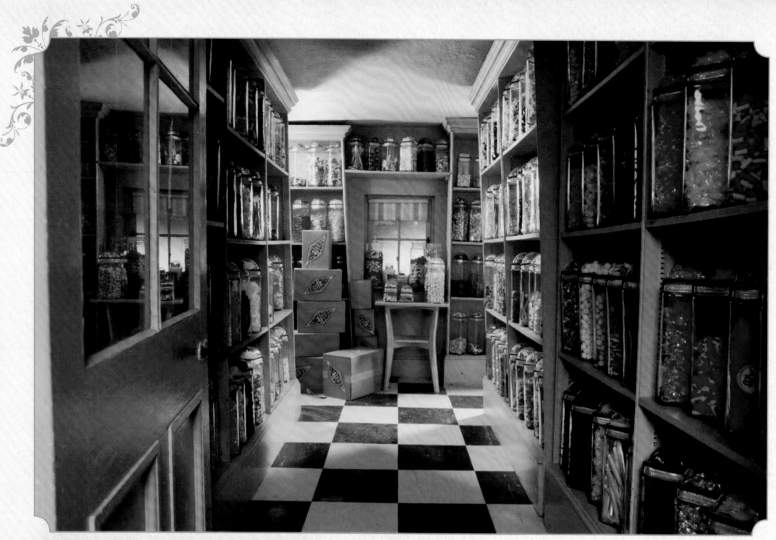

## "HONEYDUKES SWEETSHOP IS BRILLIANT."

Ron Weasley, *Harry Potter and the Prisoner of Azkaban*

# HONEYDUKES

Filled to the rafters with candy, Honeydukes Sweetshop is well known to children of the wizarding world. For *Harry Potter and the Prisoner of Azkaban*, as part of the redress of Diagon Alley to become Hogsmeade village, Honeydukes was placed in what was originally Ollivanders in *Harry Potter and the Sorcerer's Stone* and what became Flourish and Blotts in *Harry Potter and the Chamber of Secrets*. Where the set's previous incarnations were filled with wand boxes and books, Honeydukes is stacked floor to ceiling with candy, including tall dispensers of Bertie Bott's Every-Flavour Beans and jars of Jelly Slugs. The décor is as colorful as its products, with shelves painted peppermint green with accents of cotton-candy pink. Graphic Designers Miraphora Mina and Eduardo Lima created the packaging for the myriad merchandise, which ranges from melt-in-the-mouth Glacial Snow Flakes and Tooth Splintering Strong Mints to Madam Borboleta's Sugared Butterfly Wings and Limas Crazy Blob Drops. The prop department churned out racks of chocolate skeletons, and as a nod to director Alfonso Cuarón's Mexican heritage, there are rows of *calaveras*, the vibrantly decorated skull-shaped sugar candies traditionally made for Day of the Dead celebrations. In order to prevent the actors from eating up all the props, they were warned that the candy had been covered with a lacquered finish, which was actually a well-intentioned fib.

THESE PAGES: *Photos of the colorful Honeydukes set taken for* Harry Potter and the Prisoner of Azkaban.

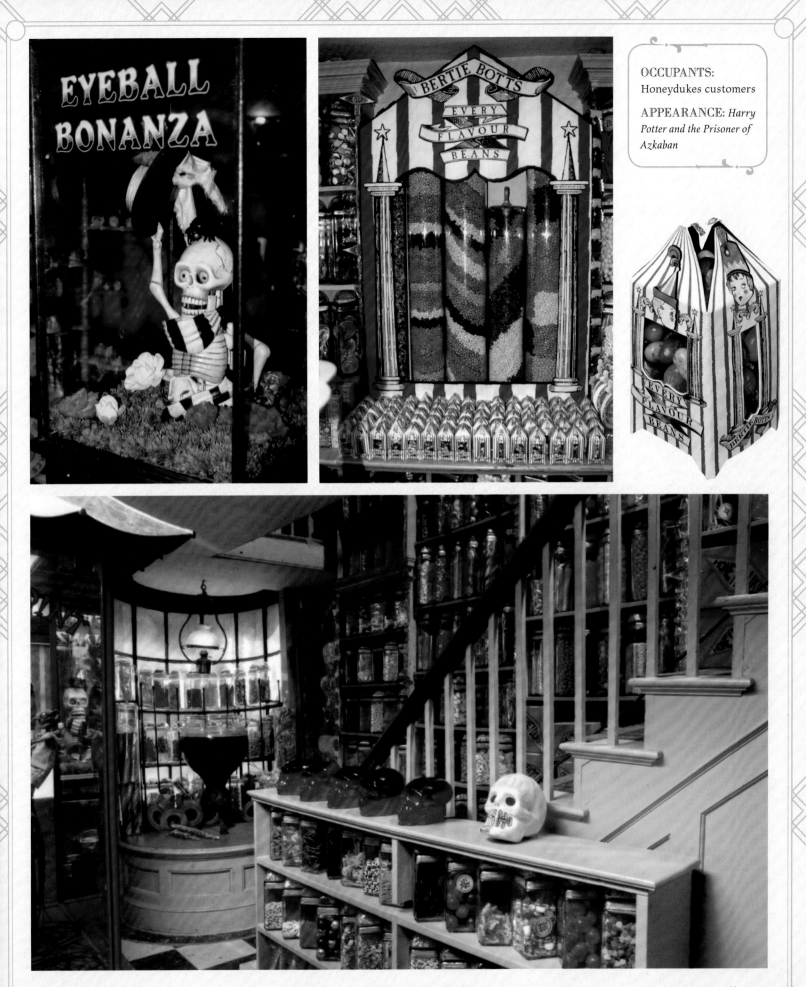

OCCUPANTS: Honeydukes customers

APPEARANCE: *Harry Potter and the Prisoner of Azkaban*

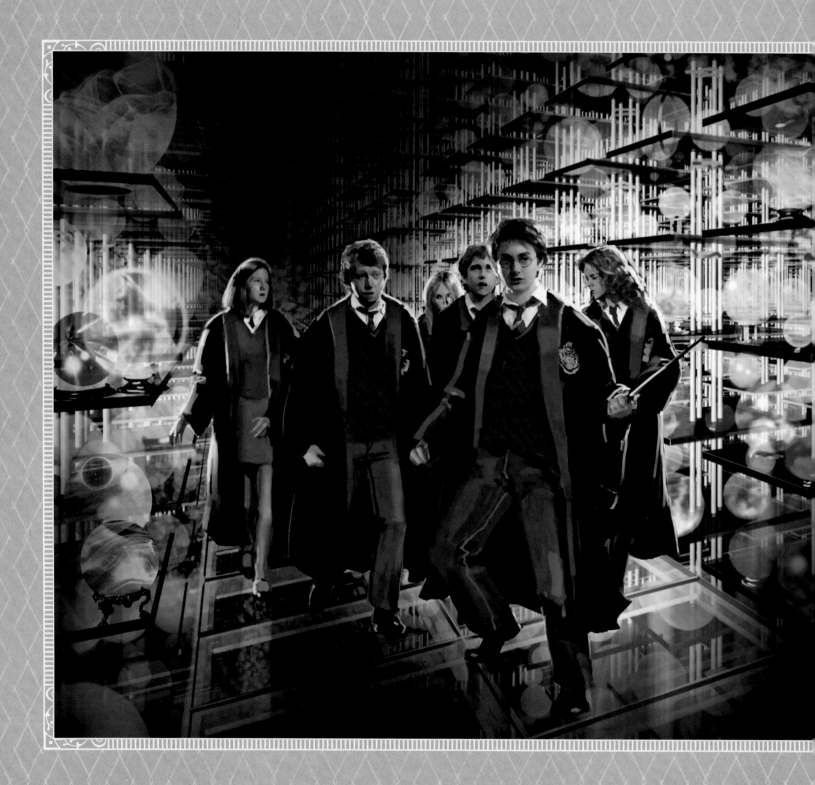

# MINISTRY OF MAGIC

# MINISTRY OF MAGIC

Stuart Craig wanted to ensure that the Ministry of Magic would have the gravitas necessary to represent any austere body of government, and as this would be the largest set built at the studio, he also wanted a great visual. "I asked myself several questions," he recalls. "What would give it credibility? What would allow me to take a visual approach? What would separate this set from all the others and make it unique and interesting?" His first task was deciding where to place it. "First, this is an underground world, but foremost, this is a ministry. We decided that our magical ministry was a kind of parallel universe to the Muggle ministry, so we thought it would be fun to set it beneath the British government's Ministry of Defense."

## "I DON'T UNDERSTAND. WHAT HAS THE MINISTRY OF MAGIC GOT AGAINST ME?"

Harry Potter, *Harry Potter and the Order of the Phoenix*

As research for the subterranean location, Craig and crew visited the London Underground's network of tunnels and stations. "We visited the oldest of the London Tube stations, built in the early 1900s, many of which used an extravagant amount of decorative ceramic tile. The use of ceramic was logical, of course, because of its being below the waterline. But the colors of the tiles and the use of classical columns and decorative elements were inspirational to the design, and photographically very interesting." Craig also knew that, as the interior was underground, there would be no natural lighting, and using high-gloss glazed tiles would reflect what light there was. The Ministry atrium was constructed with deep reds, greens, and blacks that surrounded huge gilded fireplaces connected to the Floo Network. Craig likened the area to Waterloo station at eight in the morning. "There's that huge concourse leading into this massive corridor which we first see with everybody going to work, except that instead of trotting off from trains, they appear down fireplaces."

Each Ministry worker was fitted with a briefcase and other business necessities. Set decorator Stephenie McMillan also provided the atrium with a newsstand to sell the *Daily Prophet* and a café trolley that provided coffee and pastries named "Ministry Munchies." But "the Ministry is a bureaucracy," Craig reminds us, "and rather sinister developments are happening. [Minister for Magic] Fudge is a dominating, iconic figure." Craig and director David Yates were inspired by early Soviet Union–style propaganda posters to place a large banner of Cornelius Fudge in the Atrium that watches over the workers. "There's an artificiality about it being underground," offers Craig, "with no outlook on the world." The physical set is over two hundred twenty feet long, and this is extended even farther via CGI, which quadruples what

ABOVE: *A banner hangs in the Atrium depicting a proud and strong Cornelius Fudge (Robert Hardy), Minister of Magic.* RIGHT: *In concept art by Andrew Williamson, Harry is accompanied by Arthur Weasley on the way to a trial he faces for producing a Patronus in the presence of a Muggle.*

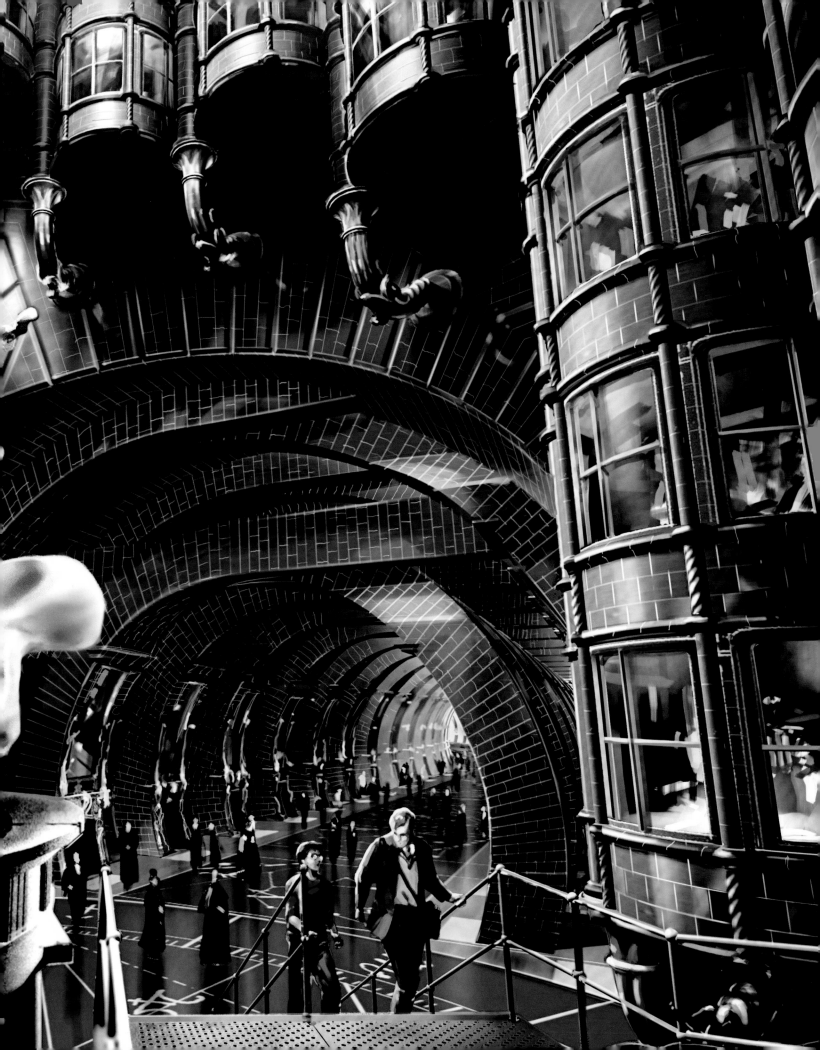

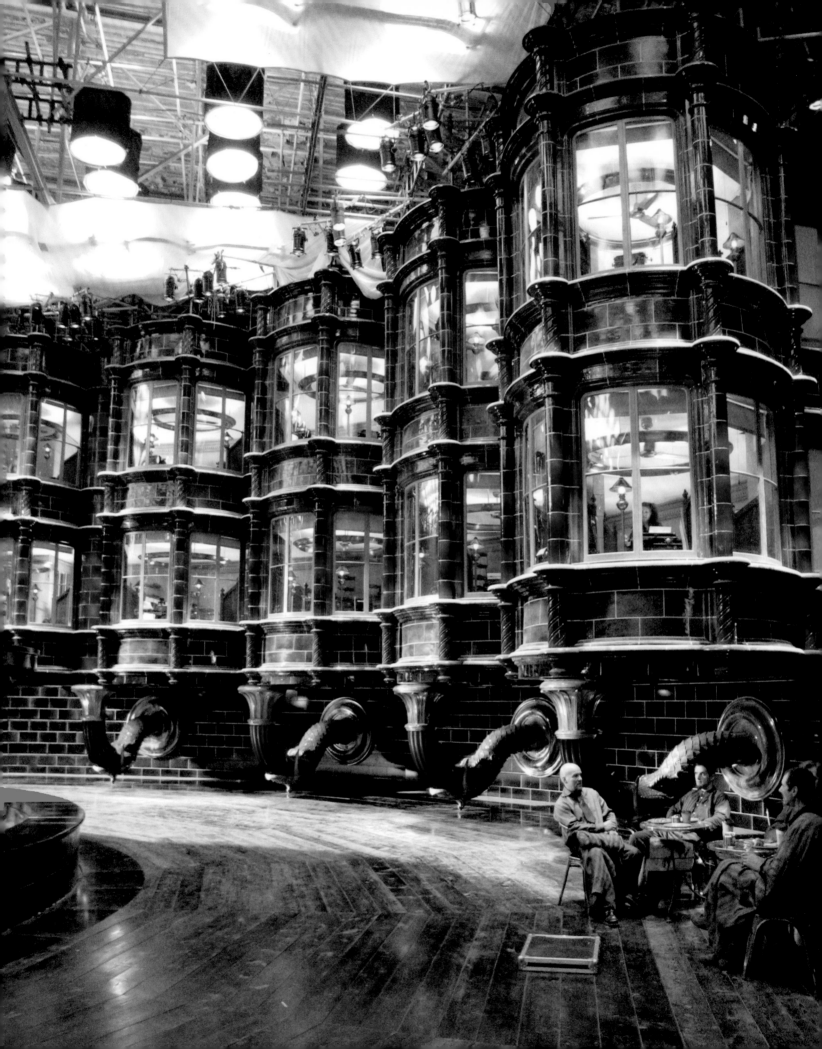

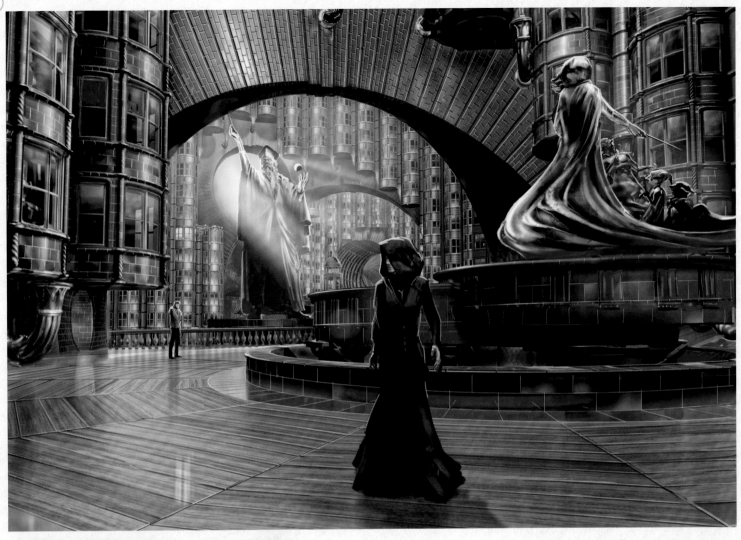

is seen on-screen. "But it's only as high as the stage would allow us—we had only thirty feet of working height," notes Craig. Only two stories of the Ministry's endless columns of windowed offices could be constructed, with the rest rendered digitally. Stephenie McMillan was required to dress these fourteen offices, and in order to fit with the wizarding world setting, none of the office equipment could have electricity. "We're never allowed any electricity," McMillan says with a laugh. "So each office was decorated with a typewriter and with oil lamps with especially tall stems. We needed to use cardboard filing cabinets and filing drawers at the back of the rooms because otherwise there would be a weight problem." In fact, only stuntmen were allowed to inhabit the offices.

In the climax of *Order of the Phoenix*, Dumbledore and Voldemort wage a magical battle in the Atrium that at one point blasts out what would appear to be the more than two hundred windows of the Ministry offices. Special Effects Supervisor John Richardson used practical explosive effects combined with additional debris. "The practical part of it had to work on the first take," Richardson recalls, "and I'm glad to say it did." In typical moviemaking fashion, the destructive battle in the Atrium was scheduled first, requiring a massive cleanup to return the location back to its gleaming state before the opening scenes of the sequence could be filmed.

OCCUPANTS: Ministers for Magic Fudge, Scrimgeour, and Thicknesse, Ministry workers

FILMING LOCATION: Leavesden Studios

APPEARANCES: *Harry Potter and the Order of the Phoenix, Harry Potter and the Deathly Hallows – Part 1*

OPPOSITE: *Stand-ins sit back on the Atrium set.* TOP: *Concept art by Andrew Williamson shows a cloaked woman crossing the Atrium in Harry Potter and the Order of the Phoenix.* ABOVE LEFT: *Another piece by Williamson shows the Atrium devastated after a battle between Lord Voldemort and Dumbledore.*

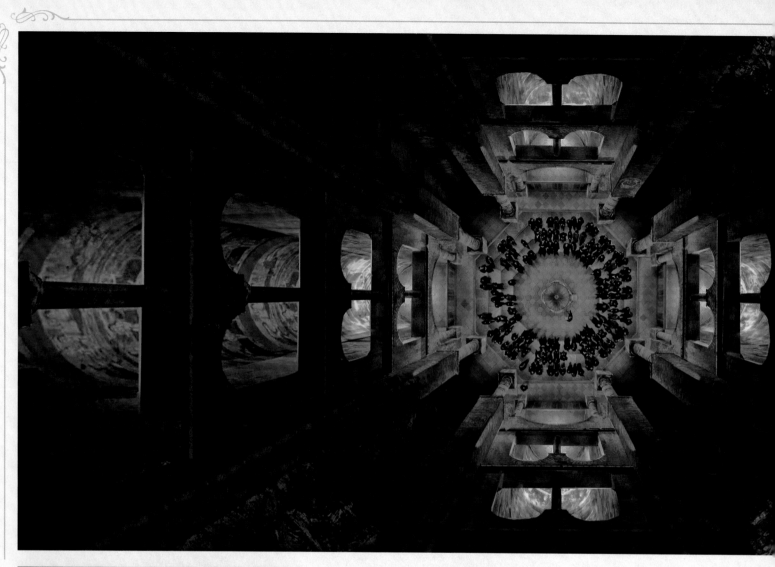

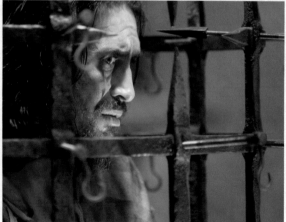

# TRIAL CHAMBER

When Harry Potter first looks into the Pensieve in Dumbledore's office in *Harry Potter and the Goblet of Fire*, he enters one of Dumbledore's memories of Death Eater trials held by the Council of Magical Law in the Ministry of Magic's trial chamber. Since, from Harry's perspective, he "falls" into the courtroom, verticality was a necessity, and with the help of visual effects, the descent from the top of the octagonal chamber's ceiling is sixteen stories high (about 160 feet). Stuart Craig designed the room in a style not yet seen in the films: "My inspiration came from ancient Byzantine churches. The city of Byzantium is where Istanbul, in Turkey, now is, and [it was] part of the Roman Empire in the fifth century. The style features round arches and domes, unlike the prevalent Gothic style of so many locations." The choice of using an ancient culture's style gave the court the sense of being ancient itself. Though the chamber's tight configuration gives it a sense of constriction and intimidation, the room can actually seat two hundred people. "It's a more oppressive, darker look than we've had in the previous movies," Craig explains, "but it needed to manifest the mood of the sequence." As the trial chamber is deep within the Ministry, it has no source of exterior light. Four huge fires glow red and gold from recesses within the tall alcoves. The inlaid floor and surrounding columns were finished with marbleized paper, using the same technique as for the floors of Gringotts Wizarding Bank (and for the giant wizard's chess board in *Harry Potter and the Sorcerer's Stone*): dipping sheets of paper in vats layered with water and oil paint, and finishing them off with brushwork. The numerous marble columns were also gilded to reflect

## "THE CHARGES AGAINST THE ACCUSED ARE AS FOLLOWS . . ."

Cornelius Fudge, *Harry Potter and the Order of the Phoenix*

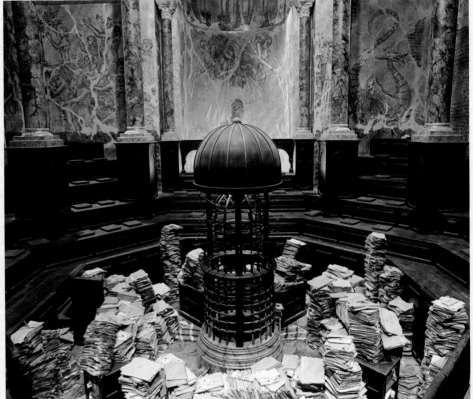

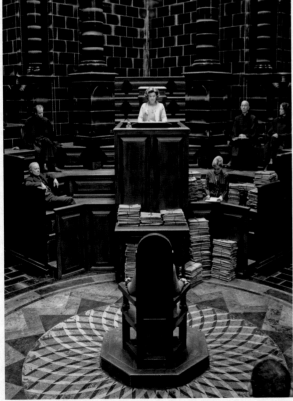

the firelight. The room is decayed with time; the walls are cracked and layered in peeling paint. Also featured on the walls are murals inspired by those in Byzantine churches, reinterpreted with wizardly iconography. At the center of the trial chamber is a metal cage that imprisons the focus of the council's questioning in Dumbledore's memory. "It's similar to medieval iron maidens," he explains. "Director Mike Newell was keen on having it seem an instrument of torture, so we added very threatening spikes turned in toward the witness inside."

In *Harry Potter and the Order of the Phoenix*, Harry is called to the trial chamber to face charges for underage wizardry. The trial chamber was rethought and expanded for this film. "We literally doubled it," Craig says. "It retains its symmetry, which was important, but we built another octagon and put the two together." The room is clear of the paperwork piled up in its previous incarnation, and it dovetails more with the tiled design of the Ministry atrium and concourse. Though doubled, there are still only four firelit light sources, and the room sinks into dark, sterile shadows.

A disguised Harry, Ron, and Hermione sneak into the courtroom in *Harry Potter and the Deathly Hallows – Part 1* to steal the Horcrux locket worn by Dolores Umbridge. Perhaps this is a different room, for the trial chamber has now shrunk back to a single octagon and is encased in a dark green-black ceramic tile.

THESE PAGES, CLOCKWISE FROM TOP LEFT: *Concept art depicts the octagonal chamber as seen from above; a still from* Harry Potter and the Goblet of Fire *highlights the chamber's gold leaf columns and Byzantine frescoes; for the trial in* Harry Potter and the Order of the Phoenix, *the room was widened to incorporate the Victorian tile seen in the film; the cage for prisoners was modeled on medieval torture instruments.*

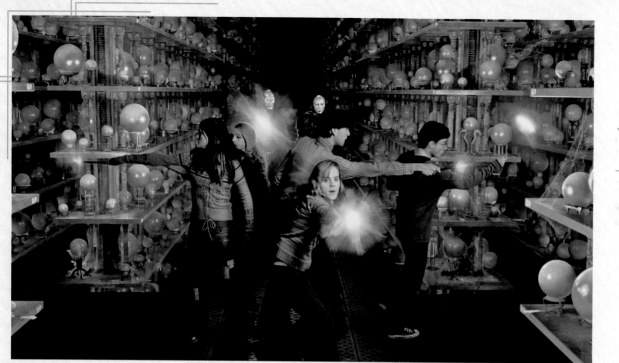

# HALL OF PROPHECY

OCCUPANTS:
Dumbledore's Army,
Death Eaters

APPEARANCE:
*Harry Potter and the Order of the Phoenix*

97·131

Lured by a false vision planted by Voldemort, Harry Potter races to the Ministry's Department of Mysteries to save Sirius Black in *Harry Potter and the Order of the Phoenix*. Accompanied by his friends from Dumbledore's Army—Ron and Ginny Weasley, Hermione Granger, Neville Longbottom, and Luna Lovegood—they enter a room that is filled with hundreds of globes of all sizes—the Hall of Prophecy.

The Hall of Prophecy was the first entirely virtual set created for the *Harry Potter* films. The decision to create it digitally was not an easy one. "We did quite a lot of test shooting and had endless debate," Stuart Craig explains. "To start with something built and to extend it seamlessly though CGI is not always easy.

## "HARRY? IT'S GOT YOUR NAME ON IT."

Neville Longbottom, *Harry Potter and the Order of the Phoenix*

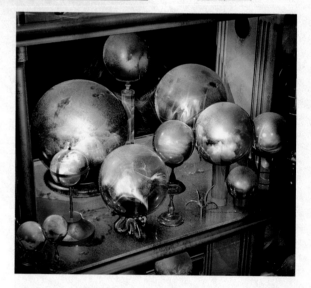

Sometimes it's better to create the entire world." The lighting of the room and its contents was perhaps the most convincing factor against building a real set. "We wanted the prophecies themselves to be some kind of low-level source of ambient light, and brighten and dim when the students walked by them," he explains. "It's very difficult to do that without them looking like some kind of light fixture. By generating it in the computer, you can have all of the magic and all the subtlety in the world."

Initial concepts did require a small portion of the set to be created practically. Stephenie McMillan and her team were asked to build a cross section of the shelving and populate it with labeled prophecy orbs that ranged from two inches to eighteen inches in size. "I think we were supposed to make about thirteen thousand globes, all together," she recalls, "which would be used for the background. The ones in front would be done by special effects." But a new consideration quickly arose. At the conclusion of the scene, shelf after shelf of glass orbs would fall and smash—something the filmmakers knew should be achieved digitally so that the actors would be safe. This sealed the decision to go digital. McMillan, the consummate prop recycler, used some of the orbs as drink dispensers on the Ministry Munchies coffee cart. The scene was filmed in a green-screen room that had a path marked on the floor and simple skeletal frames of shelving for the actors to negotiate, all of which offered the digital artists a logical geography to the hall. Then the digital shelves and globes were duplicated ad infinitum.

*THESE PAGES, CLOCKWISE FROM TOP LEFT: Harry, Ron, Hermione, Neville, Luna, and Ginny are pursued by Death Eaters through the Hall of Prophecy; a blueprint for the orbs and shelves that were built prior to computer rendering; concept art by Andrew Williamson depicts the myriad shelves of the hall; a sampling of real orbs was created by the props department; the hall shelves were marked with numbered plates.*

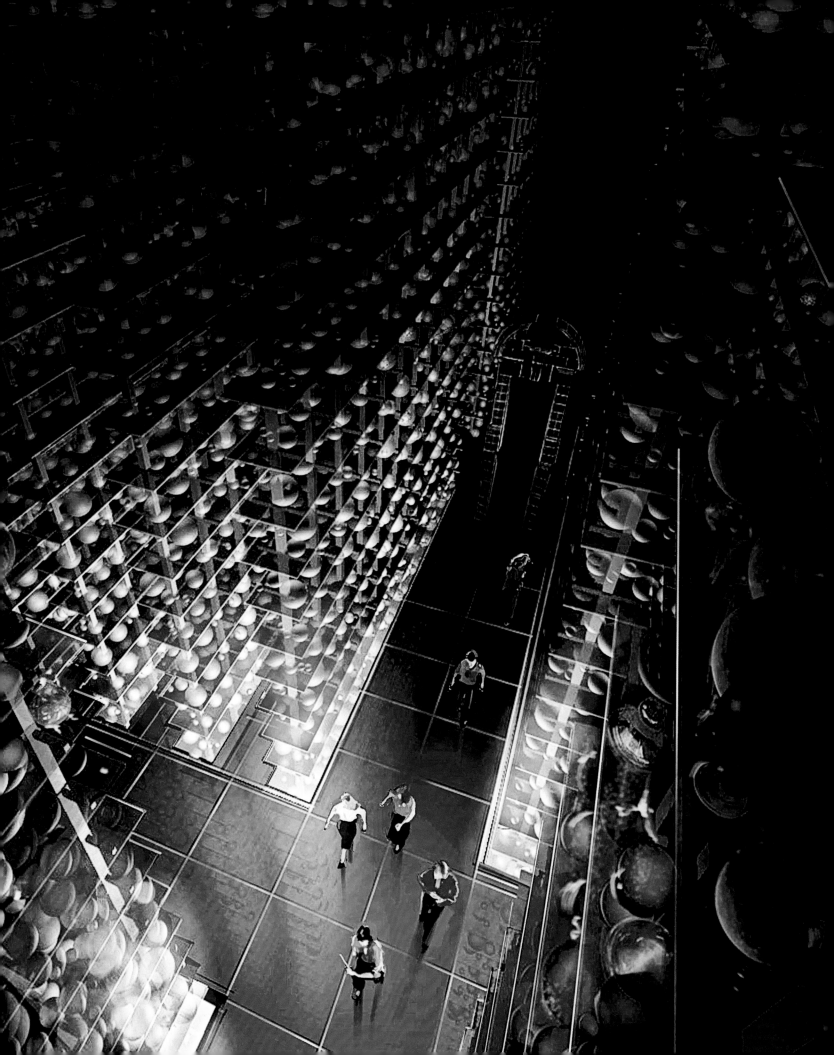

THESE PAGES, CLOCKWISE FROM TOP LEFT: *Harry and members of Dumbledore's Army enter the Department of Mysteries; concept art depicts the battle in which Sirius Black falls through the Veil to his death; Bellatrix Lestrange (Helena Bonham Carter) and Sirius Black (Gary Oldman) on the Department of Mysteries set.*

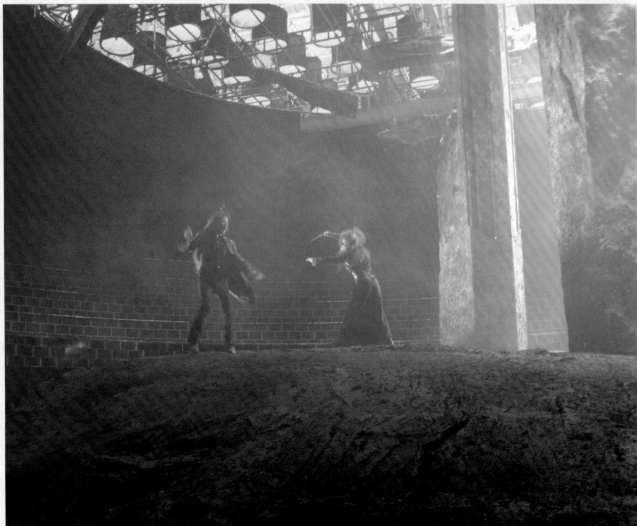

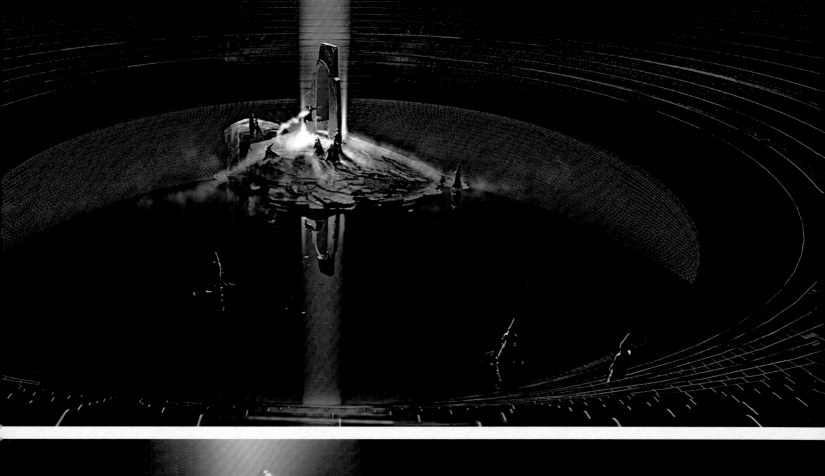
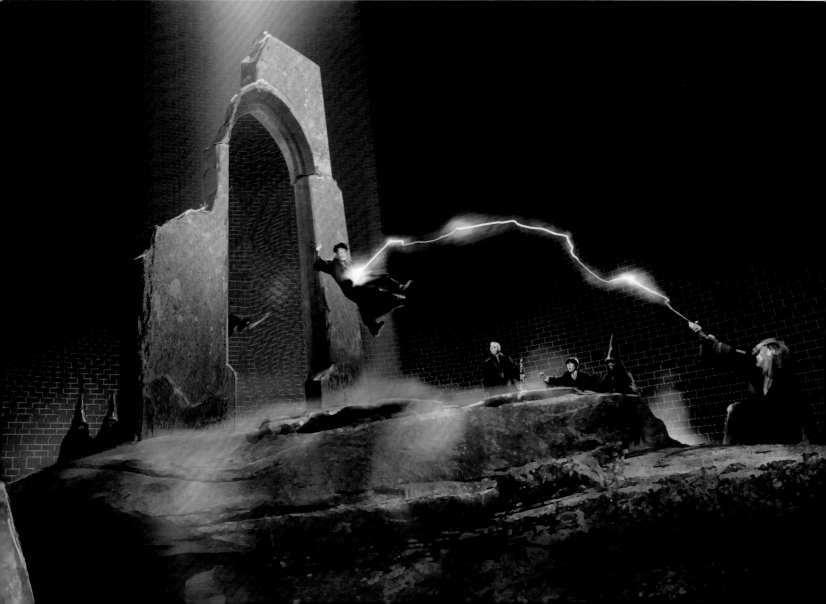

# MUGGLE-BORN REGISTRATION COMMISSION AND OFFICE

OCCUPANT: Dolores Umbridge

APPEARANCE:
*Harry Potter and the Deathly Hallows – Part 1*

In *Harry Potter and the Deathly Hallows – Part 1,* Harry Potter enters the Ministry of Magic while disguised by Polyjuice Potion, and he makes his way to the Muggle-Born Registration Commission (a new department put in place to pursue Muggle-born wizards) to search for the Horcrux locket Dolores Umbridge now possesses.

In a large, black-tiled room, the Muggle-Born Registration Commission actively collates propagandist literature that soars from the desks to receiving in-boxes. "We made forty-eight desks for the clerks who were making anti-Muggle brochures under this huge, arched vaulted set," says Stephenie McMillan. The room is bordered by gold columns topped with ornate Corinthian-order capitals. The room's carpet is purple, a color that Stuart Craig had been slowly adding as an accent to the Ministry style, outlined by a Greek key design.

Dolores Umbridge's new office is, as Stuart Craig describes, "another essay in pink," although he admits that "as the films have become darker, the sets as well have literally become darker." Umbridge's office is set facing the Atrium of the Ministry, so there is a light source that floods the room, but it is dimmed by the dark greenish-black tiled walls. The tops of the gold Corinthian columns seen in the office pool are now substantially larger, sitting on top of tiled column bases. "But Umbridge's office in the Ministry still has a lot of the elements, and quite a lot of the furniture, that had been in her Hogwarts office," says McMillan. The pink rug and the spiky French furniture have transferred over, as well as a majority of the kitten plates, although the dark office did not warrant the use of the blue-screened filmed moving cats.

---

*Concept art by Andrew Williamson shows the office where a pool of clerks create anti-Muggle brochures (below and bottom right) outside Dolores Umbridge's private office (opposite top).*

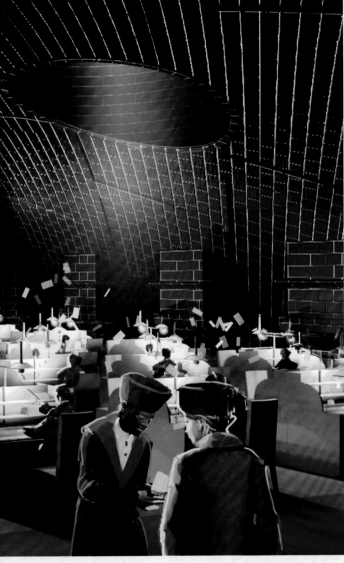

## "MUDBLOODS & THE DANGERS THEY POSE TO PEACEFUL, PUREBLOOD SOCIETY."

Pamphlet distributed by the Muggle-Born Registration Commission, *Harry Potter and the Deathly Hallows — Part 1*

# CHAPTER 9

# WIZARDING HOMES

# GRIMMAULD PLACE

In *Harry Potter and the Order of the Phoenix*, Harry Potter is escorted by members of the Order of the Phoenix to number twelve, Grimmauld Place, the ancestral home of the Noble House of Black. There he joins the Weasleys, Sirius Black, and others as they discuss plans for stopping Voldemort's army. Magically, number twelve, Grimmauld Place is only visible to those who know it's there. "Grimmauld Place appears from behind a drainpipe," explains Stuart Craig. "It starts with one dimension, then develops out into two dimensions, and then three as the front steps pop forward and the windows sink back." Craig always felt that the natural location for Grimmauld Place would be in one of London's Georgian squares among their early-nineteenth-century houses. A physical façade of six townhouses was built at the studio, but the actual emergence of Grimmauld Place was achieved digitally. Then special effects were added to the materialization: a fish tank judders, curtains flutter, and dust spills from the roof.

"The exterior is typical of that time period," he reiterates. "What is atypical, of course, is the way it magically appears. We tried to reflect that on the inside, to have a strangely distorted space. When you open the front door, for example, there's a very compressed hallway." Many of the corridors and the kitchen were created with

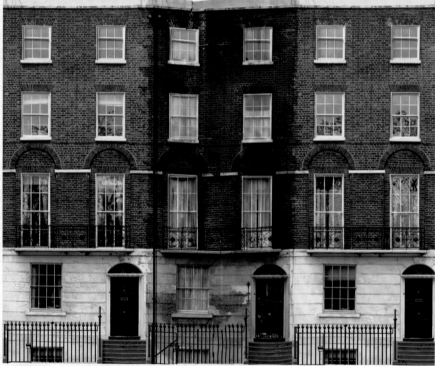

OCCUPANTS: The Black family, the Order of the Phoenix

FILMING LOCATION: Leavesden Studios

APPEARANCES: *Harry Potter and the Order of the Phoenix, Harry Potter and the Deathly Hallows – Part 1*

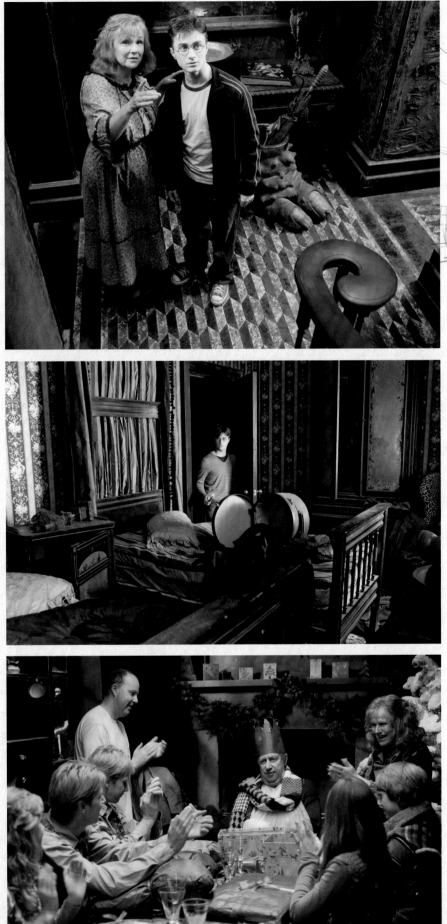

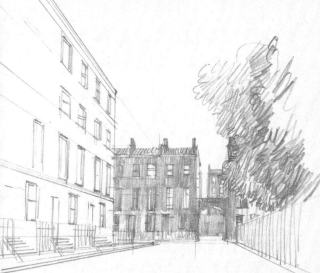

forced perspective, so they disappear into infinity. Additionally, "Sirius Black is hiding out after his escape from Azkaban," set decorator Stephenie McMillan adds, "so there's also the feeling of it being enclosed. Stuart designed it with very high, narrow ceilings. And it has tall, thin windows that are mirrored so that no one can see out, which, again, gives it another effect of enclosure." McMillan complemented the squeezed look with extra-tall wardrobes, dressers, and beds.

Craig chose a blue-black inky color for the palette for Grimmauld Place. Stephenie McMillan purchased furniture to fill the house and had it painted dark ebony, which matched the ebonized wood that makes up the staircases and baseboards. Gray was also a prevalent color, such as in the velvet curtains and the decaying walls, which are covered in a dark gray silk that glows with an eerie gleam. McMillan assumed that the guest bedroom Ron is staying in at the top of the stairs was decorated by the late Mrs. Black. In one of what she calls her "rare uses of wallpaper," an antique striped pattern adds verticality to the walls; the gray silk curtains are striped as well. McMillan dressed the room with black dressers and a curvy well-worn dressmaker's dummy. "I started collecting old fans," she adds, "which I set in black frames, with dead moths inside."

"David Yates wanted the kitchen extended even longer than originally designed," says McMillan, "which I think was possibly to accentuate Sirius and Harry being apart from the family." McMillan wasn't able to find a table that would run twenty feet down the Black family kitchen, so it was built at the studio. The sides of the kitchen were wild

THESE PAGES, CLOCKWISE FROM TOP LEFT: *The number twelve, Grimmauld Place sitting room was thirty feet long; Molly Weasley (Julie Waters) and Harry Potter in* Harry Potter and the Order of the Phoenix; *Harry enters the guest room in* Harry Potter and the Deathly Hallows – Part 1; *director David Yates on the set as the Weasley family celebrates Christmas in* Harry Potter and the Order of the Phoenix; *the Grimmauld Place façade.*

"THIS IS MY PARENTS' HOUSE. I OFFERED IT TO DUMBLEDORE AS HEADQUARTERS FOR THE ORDER."

Sirius Black, *Harry Potter and the Order of the Phoenix*

walls to allow for shooting, fronted by thirteen-foot-high sideboards. "They were jammed with old silverware and pewter in a jumbled mess, as Kreacher is looking after the house. There was also a collection of dark-blue-and-gold-rimmed china, with the family crest on it." McMillan added hanging cauldrons and huge teakettles for a homey feel.

Harry returns again for refuge at Grimmauld Place in *Harry Potter and the Deathly Hallows – Part 1,* along with Ron Weasley and Hermione Granger, when they are pursued by Death Eaters. Stephenie McMillan had new challenges. "We had a big drawing room to do, and two bedrooms that we hadn't had before, Sirius and Regulus Black's bedrooms, which we hadn't had before. The set had been taken down by then, so we had to rebuild it." McMillan already had in mind what she wanted for the drawing room, where Harry, Ron, and Hermione camp out. "It didn't feel right to have squashy sofas. I wanted Regency style, with straight upholstered backs, and I found them at a rental company. Two absolutely perfect sofas, upholstered in the most disgusting fabric." McMillan asked the owner if he would sell the sofas to her, "which he appreciated, as no one ever rented them out," she says with a laugh. The sofas were reupholstered in an Asian-themed black-and-gold fabric. David Yates asked for a grand piano for the thirty-foot-long room. "So we made a combination music room and sitting room with a fireplace at each end, and one whole long wall with the biggest bookcase I think I ever designed."

THESE PAGES, CLOCKWISE FROM TOP LEFT: *The set of the number twelve, Grimmauld Place dining room and kitchen; the rooms of brothers Sirius (top) and Regulus Black (bottom) are both disheveled but distinctly decorated; the nameplate on the door of Sirius's room.*

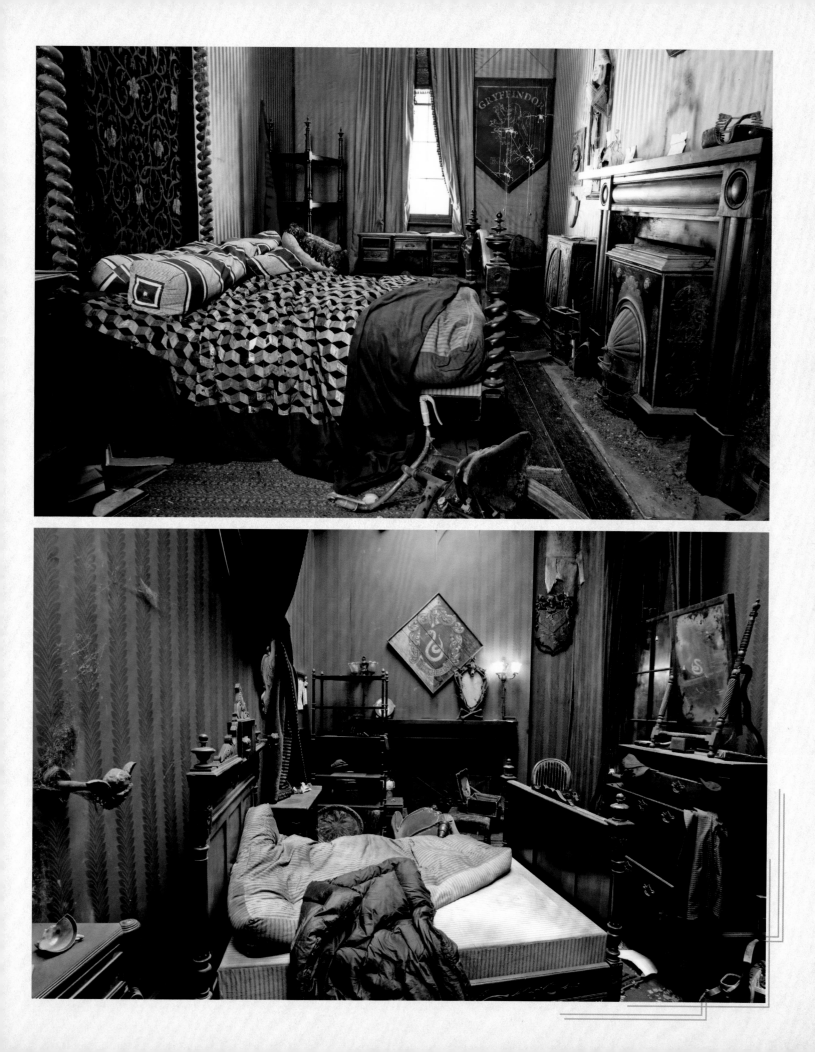

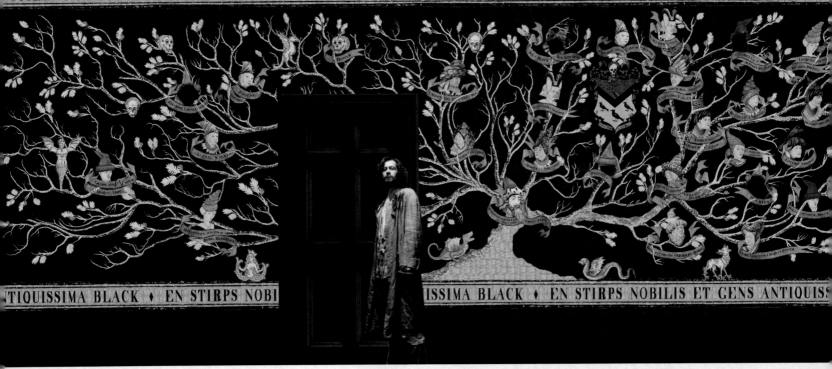

# ✦ The Black Family Tapestry ✦

The tapestry of the Black family lineage was originally planned to be a vertical wall hanging near the stairs, but the filmmakers wanted to give it more impact, and so a room was designed to house it on the second floor. The tapestry stretches from wall to wall, and to complete it, the filmmakers needed to know more of the family tree than was mentioned in the books. So Producer David Heyman called J.K. Rowling to ask what to add. What he received when the author faxed back some pages to him was five generations of names dated with births, marriages, and deaths, as well as the family crest and motto. Graphic Designer Miraphora Mina drafted the horizontal layout in consultation with Rowling and researched medieval tapestries to populate it: "I looked at a lot of tapestries to find faces that I felt visually lent themselves to be turned into witches and wizards." Then the tapestry's actual creation was discussed. "Early on," recalls Mina, "we met with tapestry makers because there was talk about having it done for real. Thankfully, we did it in the true cinema way, which was to just fake it." Stephenie McMillan located a fabric that mimicked the warp and weft of a woven tapestry, and the images were painted upon it. The disowned relatives of the noble house were burned out, and the fabric was distressed and aged.

THESE PAGES, CLOCKWISE FROM TOP LEFT: *The Black family tapestry, designed by Miraphora Mina and based on a sketch by J.K. Rowling (a photo of Gary Oldman as Sirius Black has been inserted for scale); Sirius Black embraces Harry Potter in* Harry Potter and the Order of the Phoenix; *the tapestry includes burn marks that black out the names of the family members who have been disowned.*

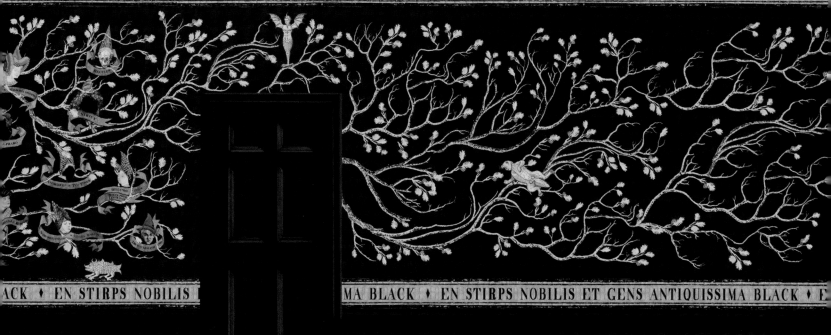

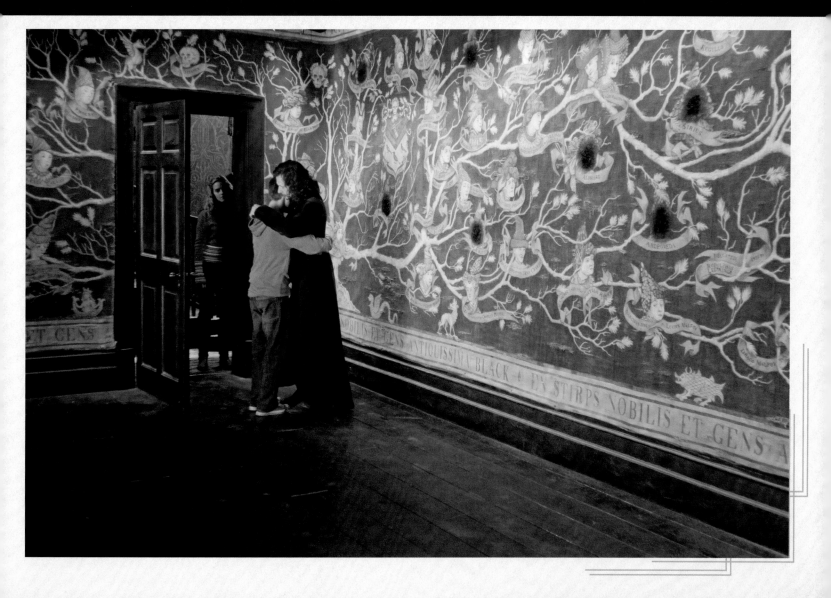

# SHELL COTTAGE

"When you see the silhouette of Shell Cottage, it's relatively conventional," says Stuart Craig. "It's a little English cottage. But when you get halfway close to it, you realize it's made out of extraordinary materials." Shell Cottage provides a place for Harry Potter, Hermione Granger, Ron Weasley, Griphook, Ollivander, and Luna Lovegood to recover after their escape from Malfoy Manor in *Harry Potter and the Deathly Hallows – Part 1* . Craig researched houses that had been made with shells but discovered that most used shells as just surface decoration. "I thought it would be more interesting to construct it with shells." But, as always, his desire was to give the house credibility, rather than a whimsy that might lessen the emotional impact of the sequence. "Basically, we used only three types of shells," he explains. "The walls were oyster shells, albeit very big ones, that could give it a solidity. We decided that huge scallop shells would make a very good rooftop, able to shed rainwater quite efficiently. And large razor shells would make good ridge tiles. It's still a fantasy building, but you'd believe that it's a plausible structure." Forty-five hundred scallop shells were used for the roof alone.

In the novel, Shell Cottage is set on a cliff, but David Yates wanted to incorporate the sound and look of crashing waves and white water, and so a beach location was sought out. The location scouts discovered good beaches all over England, but also looked in Wales, where they chose Freshwater West beach, which had huge sand dunes and, as Craig describes with a laugh, "delivered the best waves." Craig saw the overall setting as delivering something more. "I thought the notion of Shell Cottage set on a sandy beach, with the fact that the sand could drift up and partially bury the house, seemed to have strange melancholy about it."

OCCUPANTS: Bill and Fleur Weasley, Ollivander, Griphook, Luna Lovegood

FILMING LOCATION: Freshwater West, Pembrokeshire, Wales

APPEARANCES: *Harry Potter and the Deathly Hallows – Part 1, Harry Potter and the Deathly Hallows – Part 2*

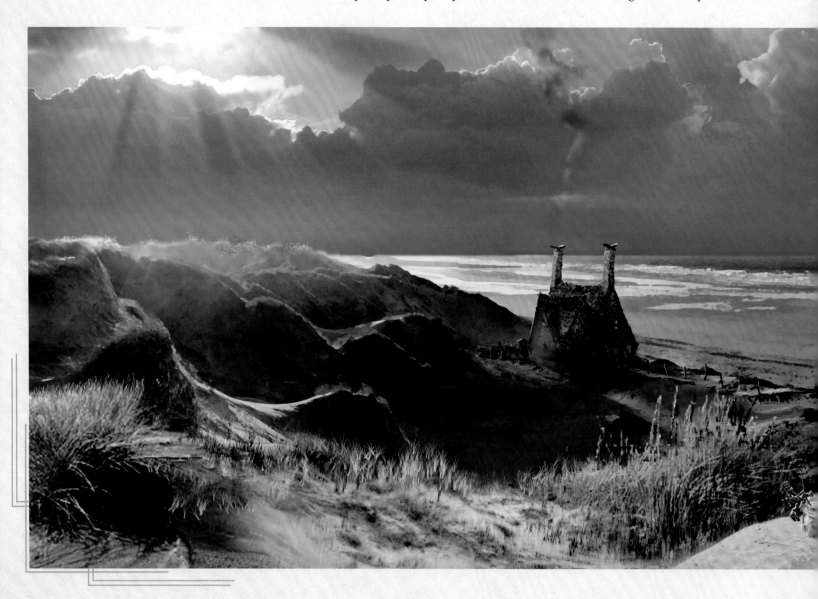

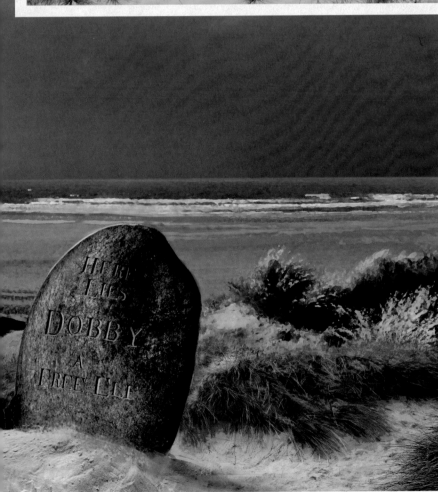

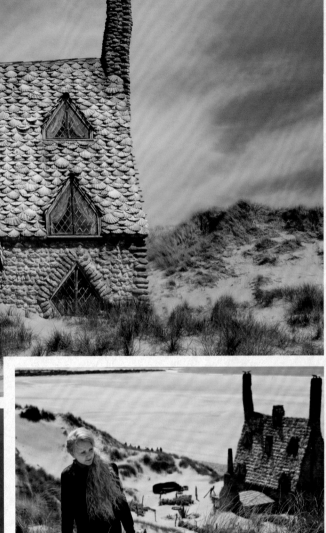

Shell Cottage was prefabricated at Leavesden Studios and then constructed on the beach in Pembrokeshire, Wales. "Building on location can be costly," Craig admits, "and just often harder to do. Those waves came at a price in Freshwater, and the price was incredibly high winds. It was really, really difficult to work out there." The winds also affected the stability of the house itself, and to keep it from blowing over, its internal structure was filled with steel scaffolding tubes weighed down with several tons of massive water bottles. "Once done, there was also the frustration of trying to establish continuity with the tide moving in and out twice ever twenty-four hours as it does," he remembers. "The beach gave us a few problems, but it gave us drama, too."

THESE PAGES, CLOCKWISE FROM TOP LEFT: *Concept art by Andrew Williamson; the final Shell Cottage exterior, built and then moved to the beach in Pembrokeshire where scenes were shot on location; Luna Lovegood (Evanna Lynch) outside Shell Cottage in* Harry Potter and the Deathly Hallows – Part 2; *concept art by Andrew Williamson.*

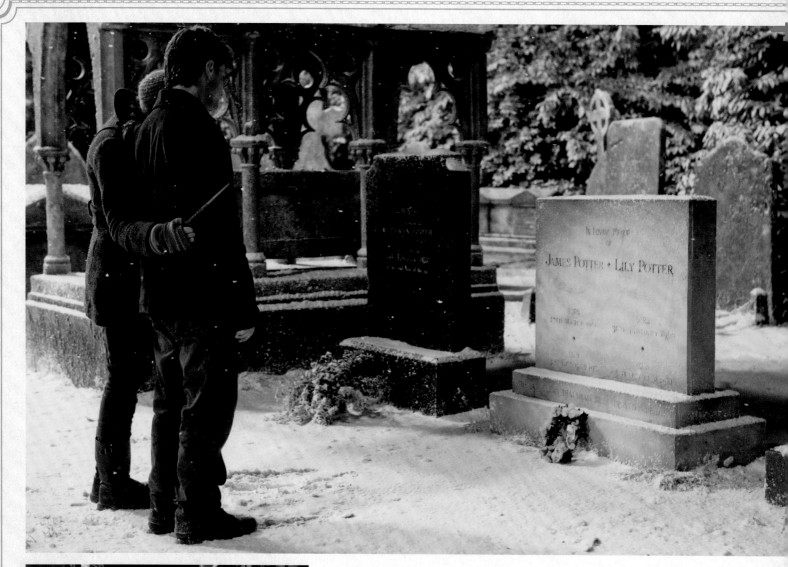

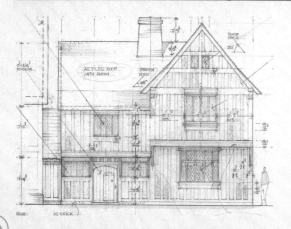

## GODRIC'S HOLLOW

The house of James and Lily Potter is seen briefly in *Harry Potter and the Sorcerer's Stone,* and later, Harry Potter and Hermione Granger travel to the small village in their pursuit of Horcruxes, in *Harry Potter and the Deathly Hallows – Part 1.* There, they visit the graves of Harry's parents and the home of Bathilda Bagshot. Production designer Stuart Craig referred back to the Potter house, as well as to descriptions in the books, when he set out to create the entire town. "I wanted to embrace something that was quintessentially English, to contrast with the Gothic style and granite of Hogwarts and Hogsmeade. Godric's Hollow is very much representative of the southern portion of Scotland, designed in the half-timbered style of the Tudor period, with brick and plaster façades." Craig and Locations Manager Sue Quinn looked for a country village that might portray the Hollow and found Lavenham, in Suffolk, which is packed with fifteenth-century half-timbered houses. "It is one of the most spectacular, most beautiful of the rich Suffolk villages," says Craig. Despite this, the decision was made to shoot the sequence on a studio lot, though not at Leavesden. "Pinewood

### "I WANT TO GO TO GODRIC'S HOLLOW. Y'KNOW IT'S WHERE I WAS BORN, IT'S WHERE MY PARENTS DIED."

Harry Potter, *Harry Potter and the Deathly Hallows – Part 1*

OCCUPANTS: James, Lily, and Harry Potter; Bathilda Bagshot; Albus, Aberforth, and Ariana Dumbledore

FILMING LOCATIONS: Lavenham, Suffolk, England; Pinewood Studios

APPEARANCE: *Harry Potter and the Deathly Hallows – Part 1*

Studios has this splendid old garden, part of the original estate before it was ever a studio," He explains. "And there is a magnificent cedar tree there." He envisioned the graveyard in Godric's Hollow underneath the spreading branches of the tree, so the churchyard, the church, and the rest of the village was built around it." Craig also researched what he refers to as traditional British churchyard cemeteries, "but there is exaggeration in ours. The stones are more monumental than you would find in a typical cemetery." The physical set was extended digitally with views of Lavenham, and the entire set was covered in snow. Special Effects Supervisor John Richardson estimates that they used forty tons. Richardson says, "We had to cover all the pavements, the roofs, windows, and trees. There were storms while we were putting it down that caused problems, but clearing it up afterward was an even bigger task." Craig admits, "Unfortunately, by the end of filming, we had ruined the lawn. But we replaced the entire garden, and they were very understanding; that often happens at studios. That's a lot of power for one tree, but it was worth it. It was a lovely tree."

THESE PAGES, CLOCKWISE FROM TOP LEFT: *Hermione Granger embraces Harry Potter in front of his parents' gravestone in* Harry Potter and the Deathly Hallows – Part 1*; views of the Godric's Hollow set at Pinewood Studios; building plans used to create the set.*

## LOVEGOOD HOUSE

The Lovegood house, where Harry Potter, Ron Weasley, and Hermione Granger learn the story of the Deathly Hallows, is where Luna Lovegood's father, Xenophilius, publishes the *Quibbler*, a quirky tabloid newspaper that serves as an alternative to the government-dictated *Daily Prophet*. Evanna Lynch, who plays Luna Lovegood, describes the house as "the perfect sort of place where all those crazy stories would be printed."

"J.K. Rowling depicts it as a black tower, looking like a giant rook, the castle piece in a chess game," explains Stuart Craig. "So there was no room for variance, but as I always try to make a good sculptural shape, the house isn't just a cylinder. It's a cylinder with a very deliberate lean and a very deliberate taper." Inside, the furniture literally takes shape around the circular design. The kitchen appliances, dressers, desks, and bookcases curve flush with the walls, which are covered in paintings inspired by Evanna Lynch's own drawings of magical beasts. "Evanna has a very artistic eye," says Stephenie McMillan, "and came up with some great ideas. The end result is wonderfully eclectic, but homey."

THESE PAGES, CLOCKWISE FROM TOP LEFT: *Concept art by Andrew Williamson of the Lovegood house; actor Rhys Ifans (Xenophilius Lovegood) confers with* Harry Potter and the Deathly Hallows – Part 1 *director David Yates; the Lovegood house interior set; a sketch by Stuart Craig.*

# "KEEP OFF THE DIRIGIBLE PLUMS."

Sign outside the Lovegood house, *Harry Potter and the Deathly Hallows – Part 1*

OCCUPANTS: Luna and Xenophilius Lovegood

FILMING LOCATIONS: Leavesden Studios; Grassington, Yorkshire, England

APPEARANCE: *Harry Potter and the Deathly Hallows – Part 1*

THESE PAGES, CLOCKWISE FROM TOP LEFT: *The interior of the Lovegood house set was designed to appear "lovingly vandalized" by Luna Lovegood; plans for the construction of the exterior of the Lovegood house set; the nineteenth-century printing press that Xenophilius Lovegood uses to print the Quibbler; concept art by Andrew Williamson; another view of the house interior.*

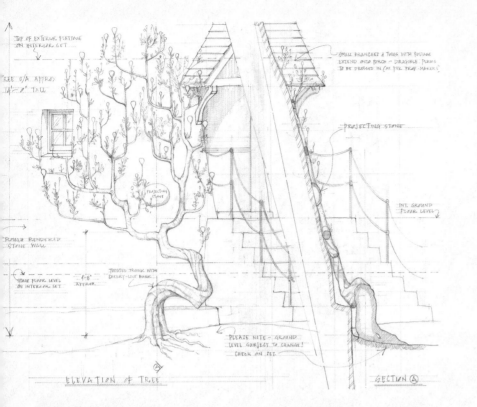

The most important piece of furniture is Xenophilius Lovegood's printing press, which has taken over the main floor. The full-sized working machine is modeled on an 1889 American printing press. Piles of back issues of the *Quibbler* are stacked on the floor around it; the graphics department estimates they printed five thousand copies between the seven issues that were "published." The current issue of the *Quibbler* circumambulates the floor on its printing belt like a roller coaster, racing up and down walls and across the ceiling.

Craig set the Lovegood house in a landscape similar to the isolated marshy ground of The Burrow. "The magical houses do better in desolate places not easily visible to the Muggle world," he asserts. While the countryside used as a background for The Burrow is set near the coast of southern England, the Lovegood residence is placed against the moorlands of Grassington, a village in Yorkshire three hundred miles to the north. "But you can believe that one is just over the hill from the other."

# "WELCOME TO THE CHARMING VILLAGE OF BUDLEIGH BABBERTON."

Professor Dumbledore, *Harry Potter and the Half-Blood Prince*

# BUDLEIGH BABBERTON

Professor Dumbledore brings Harry Potter to Budleigh Babberton at the beginning of *Harry Potter and the Half-Blood Prince*, where Horace Slughorn, the former Hogwarts Potions professor, is hiding in a Muggle's house to avoid being discovered by the Dark forces. Whilst not strictly a 'wizarding home,' the measures that Slughorn has taken to hide himself further, assuming the form of a lilac-striped armchair, are well beyond the means of standard Muggle security! When Dumbledore pokes the chair with his wand, it transforms back into the professor, played by Jim Broadbent. For the design team, the first challenge was finding a fabric that could serve as both upholstery and pajamas. "We looked for material that could serve as clothing first," explains costume director Jany Temime. "And when we found it, enough was purchased to create the pajamas and cover the chair. I also found some cord that could be used as clasps for the jacket top and piping for the chair." Special Effects Supervisor Tim Burke then took over. "We talked it through with David Yates, and realized that our approach should be to have Jim Broadbent play an armchair. A rig was created, sort of like a seesaw, that he could sit on in an armchair-like position and then allow him to rise up and deliver his performance, which is him coming out of an armchair." At the correct moment in the scene, the rig was raised and lifted the actor, who then only needed to "shake" himself out. Part of the transformation from chair into pajamas was also animated digitally. Stephenie McMillan took her cue from Slughorn's pajamas to create a complementary palette for the room.

OCCUPANT: Horace Slughorn

FILMING LOCATION: Lacock village, Wiltshire, England

APPEARANCE: *Harry Potter and the Half-Blood Prince*

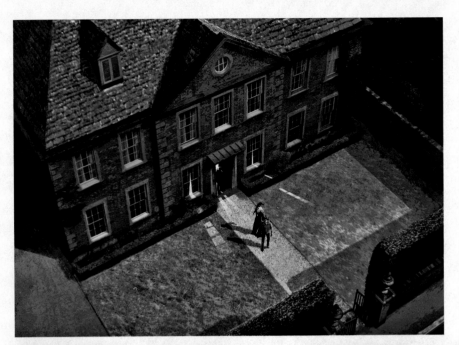

When Harry and Dumbledore arrive, the house is in a state of ruin, which is soon magically restored. To achieve this, visual effects first scanned the living room with everything in its proper place, and after a redress in which the furniture was damaged and the decorations cluttered, they scanned the room again. The scene was then shot in a mostly empty room, with only the actors Daniel Radcliffe (Harry), Michael Gambon (Dumbledore), and Jim Broadbent and a few pieces of furniture. The visual effects team then digitally animated each scanned prop to transform from wrecked to replaced as if on command, and they composited these animations with the live-action take.

THESE PAGES, CLOCKWISE FROM TOP LEFT: *Two pieces of concept art by Andrew Williamson of the village of Budleigh Babberton; Professor Dumbledore and Horace Slughorn in* Harry Potter and the Half-Blood Prince; *scattered and broken props suggest a break-in; the fabric used for the armchair's upholstery was also used for Slughorn's pajamas.*

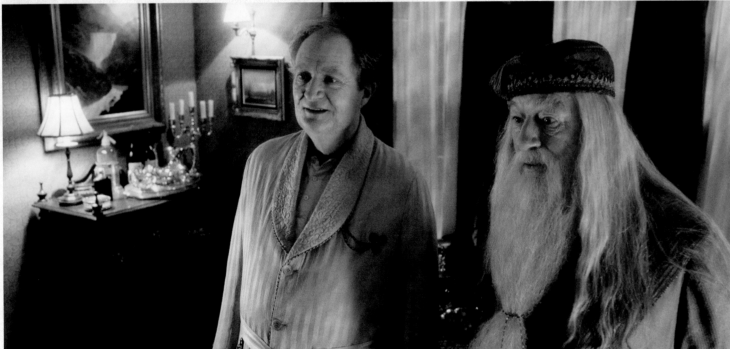

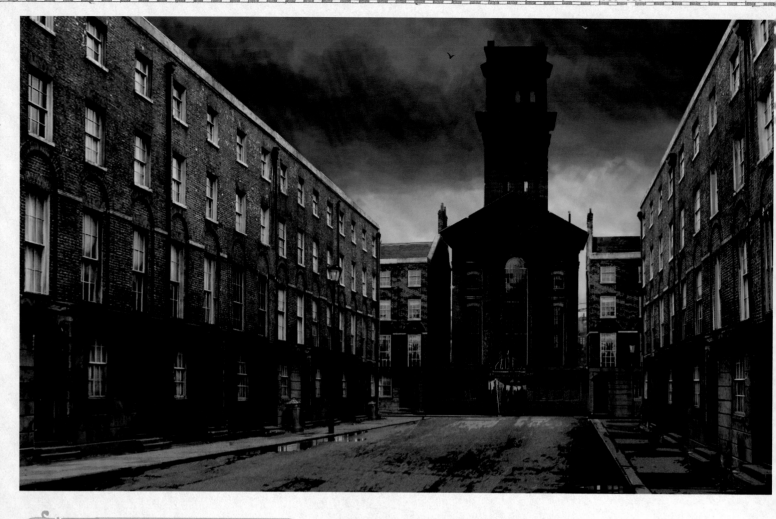

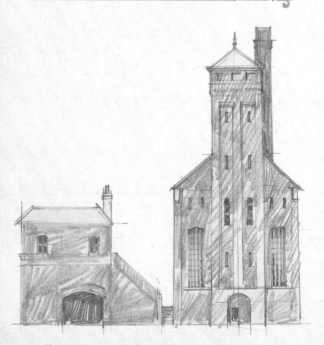

OCCUPANTS: Tom Riddle, Mrs. Cole

FILMING LOCATION: Leavesden Studios

APPEARANCE: *Harry Potter and the Half-Blood Prince*

# WOOL'S ORPHANAGE

Veteran Production Designer Stuart Craig knows that inspiration can come when it's least expected. For flashbacks of Tom Riddle viewed in the Pensieve during *Harry Potter and the Half-Blood Prince*, Craig needed to create Wool's Orphanage, the Muggle orphanage that serves as the young wizard Tom Riddle's childhood home. "Sometimes an idea can come straight out of your head, though more often it comes from something you've seen in a reference piece or physically during location scouting. Certainly, I've learned that you never reject anything. You never know what you'll bring away." Craig was scouting for locations for Severus Snape's home in Spinner's End, set in a riverside mill town. "While we were there," he recalls, "we were on one of those old, disused docks at Liverpool, and just by chance we saw this extraordinary Victorian building, so I photographed it. It's a huge red brick structure, very, very tall, dominating everything around it. Its central tower was monolithic. A real architectural curiosity. It wasn't appropriate as the orphanage itself, but nonetheless, it inspired the design."

Wool's Orphanage is set in London, not Liverpool. "We already had the façade of the partial London street built for number twelve, Grimmauld Place, so it was converted and adapted to fit another building. Now at the end of this rather derelict Georgian street is this very grim, sinister, prison-like structure." The interior of the orphanage was covered in a glazed Victorian-style tile. "This is very typical of Victorian institutions," Craig explains, "because, of course, it would last a long time and be easy to clean." Getting to Tom's room included traveling up long staircases and down long hallways in a sterile, severe environment. "It has a very distinct, oppressive look," he says. "It is not a happy place, believe me."

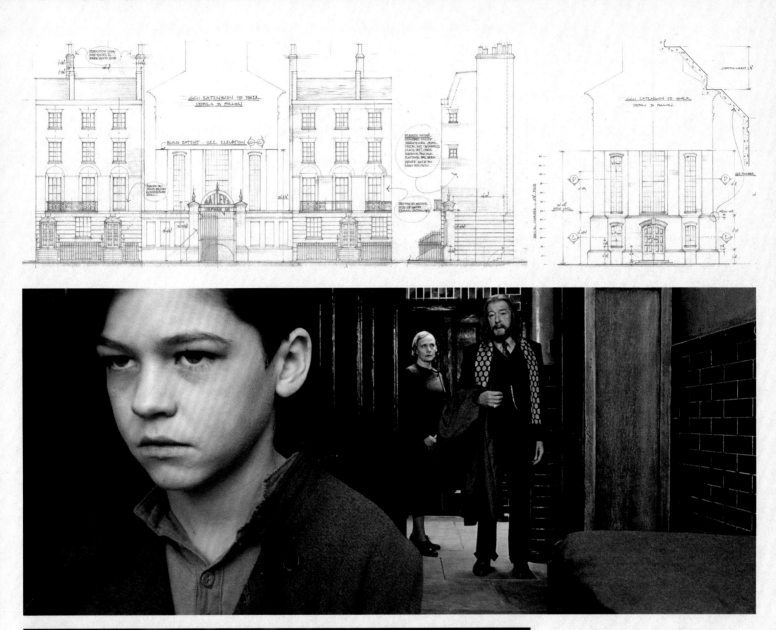

THESE PAGES, CLOCKWISE FROM TOP LEFT: *Concept art by Andrew Williamson of the street leading to Wool's Orphanage; plans for the façade of the orphanage; a young Professor Dumbledore (Michael Gambon) enters the room of Tom Riddle (Hero Fiennes-Tiffin) at the orphanage in Harry Potter and the Half-Blood Prince; concept art depicting Professor Dumbledore's ascent to Tom Riddle's room; an early sketch by Stuart Craig of the orphanage.*

## "TOM, YOU HAVE A VISITOR."

Mrs. Cole, *Harry Potter and the Half-Blood Prince*

"CEDRIC, WE HAVE TO GET BACK
TO THE CUP. NOW!"

Harry Potter, *Harry Potter and the Goblet of Fire*

# LITTLE HANGLETON GRAVEYARD

At the end of the Triwizard Tournament in *Harry Potter and the Goblet of Fire*, pretext and trickery transport Hogwarts champions Harry Potter and Cedric Diggory into a trap set up by Voldemort and Peter Pettigrew at the Riddle family gravesite. "The scene takes place in a large graveyard," Stuart Craig explains, "and I knew this was a very important set. It turned out to be one of our biggest sets." The scene was meant to be set on a small hilltop dotted with gravestones and statues, a landscape that was challenging to create. Little Hangleton graveyard was also meant to be very old, so Craig focused on evoking an ancient sensory feeling, crumbling and overgrown. "Essentially, it is about decay and dereliction. My inspiration for it was Highgate Cemetery in North London, which has been, in a way, reclaimed by nature." Built in 1839, Highgate Cemetery was planted with trees, bushes, and flowers that were allowed to grow without any restrictions.

The set was built indoors so that the eerie lighting and artificial fog that covered the misty graveyard could be controlled. "We can trap the fog inside," Craig says with a smile. "It's only practical—one good wind and the fog blows away." Another practical consideration was that shooting in the studio meant that the night scene could be shot during the day, removing the constraints on shooting child actors at night. The ground was covered with living grass, and the set was crowded with huge, moss-covered tombstones, some of which bore the names of crew members' pets. The statue over the Riddle tomb that traps Harry was originally meant to be of a beautiful angel, based on monuments studied in Highgate Cemetery. The filmmakers altered the idea to an "angel of death," given whose family tomb it was.

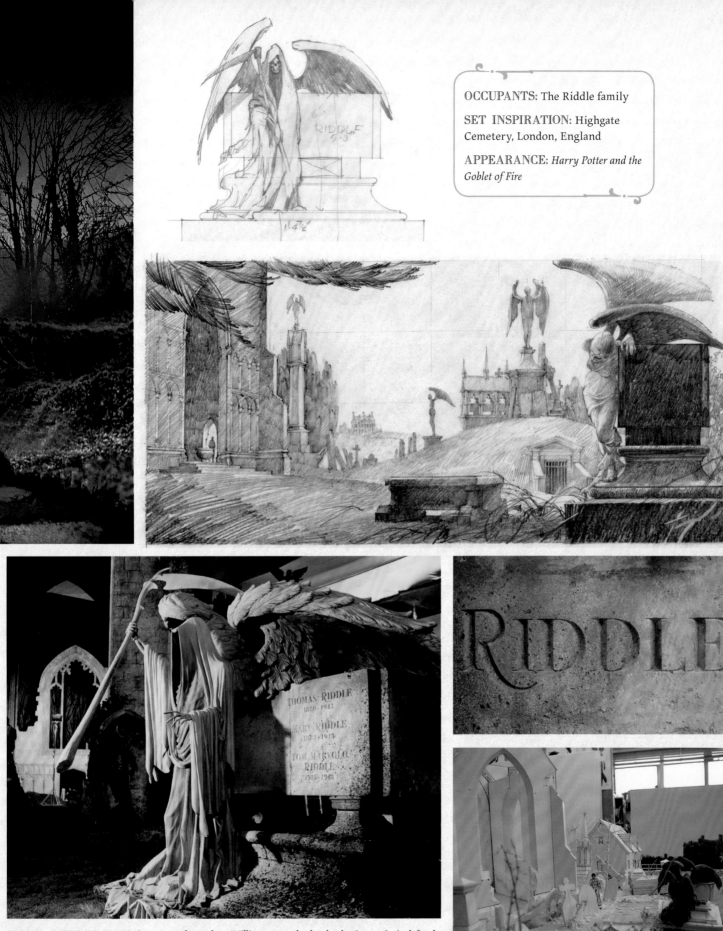

OCCUPANTS: The Riddle family

SET INSPIRATION: Highgate Cemetery, London, England

APPEARANCE: *Harry Potter and the Goblet of Fire*

THESE PAGES, CLOCKWISE FROM TOP LEFT: *Concept art by Andrew Williamson; early sketches by Stuart Craig defined the final look of the Little Hangleton set; the Riddle family tombstone; a white card model made of the set; Harry Potter and Lord Voldemort during the graveyard scene of* Harry Potter and the Goblet of Fire; *Lord Voldemort greets Peter Pettigrew (Timothy Spall).*

# MALFOY MANOR

Malfoy Manor is the ancestral seat of the pureblood Malfoy family. In *Harry Potter and the Deathly Hallows – Part 1,* the home is appropriated by Lord Voldemort as a base of operations for his growing army. The action in the films took place on two huge sets, so Stuart Craig asked himself, what size of place could house them? "In Malfoy Manor we would see a ground-floor entrance hall and a big drawing room immediately above that, linked with an elaborate staircase," he explains. "I decided to first look for an exterior to use as inspiration for the interior." One location that both he and Stephenie McMillan had long admired was the Elizabethan-era Hardwick Hall, built by Bess of Hardwick in 1590. Bess, who started from humble origins, was independent by nature and had acquired much wealth from four marriages.

## "WHAT ABOUT YOU, LUCIUS?"

Lord Voldemort, *Harry Potter and the Deathly Hallows – Part 1*

She designed Hardwick Hall, famously declared to be "more glass than wall." "Every façade is full of oversized windows," describes Craig. "And I already knew that when it's dark inside the building, they have a mysterious, slightly threatening, and rather magical quality, these acres of glass with just darkness behind." He loved the glass windows, a sign of wealth at the time, but was disappointed by its roof. "So we invented a roof that seemed more part of the magical world, with spires that, in a way, linked it back to the Gothic spires of Hogwarts, but with a malevolent feeling. In the end, I think that silhouette was terrific. And sometimes it's a good and legitimate notion to just be different for the sake of being different." Craig had concept illustrations drawn with windows all blacked out or shuttered with blinds. "So this building, with these enormous glass windows, the eyes of the building, were in fact blind, and I think it makes a very impressive initial statement to see that exterior as Snape approaches the gate on the front drive."

The interior followed through on the architectural style. "It's a pretty muscular style. We made it deliberately very weighty. We don't know how wealthy Malfoy is, but the point is he's the heavyweight and villainous, and the

BELOW AND OPPOSITE: *Concept art by Nick Henderson visualizes the Malfoy Manor gate and the remote setting of the Malfoy home.*

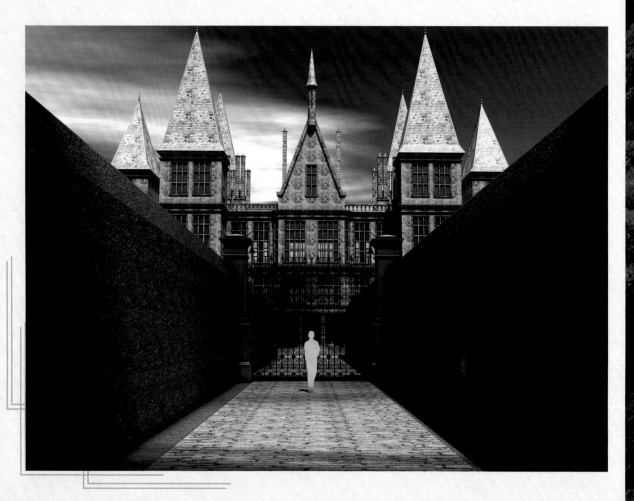

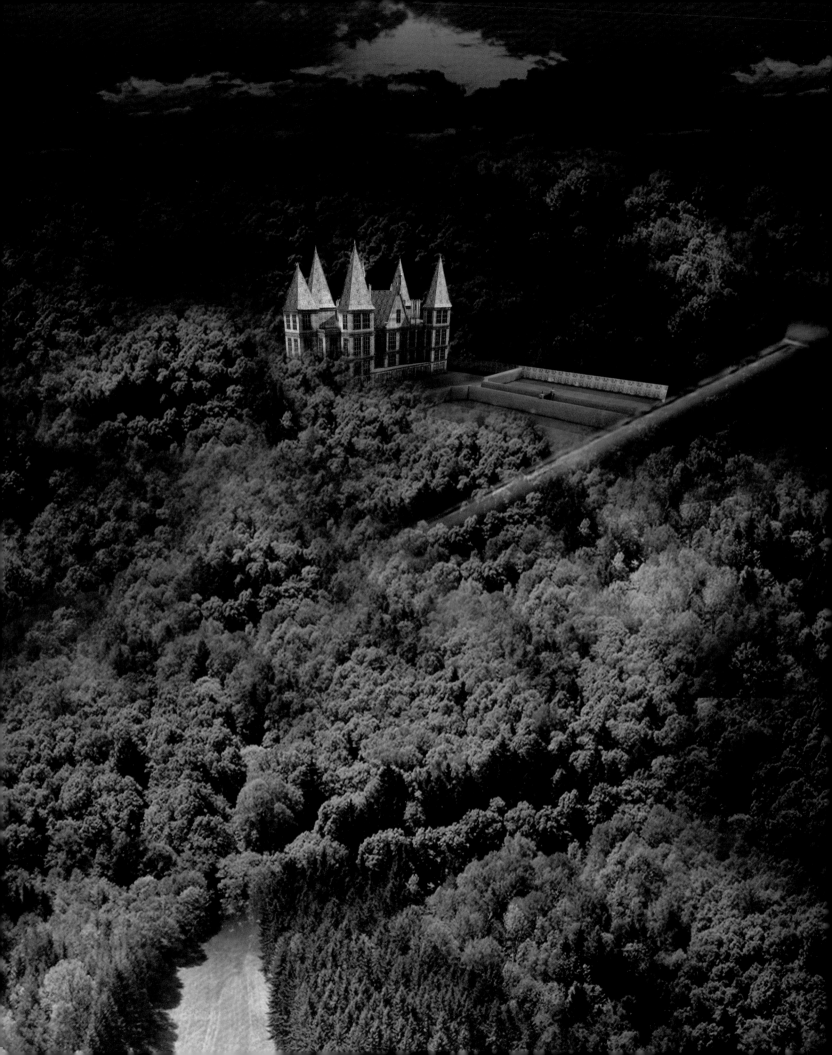

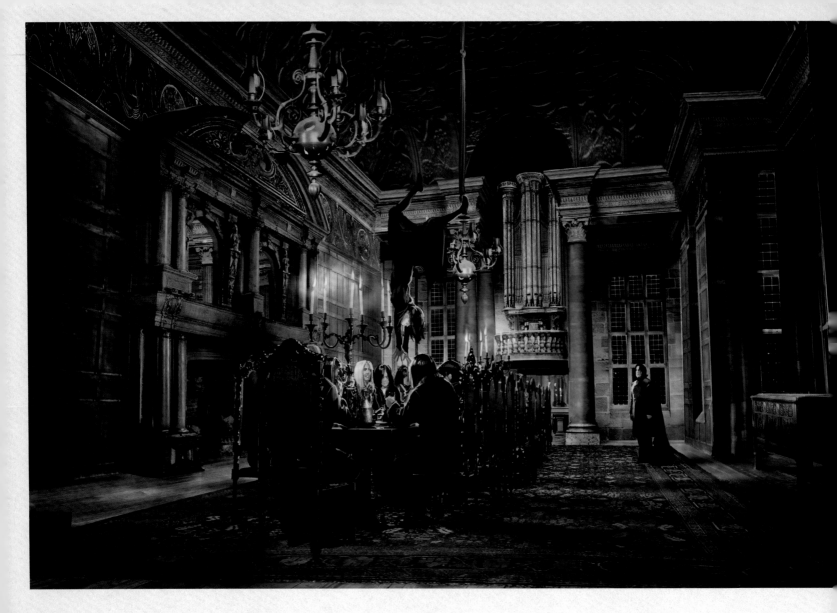

architecture is big and sinister enough to reflect that." A staircase leads upstairs, although it only goes up into a single room. "There aren't any doors. There is just that double staircase that comes up into this room," says Craig. "And there are no further doors leading anywhere." The construction, he discloses, was story-driven. "From the bottom of the house you have to be able to hear Hermione's cry as she's tormented by Bellatrix in that upper room. So there can't be any barriers to the sound traveling. It was necessary for that to be the significant and only opening down the stairwell." Craig admits that it is a happy coincidence, or really, an unhappy one, that "once you're up there, you're trapped!"

Theatrical exaggeration was employed for the room where Voldemort meets with his followers, including a tall ceiling that sports a large chandelier. Art director Hattie Storey's design is a composite of five different chandeliers, hung with glass drops that would shatter in a controlled smash when the chandelier was released by Dobby. The fireplace is one of the biggest constructed for the films, and the center of the room contains a very impressive table. "We created a thirty-foot table for Malfoy Manor," says Stephenie McMillan, "surrounded by thirty Jacobean chairs made in the carpenter's shop." The table was made to come apart into two pieces for ease of shooting. "I imagined that there were props and pieces of furniture that would be very desirable to own at the end of the filming," Stuart Craig asserts, "but that one was pretty unwieldy. I'm not sure that table would survive a move to anywhere."

THESE PAGES, CLOCKWISE FROM TOP LEFT: *Concept art by Andrew Williamson depicts Charity Burbage hanging from the ceiling at a Death Eater meeting and the basement of Malfoy Manor; director David Yates on the set of Malfoy Manor in* Harry Potter and the Deathly Hallows – Part 1; *a blueprint by Hattie Storey for the construction of an armchair in the manor.*

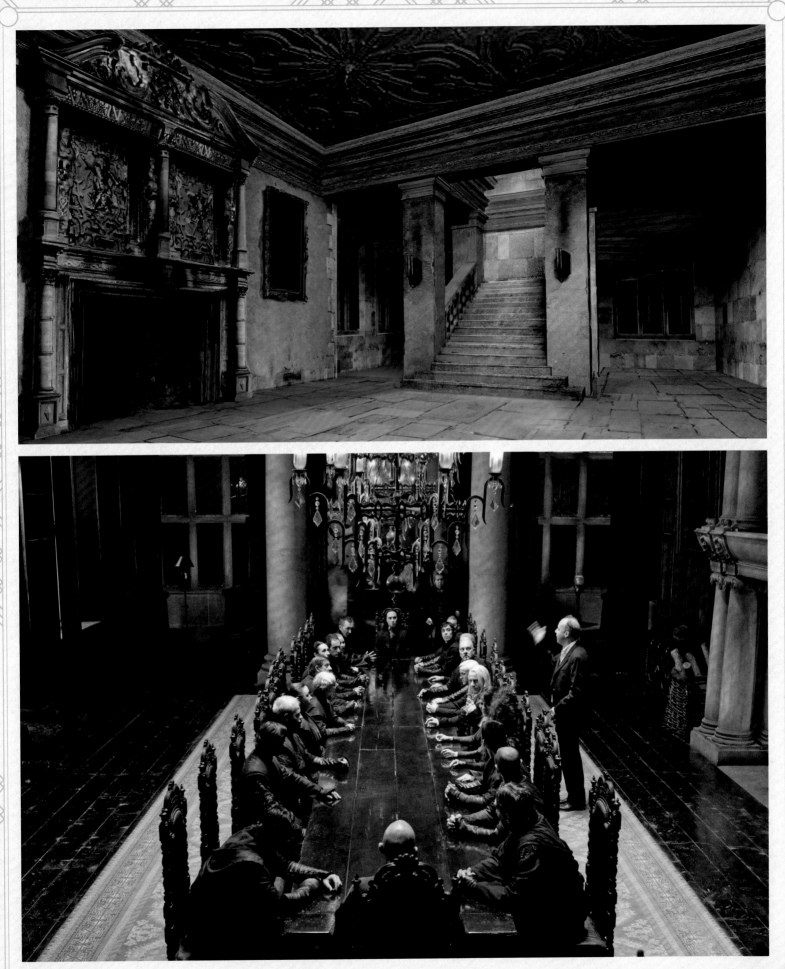

## SPINNER'S END

OCCUPANTS: Severus Snape, Peter Pettigrew

FILMING LOCATION: Leavesden Studios

APPEARANCE: *Harry Potter and the Half-Blood Prince*

Sisters Narcissa Malfoy and Bellatrix Lestrange visit Spinner's End, the home of Severus Snape, in an early scene in *Harry Potter and the Half-Blood Prince*. Set in a mill town, where blocky, square brick buildings line the streets, known as "worker's rows," it is a sad, oppressive place to live. "Mill towns in England mean the cotton mills in Lancashire and the woolen mills in Yorkshire," Stuart Craig explains, "hubs of the nineteenth-century textile industry. We went to see them, to see all these houses, which are back to back to back in infinite rows. Quite a contrast to the wizarding world." The houses were typically constructed with two rooms downstairs and two rooms upstairs with a tiny backyard entry leading to the outhouse. Craig actually considered shooting on location, but even though the buildings were intact, they had been brought into the modern era, with up-to-date kitchens and plastic extensions, so the set was built at the studio.

Stephenie McMillan furnished the Spinner's End interior with an eye toward its enigmatic, secretive owner. "In the book, Snape's house, really his parents' house, was filled with books, so we lined everywhere with books, but used primarily dark brown and blue and black bindings. That provided a sort of anonymity." McMillan also decorated the room with paintings that contained gray landscapes. As the room came together, Alan Rickman offered McMillan some creative insight. "He came onto the set to look at everything I had dressed it with. Then he suggested that he didn't think there would be any pictures in the room. I agreed, and removed them. It became even more impersonal and rather detached, echoing Snape's character."

THESE PAGES, CLOCKWISE FROM TOP LEFT: *Concept art by Andrew Williamson, for a scene that was never realized, depicts Narcissa Malfoy (Helen McCrory) and Bellatrix Lestrange approaching the mill town that is home to Spinner's End; Severus Snape (Alan Rickman) in* Harry Potter and the Half-Blood Prince; *a preliminary sketch by Stuart Craig.*

## "PUT IT DOWN, BELLA. WE MUSTN'T TOUCH WHAT ISN'T OURS."

Professor Snape, *Harry Potter and the Half-Blood Prince*

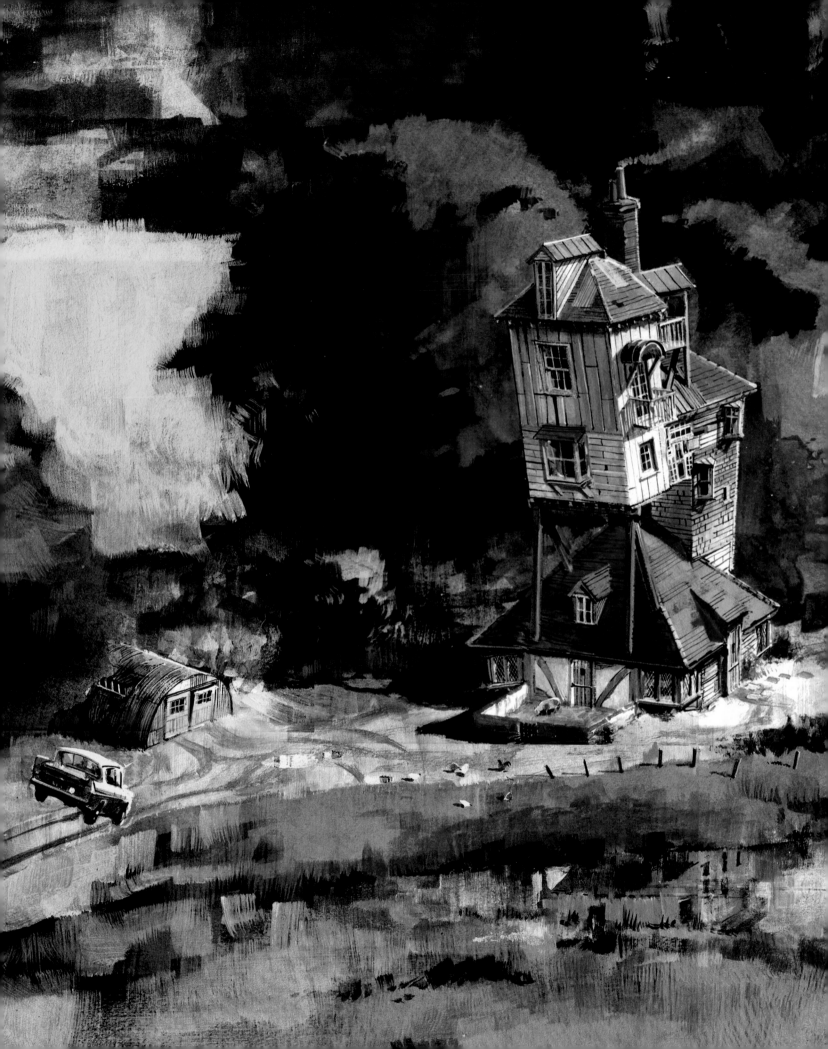

# THE BURROW

Harry Potter's first visit to The Burrow, the home of the Weasley family, occurs in *Harry Potter and the Chamber of Secrets.* Regardless of the seemingly haphazard construction of The Burrow, Stuart Craig insists there is a logic and level of reality to it. "The books mention a pigsty there, so I attached a pigsty to a very simple square, single-story dwelling that could have been a Tudor structure; this was the foundation for the whole thing." Craig maintains the assumption that from there on Arthur Weasley continued to build the house vertically, instead of laterally, and because his interest is in Muggle things, he would have built it out of architectural salvage. "Muggle salvage, really. So it is a mad wizarding home, but built out of very real, recognizable materials, readily available. His roof structure is made of salvaged timber, and it's clad with slates and tiles and wooden shingles, anything he could acquire. An amazing chimney grows through the core of it, and then all the extended rooms cling onto that, making it a sort of vertical pile." He felt that the best place to site a vertical structure was in flat terrain. "We visited this beautiful marshland just inshore from Chesil Beach in Dorset, and imagined our structure in that place. As the only vertical thing in the frame, it created an interesting visual." Placing The Burrow in a marsh also gave it a remoteness that Craig thought was important to keep it invisible to the Muggle world.

**OCCUPANTS:** Arthur, Molly, Bill, Charlie, Percy, Fred, George, Ron, and Ginny Weasley

**FILMING LOCATIONS:** Chesil Beach, Dorset, England; Leavesden Studios

**APPEARANCES:** *Harry Potter and the Chamber of Secrets, Harry Potter and the Goblet of Fire, Harry Potter and the Half-Blood Prince, Harry Potter and the Deathly Hallows – Part 1*

OPPOSITE: *Concept art for Harry Potter and the Chamber of Secrets shows the flying Ford Anglia arriving at The Burrow.* ABOVE: *An earthy color palette was used for the set of The Burrow dining room.* BELOW: *A sketch of The Burrow placed it in the field adjoining the back lot of Leavesden studios.*

The Burrow's interior was designed with a similar logic. Stephenie McMillan furnished it with disparate items and mismatched decorations. "The stairs have different carpet every third step," she explains. "None of the doors or windows match. The idea was that they shopped at secondhand shops and thrift stores, or picked things up from the curb, and that many things were acquired from Mr. Weasley's job for the Ministry of Magic. Nothing was new." The walls were decorated with artwork drawn by children of the art department crew, and the prevailing palette reflected the ginger-topped Weasleys' obvious favorite colors: red and orange. McMillan also decorated with Mrs. Weasley's choice craft in mind, employing a knitter to create pillow tops, tea cozies, and, in *Goblet of Fire*, something special for Ron's bedroom. "Shirley Lancaster knitted a huge orange patchwork bed cover with the word *Chudley* on it, for his favorite team, the Chudley Cannons, and a flying Quidditch player, which is quite spectacular," says McMillan, who lists it among her favorite props for the films.

Harry stays over at The Burrow again in *Goblet of Fire*, and he spends Christmas with the Weasleys in *Harry Potter and the Half-Blood Prince*. There they escape a Death Eater attack that burns the building down. The special effects crew used a model of The Burrow that was set afire in a controlled burn. As a result, for *Harry Potter and the Deathly Hallows – Part 1*, Stuart Craig and Stephenie McMillan faced the challenge of creating a new version of the Weasley home. "It has new timbers and it's freshly painted, so it's less eccentric than it was before . . . but only slightly," says Craig. "The furnishings are a bit more modern, a little less cluttered, as the kids are all teenagers or older," adds McMillan. "We whitewashed the floors, as if to cover burnt timber. And we've changed all the furniture, including a new grandfather clock." A few pieces made it through, luckily. McMillan decided that a big chopping block in the kitchen, in addition to the sink and the cast-iron stove, had weathered the fire. "Everything else is new but still very much in the Weasley style. It's difficult to rethink something and still give it the same flavor, but in the end it was fun to do."

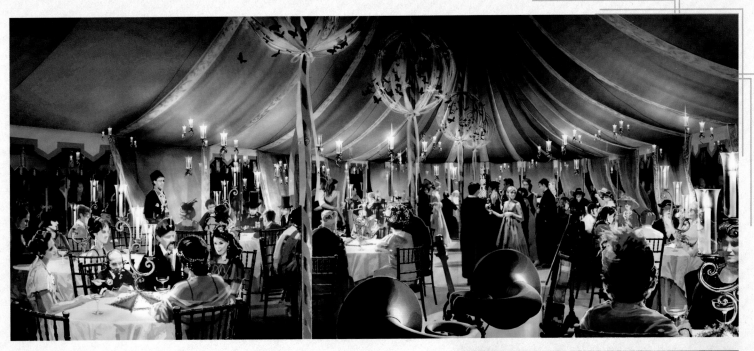

At the opening of *Deathly Hallows – Part 1*, family and friends gather for the wedding of the Weasleys' eldest son, Bill, to Fleur Delacour, the Beauxbatons champion in the Triwizard Tournament. "We decided the wedding should be, as wedding receptions often are, in a tent," Craig begins. "So the question was do we make it an extension of the Weasley house, with the same eccentricity, the same color, and rather amateurish homemade feeling, or something different." Stephenie McMillan suggested using a tent that they had in stock, once used in a Buckingham Palace garden party. "It had a pointed roof and green and cream stripes with a scalloped edge." But David Yates preferred a plain color, and so the tent became a pale gray with a purple interior. This change encouraged further thought about the wedding's design. "We decided to say that Fleur Delacour's parents had a big influence on the wedding," explains Craig. "In fact, Mr. Delacour would probably pay for it as father of the bride, and so that permitted a French influence. We really went with that, so there's a very refined soft interior, painted silks, and floating candles in eighteenth-century French-style candelabra. The whole thing has an elegant and quite un-Weasley-like look about it. It's a nice contrast with the house." Just as silver encased the Great Hall at the Yule Ball, purple trappings fill the tent: flowers, tablecloths, and carpets. The tent was woven in Pakistan, in a flameproof semi-canvas material, and lined with Indian silk printed with a scrolling French motif border in purple to complement its amethyst color. McMillan also located black faux-bamboo chairs that she thought were quite "wizardly." Black butterflies created by visual effects flit around the tent poles. Craig and McMillan were briefed at the start on the number of wedding guests. "We did a seating plan quite early on with the Weasleys at one big round table, and the Delacours at another. Additional tables seated groupings of six guests, so I think it was about one hundred and thirty people all together." McMillan declared that she never wanted to do another wedding design after this one. "It's too stressful!"

The props department "catered" four thousand artificial petits fours, small cakes, and chocolate éclairs, which were displayed on rubber molded stands. Since everything goes flying when the reception is invaded by Death Eaters, for safety, nothing could be used that was metal or glass. The four-tier wedding cake was iced in a design called *treillage*, based on trellis arches used in eighteenth-century French gardens.

Almost six hundred sets were created for the *Harry Potter* films, as diverse as a wizarding tent, a sweetshop, a Potions classroom, a hidden house, and a gamekeeper's hut. "Each film would come with a completely new collection of sets and props that needed to be built," Craig recalls. "There was always a constant stream of new work to be done, but that was what was wonderful about it."

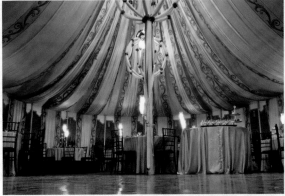

THESE PAGES, CLOCKWISE FROM TOP LEFT: *The Weasley clock has a hand for each member of the family; art by Andrew Williamson depicts the lavish, French-inspired wedding tent; a view of the set created for* Harry Potter and the Deathly Hallows – Part 1; *blueprint for the construction of the elaborate wedding cake by Emma Vane; a hand-knit blanket by Shirley Lancaster celebrates the Chudley Cannons.*

# "I THINK IT'S BRILLIANT."

Harry Potter, *Harry Potter and the Chamber of Secrets*

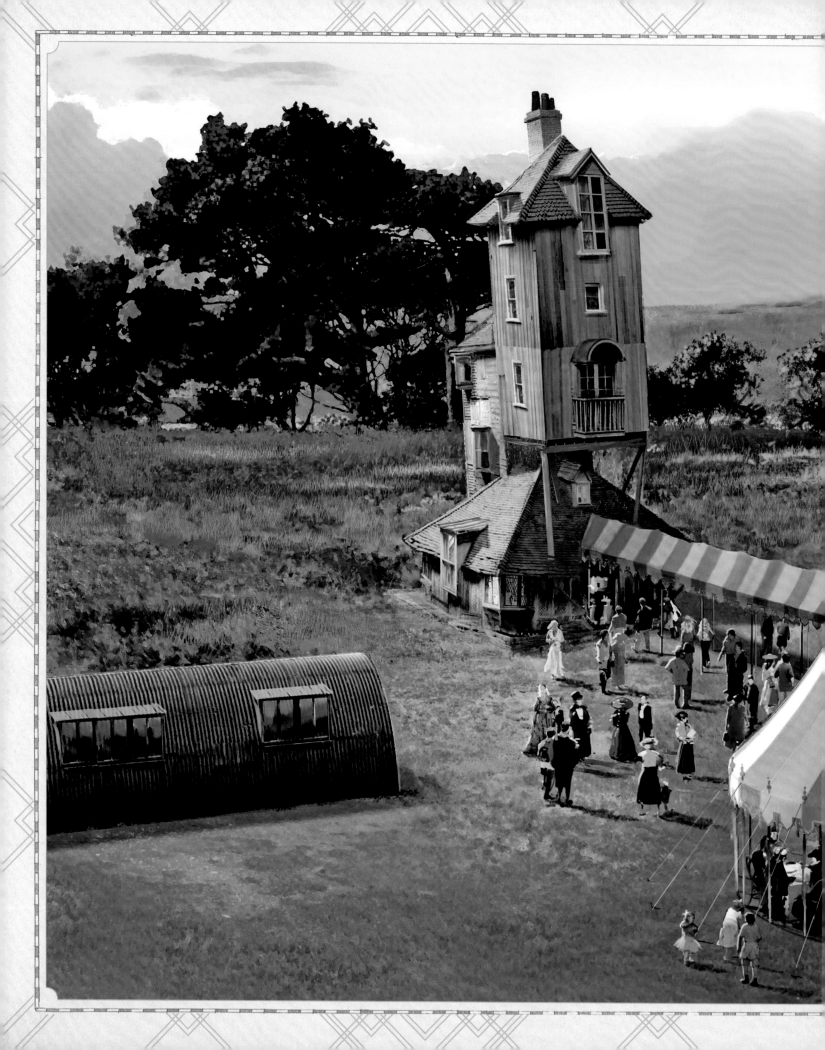

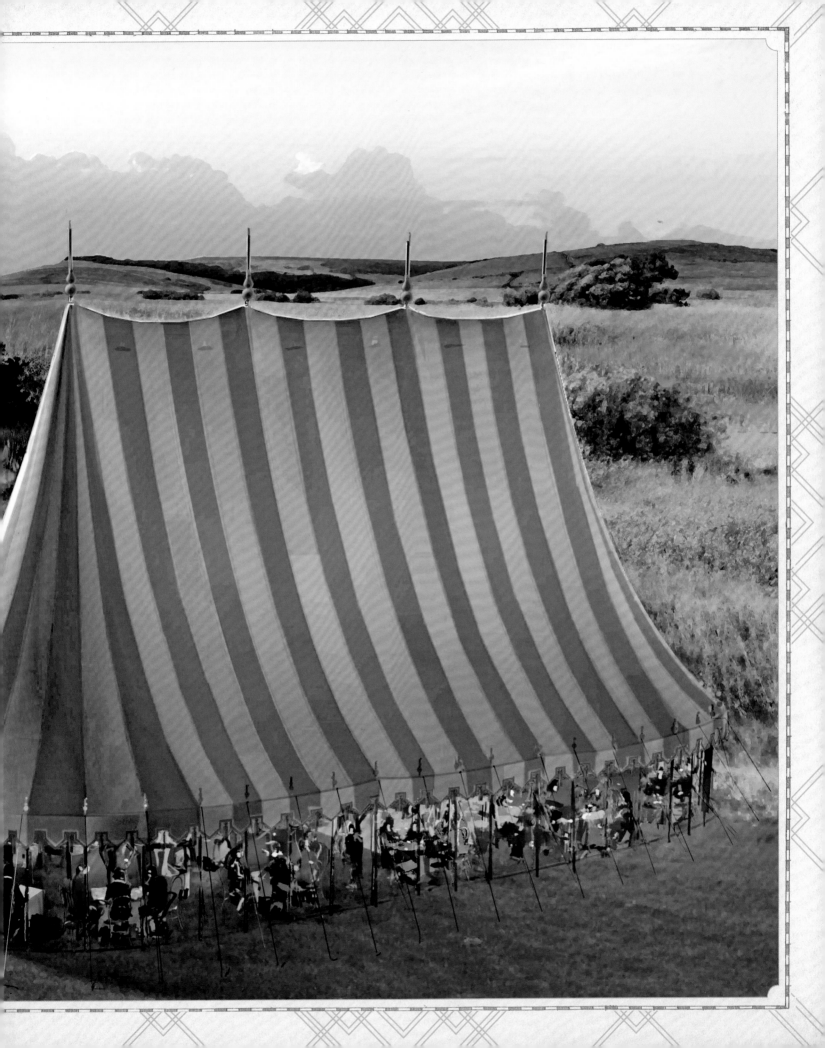

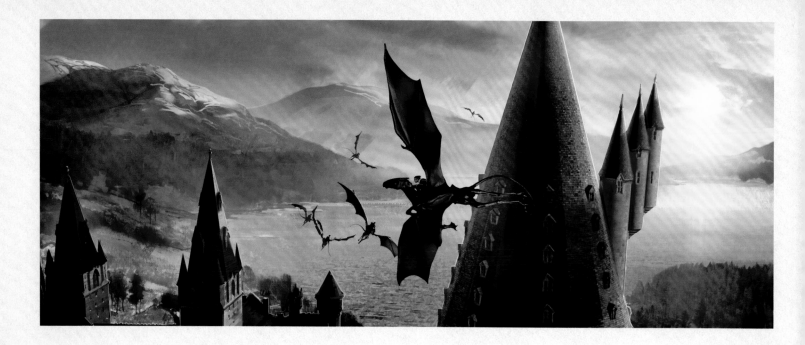

### In Memoriam

*Stephenie McMillan, set decorator for all eight Harry Potter films, passed away in August 2013. For her work on the movies, McMillan shared nominations for four Academy Awards and three BAFTA Film Awards with Stuart Craig. "On Harry Potter," she once said, "working with the very best on every level—graphics, visual effects, prop makers —nothing was impossible. I have been so lucky to have had the opportunity to dress these brilliant and huge sets . . ." Fans are even more lucky that Stephenie McMillan got her letter from Hogwarts, and we cherish the magic she brought to the Harry Potter series.*

HarperCollins books may be purchased for educational, business, or sales promotional use. For information, please e-mail the Special Markets Department at SPsales@harpercollins.com

First published in the United States and Canada in 2015 by Harper Design
*An Imprint of HarperCollinsPublishers*
Tel: (212) 207-7000
Fax: (855) 746-6023
harperdesign@harpercollins.com
www.hc.com

Distributed throughout the United States and Canada by HarperCollinsPublishers
195 Broadway
New York, NY 10007

Library of Congress Control Number: 2014957100

ISBN: 978-0-06-238565-9

*Produced by*

INSIGHT EDITIONS

PO Box 3088
San Rafael, CA 94912
**www.insighteditions.com**

COLOPHON
Publisher: Raoul Goff
Art Director: Chrissy Kwasnik
Book Design: Jon Glick & Jenelle Wagner
Book Layout: Jenelle Wagner
Executive Editor: Vanessa Lopez
Production Editor: Rachel Anderson
Editorial Assistant: Greg Solano
Production Director: Anna Wan

ROOTS of PEACE    REPLANTED PAPER

Insight Editions, in association with Roots of Peace, will plant two trees for each tree used in the manufacturing of this book. Roots of Peace is an internationally renowned humanitarian organization dedicated to eradicating land mines worldwide and converting war-torn lands into productive farms and wildlife habitats. Roots of Peace will plant two million fruit and nut trees in Afghanistan and provide farmers there with the skills and support necessary for sustainable land use.

Manufactured in China by Insight Editions

10 9 8 7 6 5 4 3 2 1